Art Center College of Design
Library
1700 Lida Street
Pasadena, Calif. 91103

DesiringPractices

DesiringPractices

Architecture, Gender and the Interdisciplinary

Edited by
Katerina Rüedi
Sarah Wigglesworth
Duncan McCorquodale

Black Dog Publishing Limited

Preface

The Desiring Practices project, culminating in a number of exhibitions and a symposium in the autumn of 1995, sought to bring together a diversity of individuals, discourses and practices to examine the role of sexuality and gender in architecture and related disciplines. A prolific response to an international call for papers led to the selection of seventeen symposium speakers whose papers form the core of this book. Ranging widely, these texts stretch definitions of 'architecture' and 'practice' far beyond their current limits and instead establish gender and desire as their common ground. This 'ground' has no singular form. It emerges as a yet-to-be-mapped territory constructed from a multiplicity of vantage points. The texts thus act as beacons for the reader; initiators of future explorations, they can, hopefully, engender further projects to flesh out the complex and always political practices of desire.

Sarah Wigglesworth
Duncan McCorquodale
Katerina Rüedi
London, March 1996

Desiring Practices
Jennifer Bloomer

The Matter of the Cutting Edge

Boys playing.
Photo: Katerina Rüedi

There may be neatness
in carving when there
is richness in feasting;
but I have heard
many a discourse,
and seen many a
church wall, in which
it was all carving
and no meat.

John Ruskin
The Wall Veil[1]

In beginning my paper with these thirty-four words from Ruskin, I have presented a ground, a playing field, if you will, for a certain kind of game. Look at the quote. In one sentence, you will find four interrelated binary pairs, three of them metaphorical: neatness and richness, carving and feasting, discourse and wall, carving and meat. I cannot imagine a ground more appropriate for entering a discussion of the politics of contemporary architectural discourse; even, perhaps of any discourse. For here we have tropes for the structural and ornamental, objective and subjective, making and interpreting, theory and practice, style and substance.

This is old ground on which many games have been played. For much of my writing and making life, I have investigated the question, "What would happen if the slope of this ground shifted?". I have never been so naive as to consider a simple reversal of slope, but have thought more about eccentric and disseminated mutations. In this paper, however, written by a me who is older and therefore believes herself wiser, I suspend disbelief in its immutability, and

accept the ground as given, assembled of multitudes of neat pairs, the units of which may slip and slide, but within each of which is maintained a disequilibrium of value.

The paragraphs that follow rest on particular conventions of difference. I have written them with hands that are beringed, lotioned, perfumed, and polished, with direction from a mind that lives in the body on to which they are attached. It is the kind of body that, in the sets of pairs body-mind, matter-form, and ornament-structure (just to recall a bit of the ground), traditionally relates to the left-hand side. Also the one which stereotypically doesn't know 'which way to move the ball'. But look: the fact that it is playing on the same field does not mean it is playing the same game.

One lovely thing about the experience of raising children as far apart in age as mine is the gift of perspective and the respect for continuity and pattern that it offers. In life so far, I have enjoyed witnessing, at close hand during three separate slices of time, the remarkable games of young children. The amazing play of boys: the ever-in-motion parry and thrust, the smashing, clamorous battles with imaginary swords and guns and airships and bombs, the itchy quest to win, to be first, to be best. Three times lived, three times (almost) the same. The protruding nose-cone and explosive cargo of the bomber drawn in pre-Bic leaky ball-point scrawl on the blue fabric notebook of Billy Joe Mullins (whose name in hearts was featured on mine) are not so different, after all, from Joshua's Mighty-Morphin-super-power-sword, with which he heroically gestures for the local gang of little girls collecting moss to make a canopy for their magic fairy tree house in my garden. And the fabulous play of girls: the mixing of sawdust tea, redolent of its production in the clash of saw and tree; the patient, collective shelling of fallen purple locust pods to obtain a swishy bowlful of seeds; the secreting of milkweed fluff in a battered cookie tin, deep in the caverns of the raspberry bramble. Their always fresh and marvellous, but also familiar, drawings of intricately rainbow-coloured birds, butterflies and fish, often accompanied by groups of small clones—mamas and their babies—mark an intriguing continuity.

Girls playing.
Photo: Gordon Wigglesworth

Temperate Rain Forest, South Island, New Zealand. Photo:
Kingston University Slide Collection

My children and their friends often keep me thinking about old and new. They
remind me, for example, of how the quarrel between the ancients and the
moderns is based on an old, old agreement (or an old, old necessity) to quarrel
that transcends the quarrel itself. I am thinking about how the desire to be the
superlative is an old, old desire; and consequently, as we live in an era based on
an always going forward, or movement out and away from what has come
before, how even (and perhaps especially) the legitimation and substantiation of
the desire to be New has become so old hat as to form a bizarre paradox
sustained by the now rather rickety crutch that is called Progress.

Much of architecture, and architectural discourse, is ever in quest of the so-called leading, or cutting, edge. This edge, this leading line of molecules of the blade that cuts into unknown territory, that whacks through the tangled snaky darkness of the jungle, through the brush and briar of the wilderness, thrust out in front, going where no man has gone before, is a remarkable metaphor indeed.

The persistent metaphor of the cutting edge belongs partially to the heroic narratives of conquest of the unknown, i.e., the New and unexplored. And in the narratives of the exploration of the 'New World', the protruding blade ever inscribing the frontier is the protagonist of a consistent allegory: the sexual conquest of a virginal female body of seductive, material richness.

> … Sir Walter Raleigh swore that he could not be torn "from the sweet embraces of… Virginia". From the beginning of exploration, then, sailors' reports… became inextricably associated with investors' visions of "a country that hath yet her maydenhead". Encouraging Raleigh to make good on his promise to establish a permanent colony in Virginia, [the investor Richard] Hakluyt prophesied in 1587, "if you preserve only a little longer in your constancy, your bride will shortly bring forth new and most abundant offspring, such as will delight you and yours".

> In 1609, one promoter of English immigration to Virginia promised there "valleyes and plaines streaming with sweete Springs, like veynes in a naturall bodie", while just seven years later, Captain John Smith praised New England as yet another untouched garden, "her treasures hauing net neuer beene opened, nor her originalls wasted, consumed, nor abused."… [I]n his 1725 verse history of Connecticut, Roger Wolcott depicted an ardent mariner "press[ing]/upon the virgin stream who had as yet,/Never been violated with a ship".[2]

This body is Nature, always female, with her primal wildness and material bounty. When, years later, the narrative tone shifts from the excitement of sweet maiden promise to the regret of rape and despoliation, the allegorical female, material Nature, and her aggressive male suitor remain.

Here, the bitter and intricate relation of children's games and adult patterns of behaviour is revealed: the fantasy of this cutting edge is not disconnected from the fantasy of the invasive bomber or the power sword. The heroic visions of exploration, discovery, conquest, appropriation, and colonisation that follow its revealing stroke have given rise to the historical realities and the interconnected cultures that architecture and architectural discourse represent.

It is interesting to ponder how, in architecture, the metaphor of the leading edge, which by the twentieth century has become paradigmatic, was and is strangely present and relevant even in the moment of architecture's appropriation of

discourses that have sought to dampen the fires in which such blades are forged. There is something beyond logic and reason at work here; I sense a fantasy, a child's game grown up.

> There's a theory, one I find persuasive, that the quest for knowledge is, at bottom, the search for the answer to the question: "Where was I before I was born?"
>
> In the beginning was... what?
>
> Perhaps, in the beginning, there was a curious room, a room like this one, crammed with wonders; and now the room and all it contains are forbidden you, although it was made just for you, had been prepared for you since time began, and you will spend all your life trying to remember it.[3]

Angela Carter's words pull a ravelling thread from the troubling perplexity of nostalgia (from the Greek, nostos—return home, and algos—pain), the sickness or longing for home, a place made distant in space and/or time. Where were we before we were born? In the beginning for each of us was a wonderful and, once left, inaccessible room: the first home, that dark, warm, saltwatery, pulsing vessel, the matter of mater.

A conjecture: every moment of significant twentieth century architectural discourse has at its generating core the needling itch, the troubling ache, of nostalgia: homesickness, that longing for something that one can never have again. And the period of so-called postmodern architecture, when a certain self-conscious nostalgia was embraced, is the least of it.

I am interested in teasing out the fibres of nostalgia in relation to the practice and discourse of architecture. In opening this subject, this word tinged with obloquy and often preceded by the qualifier 'mere', I cringe with awareness of the minefield on which I tread. But I am profoundly curious about the polarised response to nostalgia in contemporary architectural discourse. On the one hand, it is placed on a pedestal and made the universal genius of new town planning and architectural style. On the other, the one I am considering in this essay, nostalgia is covered in refusal, like a bad zit or a body odour. In the manner of these analogues, nostalgia happens; and it comes with certain pleasures.

The repression of nostalgia, a nineteenth century disease ever threatening to erupt on the skin of the twentieth, is at the core of the project of modernity; and, I think, it especially has driven, and drives, the movements of the avant-garde. The figure of the avant-garde is another kind of leading edge, another invasive metaphor, also tied to the search for the New. For decades the architectural avant-garde has engaged in a time-honoured activity: the planting of one's flag

upon intellectual territory ostensibly hitherto unexplored by other architects. But a peculiar phenomenon repeatedly occurs: the territory is then colonised under the unquestioned law of the architectural concept. Most recently this endeavour has taken the perplexing and paradoxical form of borrowing the metaphors, especially those that are spatial, of discourses that are deeply critical of this very epistemological tack, and conceptualising them as New Form. The most outstanding examples concern the appropriation of the spatial or spatialisable metaphors of Gilles Deleuze (with and without Félix Guattari)—smooth space, holey space, desiring machines, rhizomes, the fold, etc.—which he has used to tag a complex and slippery theoretical apparatus that works to undermine faith in the substantiality of epistemological structures, that authorises such conceptualisation as that in which the 'avant-garde' architects are engaged. When architectural enterprise is involved with making forms that are generated from such spatialising metaphors, architecture remains lodged in its nostalgia for form that embodies meaning, even if here the reading of that embodiment is that meaning is slippery and illusive (like an object of nostalgia). And matter doesn't particularly matter (as it certainly does to Deleuze and Guattari).

This is demonstrative of how the avant-garde, which endeavours to be new and original, fails to escape the sticky traps of tradition and convention. Furthermore,

Atlantic Wall, France.
Photo: Katerina Rüedi

Untitled. 1995.
Digital Image: Nina Pope

the ceaseless search for the New in architecture, of which making form follow philosophy's metaphors is an example, is a profoundly nostalgic project.

Design is the making of the always-in-progress New, which is always the becoming-old. The lust for the New, that telic carrot on a string, like nostalgia, is a longing for something one cannot have, for as soon as the New is formulated, it ceases to be new. And in order to stay on the cutting edge, the avant-garde architect must move on in search of the next formal frontier. This lust, driven by a necessary neglect of the weight of matter, is, in its persistent repressions, intensely nostalgic.

In its subjugation of matter by form, the modern concept of design is necessarily dominated by a nostalgia for matter, a fetishisation of an imagined absence. At the close of the twentieth century, design is driven by the necessity of the New, and, often in architecture, the Big construed as the mega, the large object that makes gestures toward infinity.

Nowhere is this more marked than in the now New offering of electronic space: the new infinite, eternal design with no bounds, no walls, infinite frontiers, no stopping. This hyperspace is the legitimate heir to the modern project. A nexus of lines, whether drawn, virtual, simulated, or troped, is the mark of a longed-for object. Form sitting on the lid of its other, matter.

Curiously, to enter electronic space is to leave home without leaving home. But in this space there is no matrix of domesticity; the cosy, sensual matter of

home has no place here. There is no room for cyber-domesticity, for electro-sentimentality. Why? Because this apparent nostalgia-free zone is, in fact, nothing if not nostalgic, a repression of 'home-sickness' so extreme that something is not quite being covered up.

The urge to virtual realities of any kind relies on a constant domestic space, whether proximal or distant. The space of domesticity, configured as 'real' space, is still, always already, the spatial envelope of the cyber-venturing subject who explores the public space of the net or the virtual space of simulation. Leaving his body, that hunk of pulsing meat, nestled in its warm, comfortable domestic space, he can project himself anywhere, into anything.

Here, the lines of nerves and the lines of communication form a continuum. Everything is transmission of information. Here is an apparent triumph of form over matter, of the rational over the corporeal. With the ostensible obviation of the body comes the repression of shame, sentiment, and nostalgia. This space replicates in certain ways the space of the infant, or even that of the foetus: interactive intake, no responsibility to any body. A nostalgic and sentimental, if not shameful, project in the extreme: the return to the natal home. That dirty place, the matter of mater. The relentless drive toward the New is a strangely directed attempt to escape from Materia, the old, generative soil, the origin. The New is never dirty; it is always bright, sparkling clean, light, full of promise, devoid of weight.

In the extravagant, blade-wielding gestures of the contemporary architectural avant-garde, there is something touchingly Cervantian, like Don Quixote, driven by serious intentions, but somehow rather endearingly misdirected. Living boldly, but fictionally-within-fiction, in deeply nostalgic visions, existing in a world of matter, but fantasising an escape into the space of imagination, a world of images. Like those little boys at play.

I would like to return for a moment to swords and nose-cones and magic houses of moss by means of one of my favourite peculiar passages of scholarship, from Camille Paglia's *Sexual Personae*:

> Construction is a sublime male poetry. When I see a giant crane passing on a flatbed truck, I pause in awe and reverence, as one would for a church procession. What power of conception, what grandiosity: these cranes tie us to ancient Egypt, where monumental architecture was first imagined and achieved. If civilisation had been left in female hands, we would still be living in grass huts. A contemporary woman clapping on a hard hat merely enters a conceptual system invented by men. Capitalism is an art form, an Apollonian fabrication to rival nature.[4]

I am interested in this remark less for what it proposes about the role of women in the construction of civilisation and the pursuit of new form, than for its positioning of the domicile, and its marked materiality, as the measuring stick of the progress of civilisation. Even that the domicile is the place where architecture would have stopped on its line of progression toward the skyscraper, that is to say, the Big and the New. The grass hut stands in for anything undeveloped, unadvanced, not extruding itself along the exalted line of progress. Furthermore, it is not simply a hut, a notation that would imply function, size, and character, but a grass hut: the material of the object delineates its 'mereness'. This picturesque grass hut suggests a notion of the primitive that the primitive hut, with its lofty theoretical accoutrements, does not. The domestic vessel of rotting material, built and rebuilt, is nothing new. It is the old, the original home, the mater, the now useless husk cast off back there at the beginnings, whenever and wherever they might be.

The selective nostalgia in which Paglia indulges so intrigues me: on the one hand, the great, rigid, erect crane angled up against the sky is a tie to a glorious past: ancient Egypt, the site of the big and new, thousands of years ago. In the next sentence, we are assured that the alternative to this sublime masculine expression, civilisation "left in female hands", is unacceptable. Why? The implication is because—*still*—the grass hut has undergone no forward-looking, progressive evolution. So here a tie to the past if evocative of progress is good; a tie to the past hitched to material and formal continuity is the object, and a weapon of, contempt.

Here we have a scheme: large and protruding and going progressively forward, versus small and enveloping and eschewing progress, masquerading as male and female, and, in the building of Paglia's thesis, Apollonian and Dionysian. But what we are really talking about here is that even more basic, old, old scheme, and of course what the Apollonian and Dionysian represent—form and matter. If we go to the customary western origin of this scheme, and from Aristotle traverse the line-space to Kant, to contemporary architectural design, we can continue to gather a tedious collection of bifolded mantric inscriptions of the formula (a word that I choose carefully here): mind and body, exterior and interior, large and small, hard and soft, sublime and beautiful, abstract and concrete, public and private, objective and subjective, culture and nature…

At this point the reader has surely recognised the simple and familiar pattern of correspondence that structures so much of the tradition of philosophical, social, artistic and literary discourses: the pattern of the gendered pair. In *De generatione animalium*, Aristotle offered an instructive architectural analogy to demonstrate the relation of form and matter in procreation: the timber (material)

Grasses Blowing.
Photo: Patricia Brown

with which the builder constructs is passive and receptive to the form idea that lies in the soul of the builder, and is inscribed in the material by the activity of his tools in the same way that the material of a female body is inscribed by Nature with mammalian form via the active, moving tool of semen.[5] And only male animals possess semen because, being connected to the two higher elements, air and fire, they are warm enough to make the form-giving elixir from their blood and to give it movement. Female animals, being of the lower elements water and earth, do not possess the heat required to produce semen, therefore mere blood trickles passively from their reproductive systems. From Aristotle's influential model of male form and female matter, to Otto Weininger's matching pair in the twentieth century Sex and Character, to the gendered children's games with which I began, the overarching pattern of the valued and devalued term has informed the lineage.[6] And the line is, in fact, a pair of more or less parallel lines defining the territory of epistemologically desirable entities— the rational, exterior, large, hard, sublime, objective, cultural, public, and masculine—by measurement against those on the other side of the tracks. And again, I am less interested here in pointing out the implications of this pairing for the status of women than in raising before it the question of the old and the new, the traditional and the avant-garde. Because things get a bit mixed up here.

Topiary.
Photo: Patricia Brown

To make a radical move, to push the edge, to make something new, one might propose to situate an architectural or philosophical endeavour in the territory of the corporeal, the interior, the small, the concrete, the soft, beautiful, private, subjective, and 'natural', and of course this has been done. But, not new now, it would be 'always already', never new, relying as it must on a move of switching the valued and devalued terms while maintaining the tidy space between.

Were we interested not necessarily in the discovery of new form, but in the invention of an instructive set of relations within a familiar space, we might find ourselves in the vicinity of the garden, the cultural artefact that is grounded in the messy, dark, nurturing decay of its own production. In the garden, we are in the space of nature and culture, form and matter, concrete and abstract, exterior and interior. And, significantly, we are in a space of the feminine and the masculine in which assignments of value oscillate and flicker in locales both esoteric and mundane. I mean, for example, the way in which the femininity associated with flowers is of positive value in the lofty world of eighteenth century philosophers and for the more terrene world of the garden club, but in the same spaces also carries negative value. This flickering of value also attends the problematic role of the matter of the garden in the discovery/exploration/ appropriation/colonisation narrative.

In the New World, after the wilderness had been cut and tamed, after the leading edge had moved on to the halting brink, came the lovingly forced

migration of seeds, scions, roots, and corms. Today, on the remains of the vast prairie, where my children and their friends play, are the vestiges of these antidotes to homesickness: fifteen-decade-old elms and oaks, and feral outgrowths of lily-of-the-valley brought west in apron pockets as seeds and pips, as tools for making unfamiliar places homes. Abiding residual documents of the westward expansion, they are, almost literally, roots of American culture. They are evidence that pinafore pockets of moss and locust pod seeds and milkweed fluff become, in time, the bearers of roots: the keeping of holiday celebrations and cultural traditions, the passing on of love and spiritual warmth, the maintenance of human connection. And the making of gardens. Furthermore:

> In the exchange of cuttings, scions, seeds, and overripe fruit (for its seeds) and in the exchange of information about their garden activities, women shared with one another both their right and their capacity to put their personal stamp on landscapes otherwise owned and appropriated by men.[7]

Humans are not only territorial animals that imagine, make forms, and vie for dominance. We are also the animals that till the soil; we are the creatures of nature that invent language, defining culture in terms of digging in the dirt, cultivation. The founding of cities is marked by a boys' game of inscribing the dirt: the Ludus Troiae, or Trojan Game, the labyrinthine marking of criss-crossing horses leaving their hoofprint paths in the soil. Boustrophedon, an ancient method of writing alternate lines right to left then left to right, is named by the pattern of an ox ploughing the earth. Culture is a bunch of animals digging in the dirt, marking their territory, hunkering down, holding on to life. The inscriptions of animals on the caves at Lascaux are necessarily tied to someone's discovering the staining power of ochre as she dug in the dirt. Here, as in the garden, cultivation and culture share a root that is more than etymological.

The garden is no more a natural thing than an electron microscope, or the Taj Mahal. As an intersection of nature and culture, however, it is slightly more complex and involuted than most things we make. Gardens are complex constructions of form and matter in which, unlike in the instrument and in the building, matter—the residing substance of nature—is the present condition, dominant over function and form. Gardens are imaginative inventions with which we try to reconcile our warring animal/child desires—for rule and control, and for the experiences called beautiful and sublime—with what we find all around us in the world: other living creatures, the order of what we call nature. Gardens are about making lovely, controlled constructions that sway and rustle, mutate, give forth exquisite and repulsive odours, and sometimes simply disappear. Gardens always threaten us with their easy potential to go utterly out of control. But this sinister potential is also their virtue.

Vast assemblages of matter, each bit of which has its own peculiarities and tendencies, garden constructions are dependent upon attention to a local and detailed materiality in an always moving balance with conception of form. The garden is "a curious room, crammed with wonders": mutating matter; palpable space-time currents; shifting colour; intimate relations with the sun's light, with the breath of animals, and with the flow of liquid; notions of order; the substantiation of histories and theories. It provides a vehicle for opening up a serious consideration of the mining of nostalgia, the longing for home, that allows the exploration of the possibilities that lie in the conversation of old and new, and matter and form. In the garden, the field and the game are indistinguishable, and the cutting edge is not a metaphor, but a material tool of the imagination.

Mottisfont Abbey Garden, Hampshire.
Photo: Sarah Wigglesworth
and Jeremy Till

To turn to the landscape, or the garden, for thinking about architecture is to make a significant and difficult turn. The landscape in modernity has been figured as supplemental, or an accessorising feature of the design of the building. To look at the potential of this architectural accessory requires a 180 degree about-face on the line of progress to look at the past, and to contemplate the riches of what came before the century of progress, that is the two that, now that we have made our turn, are receding down the line toward the vanishing point in much the same way that the future does when we peek back over our shoulder. In the webby historico-cultural panoply that comes to rest at points upon this line, we can see a number of 'accessories before the fact' of modernism, including the eighteenth century English landscape garden

tradition, with its stunning, visual culture affirming, relation with the landscape painting tradition, and the writings of John Ruskin, the fellow who, in the nineteenth century, was one of those guys who wrote a lot about the interesting relationships he perceived between architecture and culture, but built little. If, in our slight near-sightedness, we look at Ruskin's bulging pod of work way down the line, we see perhaps a quaint, but intriguing and historically important supplement to nineteenth century architecture in all its properly natural materiality and properly natural ornamentation, all set about to make a pretty architectural picture redolent of the kitschiest nostalgia. But, if we look with our handy two-way telescopes, zooming in, getting our noses right up to the matter of the reading material, we can see something quite different, something that, for me, is astonishing.

At the place on the line where Le Corbusier's and Walter Gropius' great-grandmothers and grandfathers are children at play in the garden (1837), a series of articles called "Villa and Cottage Architecture" appeared in *Loudon's Magazine of Architecture*. Here are a few excerpts.[8] In presenting them, I would like to note how nicely they accessorise the forthcoming book by Mark Wigley on the relationship of modernism's white walls and fashion.

> [W]hiteness destroys a great deal of venerable character, and harmonises ill with the melancholy tones of surrounding landscape: and this requires detailed consideration. Paleness of colour destroys the majesty of a building; first, by hinting at a disguised and humble material; and secondly, by taking away all appearance of age.

But, further on, following a note that the appearance of age in a villa is neither desirable nor necessary:

> We find, therefore, that white is not to be blamed in the villa for destroying its antiquity; neither is it reprehensible, as harmonising ill with the surrounding landscape; on the contrary, it adds to its brilliancy, without taking away from its depth of tone.

> If the colour is to be white, we can have no ornament, for the shadows would make it far too conspicuous, and we should get only tawdriness.

These seemingly prescient words, so marvellously ornamented with the language of taste, were written by an eighteen year old boy named John Ruskin, who, engaging in the literary game of the nom de plume, wrote under the signature of one Kata Phusin. Aha, you may be thinking, everybody knows about Ruskin and his psycho-sexual problems: about the frustrated love affair at seventeen which "seems to have been the effective cause of a permanent failure to attain emotional maturity" [*Encyclopaedia Brittanica*, "Ruskin"], about

the fact that his mother rented a cottage to be near him when he went to Oxford, about his unwillingness to consummate his marriage, about his ardent love at age forty for a ten year old girl. A child who never grew up, one messed-up dude, is it any wonder the boy assumed that girlish name to mark his fledgling authorship? But look again. While Kata may carry a feminine connotation in its resemblance to Kate, kata is also the Greek word for 'according to'; and phusin is, of course, the word for 'nature', from which comes the English word 'physics'. Kata Phusin, 'According to Nature', an early example of Ruskin's lifelong game-playing with words, is a rather authoritative persona indeed. Here is Mother Nature writing on the relationship of domestic architecture, materiality, ornamental detail, and colour in a manner that seems to make an impetuous leap from the grass hut to the white villa (where colour and form override materiality). And whether we see this author as Mater Natura or John Ruskin, s/he seems an unlikely source for the fathers of the white box who will come along three generations later.

But let me tell you right now that a relation of causality between Ruskin and high modernism is not what I am after here. That is not my game. I am interested in something fleshier than such a simple line as that. Let me emphasise that although here Ruskin speaks to modernism, I do not suggest that, for example, Walter Gropius or Le Corbusier had read the essays in *Loudon's Magazine*. I am making a suggestion, instead, of the possibility of looking at the past in a different way, in a way perhaps similar to the way that we look at the future: as a mineable field for inspired invention.

In Kata Phusin's discourse, the building is not a 'machine in the garden', but a supplemental element of the landscape construed as a picture, a picture composed of hundreds of tiny details, in the mind of the taste-making author/viewer. These articles form the germ of John Ruskin's 1842 paean to J. M. W. Turner, the eighteenth century landscape painter praised by Ruskin for his 'truthful' depiction of nature in all its proliferation of colour and detail.[9]

With these thoughts of architectural theory, the garden, landscape, proliferation, detail, mutating material, that our accessories before the fact give rise to, let us turn, or rather re-turn, to that accessory after the fact, the computer, and what it gives rise to: electronic space. This is again a precipitous, however simple, turn, requiring us to move 180 degrees again on our little pivot point (we are now, of course, five or ten minutes on down the line) and look at a teeny piece of the intricate panoply that now faces us, the tiny little piece that is connected to the construction of these words I speak. We will call this piece 'The Hypertextual Picturesque'. Remember that game I mentioned at the beginning of this paper? Well, this is it.

And Kata Phusin will introduce it:

"That which we foolishly call vastness is, rightly considered, not more wonderful, not more impressive, than that which we insolently call littleness."[10]

The Hypertextual Picturesque rests on the logic of the garden—the commingling of so many gendered games—exercised within electronic space. The materiality

Sands at Spurn.
Photo: Patricia Brown

of electronic space is electronic image; here form and matter have a direct relation; both are reductive versions of our conventional notions of form and matter, a situation that offers the possibility of architectures that, because obeisant to convention, escape it. In this space, the figures 1 and 0 are the codes that stand in simply for dual electronic impulse. In this space, representation and materiality share a direct, virtually unmediated relation; they are nearly in identity.

In the space of information, what is old and past—all the facts, images, and documents of history—merges fluidly with what is new and now: information, images, electronic documents. In the space of information, there is a seamlessness of time and space which mirrors (reversed perhaps) the intensity of seamless time and space that is modernism. The Swiss mercenary soldiers away from home who were the original victims of nostalgia suffered also, of course, a condition in which time and space are connected by a smooth joint.

The relationship between landscape, architecture, painting, the interweave of time and space, old and new, and constructions assembled from plethora upon plethora of detail define the old and much maligned concept of the Picturesque. The Picturesque, a collection of aesthetic theories and ideas that addressed the way we look at and make landscapes, was a phenomenon of the late eighteenth and early nineteenth centuries. Because I do not have the time to digress into a discussion of it, I will simply list some characteristics of the Picturesque:

An emphasis on detail over overall form

An emphasis on image; the manipulation of three-dimensional matter so that it conforms to a two-dimensional image

The controlled use of the distant—geography and chronology

The use of the found object, passive matter; glorification of the ugly and ordinary

A foregrounding of matter and its physical phenomena, i.e., 'Nature'

A challenge to the idea of private property

An emphasis on variety and idiosyncrasy

The object of the tourist as a collector of pictures of places

Situated between the aesthetic characteristics of the Beautiful and the Sublime—unlike either, the Picturesque appeals only to one sense: sight

Perhaps I do not need to mention that all of these characteristics of the Picturesque are also descriptive of the phenomenon of hyperspace. And listen as I read the words of William Gilpin, written in 1794:

> The first source of amusement to the picturesque traveller, is the pursuit of his object—the expectation of new scenes continually opening, and arising to his view. We suppose the country to have been unexplored. Under this circumstance the mind is kept constantly in an agreeable suspense. The love of novelty is the foundation of this pleasure. Every distant horizon promises something new; and with this pleasing expectation we follow nature through all her walks. We pursue her from hill to dale; and hunt after those various beauties with which she every where abounds.[11]

The condition of electronic space may also be described by these words of Raimonda Modiano on the Picturesque:

> [I]n the Picturesque desire remains free and unattached, continuously disconnecting from specific objects in order to return to the self or move on to another object.[12]

Furthermore:

> When desire is thus barred from its object, vision itself becomes appetite. I would like to suggest that the Picturesque traffics heavily in the erotics of denied desire, relegating appetite to the exclusive realm of vision which at once limits and sustains it. The Picturesque abounds in 'wistful gazes toward untouchable objects', and features perpetual brides and bridegrooms who never consummate their 'affair with the landscape'…[13]

Do you hear this succinct alignment of the space of the Picturesque with the space of the computer, glued together by the metaphor of the land as an object of sexual desire? But this landscape object, unlike that of Sir Walter Raleigh and others, is untouchable. Untouchable because its materiality and its desirability consist in infinite numbers of images.

To theorise a new game played on old ground by theorising an old game played in new space is logically appropriate within the necessary reflexivity of such a game. The constant pivoting and shuttling between old and new, big and small, with its concomitant confusion of good and bad, of masculine and feminine, etc., is the mechanism of the garden and the landscape. (It is also the mechanism that structures this paper.) The garden as I have used it is a metaphor of effect and event, not of formal causality. Everything is potentially on the move, coming and going, repeating patterns, but the effect of the repetition is always a little or a lot different. This construction, like the garden, is a phenomenon of cyclical consumption and production of its own materiality.

The hypertextual picturesque is an architecture of flickering texts and images. It is an aggregation of detail. It is the making of space with/in the computer that does not mime conventional architectural notions of space, but which does mine conventional architectural notions of construction. The materiality of the computer is the materiality of the hypertextual picturesque; it cannot, therefore, be reproduced in three dimensions, although it bears the potential to provide generative, methodological impetus to three dimensional construction. The hypertextual picturesque could not be classified as hyperspace, but it is constructed in hyperspace. It is a flickering hybrid (now you see it, now you don't) of something old and something new, and of the infinitely large and the infinitely small.

The picturesque landscape and the picturesque tour exist in reference to the idea of home. No matter how far one ventures into the geographical or chronological distance, there is at every point or moment the possibility of a loop in the itinerary that returns to the starting point. This home base, this safe domestic space, is an implicit, but necessary condition of the picturesque tour that parallels that of the cyber-venturer, who can always loop back to SHUT DOWN. The play of my children, the games of any children, are also played in reference to home in its material, its formal, and its metaphorical possibilities. When the games stop, the children—sometimes eagerly, sometimes reluctantly—return home, whether it be grass hut, white stucco villa, or no more than the arms of a sheltering parent. And now this little game can stop for a while. You know where to go.

This essay is a section from a book manuscript in progress called *The Matter of Matter: Architecture in the Age of Dematerialization*.

Notes

1 Ruskin, J., "The Wall Veil", *The Stones of Venice*, vol. 1., London: The Waverley Book Company, 1851, p. 66.

2 Kolodny, A., *The Land Before Her: Fantasy and Experience of the American Frontiers, 1630-1860*, Chapel Hill: The University of North Carolina Press, 1984, p. 3.

3 Carter, A., "Alice in Prague, or the Curious Room", *American Ghosts and Old World Wonders*, London: Chatto and Windus, 1993, p. 127.

4 Paglia, C., *Sexual Personae, Art and Decadence from Nefertiti to Emily Dickinson*, London: Yale University Press, 1990, p. 38.

5 Aristotle, *De generatione animalium*, (trans.) A. L. Peck, Cambridge, Massachusetts: Harvard University Press, 1943.

6 Weininger, O., *Sex and Character*, London: William Heinemann, 1906.

7 Kolodny, *Fantasy*, p. 48.

8 Phusin, K., *The Poetry of Architecture: Cottage, Villa, Etc.*, New York: John Wiley and Sons, 1877, pp. 105, 108 and 222.

9 Ruskin, J., *Modern painters: Their superiority in the art of landscape painting to all the ancient masters proved by examples of the True, the Beautiful and the Intellectual from the works of modern artists, especially from those of J. M. W. Turner esq., R.A.*, London: Smith, Elder & Co., 1843.

10 Phusin, *Poetry*, p. 66.

11 Gilpin, W., "On Picturesque Travel", in *Three Essays: On Picturesque Beauty; On Picturesque Travel; and On Sketching Landscape: To Which is Added a Poem, On Landscape Painting*, second edition, London, 1794, pp. 47 and 48.

12 Modiano, R., "The Legacy of the Picturesque," in Copley, S. and Garside, P. (eds.), *The Politics of the Picturesque*, Cambridge: Cambridge University Press, 1994, p. 214, n. 3.

13 Modiano, R., *Politics*, p. 197.

Girl and Maze.
Photo: Patricia Brown

Neutral Gazes and Knowable Objects

Challenging the masculinist structures of architectural knowledge

Introduction

In this paper I propose that the knowledge base of architecture perceives the world through the limited frame of masculinist rationality, a way of seeing which assumes the architect as objective observer and the building as transparent expression of that gaze:

> After examining many of the founding texts of philosophy, science and political theory and history, feminists have argued that the notion of reason as developed from the seventeenth century onwards is not gender neutral. On the contrary, it works in tandem with white bourgeois heterosexual masculinities. To generalise, they argue that what theorists of rationality after Descartes saw as defining rational knowledge was its independence from the social position of the knower. Masculinist rationality is a form of knowledge which assumes a knower who believes he can separate himself from his body, emotions, values, past and so on, so that he and his thought are autonomous, context-free and objective… the assumption of an objectivity untainted by any particular social position allows this kind of rationality to claim itself as universal.[1]

In this reading, the Subject-architect can, through the act of reason, make a comprehensive, exhaustive and objective diagnosis of the design problem which is therefore 'true' (and where contested interpretations are seen as unknowing, irrational and/or banal). Crucially, this gaze has come to perceive the Object-building as a mirror to itself: as a transparent, knowable and objective reflection 'of what it really is' (that is; how the gaze 'knows it', but where the act of looking makes itself invisible, so that the Object-building appears to be revealing its 'true' self). This, it turns out, can only be read through the gaze of masculine rationality, but is offered up as objective, universal and 'transparent' truth.

Here it will be argued that in England from around the 1830s onwards, the specific set of assumptions which enabled such a framework were self-consciously constructed into the 'common sense' of architectural knowledge, constructed so successfully that we still often fail to 'see' the underlying beliefs we have, both about how to make architecture and how to interpret it.[2] These assumptions are as follows:

1. Architectural form is seen to 'reflect' the society in which it is made. In the nineteenth century, many architectural writers argued that whilst in previous periods this occurred 'naturally', such an act of reflection could now only be undertaken consciously.[3] How architecture might reflect society thus became a major component of radical architectural debates. By the 1920s, it had become such a commonplace (to avant-garde Europeans at least) that architecture did/should express the Zeitgeist, that the nature of this particular connection was no longer questioned.

2. This relationship between architectural form and society was/is structured in a specific way. Society is described through abstract social concepts (such as progressive/industrialised/democratic) which are then expressed by/reflected in/analogous to/simultaneously occur in particular aspects of architectural form—such as the character of those who built it, the materials and technology from which it is built and/or the activities it contains.

3. These abstract social concepts are linked to architectural characteristics through associative references. In the modern movement, rational was paired with rectilinear, social order with mathematical order, clean lines with the progressive and modern. In the contemporary period, pluralism is connected with layering, and complex social structures with dynamic and fragmented form.

4. The appropriateness of specific sets of socio-spatial concepts as descriptions of society and/or architecture is then justified first by 'strings' of association and then through binary opposition to other adjectival chains. So rational is linked to rectilinear/plain/repetitive/industrialised, and then juxtaposed with irrational/dynamic asymmetry/complex/varied/junk. These appear to provide a 'cycle of evidence' whereby the appropriateness of an *architectural* concept-chain is justified by its similarity to a *social* concept-chain, which in turn is offered as evidence of the 'correctness' of the architectural concepts.

5. Each of these associative concept chains is then given a positive or negative value, and argued as either a true or false description of society/architecture and therefore as good or bad architecture (or social values). So if [rational +] links with stable/ordered/democratic/mass, and [irrational +] with unmappable /exhilarating/transient/individualised then interpretation depends on whether, for example, 'exhilarating' is seen as a positive or negative virtue. Such a conceptual framework in fact results in the ability to argue that any particular architectural language is 'good', that it is bad, and even that it is 'good' and 'bad' simultaneously depending on the observer's interpretation of these relative values.

35

Yet it is this 'structure of knowing' delineating cultural artifacts as visual and/or spatial *representations* of aspects of society which enables (privileged) observers to consider themselves to be making a neutral and justifiable case. Since the building *obviously* 'reflects' society, it is the architect/cultural intellectual's claim to specialised knowledge that they *in particular* have the ability to create/read that reflection truthfully and objectively. As the architectural profession at the turn of the century increasingly consolidated itself around providing 'design in advance', the claim (over other built environment professionals) to this area of diagnostic/analytical knowledge became increasingly important. It simultaneously enabled architectural professionalism to appear to be 'above' lower status problems, such as economics, building production, client taste and fashion cycles.

In this paper, such a framework is not taken as a model for either the design process or for architectural criticism. Instead it is understood as a (rather idiosyncratic and culturally specific) structure of ideas through which a *particular* view of society is articulated as obvious and unproblematic. We then have new and interesting questions to ask. Why have ideas been constructed and maintained in this form? Whose interests does such a view legitimate and which alternative interpretations are silenced? And how might new forms of architectural practice be construed that are not framed around the assumption of a neutral gaze and an ultimately knowable object, defended through this simplistic logic of abstract socio-spatial concepts and binary oppositions?

This argument has potentially surprising results, particularly in my own field of community and feminist practice, which has conventionally felt it essential to express aspects of the social in design precisely through such adjectival chains; but where, by a simple binary reversal, an aesthetic generated from a more 'authentic' design process appears to express radical social values precisely by its opposition to the 'false' formal design approaches of the architectural avant-garde. Here I want to suggest instead that politically radical design practices can and should be generated from a deliberate refusal of socially expressive architecture and by a new valuing of formal design characteristics, but that these *must be* re-embedded in real economic, political and social processes.

To do this, I will first briefly outline how architectural practice in England came to emphasise the importance of reflecting society in building form through the paradigm of a masculinist rationality and then look at how we might begin to build alternative forms of practice.

A brief history of
masculinist rationality
in architectural thought

For much of the history of Western architecture, the vocabulary of building elements (such as columns and pediments) and the methods of their combination (proportion, ratios, 'figures') have been codified by tradition and precedent—what Campbell calls "techniques in conformity with long established principles".[4] The continued use of both major western architectural languages, Gothic and Classical, right through to the nineteenth century was justified via the assumed certainties of beliefs handed down from Classical civilisation and from the Bible. Vocabularies of form were thus seen as 'external' to every day society and experience. These systems of form-making reinforced a patron's claim to supreme authority—that is an authority legitimised by religious faith and the Ancients: symbolic and social interpretations of that form were a contingent element, added through the shared associations of patron and builder. For the history of Western architecture up to about 1750, attempts to inscribe it with social meanings *built on* or played with, these existing vocabularies of elements and the rules for their combination. Innovation, then, was limited on the one hand to variations in the manipulations of parts (what we now tend to see as more 'pure' or more 'mannerist' versions) and on the other to different interpretations of the rules of combination—that is, for example, in preferring certain number or geometric relationships to others.

Of course, whilst the bodies of design and building knowledge were codified—both in the sequence of architectural treatises following the first century Roman Vitruvius and in the building lore of the mediaeval building guilds—they were also malleable, that is, they were adaptable to individual and group preferences, open to other influences (particularly from the East) and highly susceptible to fashion and changing interpretations. Whether it was Vitruvius arguing for a simpler, less decadent society in third century Rome, fifteenth century Florentines identifying with an idealised image of the Republic, Palladio impressing his clients with 'domestic temples' in sixteenth century Venice, or eighteenth century English Whigs expressing their politics in what became Georgian architecture, the 'external' language of classicism proved itself very flexible to associative (but essentially contingent) social meanings among competing social groups.[5]

However, as some historians have shown (particularly in relation to France), the logic behind these architectural vocabularies began to break down in late seventeenth and early eighteenth century Europe as the certainties which had

justified them were increasingly undermined.[6] Architectural archaeology was replacing the concept of ahistorical precedent with ideas of historical development and progress and philosophers were increasingly concerned with incorporating human action into explanations of how the world worked. These shifting patterns led to a 'new' problem—how to judge the value of any particular architectural language over others. The belief in an ahistorical, externally justified precedent had, in fact, enabled individual architects and patrons to select widely from the available vocabularies, to 'add' their own social meanings. Both the massive expansion in possible examples and the critical theories which tried to order these examples by historical evolution exposed the process of architectural selection as a problem which had to be explicitly addressed.

Simultaneously the whole process of land development, building design and construction was changing. The aristocratic amateurs and artisan builders of the seventeenth and eighteenth centuries were increasingly replaced by a new professional class (not yet sure of its various roles or disciplinary boundaries) and by the rationalised, mass production methods of new building contractors.

Many authors have argued that the publications of A.W.N. Pugin (*Contrasts,* 1836 and *True Principles of Pointed or Christian Architecture,* 1841) exemplified this changing perspective. Pugin insisted on a direct relationship between architectural form and the society in which it was made. As Macleod writes:

> few of the propositions of Pugin are new, but their collation and remarkable presentation made an ineradicable impact on the architectural scene. Pugin extracted, from Southey, Cobbett, and almost certainly Carlyle, the principles of social criticism which were current, and used them as a basis for contemporary architecture. What he produced out of this extrapolation was a distinctly new proposition: that the artistic merit of the artefacts of society was dependent on the spiritual, moral and temporal well-being of that society.[7]

In so doing, Pugin shifted associative symbolic and social meanings from their contingent relationship to externally justified pre-existent architectural forms and made them central and causal. The new (and essential) design task was to find an architectural language which could be justified through the authenticity of its reflection of 'true' social meanings. Architecture could then be judged good/beautiful when it could authentically express a good/beautiful society.

Through the nineteenth century cultural intellectuals increasingly agreed that architecture *should* reflect society but, not surprisingly, they were engaged in major struggles over which were relevant social aspects to represent and which

were the most appropriate design vocabularies for expressing them. Different authors and architects made associations by reference to the 'truth' of some or all of the following: specific types of building practice, particular construction techniques and particular societal structures and values. Possible vocabularies ranged from variations on the Gothic in the earlier parts of the century, to freer mixes of Gothic, Classical and other elements by the 1860s, and to Arts and Crafts, Queen Anne and Free Styles at the turn of the century. Thus Ruskin searched for "the expression in the object of the God-given urge in man to find material through which to breathe his spirit" as specific pieces of Gothic decoration which he believed literally embodied the workman's character, whilst Morris was much more concerned to find designed forms which could express a 'whole way of life', defined through idealised understandings of mediaeval English social life.[8] Paradoxically it was the search for one authentic architectural language which itself produced Victorian eclecticism and variety.

Here a specific form of 'knowing' (constructed around particular understandings of national identity, masculinity/femininity and social, professional and class positionings, as well as personal beliefs) was justified as objective and obvious through a series of binary oppositions which juxtaposed concepts such as rational/irrational, deep/surface, structural/decorative, essential/trivial, masculine/feminine and then judged one set 'obviously' true, precisely through both 'good' associational concept chains and through their assumed relationship to 'bad' opposites. This, in turn, was/is based on the assumed neutrality (and simultaneous superiority) of one particular Subject-gaze over others. An essential justification for that gaze itself was the need to express the assumed autonomous cognisance of the Object as architectural form, thereby centring the design process on the physical revelation of a building's 'inherent' purposefulness, on its rational coherence between forms and across types, and of the 'honesty' with which it described the society in which it was/is made.

However, such a construction of Subject-gaze and Object-building contains its own contradictory flaws. The two are linked by an associative relationship where one is seen to 'stand for' the other truthfully and without redundancy. The act of association (and the particular social values it supports) then hides itself behind masculinist rationality and appears to no longer exist. Yet associative connections are, by their very nature, partial, variable and contested. William Morris' image of how men and women should behave was both *not* obviously 'true', nor somehow 'authentically' contained in specific appearances or spatial arrangements. It is only the reinforcing power and associational 'cycle of evidence' which has such a seductive logic. Similarly Modernism's or Post-modernism's many attempts to create new, more 'correct' forms, justified as an expression of some aspect of society, does not, in reality, extricate architecture

from the messy and contested territories of economics, politics, social structures and values, culture and power. Instead, it traps architecture in an artificial 'higher' plane of moral rectitude, professional neutrality and disregard of the market, leading in the current political and economic climate, to almost complete marginalisation. Recent criticism, both politically and more popularly, of architects' and other professionals' beliefs in their own neutrality and the accuracy of their gaze, has led to a profound crisis in architecture (and a deep undermining of its assumed body of knowledge) in the contemporary period.

Modernism and masculinist rationality

The bundle of concepts around which these notions of an authentic associative form for architecture 'describing' aspects of society were consolidated into architectural 'common sense' and taken forward into a more 'unified' Modernism were structural rationality, honesty to materials, and form which expressed content truthfully. By the early twentieth century, this framework supporting particular architectural languages as a 'true' reflection of society, had began to interlock smoothly with concepts of public sector professionalism. It made sense because specific forms of building and urban design were justified by a 'true' relationship to the social values of a newly forming welfare state. They were framed as both separate and ethically superior to the free market and the cash nexus (that is, to the context within which architecture was actually produced) and required specific expert aesthetic knowledge which was offered up as simultaneously socially and ethically appropriate, rationally objective and both progressive (the best) and the (unproblematic and obvious) *norm*.

In the short-lived period of High Modernism in England (say 1945–1968) new oppositional concepts (which had been argued out intellectually, via European modernist theories through the inter-war period) became dominant among radical architects, who, during this period, tended to be concentrated in the public sector. The act of association itself was now perceived to be false; architecture was to be truly transparent, to express itself as it really was through the language of building itself (that is, structural elements and materials). The language of a radical vernacular in Britain (represented by places like Hampstead Garden Suburb, London and the huge inter-war cottage estates such as Wythenshawe, Manchester) was increasingly undermined both because it was perceived to be associated with a romanticised English past and because it did not 'express' industrialised progressive society. Instead, binary oppositions framing society as divided into (false) appearance and (true) essence, surface and depth, superstructure and base, were literally translated into architectural form as decoration (trivial, superficial, false, feminine) and structure/form (essential, honest, true, masculine).[9] This is masculinist rationality

at its clearest: a cultural elite literally attempting to represent society in built form as transparent and totally knowable—exposing architecture's (society's) structural essence and disposing of its decorative surface weaknesses. They were deeply well-meaning, but blind to the specificity of their own discourses which were taken to be obvious, rational and universal, and blind to, and often dismissive of, the interpretations of Others.

Of course, such a formulation contained the seeds of its own destruction. First, there was basic popular resistance to accepting the specific associational references of a professional and cultural intelligentsia. Whilst the structure of thought perceiving architecture (and other cultural artifacts) as a reflection of social values did have popular resonance metaphorically in language, the assumed values of design intention bore little connection to their popular transformations on reception. Modern and progressive rationality, reflected architecturally in much post-war public sector housing through use of the repetitive grid, was 'renamed' an imprisoning conformity—Alcatraz. Furthermore, these associational references were clearly not enough to articulate the complexity and variety of different lived experiences. The symbolic resonance of 'streets in the air' or 'defensible space' actually obscures rather than elucidates the economic and social interrelationships such phrases aim to describe.[10] Even worse, the physical making of these associative images has had, in return, unintended and often unsatisfactory consequences on 'the social'. Yet the consolidation of a professional aesthetic built on producer intentions and associations as both obvious and *true* meant that these alternative interpretations literally *could not be heard*. By the 1970s, however, popular opinion, whatever its political stance, was challenging these suppressions and frustrations.

The architectural establishment, in attempting to stand above the cash nexus, the market and 'fashion' had developed a body of knowledge which centred on offering 'representational' solutions to economic, social and political inequalities and conflicts. With the rise of Thatcherism in the 1980s, the Right was able to undermine not only this form of architectural expertise but also public sector professionalism in general by merely reversing certain associational connections. 'Tower Block' shifted smoothly from Utopia to Dystopia (without anyone needing to bother analysing the thick complexities of housing production and consumption processes in Britain), the Left was delegitimised and the architectural profession itself now *silenced* as the Other (in opposition to 'public common sense') without any obvious representational truths on which to rely.

Postmodern architectural knowledge(s)

Part of the decisive shift in ideas often called Postmodernity has been the challenge to the neutrality of the gaze and to the 'transparency of the object-building; the investigation of the possibilities allowed by a deliberate lack of correspondence between objects, buildings, functions and expressions of society; and the inherent problems in structuring knowledge through binary oppositions (where one is simultaneously the norm and superior through its relationship with the Other). However, as I have described elsewhere, it is clear that the assumptions of masculinist rationality remain deeply embedded in many contemporary architectural debates and practices.[11] Within architecture the delegitimation of Modernism has been predominantly interpreted as a crisis of *representation* (rather than, say, economic, political, cultural or design processes). As with previous shifts from one architectural style to another, the search is on again to find a language of form which (this time) really and truly reflects the society in which it is made. This could be a more accurate representation of 'what people want' (popular vernacular), or an expression of the essence of peoples desires (phenomenology) or the making, through form, of society's new chaotic, surface and relativist characteristics (Deconstruction). All, of course, are doomed to failure. All are constructed on associational relationships offered up as universal and authentic through the distorting lens of masculinist rationality.

The argument is, then, that whilst many architects are attempting to readdress theories of space and form, the 'space' of dominant architectural theory itself remains blurred and underexposed. In terms of a critical practice of design, the framework of rationalist masculinity which ignores its own positioning and believes in an ability to create/interpret form through the associative adjectival chains 'describing' society must be ripped open: first, to an awareness of the architects' own partiality, secondly, to the impact of engagement with the great multitude of everyday social associations and their various 'positionings' rather than merely relying on reductivist abstractions of A/not A and, thirdly, to making a commitment in both theory and practice to involvement in the economic and social beyond representation.

Changing practices

I believe that this aspect of architectural knowledge is not only now deeply undermined politically and popularly but that it has also prevented potentialities in *thinking* through the social (and especially radical social ideas) in architectural terms. Feminist and radical community architects have been equally constrained by an avant garde architectural knowledge focused on translating (alternative)

aspects of gender and class into built form. In the 1970s we believed that the architect could be an enabler for an alternative aesthetic generated by empowering people through involvement in the design process. This was, and is, a noble aim. Yet, in my experience, the frame of masculinist rationality meant an unfortunate combination. Strong (frequently abstract) political values combined with deep professional angst about making any formal or architectural choices at all. We hoped that aesthetics would somehow spring 'automatically' from a more democratic process. In reality, the language of (community) form was all to often based on designers believing they should express 'ordinary' social values through primary colours and whitewashed blockwork.

Here, I want to propose some alternative disruptions to this masculinist model of architectural knowledge as part of broader attempts to think through more appropriate forms of practice:

1. A refusal to conceptualise architecture as a mirror of society. Architectural form is not a map of social activities, nor a representation of individual psychology, social values, or 'society'. Form is free to have its own language relating to abstract concepts of beauty and quality. These are, of course, not external to society, but an integral part of culture. As such, they must be contested and argued over in order for architecture to remain alive. The key issue, though, is not architects arguing over what each formal move might represent associationally, but enabling equality of opportunity in engaging with issues of *pleasure in form*, in what constitutes beauty, comfort, elegance. One model for this is obviously Lubetkin and Tecton (chastised in their own time for 'inappropriate' formalism) but which will necessarily transmute as a result of the changed development, regulatory and procurement processes of the late twentieth century.

2. Whilst not attempting to construct universal abstract socio-spatial concepts of society through the myth of the neutral gaze, we can still use the actual and potential associational languages of relating to objects/spaces for what they are: metaphors for aspects of social life articulated by different social groups (with different degrees of power and authority). There is no 'proper' language to be found here, or moral high ground on which to sit. These are the partial and contested languages of groups competing over territory and meaning. Within the knowledge base of architecture, an acknowledgement of these languages—variable through time, space and 'position'—is threatening (whilst dismissed as trivial), because they undermine the professionals' reliance on masculinist rationality to justify the 'truth' of their solution over others. It is these languages which firmly 'place' every observer within a socio-economic and cultural milieu. It is within these languages of both representation and space-making that a way

can be found of engaging with the struggles for position around aesthetic and spatial practices which simultaneously analyse inequalities in access to and control over both territories and meanings.

3. Associational qualities linking social and formal characteristics are neither central nor fixable: they are contingent, partial and contested. What is more, associational qualities do not need to be structured around A/not A. Architects can play with and exploit different associational meanings and make new and genuinely 'believable' relationships which are knowledgeable and explicit both about their sources and their potential audience. Such languages already exist in the fashionable spaces of the privileged (clubs, designer shops, bars) but make no challenge ethically, politically or socially. What might happen if we could liberate this formal energy to a socially committed architecture-as-fashion which plays with and disrupts the categories of the status quo (secretary/boss, teacher/pupil, husband/wife)?

4. Architecture *is* deeply social as a *process*. Radical practice needs to regain a concern with disrupting existing patterns of power and control across the whole development, design, building and regulatory process. Such activity should attempt to reallocate both actual resources and formal qualities to those with the least power. It should re-engage with key contemporary issues about the free market and the public interest, about the relationships between individuals and society, about ethics and about the nature of professional roles.

5. Architectural professionals need to accept, and be explicit about, the partiality of their own gaze, and the very minor importance of issues of representation compared to economic and political processes in affecting building form.

This does not negate the value of architectural knowledge and expertise; instead it moves it to a different place. These architects would have sophisticated skills in the formal manipulation of three-dimensional spaces and an up-to-date involvement with, and broad based discussion of, design and popular cultures. They would combine this with a detailed understanding of, and an entrepreneurial approach to, how procurement, design, building and management processes impact on the actual shape of buildings and of the complexity of relationships between architectural form and its actual social use and experience by different groups in society. This is a rather different mixture to the two main available contemporary roles: on the one hand the socially and politically committed who refuse formalism but rely on associative representation to compensate for lack of political power, and on the other sophisticated formal explorations by an architectural avant-garde, also based on

associational values articulating 'the social', but completely abstracted from actual political, economic, social and cultural processes.

Only by unravelling the limitations of masculinist rationality, by arguing for the partial but committed gaze, and by analysing buildings not as knowable objects but as unstable and changing mediators of territory and meaning, can we begin to escape this impasse. Only then can we begin to define new forms of architectural practice that can be both socially responsible and develop building design that is centred on an interest in *pleasure in form*.

Notes

1 Rose, G., *Feminism and Geography*, London: Polity Press, 1993, pp. 6 and 7.

2 Boys, J., *Concrete Visions? Representing Society through Architecture 1830 -1990*, Ph.D. thesis, University of Reading, forthcoming.

3 Mordaunt-Crook, J., *The Dilemma of Style: Architectural Ideas from the Picturesque to the Post-modern*, London: John Murray, 1989.

4 Campbell, C., *The Romantic Ethic and the Spirit of Modern Consumerism*, Oxford: Basil Blackwell, 1987, p. 148.

5 There are now some excellent studies of the commissioning, designing and making of buildings in different historical periods which show all too clearly the competitive struggles between wealthy and powerful patrons supporting particular versions of Gothic or Classical forms through making associative links to their own cultural, religious and political values. See, for example, Goldthwaite, R.,*The Building of Renaissance Florence*, Baltimore: Johns Hopkins University Press, 1980, Ackerman, J., *Palladio*, Harmondsworth: Penguin Books, 1966, Saumarez-Smith, C., *The Building of Castle Howard*, London: Faber, 1990.

6 Rykwert, J., *The First Moderns: The Architects of the Eighteenth Century*, Cambridge, Massachusetts and London: The MIT Press, 1980, Vidler, A., *The Writings on the Wall: Architectural Theory in the Late Enlightenment*, New York: Princeton Architectural Press, 1987.

7 MacLeod, R., *Style and Society: Architectural Ideology in Britain 1835-1914*, London: RIBA Publications, 1971, pp. 10 and 11.

8 Swenarton, M., *Artisans and Architects: The Ruskinian Tradition in Architectural Thought*, London: Macmillan Press, 1989, p. 3.

9 For a discussion of the association of femininity and decoration, masculinity and 'essence' and notions of fashion in modern European architecture, see McLeod, M., "Undressing Architecture: Fashion, Gender and Modernity", in Singley, P. and Fausch, D. (eds.), *Architecture in Fashion*, New York: Princeton Architectural Press, 1994.

10 Boys, J., "From Alcatraz to the OK Corral: Gender and British Post-war Housing Design", in Kirkham, P. and Attfield, J. (eds.), *A View from the Interior: Feminism, Women and Design*, London: Womens Press, 1989 and "Women and Public Space", *Matrix, Making Space: Women and the Man-made Environment*, London: Pluto Press, 1984.

11 Boys, J., "(Mis)Representations of Society: Problems in the Relationships between Architectural Aesthetics and Social Meanings", in Palmer, J. and Dodson, M. (eds.), *Design and Aesthetics*, London: Routledge, 1995.

Architecture and Obstetrics:

Judi Farren Bradley

Buildings as Babies

We appear to be creatures of opposites; we prefer to perceive matters in polarities. Recently biologists have suggested that this may have a deep rooted basis in our earliest interpretation of our physical environment, including that of our own bodies. This binary of dark/light, cold/hot, wet/dry has pervaded much of our cultural development and it is in this context that I use it in this paper; that is, the binary of male/female. This is not to justify or support such a simple dichotomy, as later in the paper I hope to demonstrate how more can be gained by exploring the 'either/and' rather than the 'either/or'. However, the oppositional distinctions of male/female are so ingrained in our Cartesian world view that it is useful to use these as a means of shifting the paradigm, to propose a 'what if?'. It would be useful, however, to keep in mind the image of Escher's black/white birds, or one of his many other optical illusion etchings. We know that both images are present on the paper, but it is exceptionally difficult to read them both simultaneously.

The aim here is to explore whether the discomfort and dilemmas currently experienced by architects might find a useful parallel in feminist readings of the position of women within society and whether the methods developed through feminist theory to resist concepts of 'male' territory and confront attitudes of 'male' dominance might be usefully applied. In order to do this I aim to juxtapose architectural creativity as perceived as the core skill of the architectural profession and procreativity in the sense of human reproduction and investigate whether the gender issues raised are useful in either viewing the architectural past or proposing an architecture for the future. This parallel may or may not be fruitful in itself, and is not a fully researched academic thesis. It is written as an exploration of personal experience working within the architectural profession and as a woman and mother of two children. This brings in another binary of profession/home and the reluctance of western society to allow the private, home experiences to inform the professional, work experiences especially in relation to the experiences of parenting.

A further issue addressed is how professional structures, as demonstrated by the medical profession, have developed power over, and impacted upon, the experience of procreativity and whether this can be used as a cautionary analogy for its affect upon architectural creativity and production. In identifying

these as being predominately male attitudes and attributes I am aware that they have not been exclusive to men. Women working within both architecture and medicine rely upon the patriarchy of the profession and adopt male stereotypical attitudes and responses. This is not therefore sex specific nor about the experience of working with men per se.

The architectural profession believes itself to be in sex/gender terms 'male'. Traditionally, as an individual, the architect is 'male' in terms of his gender model and both exhibits and reinforces stereotypical 'male' attitudes and practices in the way in which he conceptualises the profession's core activities and acts out its function. This is reinforced by, but not necessarily created by, the statistical fact that by far the majority of the profession is both male and empowered, as it is also predominantly white and middle class. One of the major factors contributing to this assumption is in its professionalisation, an organisational ethic, which reinforces concepts of patriarchy and ensures the retention of intrinsically 'male' gender models for its membership.

The proposal of this paper is that the architectural profession is no longer considered by either the immediate environment within which it operates, that is, the construction and property industries, or the larger, more disparate groupings of society as being 'dominant' and 'male'. In briefly considering an alternative, such as the consequences of the architectural profession being sex/gendered 'female', does this paradigm shift actually liberate the activity of architectural production and offer alternative modes of architectural practice?

The length and nature of this paper precludes any detailed chronology of the creation of male dominance in human reproduction. I am relying on the work of others such as O'Brien[1] and Lerner[2] to ground the analogy between production and reproduction, which is a necessary starting point from which I propose to develop an architectural analogy. O'Brien painstakingly maps the historical, theoretical analogy between production and reproduction and develops this into an analysis of human reproduction as a dialectic. The alienation of the male from the processes of human reproduction, yet the maintenance of power over it, is a key issue for my analogy.

O'Brien tracks back from classical antiquity to the present day to demonstrate the various myths and methods whereby male dominance is established in relation to human reproduction. She also reveals the background from which 'femaleness' is associated with 'first nature' and biological imperatives whereas 'maleness' is allowed to develop 'second' and even 'third nature' if liberated from the imperatives of biological reproduction. To vastly simplify the background to this paper, I have chosen to divide the key stages of the

chronology as Myth, Means and Maintenance—the creation of mythic structures to lay initial claim to reproduction/production; the means whereby these claims are further substantiated through the creation of a knowledge base and the development of power; and the maintenance of power through patriarchal structures such as professionalism.

In *The Creation of Patriarchy*, Lerner suggests that the "appropriation by men of women's sexual and reproductive capacity occurred prior to the formation of private property and class society. Its commodification lies, in fact, at the foundation of private property.".[3] The relationship between Capitalism and Patriarchy cannot be adequately explored here, but will be referred to later.

Myth

In *De generatione animalium*, Aristotle attributes the essence, spirit and final form of the child to the sperm [the man] and only the 'material' to the woman. Further discussions from the *Symposium* attribute 'culture' features in human development to the male, and only 'nature' attributes to the female. In Judaeo-Christian culture the differentiation and hierarchy of male/female is substantiated via the Fall. It is even suggested that the concept of earlier matriarchal societies may have been a means of legitimising current patriarchy, since their failure to survive could then be attributed to their being either inherently flawed or inferior to the patriarchal societies they encountered. The myth of the duality of human nature was incorporated into early models of physiology by Hippocrates and continued well into what we might now consider the era of medical science. Physiological reasons were still being used into the late nineteenth century to justify the exclusion of women from higher education such as Edward Clarke's *Sex in Education* of 1873.

It is possible, therefore, to parallel O'Brien's description of the male view of reproduction with the view of architectural production as circumscribed by the dominant concept of the design process. The design is the seminal idea which contains the complete programme for the project. The idea or ideal of the project is always superior to the reality and the physical production of the ideal can only either fulfil the potential of the ideal, or fail it through incompetence. The 'fathering' of the design is perceived as a relatively short term and limited, individual act. The architect maintains dominance over the physical producers of the building using these hierarchies of idea and action.

Means—
The Appropriation of Knowledge

In pre-industrial societies within which mythic structures underpin social and hierarchical structures, the keeping of mystic secrets is used to create and substantiate the dominance of one section of that society over other sections. The dominance of male over female is no exception. This is despite, if not because of, the obvious actual power that women have in relation to the survival through regeneration of that society. From the keeping of secrets develops the privileging of information/knowledge. The development of the written tradition from the oral becomes the first disembodiment of information and moves knowledge from the intimacy of the private to the arena of the public. The drawing as visualisation is particularly important as a means of appropriation. In her essay, "Science and Women's Bodies: Forms of Anthropological Knowledge", Emily Martin describes the effect of visualisation as a primary route to scientific knowledge:

> Anthropologists have claimed that the privileging of the visual mode of knowledge is particularly likely to lead to forms of representation impoverishing the complex whole that actually exists. The emphasis on observation, on mapping, diagramming and charting, has meant that the "ability to 'visualise' a culture or society becomes synonymous for understanding it".[4]

The release of the ban on dissection and its recording in drawn form facilitated not only the development of the medical profession into what had been formally considered the 'natural' process of childbirth, but also made easier the dissemination of this knowledge within proscribed groups. Physicians could now 'know' more than the women who gave birth. Their knowledge was of a higher order and they acted within empowered environments to both extend and apply their knowledge. The profession of medicine could develop the characteristics we still see as common contemporary professional structures in the area of obstetrics.

Many of the readings of the history of architecture identify key 'moments' in its development. The disassociation of the act of design from the act of construction is one of the primary 'moments'. The precise moment at which this occurred can not be defined but it became increasingly visible from the Renaissance onwards as architectural propositions were developed via the intermediary of the drawing. It is not surprising that the theoretical architectural project develops at this disjunction of theory and realisation. This can be seen as another form of disembodiment. The drawing becomes its own context and

becomes self-referential. The abstraction of the act of design and its alienation from the construction process also makes not only possible, but necessary, the eventual professionalisation of the architectural occupation in the nineteenth century.

From the Renaissance, just as the visualisation of both city and architecture develops with the drawing, the parallel is true for the human body. The female body before and after birth is mapped and recorded. Leonardo's anatomical drawings of the child in the womb are some of the earliest of such drawings that present this image now so common as to be part of popular culture, as opposed to specialist publication. The drawing or the image is the development of the intellectual appropriation of the actual. The analytical drawing is not an imitation, it is a physical expression of an impossible state, one from which time is excluded. Its insidiousness lies in its apparent ease of assimilation by those with little or no experiential knowledge.

Maintenance—The Professionalisation of Medicine and Architecture.

The work of Anne Witz[5] and others has proposed that the characteristics of a profession as previously explored in a sociological analysis of professions by Johnson,[6] can be developed to reveal the inherent patriarchal character of a profession. The analysis of a profession as an institutional means of controlling occupational activities is therefore also an exploration of the means whereby power is achieved, retained and utilised. The trait and process definitions of Greenwood[7] and Wilensky,[8] however, are most often those identified by members of the professions themselves as constituting their dominant characteristics. Witz refers to Crompton's work addressing the issues of gender in relation to professions and professionalisation, and talks about the sex-typing of professions as the occupation emerges as a recognisable, functionally differentiated entity.[9] The role and characteristics of the physician and architect as members of a profession developed as 'male'. The role was therefore devised to be carried out in an expectation of commanding the responses of trust, acquiescence and respect.

The professionalisation of medicine occurs relatively early and fulfils all the necessary requirements of such a process. The architectural profession is unusual in relation to all other professions in that its occupation is one centred on design creativity, and which uses the other characteristics of a profession to both empower itself and retain control of design as a mystic act. The 'body of knowledge' in the case of architecture is in no sense as clearly defined as in

other professions, such as law or medicine. We were after all the only profession to include 'delight' as one of the areas, along with 'firmness' and 'commodity', through which we wished to retain the authority to provide for others.

The development of science and the shift in perception from the time of the Enlightenment left the synthetic act of design as increasingly difficult to support. The intellectual fragmentation of the world, begun in the seventeenth century, became the fragmentation of production in the eighteenth and nineteenth centuries. The move to industrial production over hand production intervenes in the relationship between architect and constructor. There is a significant reordering of the hierarchies and one of the contributing factors behind the professionalisation of architecture was to formalise roles and relationships which were already untenable, in a time of shifting boundaries.

The Feminisation of the Architect

Maria Mies states that, "Patriarchy… constitutes the mostly invisible underground of the visible capitalist system".[10] With the development of capitalism began the commodification of architecture. The development of abstract land value, the needs of an industrialising society and the expanding middle classes all offered opportunity to architects. Capitalism also provided the impetus to harness science into the development of technologies for production. The machine as metaphor becomes dominant for universe, nature, society and body. Malfunctions or even events which disturbed the equilibrium, such as childbirth, were seen as requiring intervention and control. The history of the relationship between medical science, women and childbirth has been well documented and explored by many feminist writers. The perception of childbirth as, "a potentially diseased condition that routinely requires the arts of medicine to overcome the processes of nature," has been one of the major foci in feminist analyses and campaigns.[11] The perception of everything as a technical or functional issue requiring technical intervention dominates.

The increasing use of technology in obstetrics has reinforced the disembodying of the foetus and arguably the privileging of the foetus over the mother in popular perception. The in-utero fibre optic camera has provided extraordinary images of the earliest moments of fertilisation and development. The massive magnification provides luridly coloured images easily juxtaposed with those from the space probes such as GIOTTO and GALILEO. The foetus floats in the internal universe and 'man can go boldly' in the best Trekking tradition. Stranger than fiction, the closing sequences of Stanley Kubrick's 1968 epic *2001 – A Space Odyssey*, have their own progeny in medical textbooks and popular journals.

In architecture, this development, although later to impact, probably caused an even more radical shift in society's perceptions of the architect. Architects were judged in relation to performance criteria and reinforced their acceptance of this through the public competition system. Even so, architects failed to fully establish the position of respect and influence that they considered was their due as 'fathers' of architecture:

> Simply because a large portion of those styling themselves architects have proven themselves incompetent to plan and build, and others incompetent to design a beautiful building, the public have not a respect for us as a body of professional men...[12]

The attempt to re-establish a credible new role for architecture was made through the Modern Movement within which the heroic, potent architect was to be recreated. Power had undoubtedly moved from the arts to the sciences and the applied sciences. The new architect would rely upon a technical body of knowledge from which to synthesise his designs. As a technical, as well as an artistic innovator, it was hoped that a dominant position could be re-established and the profession re-invigorated. But it could be argued that other gender/power perceptions had also changed. The very physicality of mechanical production was allied to masculinity. Returning to Aristotle, it was believed 'natural' men were best suited to productive activities. Hence, through the machine, man could create prolifically—the combination of science and technology apparently offered the possibility to solve all problems, including those of human reproduction. Marx, too, had seen the machine as the means by which the labouring man was to be liberated. However, it should be remembered that female reproductive labour had not been included in the discussion of labour and the economy by either Marx or Engels. As machines replaced human labour, so biological technology might eventually supersede female reproductive labour and eradicate the possibility of 'failure' through total control.

For the architect, the development of pseudo-scientific methodology offered a new myth of total knowledge and therefore total control of the design process. Prefabrication and machine production offered total control of the design product. Both are prominent aspects of Modernism. The machine aesthetic was developed to meet the intellectual and philosophical needs of the architect and thus establish the modernist 'tabula rasa' from which architecture could be reinvented. This completed the commodification of architecture because it set it within the framework of classical economic models. The star system retains this myth and colludes in the public perception of architecture as commodity. Howard Roark stands astride his edifice, institutions urge marketing strategies of product differentiation and the architectural press produces 'pin-ups' of the latest models.

Why, then, has this reinvigorated profession failed to emerge in the UK?

The profession is experiencing a severe crisis of confidence and has found that the environment in which it is now operating appears to be rejecting its claims of virility and potency. In comparison with an increasingly dominant construction industry which derives its power from its technological base, the architect and the architectural profession is unable to maintain its claim of ownership of the architectural process or product. The subsuming of design into production with the rise of contractor-led design-and-build makes blatant this loss of power. The architect is now the invisible producer of ideas destined to service the production industry and relegated to a private world of domestic design sub-contractor.

With the Ronan Point collapse in 1968, and the technical and social failure of many of the other systems in use, the profession retreated. Prototypes usually fail and most buildings are prototypes. The social power base of the profession has been significantly eroded with the demise of the public sector. Subsequent economic recessions have debilitated the profession's financial base, which is essential for the maintenance of a professional superstructure. The nature of much of architectural education, with its emphasis on individual design talent rather than collaborative and supportive inter-relations, has made it difficult to create a common vision.

In attempting to rebuff the apparent onslaught from the construction industry, the profession has attempted to seek the protection of the client by laying claim to being the champion and protector of his best interests. The expert client is unable to perceive the need for such protection. Being mainly finance and performance driven, he finds more in common with the large contracting organisations. The inexpert client is wary of the architect as an unnecessary expenditure as the commodification of architecture leads him to look to the end producer, the builder. The new analogy might therefore be client 'father', architect 'mother' and construction industry 'obstetrician'. Perhaps the architect is the 'surrogate' mother who is 'used' for the essential synthetic act of forming the embryonic design but who cannot be trusted to 'deliver' without the caesarean section offered by the increasingly professionalising construction industry.

Me? I'm only a Mother

Is this analogy of any use at all, other than as entertainment? It could be. If the architectural profession is still believing itself to be essentially male sex/gendered and reliant upon outmoded ideas of paternity as its means of

claiming ownership of architecture, it would explain its current identity crisis. If it is still reliant on paternalism and patriarchy as a means of maintaining and sustaining the activities of the profession it is not surprising to find those structures increasingly unsustainable. However, if it is prepared to consider that being gendered 'female' by the external environment might be a very positive position from which to reassess its position, then the analogy, although stretched, might prove fruitful. As women architects, we should seriously consider whether the models of architectural practice to date are in any way relevant to either current and future society or our sanity as practicing architects. In attempts to demand the right to practice within the profession we all too often collude in the structures which have not only excluded us, but have brought the creation of architecture to this sorry state.

In offering some suggestions for women to escape from the oppression of patriarchy Gerda Lerner states, "Where there is no precedent, one cannot imagine alternatives to existing conditions".[13] In the case of the architect it may be that the precedent sought resides in female experience rather than male and that this transformation will transform future practice.

The various readings of female experience, especially those related to childbearing and mothering, offer possibilities and lessons for future action. Much of feminist analysis can be very crudely split between what Janet Sayers in *Biological Politics* describes as "Biological Existentialism and Socialising Theory".[14] Another split offered by writers such as Maria Mies is the sex/gender dialectic. In the former, the biological processes of the female body are taken as being the main determining feature of the feminine experience, both negative and positive. The celebration of this femaleness therefore constitutes the key to equality and empowerment. In socialising theory, much of the negative experience of women is attributed to societal and not biological factors, and apparently 'instinctual' behaviour is perceived as a product of complex social influences and education rather than biological imperatives.

To translate this into an analogy for architecture, we are already seeing one view that the 'creative' act of design is analogous to biology. This view claims that the uniqueness of the act of design, and the necessary attributes of a designer are the reason for the present oppressed situation of the architect and that the best means to remove the oppression is to celebrate and concentrate exclusively on design, to divest the architect of all other activities and to reject any other aspirations. A contradictory view is that whilst design is accepted as an integral part of the role of the architect, it does not limit the ability of the architect to contribute fully to other areas of activity and that much of the circumscription of the role of the architect has come from the constraints set upon it by external

pressures and internal paradigms. This latter view rejects any attempt to mystify architectural production and seeks to ground it within other forms of production.

As Sayers suggests, whilst the two former positions are mutually exclusive there is much interesting territory which lies between these polarities.

The following are offered as points for further discussion:

The concept of mothering rather than fathering offers a new paradigm. In mothering/nurturing, as a gender activity, not a sex-specific activity, a different time scale and long term commitment is suggested. This requires a different order of decision making. It is essentially contextual and, within it, has inherent contradictions which cannot be resolved but must be balanced. The relationship between the labour of creation and the future of that which is created should be more fully explored. We should accept the present context as unstable and seek to creatively exploit this situation. We should not seek power through the adoption of particular roles or activities but rather seek influence wherever and whenever. The confusion between control and comprehension should be addressed. At best, we may better comprehend the many influences and contributory factors which inform architecture. However, the myth of control and finite solutions should be consigned to history.

The empowering of women in relation to their own health and the health of children has been achieved through a combination of the demystification of professional knowledge and the education of women by women, with an emphasis on experiential rather than theoretical knowledge. Architectural education at all levels is, in the main, refusing to do this. Experiential knowledge of architecture lies, to a great extent, outside the profession. We offer no incentive to source this knowledge in anything other than abstracted theoretical ways which deny the potency of individual or collective experience. The profession has constructed an elaborate filter through which it attempts to assimilate information. The interdependency of architectural production should be emphasised and it should be developed as an inclusive, and not exclusive discipline. This should be reflected in the architectural constituency.

In education, the abstraction of architectural design away from the material and social world into theoretical and philosophical territory should also be resisted. This is not to deny the intellectual and substitute the manual, but, it is to challenge and positively discriminate in favour of the material and contextual, in order to balance the current situation. In the profession, the converse may be true, but no-one, least of all society, is served by the current

schism. The failure of the architectural profession to address the reality of the environmental and social as they are experienced and not as they are theoretically sanitised is scandalous. It is a form of architectural monetarism where propositions are applauded as theoretical successes when they create catastrophic failure at the level of implementation. I believe the push toward specialisation within architecture, including the specialisation of rarefied design within education and practice should be resisted. If the quality and availability of architecture is circumscribed by economic and political constraints, then these issues need to be addressed at the level of economic theory and political action. A retreat into ever more dense architectural design theory is a form of escapism that serious practitioners must recognise.

The architect as hero, whether male or female, must be rejected. A reinterpretation and revaluation of architectural history could go a considerable way to challenge the cult of the 'star' architect and their bonny 'babies'.

We should beware of falling into the sex/biology or gender/society trap. The fundamental physical nature of the 'biology' of architecture and the theoretical/cultural assessment of it must be balanced. Single solutions should not be sought. The recognition of the particular, the experiential and the actual should be seen along with the interconnectivity of the political and the environmental. We must consider ourselves as part of society, not apart from society, and recognise that the practice of architecture infers responsibilities and should not be used to protect the rights or private fantasies of its practitioners.

Other female role models for the profession have already been used. The often quoted analogy of the architect as prostitute has been used throughout architectural history, and vividly by Katerina Ruedi in her recent lecture at the RIBA. The often heard plea of "what we need is good clients", might be interpreted as looking for the right kind of protector. Our search for Patrons rather than Clients follows this idea. If the appearance of masculinity, as opposed to the retention of a level of real influence, is important, then the architectural profession can take comfort in its current popularity as the sensitive but still heroic character in a bevy of recent Hollywood films. Wendy Wasserstein's, "Designing Men", in a May edition of *The New Yorker* says it all.

Notes

1 O'Brien, M., *The Politics of Reproduction*, London: Routledge & Kegan Paul, 1981.

2 Lerner, G., *The Creation of Patriarchy*, London: Oxford University Press, 1986.

3 Lerner, *Patriarchy*, p. 8.

4 Martin, E., "Science and Women's Bodies: Forms of Anthropological Knowledge", Jacobus, M., Keller, E, F. and Shuttleworth, S., *Body/Politics*, Routledge, 1990, p. 69.

5 Witz, A., Professions and Patriarchy, London, Routledge, 1992.

6 Johnson, T., *Professions and Power,* London: Macmillan, 1972.

7 Greenwood, E., "The Attributes of a Profession", *London: Social Work* no. 2, 1957.

8 Willensky, H., "The Professionalisation of Everyone", *American Journal of Sociology*, no. 70, 1964.

9 Crompton, R., "Gender, Status and Professionalism", *Sociology,* no. 21, 1986.

10 Mies, M., *Patriarchy and Accumulation on a World Scale*, London: Zed Books Ltd., 1986, p. 38.

11 Wertz, D. C. and R. W., *Lying -In: A History of Childbirth in America*, New York: The Free Press, 1977, as quoted in Treischler, P. A., "Feminism, Medicine and the Meaning of Childbirth", *Body/Politics*.

12 Seth-Smith, W. H., *Builders Journal*, 30. 09. 1896, as quoted in The Centenary Issue, *The Architects Journal*.

13 Lerner, *Patriarchy*, p. 223.

14 Sayers, J., *Biological Politics*, London: Tavistock Publications Ltd., 1982.

Bainbridge Copnall: Mural Painting, Jarvis Hall,
Royal Institute of British Architects, London, 1930's
Reproduced by Permission of Herbert Felton, British
Architectural Library, RIBA

Venise

Victor Burgin showed his video *Venise*. The video is constructed from simultaneous and parallel relationships: between the cities of San Francisco and Marseilles; between a detective and the woman he is hired to follow; between Hitchcock's film *Vertigo* and the French crime novel on which the film is based; between memory and place. *Venise* is basically 'about' the production of an identity in relation to places, the history of those places, personal memory, and other people. Commissioned by the Ville de Marseille in 1993, *Venise* was first screened outside of France at the Museum of Modern Art, New York, in 1994.

Victor Burgin: The moderator of this symposium, Helen Mallinson began by commenting on the heterogeneity of the backgrounds of the participants. She concluded that they were all coming from different places. Perhaps I should begin, then, by saying a little of where I came from. The last time I spoke in London in an architectural theory context was at the Architectural Association in Bedford Square. That was in 1987. The paper I gave on that occasion was published, in the same year, in *AA Files*. The title of the paper was "Geometry and Abjection": on the one hand, rational and rationalist schemas of space; on the other hand, the desiring entropic body which attempts to inhabit them. I moved to the US in 1988 and contributed to a symposium in the School of Architecture at Princeton University, for which I suggested the title 'Sexuality and Space'. So again, pretty much the same sort of problematic. I gave a paper on that occasion called "Perverse Space". So I thought that a symposium called 'Desiring Practices' had to be right up my street, because that is where I am coming from. I've gathered my theoretical writings on that problematic in the book that Bert Hallam mentioned—*In/Different Spaces: place and memory in visual culture*—which will be published by the University of California Press in 1996. I do not intend to read a chapter from that book now; what I do intend to do is show a video. The video is about desire in and for a city, and, in a sense, desire *of* a city—in this case, the desire of the city of Marseilles to be represented. In France, the government gives money to cities to hand out to artists to do things in the cities. Often, much as in Karen Burns' remark about the visiting architect who rides into town and rides out again having 'fixed' things, the artist will ride into town, sign the city with his own particular signature and ride out again. He or she may then go to other cities and leave the same

signature on that city. In the late 1960s I wrote a paper called "Situational Aesthetics" in which I argued for more of what John Cage called "response-ability", hyphenating 'response' and 'ability', the ability to respond to specific circumstances. So, how to respond to Marseilles? As I say it was a commission to make a work about a city. I was in Paris in 1992, teaching at the Ecole des Beaux-Arts, and I got a phone call from Marseilles to ask if I was interested in going there the following year to make a work. I said I would be interested and they said: "Well, in that case, could you tell us now what it is you intend to do". Off the top of my head, I said I wouldn't mind doing something about the relationship of San Francisco to Marseilles. There was a pause, and then the person on the other end of the line said: "What relationship?" But the idea of a relationship between the two cities has an immediate sort of plausibility. On the topographical level, they are both cities built on hills that surround bays. They both have polyglot, heterogeneous, multicultural populations. There was also something else which interested me. Having got into the practice now of hopping between California and Europe, I have started to think of the Atlantic pretty much as a large interior lake—like Lake Erie—in the space of European and US cultural hegemony. But if you leave the Bay of San Francisco, and head out to sea, you head towards a radically different cultural sphere, that of Asia. And if you leave by the Bay of Marseilles you head out into the radically different cultural sphere of Africa. So I was interested in the marginality of those two cities—in that always relative sense. The tape was made for Marseilles, it has a number of references which are very specific to Marseilles and which may very well escape people who aren't familiar with Marseilles and its history.

Something about Marseilles itself, very briefly. It's probably the oldest recorded French city. It is believed to have been settled first by the Phoenicians around about 600 B.C. Other people from the Mediterranean basin followed, Greeks, Romans, people from Corsica, from Spain, Italy, people from Northern Africa, from sub-Saharan Africa, and then from further afield—like Asia, and more recently, from Eastern Europe. So Marseilles has always been a breccia of different languages, races, ethnicities and so on. Marseilles got rich in the nineteenth century on the proceeds of the French colonial adventure. In 1830 the French took the port of Algiers, and then the rest of Algeria. From 1830, until it gained independence in 1962, Algeria was a protectorate and then a *département* of France. Marseilles became rich on the proceeds of the port trade—the shipping, taxes, and so on. It also profited from the industrial processing of raw materials coming from Africa—sugar, oil and so on. If you go to Harrods, you can still find *Savon de Marseille*, Marseilles soap. All of that business more or less came to an end, almost abruptly, with independence. Now until that time, Marseilles hadn't developed in the way that most French cities have developed: with the rich *centre ville* and then the *banlieue*, the suburbs,

which contain the largest number of young, unemployed, recent immigrants and so on. Marseilles never developed that centre/periphery opposition, it has always been a sort of aggregate of village societies, and the identity of those little village societies has been centred upon an ethnic identity, a racial identity, a language. Yet, nevertheless, there was always a politics in Marseilles which cut across those different racial and ethnic identities and that was the politics of the workplace. In France, Marseilles was always known as 'la ville populaire'—the working class city—and it was the politics of the workplace which dominated until the beginning of the 1980s. In 1982, Gaston Deferre, who had been socialist mayor of Marseilles for twenty-two years, lost his seat. In 1984, the first National Front deputy was elected to the Marseilles Assembly, and what had been a purely working class politics gave way to an increasingly racist politics—which exploited the situation that essentially began in 1962, with the end of colonisation, when the wealth of industrial employment declined very rapidly and when the population simultaneously increased by some 1.5 million of *pied-noirs* (French citizens of North African birth) who came to settle in and around Marseilles. So that was the background to the situation that I went into.

I went into that situation in Marseilles at a time when they were literally trying to re-invent the city. They had a lot of money which Mitterand had hard-wired into Marseilles and there was no way that—after the decline of the Socialists—it could be taken away from the city. So they were ripping Marseilles apart, reconstructing its urban fabric; but at the same time, they had this problem of the perception of Marseilles, both within Marseilles and outside of Marseilles, the sort of image you see in the movie *The French Connection*. Marseilles has always been considered to be a criminal, dangerous sort of city. I felt that it was one of my tasks to contribute to the re-vamping of the myth of Marseilles. Basically, there were two issues to address. One was the poor self-image of Marseilles, of particular concern at a time when Marseilles was trying to resurrect itself from a sort of economic and cultural death. The other was the issue of racism, which was being expressed there, as so often here, in terms of immigration. There are two voices you will hear on the video. Both of these voices speak with an accent marked by an origin elsewhere. The first voice is a man's voice who speaks with an English accent (this is a cheap production). The second voice is a woman's voice, a native French speaker, but who clearly speaks with an Arabic accent. Again, thinking about Karen Burns' presentation, and the issues of marginality and the ideologies which construct our built environment, I would ask you to look at the mural on the wall behind you. I think Burns' remarks, and my own video, were addressed to a world in which, hopefully, that particular view of the world will no longer hold.

Projection of *Venise*, 1993.
(French, English subtitles. PAL U-matic SP, colour, 29 mins.)

Discussion

Question from the audience: I'd like to start with one observation actually. It's a very, very beautiful film and it seemed to me to sum up both the beauty and the horror of identity. It's something that is completely wonderful and also something that is completely terrifying. When Paul [Finch] makes a suggestion that we infiltrate the corridors of power, there's this terrible sense of loss: in order to save architecture, one has to give up being an architect. And Karen Burns comes up with a similar dichotomy in a sense: in order to become more human as architects, we have to relinquish architecture and think about building. And it seems to me to come back to this crisis of identity—architecture is something that we want and yet it is something that binds us in the past.

Question from the audience: Despite the very lively differences of this morning's presentations, one theme did lightly connect all of them, and that is the particular virtue, and the particular value that is put on being in the peripheral and the marginal situation. But by doing so, one does tend to pull the marginal towards the centre and thus to rob it of its alleged virtues, the virtues afforded by being on the outside looking in. I think my question is: how much is this current respect for the peripheral situation really just a strategy of making the best of a bad job, or does the peripheral situation have an absolute value of its own which can and must be preserved?

Paul Finch: I think it's a very appropriate question in Britain, this peripheral little island which used to be a centre, and we now have absolutely no idea whether it is a centre or not. I think that we all started from different directions and, as you pointed out, that made us all the same. I have always liked that Michael Graves line that one of the effects of postmodern architecture was that you got the same difference everywhere. That was presented in those images [in the video] where one city starts to fade into another and one identity starts to fade into another. It seems that the interesting thing about the centre and the periphery is whether the periphery is only defined as a periphery in relation to that centre or whether the peripherals join and make their own connections. A physical example I would give of that is what happened to Atlanta, where you have a downtown and peripheral areas which are only defined in relation to downtown, but then all of a sudden they make highways between them and downtown is now in the peripherals and it is the centre which has become the periphery. I think it is that kind of game which goes on—well, not a game—that thing that happens in cities is a reflection of our own relationships with people and in a sense the way of describing that. The film we just saw is as good a way of describing that similarity, or parallel, as I think one can make. I don't think you can do it in architecture as such.

Karen Burns: I'm not actually happy about the label 'marginal' in relation to the paper I presented. I think one of the interesting things about the essay by Peter Myers is that it was commissioned by the Australian government, which isn't a marginal institution of power in Australia, and I think that work has been published in a book which is internationally distributed. Partly, I looked at that material because it's not really marginal work, the kind of consultancy work that is undertaken by architects a lot, and so that's probably what I would have to say about that label.

Victor Burgin: I would again invite you to look at the mural which dominates this theatre. Because again it's an image which speaks volumes to that particular mind-set in which there is a single centre and there are peripheries to this centre. What we see in the centre of the mural is indeterminately, I guess, the House of Commons, or the British Courts of Law, but it's certainly the centre of power and authority. And then off around the edge we have these literally 'marginal' people: Asians, Africans, indigenous Australians and so on. The video I made progressed through 'dissolves' and, thematically, it represented a dissolving of differences between cities and identities, and attempted to—in a jargon word much over used but I'll use it anyway—'deconstruct' the binarism of centre and margin, of self and other. This is a time when Marseilles is trying to re-invent itself, a time when western capitals and western countries, in general, are trying to re-invent themselves. Britain is certainly no exception to this and Paul summed up that existential quandary for Britain. In this period of Le Pen and 'France for the French' I think it is really essential, politically, to continually focus on the impossibility of immutable difference, and on the contingency of identity, and on the fact that no identity exists as an essence within anything but is only ever forged in relation to another. The relation can be amorous—a desiring practice—or it can be antagonistic, or it can be both at the same time. It is only through addressing these issues, learning to tolerate the pain of that condition, that I think we have a hope in hell politically. I don't think this is a matter of opportunism or fashion, I think it's rather a matter of looking at what's happening in the world, looking at what's happening to us and trying to find ways of representing it so that we can do something about it. Marshall McLuhan was fond of saying that we don't know who discovered water, but we can be damn sure it wasn't a fish. The point being, of course, that when you are breathing in the very condition of your being, it's difficult to get a critical distance on that condition. So I think that the work of a symposium like this, and the sorts of cultural workers who are involved in symposiums like this, is not to tell people anything they don't know already, but rather to try to find a way of representing what they know, so that they know they know it.

Paul Finch: There's a strange thing about anonymity in the city. The point about the medieval city was precisely its anonymity, which gave it its desirability. There's that old tag 'town air makes free', and it most certainly did. Those city walls were not just to keep out strangers, they were also to keep out kings, and other peoples' armies. The desirability of anonymity in the city ebbs and flows, sometimes you want to be anonymous and sometimes you don't. It seems to me that a place like Marseilles is both anonymous and marked at the same time, which comes back to your binary about the way the architecture immediately marks something as something, and not as something else. And of course the problem for black immigrants, and certainly not for white ones, in the European city is that in one sense they cannot be anonymous. I suppose by extension one might say in relation to gender, if you think about the City of London, those medieval guilds, the point was that you couldn't tell from looking at somebody on the street—you could tell by class what they might be, whether they were a burgher, or whether they weren't—but you couldn't tell whether they were members of the livery company of fishmongers, or whether they were involved in leather business, or the glass business or whatever it was. But of course they were all men, and as that has changed, so these ideas of peripherals again emerge. There's that old thing about people who taught in architecture schools about cyberspace being on the outer edges of reality, whereas what you really wanted to know was more details on flitched timbers if you please. But, of course, the people dealing with cyberspace were the ones who were actually at the centre, and now that has become very apparent because that model, the city wall… what on earth does it mean when you can speak to somebody on the internet as though they are as close as you are to me?

Question from the audience: Could I refer to last night's talk which dealt with the picturesque and cyber-reality? The question I have is: is the pain that you are actually talking about to do with trying to force ideas of centrality when we have got a cultural perception which actually allows us to be multi… more like a Nietzschean image of a multiplicity of points, but this liberation of spatial understanding from a three dimensional to a multidimensional idea of space is actually part of everybody's life, even though the language we use does give us moments of acute disquiet. And in terms of architecture, and the loss of architecture, there is something about the edge which is not the other side, or looking back to the picturesque but actually maintaining a position on this point of origination—which does mean we lose our personal identity, but at that moment, briefly, or in an infinite amount of time one is actually making universal artistic sense.

Victor Burgin: Well, what I hear in what you are saying, one of the issues it raises for me, is that—as we know from modern physics—we cannot talk about space

without talking about time. When I give the example of Marseilles as an aggregate of village societies, then that's a spatial picture of these many points of which you spoke, and differences between the points: cultural differences, linguistic differences and so on. But, of course, the other thing that you have to bear in mind with the spatial picture is that the histories and the memories which pass through those points are different. So we are passing not only from a spatial picture which included the model of the centre and the periphery, but also passing into a different temporality, a different picture of time in which it is no longer a question of history as a single linear story—and neither his-story nor her-story—but rather a picture of a multiplicity of simultaneously existing histories and memories. To give a practical example: in North America, now, I can't imagine any more difficult position to be in than a history teacher in a grade school. What history do you teach? What is the 'history of America'? Now against what I have characterised as the anxiety and the pain of that recognition, we have the blind, brutal assertion of power of the politicians. So Bob Dole, running for the Republican nomination in the primaries at the moment, is saying: "We've had enough of hyphenated Americanism. We're all Americans, so let's have no more of this African-American, Asian-American, Spanish-American nonsense. We're all Americans". Well, go tell that to the kids in the ghetto. So I think it is necessary to re-represent in different ways what we already know in order to find a way of dealing with the world as it exists, and not the world as it exists in the fantasy of those in power.

Karen Burns: Could I re-describe that word 'loss' in another way? I'm not trying to be a Pollyanna here, but 'transformation' might be another word that one would use instead of 'loss', and in that transformation there are possibilities that we can't envisage now and that we shouldn't foreclose upon. In that transformation of architecture there may be positive things that will come out of that experience, and so I'm not sure that we should hold on to the past with this tremendous sense of loss, but try and somehow negotiate this transformation and expect that there will be some positive outcomes.

Helen Mallinson: Well, this is what interested me about the film, this kind of balance between the beauty and the horror, because in a way the story had a kind of tragic consequence, a tragic outcome. You know, if we wish to transform the situation, whatever it is, political situation or whatever, then the loss is inevitable, and yet what are the possibilities for that transformation? There is a kind of a sense of beauty in the process of loss, because the process of loss is also an opening out, it's also an opening out of new possibilities. There's this kind of incredible sense, like in the way you shot a lot of the scenes of passage through the city, that suddenly time transforms into something else and you begin to take on another kind of sensuality.

Paul Finch: The question of time in relation to these histories is interesting because the only tracks on which that might work is chronology. One could be saying, "Yes, of course, there are alternative histories which you could take from any perspective. They are moving at different speeds." But I think it is interesting to think about what are the physical manifestations of any of those histories, because they all will have physical manifestations, and curiously enough the one which is simplest, but most undervalued, not least in schools of architecture, is the history—one might even say the archaeology—of cities and planning and buildings themselves. Let us take the Houses of Parliament, that model of a city; you can tell a series of parallel histories about that, quite apart from the ones told in terms of its construction and formal architectural design. Ultimately, a building embodies everything, it embodies the power relations, the gender relations, the economic relations. It is only a question of how far you can get into that building to find out what it shows you. It seems to me that for any culture to examine its own architecture it needs to undertake something that is both literal, metaphorical and historical at one and the same time. It seems to me a sort of madness that schools of architecture have marginalised the history of their own subject to such a tragic degree, when in many ways it is that history of architecture which is one of things that architects most have to offer as an explanation and even a legitimisation of what they have done in the past—and why they think they might have something to offer a particular community now.

Question from the audience: This is a question directed at Victor Burgin whose film I found very provocative, but the question I had, really, was that the film seems to be directed towards the notion of dissolving difference, which I think is very provocative within this particular symposium. And something which came to mind from a comment that Paul Finch ascribed to Michael Graves—"that there is the same difference everywhere"—it brought to mind the final comment that comes in Frederic Jameson's recent book, in the essay "The Constraints of Post-Modernism in the Seeds of Time", where he is basically taking apart Kenneth Frampton's article on critical regionalism and exposing the paradoxes within that. The conclusion he comes to is that the notion of difference, in the sense of critical regionalism, is in some way sanctioned by the very universal capitalism that it is out to call into question. I think if you transpose that to the context of a symposium about gender and about difference in this particular situation... I'm just interested in what Victor would have to say about the role of difference in the question of gender.

Victor Burgin: The term 'difference' of course, like a lot of other abstract terms, itself functions differently within different discourses. The people you invoked, who speak from within architectural theory, probably construe and construct difference rather differently from the way in which it's constructed in my own

favoured methodological discourse, which is psychoanalytic theory. The book that I have just finished rests upon a basis of psychoanalytic theories, and when I think of difference it's always within those terms. The theory in the book is psychoanalytic, and the context is that of North America, of modern American cities. The context is also the politics of the American university today, which is a politics of identity. I think that this is probably true, increasingly so, for Europe although America seems to have got there first. The class politics with which we entered the twentieth century have given way, by the end of the twentieth century, to a politics of identity. The consequences of that politics of identity in the US today is no better expressed than in the O. J. Simpson trial, and the result of that trial. It seems that even the possible range of meanings of a criminal trial have now become totally displaced into the arena of identity politics and the re-vindication of past wrongs—such that the actual circumstances of the case become irrelevant, and the protagonists in the case become signifiers in another drama, a greater historical drama. If you will forgive me, this slogan which keeps getting repeated at this symposium—"it's always the same difference everywhere"— sounds to me sort of tired and cynical. It doesn't actually help me think about anything. I'm interested in how, precisely, we form an identity across a number of instances of experiences of difference. The difference, originally, from the body of our mother. Then the difference ascribed to us in gender terms, and the consequences of that. And then racial, ethnic, class differences, and so on. At the time I was growing up, the complexity of this picture was largely obscured by the shadow of monolithic ideologies. On the one hand, the ideology of the State, of 'little England', and on the other hand the ideologies of the Labour movement—which resulted in a sort of 'us and them' simplification. Then the kind of feminism which saw gender only by analogy with class… What I am interested in in contemporary theory is the attempt to get beyond those sorts of simplistic pictures and to represent the complexity of multiple differences. Not in order to solve the puzzle of identity, I think it's insoluble, but rather to communicate the sense that to live is to *attempt* to solve it.

Helen Mallinson: One of the issues that seems to be coming up… You know you talked about the relief of getting rid of monolithic structures in one way or another, and this issue of the kind of complexity of identities that dissolve and transform. You are talking about the need to represent our position, and the difficulty is how do you represent it? How do you spatialise a new situation, how do you reinterpret the sets of relationships that we are looking forward to being somehow more open, more free, more democratic, more tolerant—a way that allows specific identities to be maintained, in order that you have a basis on which to differentiate but which does not homogenise them or crush them. It is interesting listening to the spatial models that people are coming up with in their

papers. Kind of binary systems, centres and peripheries and the types of fragmentation, dissolves or transformations. It's this question of representing this spatial set of analogies that I think is quite curious to this debate.

Karen Burns: I would just like to say that I think one of the things we have to do is reconceptualise our notion of what built space is, which I think means leaving that notion that it is purely an object and thinking about the relations between space and the people who live within it, which is what the work of Myers does.

Victor Burgin: There is a rider I'd like to add to that. Perhaps because I haven't been in London for a while, I'm just astonished by the way it's collapsing under the weight of its own populations. I'm living at the moment with my sister out in Stoke Newington and it took me an hour and a half to get into this particular centre. That's the time it takes to me to drive from my home in San Francisco to my office in Santa Cruz, seventy-five miles away. There has been talk of cyberspace, the internet and satellite television. But none of it helps me to get my body across London. This is one of the most poignant architectural situations right now: the metropolis is setting as solid as concrete, while the only architecture we cross freely is virtual and disembodied.

Architecture/ Discipline/ Bondage

My paper may seem somewhat perverse in the context of this symposium, for it is not about women as such, nor men for that matter. It is not about representations of the feminine, nor is it a study of women's lot (the Lot's Wife position) in architecture. Finally, it is not an analysis of the spaces primarily used by women. Its angle is thus more oblique, and this comes from my own, and some feminists', certainty, that it can be useful to engage material that does not immediately register as a known object in the terrain of feminism (if such a territory can ever be mapped).[1]

Rather, the given material of this essay is heterogeneous, at first glance not really the right stuff for a feminist project. It takes some canonical architectural texts, some generalised remarks about recent work in cultural studies, and the research and enunciation practices of Peter Myers, an Australian architect, teacher and theorist. These are the things caught in my Australian drift net— some shiny and new, some old, some borrowed—that I will work on to make bonds and connections, to repair old nets and fabricate new ones.

In this way, mine is a feminist inquiry in the terms once articulated by Meaghan Morris, as she tried to account for feminism as a *motive force* rather than a given *object* of inquiry in her essays. She declared that her feminism operated implicitly, as a set of theoretical and political assumptions about the questions criticism might ask.[2] Thus, one might think of feminism, as Jenna Mead quoting Constance Penley has done, not as "a superior authoritative truth that stands as a corrective to the sexism of men" but as "a political theory and set of strategies".[3]

My questions today are about the term 'architecture'. I think it is fruitful to ask questions of that term as well as pursuing questions about the terms 'man' or 'woman' in relation to architecture, or alternatively, tracing the always/already inscribed incisions of sexual difference as architecture. In asking questions of the term architecture, and its definitional borders, this paper connects (bonds with) one strand of contemporary feminism outside the architectural disciplinary enclosure. It re-deploys some key terms under investigation; feminism's interest in identity categories and the precise calibrations of difference.

That is a very abstract remark, so I will come clean and tell you what I mean to do before upending the contents of my net. I want to consider the terms 'architecture' and 'building' as identity categories, as terms that identify and signify what architecture is, and what it is not, and to argue that attempts to distinguish between the two terms are relevant to a feminist inquiry, and to an understanding of architecture's disciplinary identity, and thus its relation to other disciplines. A relation, I understand, that is one of the strands of connection for this symposium and one of its terms of scrutiny. So, the terms architecture/building, discipline/interdisciplinary are the threads that weave through this paper and bind it together.

There are knowledges of built space other than those that circulate within my discipline (architecture).[4] This symposium overtly recognises other knowledges about built space and intimates that architecture is interested in this work. However, I believe that architecture cannot incorporate this material without considering the challenges posed by this "different knowledge, an other competence impinging on", architecture's "neatly delimited space".[5]

Part of the possibility of interdisciplinary study is perversely, the project of paying careful attention to the specificity of knowledges, to its neatly delimited spaces, and to the histories of the formation of particular disciplines. It is a project that asks questions of a discipline's protocols: what values organise a discipline, give it coherence, form its methodologies and constitute its range of objects? Given this definition my interests in *other* knowledge and architecture are two-fold. First, how might we (architecture professionals) theorise rather than celebrate or take as inevitable, the meeting of architecture and other particular knowledges? Secondly, what has been the place of other knowledges about built space within architecture? The following part of the paper is addressed to my curiosity about other knowledge of built space as a figure of alterity in architecture.

Other knowledges of built space are not just happy accidents of the mid-1980s.[6] It is possible to argue that other knowledge of built space has been around for some time (whether one cites Michel Foucault's study of the productive relations of space and circulations of power, or Michel de Certeau's attempt to theorise, and in so doing, also produce a range of spatial knowledge as everyday practice). However, my interest is in what architecture has already named, marked and defined as its understanding of other knowledge about built space. I will argue that for some time, it has represented this other knowledge to itself as *building*, perhaps, at least, since the professionalisation of the building trades in the nineteenth century.[7]

It is a risk to talk about the familiar building/architecture binary. The risk is that you (and even I) will be bored. However it is worth trying to think again about the figure of the familiar in our discipline. Building as a category is used to designate and describe the everyday, familiar built environment. In Australia, this represents some ninety-odd percent of built space.

The building/architecture categories might be thought of as a simple classification scheme; is a built space designed by an architect or someone else, and thus as a guide to asking whether that built space is a building or architecture? Or is it a scheme for designating the *value* of built objects; are they merely functional, aesthetic or more than that? (Of course to pose the terms in this way is to keep sawing away at the same old piece of driftwood…). However, I want to think about the categories in different ways, as identity categories. Architecture, like building, is an identity category, a category that signifies and identifies what architecture is, what it may be, and what it is not. In some ways it is a story about sameness (architecture) and difference (building).

These identity categories are produced within and by the institutions of architecture. They do not merely classify built 'objects', but work to define the range of practices, values and terrain of inquiry available to someone called an architect. Learning the divisions is part of an institutionalised process of identity formation. Architects are made, not born.

Samuel Weber has written of institutionalisation as the attempted systematic closure of meaning.[8] To rethink the terms of the architecture/building binary is to think about the designated range of meanings given to those terms and the function of certain university and cultural institutions to act as the sole or privileged guardians and transmitters of those meanings.[9] Until the proliferation of other knowledges of built space in the university, my discipline has constituted itself as a privileged guardian (perhaps the sole guardian) of knowledge about built space.

I would like to pause and take a brief look at one of those cultural institutions, the history of architecture text, at home most often in undergraduate reading lists. To investigate the building/architecture binary, is a project ridiculously large for a paper of this size. I have begun the reading list, but it could go on for ever. I am not going to present a Gargantuan feast, instead I will begin where I started this foolhardy study, attending to some of the differences between architecture and building as they have been produced in a series of canonical architectural history texts published in the Anglo-American world in the last thirty years (texts by Nikolaus Pevsner, Spiro Kostof, Bernard Rudolfsky and Patrick Nuttgens).[10] So there is a certain level of generalisation in my haste to explicate the argument and make a point.

There is a lot to say about these terms architecture/building, which are, I think, the basis of my discipline's sense of what its projects are. But only a few recent writers (Mark Wigley, Miriam Gusevich and Diane Agrest) have turned their attention to this area.[11] I think more people should be talking about this. Putting aside the many things one might want to say, I will focus instead, on the one thing that really struck me as I read Pevsner, Kostof and their brothers.

One way of describing architectural history might be that it is a history of proper names. It collects and inscribes the names of persons identified as the architect. The definition of architecture in these texts by Pevsner *et al* is inextricably linked to the singular figure of the architect. In this way, architecture is a signed surface not *just* a built space.[12] Unsigned built spaces in this order are attached to other entities; the landscape, the community, anonymous builders, nature. Architecture can be traced to singular, often male identities. Architecture has names (and presumably faces) whilst building is faceless.

The signing of a building transforms it into an individual object constituting its value. The signature is construed as proof of a singular identity. The historian's attachment to a self 'located' behind a building seems to involve a greater investment than securing a recognisable name in order to value a building as a unique, and thus highly valuable, commodity within an aesthetic economy. A whole series of other values is conjured up by the spectre of the individual signature. For example, when Spiro Kostof argues for the building/architecture distinction he invokes masculinist biology. Architecture he tells me, "is conceived".[13] It is not an unplanned pregnancy or somehow unproductive sex, it is willed and directed.

There are two further things to note about the attribution of individualised identity to architecture, the positive term of the binary. The binary works to position architects as producers not users of the built environment, since individuality is equated with a particular kind of production recognised as 'The Production'. It does not consider other kinds of production (use such as my own writing). Secondly, in the end, building is not defined as another mode of spatial knowledge, and knowledge-making. Building is the naive other that does not know what it means or does. Rather, architecture deems building incapable of theorising its own activity.

I apologise for the crude caricature of a binary that has its subtleties and exceptions. I will redress this cartoon towards the end of the paper.[14] But I believe that most of our activities as architectural professionals are directed towards what is recognisably marked as architecture (and only a small percentage of that work is published, registered in discourse). Building may be

the 'inert' material that architecture takes on to reform, but I think it does this largely as an *a priori*, not as a carefully studied field. The point of all this, for me, is to ask what happens when this map of architecture's site of inquiry meets a 'discipline' (relentlessly interdisciplinary though it is), like cultural studies?

Much of the theoretical work on built space and sexual difference that interests me has been produced by feminists working in the disciplines of film and cultural studies. Built space in many of these studies is unrecognisable as 'architecture' in the given terms of my discipline; display homes, suburban homes, suburbia, shopping centres, the signification of domestic space in television soaps, the relation between film narrative, sexualities and space, the rewriting of the genre, conventions of tower, motel, shopping centre, women's work and leisure practices in the work of Meaghan Morris. And it goes on.[15] I, and other architectural professionals I have met, have been interested in using this work. But in a cautionary mode I wonder, can architecture merely disgorge this writing from the net of its new seas of inquiry? Can it merely digest and absorb what it has hitherto considered largely unpalatable (building), or will it examine before swallowing?

To briefly examine the cultural studies morsel: for me, there are at least three things about these writings, if one works in architecture, that should make one think *otherwise* about one's disciplinary assumptions. First, these are built spaces regarded as worthy of serious theorisation, of the kind of temporal scholarly activity usually only devoted to architecture in our discipline. Secondly, this range of spaces is not primarily identified as architecture or building, that is, by the Origin of the producer (although architects as producers can come in for some stick).[16] Space is often defined by genre and a genre's probable spatial uses, conventions, practices and possibilities, or by the set of questions and connections concerning the writer. Thirdly, these spaces may or may not have been *designed* by architects. It is not an issue that raises *much* of a flicker of interest in the eyes of many a critic. (Of course the symbolic status sometimes accrued to that position 'Architect' is another matter.)[17] This makes perfect sense in the work I am interested in on 'women and built space', because feminism as a political project is less interested in built space as an emanation from a sole author, than in considering built space as productive of political events.[18] Writers seek other frameworks for explanation.

I am not saying that this therefore makes architecture an irrelevant practice, I will come to that shortly. Whatever the theorised built space in these works I have admired, whether shopping centres or the figuration of space in films, television soaps, gothic and romance novels; whatever, in these writings, built space is inseparable from its use and uses (including, I should add, its use in

architectural discourse). This is a radical shift of frame for an architectural audience whose concern has largely been with narratives of explanation which 'revive' the architect's conception of the building.

However, a number of the writings I have cited above, work with issues of audience and spectatorship, sometimes merely reinvesting Authorial Origin as explanation.[19] Whatever hesitations and qualifications I (and others) might have about this work on 'Ordinary Women', audience and spectatorship, this knowledge-making has done at least two things.[20] First, built space as architecture has had its identity as an isolated discipline collapse. Feminism has framed built space as a site of women's practices in order to make surprising connections which unsettle established orthodoxies. For example, in Lynne Siegel's study of the 1950s North American suburban home, disparate material (house lay-out, housework, television viewing practices, the reformation of visual entertainment, the feminisation of certain TV programmes) is used to resignify Woman/Home. Public spaces, conventionally construed as the binary opposite of Woman/Home are shown to be inside the home (in the space of the viewing screen) and the home is understood as a signifier that works in the space of television programmes to code the possibilities of Home/Public Sphere. Both 'Home' and 'Public Sphere' have laid out spaces inside themselves where they might imagine their outside.

Secondly, the work of these writers and of other artists and film makers not mentioned here, has created different constituencies for discussions of built space, different to the one (of architectural professionals) my discipline has always imagined existed.[21] These constituencies are scattered across a number of sites: in the academy, in private reading groups, non-university courses, discus-sion, art galleries, arts bureaucratic reports and government reports generally.

These constituencies and their sites provide possible places for thinking other practices of architecture. The convenors of this conference have consistently challenged all the presenters to suggest new (desiring) practices and I am going to offer four that could emerge from these new constituencies; first, fanzines in which people generally write about built space, secondly, speculative projects about built space in public spaces, funded by arts bodies, thirdly, an alliance of people inside and outside the architectural profession which can lobby governments for the reform of discriminatory practices in the profession and promote other discussions of what the profession might do, what its competency is and why it matters.

My final suggestion about architectural practice involves telling you a few stories about a particular Australian architect, Peter Myers, who practises consulting, teaching and writing, amongst other things. His work offers me a way of marking another kind of architectural practice in my discourse. It is also an allegory about not having to reinvent the wheel. Thinking about what architecture might do, what very modest claims it might make, could involve taking a look at what is already in our own backyard, but has not been decreed as 'The Way To Go'.

I want to discuss briefly one of Myers' essays. One of the things that draws me back to his work is the way in which his writing is made within, and remakes those categories, building, architecture, identity, that keep detonating at regular intervals in this essay.

The piece is titled On "Housing" Aborigines—The Case of Wilcannia, 1974, rewritten and published in 1988.[22] It was originally written in 1974 at the request of the chairperson of a Senate Committee on the Environmental Conditions of Australian Aborigines and Torres Strait Islanders. It begins unconventionally for a government report, as a first-person prose piece about watching a racist situation unfold in a roadhouse at the site, in outback Wilcannia, (the classic opening to a redneck movie) one of the many such incidents Myers witnessed in the course of his research. Myers, the undercover researcher, is left with a split-second decision, should he step in to cut the racism and risk being beaten up, or having his cover blown? In the end he does nothing.

It is important he begins the essay this way. He is not only providing a slice of life realism to fill in what an official report genre does not allow to be included, he is placing himself and his professional identity within the process and landscape of his research. At Wilcannia, he observes, "The role of 'consultant' is always suspect".[23]

Myers' essay offers me some ways of rewriting the professional architect's given terms of identity. First, Peter Myers The Architect appears in the landscape he is researching. His story about having to make a choice as to whether to intervene at the roadhouse might be read allegorically, as a description of the architect's pro-fessional persona. He does not serve up the familiar tale of the stoic, architectural hero riding in from outside to fix things up and then enigmatically slipping out of town. Nor does he claim that he, the architect, is only an instrument of the bureaucracy that commissioned him. He is offered choices, to intervene or not (or to write about it later), but these choices exist within conditions that are not of his own making. Individuality as wilful authority, those key definitional terms for architecture are woven back within those definitional terms given to building; the Community, randomness, conditions not of one's own making.

Secondly, Myers' essay can be read as a rewriting of those apparently separate categories architecture/building. In analysing the built spaces produced by the Bakanji community at Wilcannia, Myers discovers that the template of his own architectural values does not fit over his research material. He discovers that maintenance is of a symbolic rather than functional nature, entangled as it is within white Australian notions of order, tidiness and propriety that do not register in the order of this community. He discovers that relationships between rooms and their apparent functions (kitchens as the place for cooking for example), are culturally particular and not universally given. He discovers here, in this community, that privacy can exist without material structural supports, without the acoustic and visual separation that white Australia takes for granted as a defining condition. So here what architecture has hitherto designated as 'building' teaches architecture new ways of theorising about built space and reflecting on architecture's values, rather than offering raw material for appropriation.

This shrewd socio-spatial analysis (a theorisation of knowledge) is part of his proposition for change. Part of the 'problem' at Wilcannia is the continued imposition of a highly culturally particular (white Anglo) form of housing on another culture without consideration of the lack of fit. In Myers' recommendations, reassessing the 'spatial' is entangled with other issues: the cultural values of built space, poverty as illegal dispossession from one's land, and the community's right to economic self-determination.

Thirdly, Myers' own architectural knowledge and values are reformed through his reflection on another set of values and frameworks, even as he presents these *in translation*, through a white Australian professional's set of understandings. Myers not only embodies a set of cultural values as the architect, he works within and is worked on by these values. His professional identity in the Wilcannia landscape is inescapable, he does not merely let it merge with the scenery.

Lastly, Myers is the figure of difference in the black Australian landscape of the Bakanji community. His identity as a professional white Australian is as important as, perhaps more important than, but inextricably part of, the conjunction of his identities as an architect and a man. Here he is the outsider, architecture is the outsider discourse. The identity categories of architecture/sexual difference are woven within other junctures of difference. Sometimes, in a given built space, these bonds may be the foremost pattern of identification, more significant than the two on offer at this symposium (discipline and sex.) It is a reminder that sexual difference is the beginning, not the end, of the possibilities for reformulating architecture's identity, and that knowledge of identity is "always situated not universal".[24]

I have cited and reread Peter Myers' Wilcannia research, because I believe that his work is part of the project of making a difference in one community in outback New South Wales. It may only happen in the long term, and not in the short term, as built space. In this way he continues struggling to make a difference. Part of this difference is formed by remaking his work in this discourse, so that we know that this is the kind of useful work architects can do, and have already done. Myers, the architect, is aware that architects like everybody else, are positioned in conditions of built space which are not of their own making, and that this is the beginning not the end of the problem. How do you make (transform) history in this condition?

In many ways of course, I have kept the architecture/building distinction intact, even as I have suggested that the distinction may not be useful depending on the type of questions asked of the built spaces analysed. However, the architecture/building divisions might be displaced again (not erased) by thinking about them as built space, whose producers do not hold an Originary function, but do hold different, sometimes powerful positions that inscribe, and (sometimes) circumscribe, their speaking positions, and the social power that determines how and where and by whom, those speaking will be heard. Myers is attentive to this difference of speaking position as the Government Commissioned Architect.

Lawrence Grossberg, the North American-based cultural studies writer and fan, in pondering the critical authority of cultural studies theorists argues that this authority cannot be based on privileged distinctions of taste and distaste. He wisely observes, "the problem is not to deconstruct authority, but to re-articulate new forms of authority which allow us to speak as critical fans".[25] One way of doing this is to think again about this quotation in relation to the producer (architect)/user (community) distinction. Architects are critical users of built space. Like a number of others they are involved in articulating new possibilities, and *building* them. This demands theorisation of existing practices, specificity of the problems involved, an awareness of how professional identities are constituted, and a commitment not to abandon the possibilities of the everyday built environment, as a place for situating a political practice.

The next time you (if you are an architect) are at the video store, the movies, the shopping centre, sauntering along a city street, you may be snapped by another person. You may see someone taking notes. You may meet another's glance. This someone may well be another critical user of the built environment, a cultural studies academic, a koori writer, an artist or houseworker. In their glance the other identities which inform you, may well come to the fore (shopper, walker, dress, class, sexuality, race, ethnicity). You are all of these as well as being an architect, and this may be the beginning of a way out.

The way out, reminds me again of Lot's Wife. Since I mentioned her at the beginning, I have had to do a bit of biblical research (Genesis: 19) in between, and I wanted to end with her since her biblical position is pretty dismal. She was the woman, you may remember, who could not resist looking back, poking her nose into things she had been told to leave well alone (two cities on the plain) and so was turned into a pillar of salt, radically changing her identity (from woman and spouse into memorial mound). This is a good starting point for any feminist investigation of the western, Christian urban (homophobic) imaginary. Lot's Wife did not die however, she lives on as the university student newspaper at Monash, in Melbourne, suggesting how one kind of dead-end identity might be rewritten under different conditions, and that salt can be used to savour new food for thought, not just to remind one of old wounds.

Acknowledgements
Many thanks to the organisers, for their invitation, hard work and creative juxtaposition of the two terms, gender and interdisciplinary; thanks to my (former) colleague Jason Pickford, for enthusiasm, belief, reading materials and ideas that ignited the first draft; thanks to Stephen Cairns of the University of Melbourne for reading the first draft of this paper and offering encouragement in the face of adversity; to RMIT University for sustaining me with a travel grant, and to Dean Cass and Johnnie Colbasso, who were there, with care, on the day.

Notes

1 This, of course, does not rule out the political necessity of carrying out these projects, but with ever more careful attention to what is at stake in such work, and with an awareness that knowledge, as Jenna Mead observes, "is situated, not universal". It involves ever more precise articulations of difference, as well as a recognition of the fundamental instability of the category 'Woman', whilst considering how 'essentialism' has informed feminism historically, since its political programme is based on an identity category, and the challenges to feminism's ability to articulate difference as women otherwise. In listing them this way, I am not suggesting that all of these questions are resolvable in one unitary position, but they are important questions for feminism today. See Chandra Mohanty's critique of western feminism "Under Western Eyes: Feminist Scholarship and Colonial Discourse" in Mohanty, C. et al. (eds.), *Third World Women and the Politics of Feminism*, Bloomington and Indianapolis: Indiana University Press, 1991, pp. 51-80; Kirby, V., "Corporeal Habits: Addressing Essentialism Differently", *Hypatia* 6, 3, Fall 1991, pp. 4-74; Jagose, A., *Lesbian Utopics*, New York and London: Routledge, pp. 15-17; Mead, J., "Where is the West", *Meanjin* 4, 1993, p. 728.

2 Morris, M., *The Pirate's Fiancée: Feminism Reading Postmodernism*, London: Verso, 1988, p. 6.

3 Jenna Mead quoting from Penley C., *The Future of an Illusion: Film, Feminism and Psychoanalysis,* London: Routledge, 1989, in Mead, J., "Where is the West", p. 736.

4 Over the last eight or nine years these spatial knowledges have boomed in the disciplines of geography, cultural studies, film theory, art history, english and philosophy.

5 Morris, M., "Cultural Studies", in Ruthven, K.K. (ed.), *Beyond the Disciplines: The New Humanities*, Canberra: Australian Academy of the Humanities, 1992, p. 18.

6 Michel Foucault's *Discipline and Punish*, London: Allen Lane, 1977, was first published in French in 1975 and Henri Lefebvre's *The Production of Space*, Oxford: Basil Blackwell, 1991, was first published in French in 1974.

7 See Saint, A., *The Image of the Architect*, New Haven: Yale University Press, 1983.

8 Weber, S. (ed.), *Demarcating the Disciplines*, Minneapolis: University of Minnesota Press, 1986, p. x. Weber makes this remark in passing, as he explores the links between Derrida's so-called 'earlier' work, up to *Dissemination* and after that text.

9 Derrida, J., in Kearney, R., *Dialogues with Contemporary Continental Thinkers*, Manchester: Manchester University Press, 1984, p. 125.

10 The texts are Pevsner, N., *An Outline of European Architecture*, Harmondsworth, Middlesex: Penguin, 1977 rpt; Kostof, S. (ed.), *The Architect, Chapters in the History of the Profession*, New York: Oxford University Press, 1977; Rudofsky, B., *architecture without architects: A Short Introduction to Non-Pedigreed Architecture*, New York: Doubleday & Co., 1964; Nuttgens, P., *The Story of Architecture*, London: Phaidon Press, 1983. I realise the discussion is extremely abbreviated, but I analyse these texts in more detail, in relation to these and other questions in a paper titled "Architecture: That Dangerous Useless Supplement", in the collected papers of the Accessory Architecture Conference, Auckland: Department of Architecture, University of Auckland, July 1995.

11 Mark Wigley, for example, has examined the ways in which the split is stained by classical metaphysics with its division of nature/art, speech/writing, unadorned/ornamented. Wigley, M., *The Architecture of Deconstruction: Derrida's Haunt*, Cambridge, Massachusetts and London: The MIT Press, 1993, pp. 130-133. Miriam Gusevich has argued that the binary terms are deployed as part of architecture's canon formation, institutionalising the difference between the so-called common structures and monuments. Gusevich, M., "The Architecture of Criticism: A Question of Autonomy" in Kahn, A. (ed.), *Drawing, Building, Text*, New York: Princeton Architectural Press, 1991, pp. 8-9. Diane Agrest, in an essay originally published in the mid-1970s, refigured the terms as design/non-design. She argued that these categories were used to instigate a non-sustainable division between one cultural system and others. Agrest, D., "Design versus Non-Design" in *Architecture from Without: Theoretical Framings for a Critical Practice*, Cambridge, Massachusetts and London: The MIT Press, 1991, pp. 31-65. Thanks to Stephen Cairns for drawing my attention to this essay. My own interest is slightly different. It circles around a series of other values attributed to the terms, and the status of building as a figure of difference.

12 Here I am transforming Eric Michaels' observations on the role of the signature in art. See Michaels, E., "Bad Aboriginal Art" in *Bad Aboriginal Art Tradition, Media and Technological Horizons*, Minneapolis: University of Minnesota Press, 1994, p. 43: "The painting is a signed object as much as it is a painted surface".

13 Kostof, *Chapters,* p. v.

14 For example, Rudofsky rescued building from its excoriated state, but did not displace the binary's terms. Patrick Nuttgens also included a wide variety of buildings in his history.

15 On the suburbs, representations of suburbia and display, see Louise Johnson's paper on display homes delivered at the Imagining the City Conference, RMIT University Melbourne, April 27-28, 1990, and on Australian suburbia see Ferber S., Healy C., McAuliffe C. (eds.), *Beasts of Suburbia: Reinterpreting Cultures in Australian Suburbs*, Melbourne: Melbourne University Press, 1994; on shopping centres see Morris, M., "Things To Do With Shopping Centres" in Sheridan, S. (ed.), *Grafts: Feminist Cultural Criticism*, London and New York: Verso, 1988, pp. 193-223 and Friedberg, A., *Window Shopping, Cinema and the Postmodern*, Berkeley, Los Angeles and London: University of California Press, 1993; on domestic space and television see Spiegel, L., *Make Room For TV: Television and the Family Ideal in Post-war America*, Chicago and London: The University of Chicago Press, 1992, Spiegel, L., and Mann, D. (eds.), *Private Screenings: Television and the Female Consumer*, Minneapolis: University of Minnesota Press, 1992; Bowles, K., "As Commonplace as a Neighbourhood: Television, Space, Power" in Bowles, K., and Turnbull, S. (eds.), *Tomorrow Never Knows: Soap on Australian Television*, Melbourne: Australian Film Institute, 1994, pp. 74-90; on narrative, sexuality, genre and space see de Lauretis, T., *Alice Doesn't: Feminism, Semiotics and Cinema*, Bloomington: Indiana University Press, 1984, pp. 103-157 and Willis, S., "Disputed Territories: Masculinity and Social Space" in Penley, C., and Willis, S. (eds.), *Male Trouble With a Vengeance: Mass Produced Fantasies for Women*, New York and London: Routledge, 1990, pp. 59-84 and Meaghan Morris' tower essays, "Great Monuments in Social Climbing: King Kong and the Human Fly" in Colomina, B. (ed.), *Sexuality and Space*, New York: Princeton Architectural Press, 1992, pp. 1-51, "Australian Mythologies: Sydney Tower" in Burns, K. and Edquist, H. (eds.), *Transition: Discourse on*

Architecture, 25, Winter 1988, pp. 13-22, "Metamorphoses at Sydney Tower", Australian Cultural History, 10, 1991, pp. 19-31. As well, there is her essay on motels (amongst many other things) "At Henry Parkes Motel", Cultural Studies, 2, 1, 1988, pp. 28-47. Many architectural readers will be familiar with the collection of architectural and interdisciplinary essays, Colomina, B. (ed.), Sexuality and Space, New York: Princeton Architectural Press, 1992.

16 A notable exception to this would be Frederic Jameson's (in)famous essay "Postmodernism and Consumer Society" in Kaplan, E. A. (ed.), Postmodernism and its Discontents, London and New York: Verso, 1988, pp. 13-29. Not that Jameson's essay touches on sexual difference, but it is a rare example concerned with the big names of architecture.

17 For example, in Rosalyn Deutsche's work on the politics of redevelopment at Battery Park, it is quite clear that 'urban professionals' (architects among them?) are heavily invested in defining the symbolic stories that situate a site/building's place, and the particular sections of the community to whom those meanings and narratives are deemed to belong and legitimise. See Deutsche, R., "Uneven Development: Public Art in New York City", October, 47, 1988, p. 33.

18 My paraphrase of a line from Meaghan Morris concerned with texts, not built space, the origin of which has become lost in travels around my room.

19 However, my discipline has to be very careful to not merely reinscribe, in its borrowings, some cultural studies' investment in an entrenched binary of product/user. I would urge caution and suggest that this material is read in conjunction with Lawrence Grossberg's and Meaghan Morris' criticisms of the assumptions of cultural studies work which produces figures of difference whilst it purportedly observes them. See Grossberg, L., Curthoys A., Patton, P. and Fry, T., It's a Sin: Essays on Postmodernism, Politics and Culture, Sydney: Power Publications, 1988, pp. 6-71; Morris, M., "Banality in Cultural Studies", in Mellencamp, P. (ed.), Logics of Television: Essays in Cultural Criticism, Bloomington and Indianapolis: Indiana University Press, 1990, pp. 14-43 and Morris, M., "Cultural Studies", in Ruthven, K. K. (ed.), Beyond the Disciplines: The New Humanities, Canberra: Australian Academy of the Humanities, 1992, pp. 1-21.

20 Some of the problems are discussed in a special issue of Camera Obscura devoted to 'The Spectatrix'. See Camera Obscura, 20-21, May-September 1989.

21 Artists like Judith Barry, Jenny Holzer and Renée Green.

22 Myers, P., "On Housing Aborigines: The Case of Wilcannia, 1974", in Foss, P. (ed.), Island in the Stream: Myths of Place in Australian Culture, New South Wales: Pluto Press, 1988, pp. 139-159.

23 Myers, "Wilcannia", p. 143.

24 Mead, "West", p. 728.

25 Grossberg, "Sin", p. 69.

Detailing

The word 'garb' has
its etymological roots
in the word 'garbo',
which means grace,
generosity, good
manners in both
Italian and Spanish.
Both words are
associated with
outward appearances,
coverings—habits.
The word garbo is also
specifically associated
with 'contour' and
'outline', sometimes
used in reference to the
gentle curvature of the
hull of a ship.[1]

The joint, that is the
fertile detail, is the
place where both the
construction and
the construing of
architecture take place.[2]

Owatonna Bank: Exterior view of building

This paper focuses on one of Louis Sullivan's most celebrated buildings, the National Farmers' Bank in Owatonna, Minnesota. The bank was designed and constructed in the first decade of this century and marks the beginning of the end for Sullivan's career. While the building is often cited as an example of organic regionalism, at the time of its construction it was a freak of nature, an odd weed that had found room to grow. To this day it remains exotic in every sense of the word. First time visitors to the bank often mistake it for a house of spirits. Locals go about their business, but are afraid to be caught looking. The building throbs like a pair of lovers in church, subverting its own intentions. Its form clearly transcends its function.

Frank Lloyd Wright once described the National Farmers' Bank as "a high wall with a hole in it".[3] His hidden agenda, of course, was to divert attention: "How long will it be before the world recognises me as the Master and Sullivan as the man?".[4] Although he later changed his tune and praised the building as one of Sullivan's best, his earlier condemnation betrays his uneasiness with the bank's surplus detail. His critique suppresses the parts in favour of the (w)hole and its high wall. His fear was understandable; the building's simple geometry is a clever ruse: without this centring device, we would be swamped.

In *Reading in Detail*, Naomi Schor questions the gender and the sexuality of the detail.[5] Her 'Archaeology' traces its traditional association with the 'feminine' and the decadent, and deconstructs a variety of attempts to sublimate, displace, and fetishise 'detailism'. While Schor's aesthetics are built primarily on examples from literature and painting, a more comprehensive 'history of the detail' would certainly find much to ponder in architecture. In light of Schor's tentative conclusions that no evidence so far supports a gendered explanation of the historical opposition in Western culture between idealism and detailism, this study is not framed in those terms. I am interested, instead, in Schor's comment that "Whether or not the detail *is* feminine… The need to affirm the power and positivity of the *feminine particular* cannot for the moment be denied.".[6] She elaborates:

> Indeed, further investigation of this question may lead us to formulate a surprising hypothesis, namely that feminine specificity lies in the direction of a specifically feminine form of idealism, one that seeks to transcend not the sticky world of prosaic details, but rather the deadly asperities of male violence and destruction.[7]

Therefore, "a high wall with a hole in it" suggests a weak aesthetic position for the National Farmers' Bank only if one chooses to draw a line between detailism and idealism. Guided by Schor's hypothesis, then, it would be a mistake to take sides in any war between the material and the immaterial. While this paper suggests another reading of the National Farmers' Bank through an examination of its details, it is not an attempt to validate detotalisation, but to make room for another kind of intelligence, one not usually associated with architectural design: the building is stitched together, at once se(a)mly and unse(e)mly. It must be considered 'master-piece-work' because it is both brilliantly conceived and out of control. It defies dichotomy. An ethereal *and* erotic bank? The details alchemise as they organise.

This case study's larger ambition is not to fetishise the detail itself, but to arouse interest in methods of detailing. The everyday practice of construction documentation precedes the object—the process of fabrication is a more significant subject. I have no desire to take the bank apart according to its details; I crave, instead, its reconstruction. The architectural detail can only be

read in the context of re-enactment. Architecture is a collaborative performance art form where methods of production are at least as consequential as the final product. A history of architectural *detailing*—as opposed to that of the *detail*—would be another history:

> It would be possible, I think, to write a history of Western architecture that would have little do with style or signification, concentrating instead on the manner of working. A large part of this history would be concerned with the gap between drawing and building. In it the drawing would be considered not so much as a work of art or a truck for pushing ideas from place to place, but as the locale of subterfuges and evasions that one way or another get round the enormous weight of convention that has always been architecture's greatest security and at the same time its greatest liability.[8]

The most potent issues of gender in architecture—those which arise from practice—are suppressed by conventional history which privileges the product over its methods of production. Architecture remains intransigent to the extent that its everyday practices are bound and gagged. This case study of the National Farmers' Bank through its techniques of detailing is an attempt to rescue the everyday practice of working drawing production from history's indifference. This study is also a demonstration of what architecture has to contribute to the question of detailism raised by Schor's work.

The original transparencies of the National Farmers' Bank working drawings are lost, along with Sullivan's diary and most other records of his office's daily transactions. My story is necessarily *pieced together* from those documents that remain behind, a relatively complete set of blueprints used during construction and a few letters by George Grant Elmslie, Sullivan's draftsman and this project's most significant other. Four years ago, I stumbled upon the blueprints, which had been stored unceremoniously in the bank basement since its actual construction. The prints I found had clearly been discarded, sloughed off like work clothes at the end of the day. Many of them were full-size details. As I pulled the largest ones from the abject heap, I marvelled at their survival:

> As all working drawings and specifications of architectural work are instruments of service for use during the actual construction, full-size details may perhaps be called 'temporary instruments' of service. The general working drawings, specifications and scale drawings are always sacredly filed and guarded after the completion of the work, to serve as permanent records of executed work, and very often become active again should any addition or alteration to the executed work be required.
>
> Full-size details are not so sacredly treated, for although they may be kept for some time after their service is over, they are usually too large to permit permanent economical filing. Often the method of construction or use of a particular material, which was the very latest at the time the detail was made may have become entirely out of use, with the progress of science, in

Owatonna Bank: Cornice section

a short time. Should later information be required of work executed from a particular drawing, this can best be obtained from actual conditions at the completed building. Therefore, detail drawings should be made as simply and as economically as possible; but making details simply and economically does not mean neglecting careful study.[9]

The blueprints left behind in the basement inevitably call attention to details. Over half of the drawings were drafted full-size, a practice common among Sullivan's peers but starting to wane when the bank was constructed.[10] In the context of Sullivan's entire career, and of common practice among his contemporaries, the large number of full-size construction details produced for the National Farmers' Bank is quite unusual.[11] Full-size drawing was normally reserved for ornamental details. Full-size details of other building components were called for in special circumstances only. In this set, full-size details are the rule, not the exception. This anomaly forces a consideration, then, of a more ambiguous relationship between ornament and structure than is the case with most of Sullivan's other work.

Throughout Sullivan's career, his ornamental designs were usually sketched freehand with a soft pencil at whatever size the paper at hand dictated.[12] Many of Sullivan's preliminary sketches that survive are on small scraps of paper and pieces of stationery. At the outset of the design process, these details were often simply graphic designs with no designated scale.[13] Although Sullivan did occasionally prepare full-size working drawings for ornamental elements, that task was usually assigned to his draftsmen. The final design emerged from a three- or four-step process of enlargement and refinement; the ultimate tracing was frequently inked. The design process did not stop with drawing, however. Most elements were also subsequently modelled and prototypes were necessary for many methods of their manufacture. Sullivan's practice was common, and no doubt he thought of himself as the overseer in this process. Nevertheless, the degree and nature of his participation must be questioned in many cases, especially in that of the National Farmers' Bank. All surviving sketches and drawings of the building are in George Elmslie's hand.

> I made every drawing that enters into the fabric of your building, every design from your stencilled walls to your stained glass, your clock, electroliers, grilles, everything. I never meant to say anything of this kind, but at the parting of the ways surely no harm is done.[14]

> How many times with a modeller at his clay, in interpretation, I have watched the 3-dimensions appear and what high grade pleasure it was, 'Emphasise this more! Too deep here! Raise this part of the foliage! Subdue here.' Finally O.K. and just as desired and impossible to show on a drawing.[15]

By the 1920s, architectural magazines were publishing articles about drafting-room practice that dismissed full-size drawing as outmoded.[16] The reasons are very clear: ornamental embellishment of building was denigrated in some circles and many draftsmen had lost patience with the instability of dimensions over wide expanses of shrinking and stretching drawing surfaces—many had been trained in more reliable methods of detailing. Given the newly emerging machine aesthetic, tolerances of all sorts had become very narrow.

Just after the turn of the century, however, full-size drafting was a flourishing practice. At the time it might have even seemed relatively efficient: in contrast to just a few years earlier, large sheets of linen could now be unrolled, not pieced; special drawing tools could be purchased, not adapted; and, most importantly, the blueprinting process could be more carefully controlled because it now used artificial illumination, not sunlight.[17] These advantages notwithstanding, the full-size drawing still presented a challenge—to its maker and the builder. The question remains: why did George Elmslie, an experienced draftsman, choose to make such an extraordinary number of full-size construction drawings for the National Farmers' Bank? While Sullivan's part in this decision will probably never be known, it is safe to assume that, given all the evidence, Elmslie made most of the day-to-day decisions in Sullivan's office at this time: any ambiguity these prints create between the necessary and the excessive must be his doing. If the building is something other than a bank, it is because George Grant Elmslie, the quintessential everyday man with time on his hands, found too much freedom in his anonymity. The drawings, like the building, are a sanctuary for his proclivity to overdo.

Casually inspecting the bank blueprints, we see little precise delineation of ornamental surfaces in elevation—only bits and pieces of this skin cling to the drawing surface here and there. Since most of the full-size details in this collection of blueprints were drawn in section, they often present aspects of the building obscured by ornamentation. These sections are rarely literal slices through the building: the skin is sometimes detached for closer inspection. On rare occasions, the ornamental skin is peeled away completely before the cut is made. A section through one of the four 2-ton electroliers, for example, describes the monstrous fixture as if it were a bony structure, not as it appears: a massive surge of foliage through the banking room ceiling. The electrolier print was prepared as a shop drawing by Winslow Brothers Ornamental Iron, not by Elmslie. It is dryly intriguing but ultimately disappointing: we need to touch the models and casts that produced the light fixtures' extravagant garb.

Elmslie's full-size section through the building cornice, on the other hand, is much more intimate: it lets us rub against the out-of-reach and put our hands in secret pockets. The cornice's elevation is only lightly delineated; its brave front barely shows. Elmslie exposes the hidden contours of this apparent boundary

between building and sky. Now we know: the proud top of this building is a fragile rim of lonely spaces. Elmslie claimed the cornice was one of Sullivan's two contributions to the bank design.[18] This drawing lets us feel the corbel's doubt: is this too much? Is this too far?

Below the cornice, the building's ordinary brick bearing wall comes to life when it hits the outside air: the exterior tapestry brick surface is braided with tile and studded with terracotta. Sheet 42, a full-size plan section, details how this spectacle quietly wraps a corner. It takes a reduction in scale, however, for its companion, sheet 42 1/2, to show how the display plays out across the elevation. Horizontal and vertical sections impose upon the elevation—and weave it together. Inextricably linked, these two drawings are not static cross-sections and fixed elevations, they are diagrams of a dynamic tectonic scenario. The prints are most easily read by acting out the construction process, brick to tile to brick: the fabric becomes a fabrication. These prints threaten to lose us if we do not play along. Trapped in the necessity of joining, no detail seems excessive.

The brick details, like the cornice—unlike the electrolier—are concerned with the materials which define the building's surfaces. While methods of attachment to the larger architectural armature are conspicuously absent from most full-size fragments, the details reveal the extent to which these pieces have been embedded, not merely draped. For example, the sandstone plinth actually bleeds into the common brick backing at the bank's corner; taking the place of brick, stone bears a more pedestrian burden. The skin of this building is a thick assemblage, not a simple profile.

If the number of full-size construction details for the National Farmers' Bank seems improper, it is simply because they blur distinctions between the building and its ornament and between building and drawing. The National Farmers' Bank blueprints are the primary demonstrations of a spectacular architectural event. They affirm, simultaneously, the pleasures of drawing and building and, in doing so, affirm their intimate corporeal connections. The blueprints make a place for our hands even as they describe a construction too large and complex to grasp.

These enormous prints are the luxurious, erotic conflation of sight and touch. They intend to seduce. We want to lie down next to them, trace their contours. We want to wrap our bodies in sheets of details. We want them in the same way we want the bank: both these drawings and the building make us forget, for the moment, that we came to make a transaction. Not since medieval times has the gap between drawing and building been so infinitesimal, yet charged.

Owatonna Bank: Plaster details

Of all the prints in the bank basement, the most beautiful is sheet 43—plaster details for the banking room ceiling. Due to its leathery texture, the 42 inch x 94 inch print is easy to handle, despite its frayed and stained appearance. This sheet was handled a great deal during construction: a template in the most literal sense, it is pricked with the scars of its own projection, traces of translation from drawing to building. We naturally imagine that the building itself must be correspondingly wounded, but the plaster mouldings are too distant to examine. To assume this blueprint was the only tool necessary to define these plaster details is an innocent mistake, however; it had an accomplice. As is true with many buildings, the models, casts, and other devices produced for the National Farmers' Bank have been discarded or consumed by their own construction. In this case, the secret link between this drawing and the building was a temporary contrivance, another template, fabricated on the construction site to mediate their differences.

The delineation of the ceiling moulding profile barely survived its fabrication. The precisely drafted edge is interrupted and erased. It is also defaced by a trail of tiny holes that mark a contour once shared with the zinc-and-wood mould that ran its length. The running mould itself required temporary guides, slippers, at its nib and toe. Brushed with paraffin oil to prevent swelling, the mould dragged its

negative impression into the wet plaster surfaces. Spread out on firmer ground below, the full-size plaster details recorded this messy construction process. The drips and stains now ornamenting the print collect and organise another image of the bank interior.

Medieval architects used similar techniques.[19] The use of full-size templates was an especially sophisticated practice in the Middle Ages. While they were frequently custom-made for specific projects, they were also reused and shared among guild members. Methods of template production and specifications for particular patterns were often carefully guarded in-house secrets. Medieval templates were encoded with instructions that went beyond their obvious two-dimensional shape or outline; they were devices which, when properly deployed, generated three-dimensional details and components. In a sense, they were instruments of projective geometry before its invention. Architectural projection is now most often used as a prefiguration device, an aid to formal composition. Any notion that the drawing might guide the fabrication of a builder's implement, survives only in the most inventive practices. Like the National Farmers' Bank plaster details and the brick diagrams, the medieval designer's working methods linked hand to eye to mind.

As we might expect, in contemporary practice, templates are frequently configured on, and implemented through the computer, not by hand. In Frank Gehry's office, for example, manufacturing software appropriated from the aerospace industry will be used to cut complex curves in the Disney Concert Hall stonework. A similar process is being examined for the production of curved glass templates. In the case of stone, the computer model will control the production of component parts directly, while, in the case of glass, it will define a template only and serve as a link between model and materialisation. In Gehry's practice, where the model comes first and drawings follow, the computer is becoming a method of doing away with the production of traditional working drawing, a tradition which makes complex and idiosyncratic geometry difficult and expensive to realise: the computer is not a medium for streamlining working drawing production, it is instead a convenient tool that further enables the firm's haptic and intuitive aesthetic.[20] In architecture, desire and pleasure as well as signification are materialised or suppressed by methods of detailing. Frank Gehry's use of computers, then, is both evasive and subversive: in the laboratory of this alchemist, the war machine is disarmed.[21]

Like Gehry's computer models, the partially destroyed sheet of plaster details for the National Farmers' Bank is not a drawing in the conventional sense. A template of a template, its enigmatic surface brings to mind the medieval tracing floor.[22] In the Middle Ages, the tracing house protected a large plaster floor that medieval designers inscribed and reinscribed as they worked, floating new layers of plaster over mistakes and revisions.[23] Archaeological reconstructions of

these floors are palimpsests of the construction process. It was the first structure built at the cathedral site, the place where the building was configured and its templates were designed. There was a built-in reciprocity between drawing and building; the construction process—to borrow a phrase from my colleague Julieanna Preston—made a life-size formwork for the activity of drawing. This blueprint—like its contemporary counterpart, the electronic workspace—is a portable tracing house.

In addition to their work within the tracing house, medieval designers also mapped out full-size figures directly on the site itself, or on the building as it was being constructed. Vestiges of these practices remain in contemporary construction methods, but the architect usually makes his or her marks on a model in the office. In contrast to medieval methods, modelling is now a substitute for building and, in many cases, the mock-up makes a mockery of materiality. In the office of Venturi and Scott-Brown, Robert Venturi makes a habit of revising studies, line drawings pasted to foam core boards, with a pink magic marker. These drawings, and subsequent revisions, are frequently plotted full-size from a digital file. The stone arcade for the Seattle Art Museum was studied this way—the final dimensions of the reveals determined from a series of full-size facsimiles constructed of foam sheets. In Venturi's case, however, the process is simply a validation of intention: the stone itself is a veneer not much thicker that the model itself.[24] In contrast to Frank Gehry's CAD/CAM models, Venturi and Scott-Brown's full-size models and drawings are tools for composing, not constructing. The building itself becomes an armature for similar surfaces of cultural projection.

Postmodern ironies aside, to those of us burdened by a more conventional approach to orthographic projection—point to point, plane to picture plane— full-size drawing seems curiously anachronistic, excessive, labour intensive. Consequently, we are prone to misread the National Farmers' Bank blueprints, just as we misread the medieval tracing floor. These full-size drawings are not pictures but demonstrations of how drawing becomes building: no polite dialogue but an erotic *ménage à trois*. These prints seek the hands of the drawing's illicit accomplices, the builder and the builder's tools. Exaggerated to the point of hallucination, these details do not simply delineate the building, they embody its fabrication.

Despite their obvious differences, the medieval architect's plaster tracks, Frank Gehry's electronic signals and the National Farmers' Bank blueprints share a similar approach to architectural production. In each instance, the full-size image is a demonstration not a prefiguration. The full-size detail, then, gently draws together the building and its makers; it maps another architecture, the architecture of materialisation.

At the turn of the century, the production of full-size details usually followed the construction process and mirrored the social organisation of the building trades involved in the project; a detail was drafted, as the need for specificity arose, often taking its fundamental dimensions from the partially completed building. In the case of the National Farmers' Bank, however, several full-size details were drawn prior to any actual construction at the site. In general, these details represent a certain amount of prefabrication, appropriating information about building elements that had been modelled and cast elsewhere by the various craftsmen involved in the project. In the act of manufacturing the bank, drawing alone was often an impotent technology. The excessive number of full-size details—some of which might be considered wholly unnecessary—must be considered a civil attempt by Elmslie, who perhaps had too much time on his hands, to reclaim the building from its subcontractors, to gather close around him—like so many Pygmalion fragments—this more distributed construction site. His obsessive delineation might also be considered an attempt to participate, vicariously, in the construction process. The bank's full-size details not only demonstrate its materialisation, they also construct a more fugitive architectural image: in Sullivan's office, hundreds of miles away, Elmslie's elegant contours took the building's place.

The National Farmers' Bank is not a bank but an armature for material excess—responsibility for the building's excesses is distributed and concealed among its details. For the most part, the building's overall ornamental effects are the product of relentless repetition of the individual unit, and this accumulative effect—the flow of various materials and methods of assembly, one into the other—was co-ordinated but unforeseen. As the bank materialised piece by piece, the scale of its effect became apparent: the building as a whole was both formed and deformed one piece at a time. In the end, however, the full-size details remain the bank's most significant surplus: more like diagrams of collaboration than instruments of prefiguration, they focus our attention on the dynamic act of detailing, away from the static image of the detail. They beg us to re-examine our daily habits—to practice architecture *con garbo*.

The practice of full-size detailing is not so much a gendered practice as it is a *gendering* practice. Methods of detailing, then, call attention to the architect's lived body. This body is:

> regarded as neither a locus for a consciousness nor an organically
> determined entity; it is understood more in terms of what it can do, the
> things it can perform, the linkages it establishes, the transformations and
> becomings it undergoes, and the machinic connections it forms with other
> bodies, what it can link with, how it can proliferate its capacities—a rare,
> affirmative understanding of the body.[25]

This rare, affirmative understanding of the body animates the "feminine particular" but it does not necessarily predetermine its form.

Although the full-size working drawings for the National Farmers' Bank do not seem to present a viable methodology for new practices, Frank Gehry's work demonstrates how the desire to manipulate materials in new ways demands its own methods of mediation and frequently rediscovers the full-size template. While digital codes seem far removed from George Elmslie's gentle superfluities, it is simply the hard, bounded surface of the computer projection, the video screen, which appears to sever our relationship with materiality. The corporeality of architecture persists, however.

The practice of full-size detailing is, of course, only one particular method of architectural inscription, but this practice of excess persists—perhaps because it is a desiring practice:

> It has been argued that while psychoanalysis relies on a notion of desire as a lack, an absence that strives to be filled through the attainment of an impossible object, desire can instead be seen as what produces, what connects, what makes machinic alliances. Instead of aligning desire with fantasy and opposing it to the real, instead of seeing it as a yearning, desire is an actualisation, a series of practices, bringing things together or separating them, making machines, making reality. Desire does not take for itself a particular object whose attainment it requires; rather, it aims at nothing above its own proliferation or self-expansion. It assembles things out of singularities and breaks things, assemblages, down into their singularities. It moves; it does.[26]

All Photos: Clare Cardinal-Pett

Notes

1 A footnote offered by Marco Frascari after presentation of an earlier version of this work at *Open and Closed Representation*, the University of Pennsylvania, March 1995.

2 Frascari, M., "The Tell-the-Tale Detail", in *VIA* no. 7,1984, p. 36.

3 Elmslie letter to Frank Lloyd Wright, 1936, reprinted *Journal of the Society of Architectural Historians*, vol. 20, pp. 140-142, October 1961.

4 Elmslie letter to Frank Lloyd Wright, 1936. pp. 140-142.

5 Schor, N., *Reading in Detail: Aesthetics and the Feminine*, New York and London: Methuen, 1987.

6 Schor, *Reading*, p. 97, (author's italics).

7 Schor, *Reading*, p. 97.

8 Evans, R., "Translations From Drawing to Building", *AA Files*, no. 12, 1986, p. 16.

9 Breiby, J.C., "The Making of Working Drawings: Part III, Full-Size Details", *Pencil Points,* July 1923, p. 23.

10 Breiby, "Making", *Points.*

11 See, for example, Paul Sprague's catalogue of the Sullivan collection at Columbia University's Avery Library Archives, *The Drawings of Louis Henry Sullivan*, Princeton: Princeton University Press, 1979. Many historians have been frustrated by the fact that a larger number of working drawings for Sullivan's buildings have survived than preliminary sketches. This has happened partly because Sullivan had a tendency to hang on to the construction documents and throw away other work. I think it is interesting to ponder why he threw away what, even at that time, he knew might become objects of desire.

12 Sprague, *Drawings*.

13 During the discussion following my presentation, "Full Size", at *Open and Closed Representation*, Alberto Perez-Gomez pointed out that the notion of scale commonly associated with architectural practice did not exist during the Middle Ages. While it is important to remember Perez-Gomez's comment when, later in this paper, I draw some parallels between full-size detailing and medieval practices, it is interesting to point out here that Sullivan (and possibly Elmslie, to a certain extent) did not seem to have much interest in issues of scale, leaving that practical matter up to others; his imagination may have been more medieval than he would have liked to acknowledge.

14 Elmslie letter to Mrs. Lydia Bennett Freeman, December 7, 1909. Typescript copy at the Northwest Architectural Archives, University of Minnesota.

15 Elmslie letter to Purcell dated October 15, 1940, at the Northwest Architectural Archives.

16 Breiby, "Making", *Points*.

17 Gray, C., *Blueprints*, New York: Simon and Schuster, 1981.

18 Elmslie letter to Purcell, April 18, 1939, Northwest Architectural Archives.

19 See Shelby, L., "Medieval Masons' Templates," *Journal of the Society of Architectural Historians*, vol. 30, 1971.

20 Author's conversation with Michael Maltzan of Frank Gehry and Associates, Summer 1994.

21 Historically, aircraft production and shipbuilding have many techniques in common with architectural practice—that the two industries (which have obvious military purposes) have, until quite recent times, made prevalent use of full-size drafting is only briefly noted here. A more comprehensive study of the history of full-size detailing in architecture would call for a richer elaboration of the connections between architectural production, the aerospace industry, and shipbuilding.

22 See Harvey, J., *The Medieval Architect*, London: Wayland Publishers, 1972.

23 In aircraft production the 'tracing floor' is referred to as the 'lofting floor' and full-size drafting is called 'lofting'. Smooth, level, wooden platforms were common—eventually replaced by metal. The drawing surface was typically painted light green to reduce glare. In shipbuilding, the terms 'lofting' and 'laying off' are used interchangeably. In the shipyard, 'mould loft floors' were usually carefully constructed wooden platforms, blackened, then marked with chalk. The floors were occasionally 'scrived' to make chalk-catching grooves in the wooden surface. In both cases, the 'floor work' led to template production. All these activities now take place in electronic space.

24 Conversation with Mark Stankard formerly of Venturi, Rauch, Scott-Brown, Summer 1994.

25 Grosz, E., *Volatile Bodies: Towards a Corporeal Feminism*, Bloomington and Indianapolis: Indiana University Press, 1994, p. 165.

26 Grosz, *Volatile*, p. 165.

Mark Cousins

Where ?

Above all, philosophers have enjoyed thinking about what there is. Ontology, the nature of what there is, and what general conditions things need in order to be—such questions form the background and foreground of the eminent arguments which describe the basis of seriousness in philosophical thought. In less systematic arenas of knowledge, it breeds the habit of a certain kind of question. Confronted by something, it provokes the question—"what is it?" Whether we feel compelled to answer with an essence, a definition, a designation of it as a member of a class, whatever the form of identity it takes, the *it* stands out as the elementary form of an object. It is true that this may take a wide range of logical forms, from a platonic idea to a grammatical category. Nothing, in essence, links all the different uses of the term 'object'; there need be no object in general. And yet, if we read philosophical texts or logical treatises, not in a philosophical sense, but with a novelistic concern, something immediately becomes apparent. In so many texts, the example of an object will take the form of a physical object which is distinct. Why else would the examples so often use mountains and rivers as their prime candidates for the transparency of what an object is?

We might consider that philosophical texts had a kind of pre-conscious, the arena within which the idea of an object is appropriated by a certain medium of expression. The medium of expression in this case is that of a physical object which is *seen*. Philosophers may retort that the logical status of examples is of no account; but still, we are left with the interesting fact that the first idea (first in the sense of initiating a chain of associations) of an object is this *thing*, a thing most aptly rendered by rivers, mountains, bald royal heads, pyramids, and the various stars of the heavens. Whatever the philosopher may wish to discard as the logical status of this mode of exemplification, it remains the intuitive point of the communication of an object. But it is a point which is subject to immediate repression.

The idea, we might as well say flatly the *phantasy* of an object, is subject to repression in the following way: the logical text encourages us to think only of the object as it is abstracted from its exemplification. It is as if I have to put the idea of a river or a mountain *on the table* before we can begin to refine it as the example of an object. Soon, the mountain must become non-physical, the river

must lose its dimensions, and the bald royal head be turned into a question of reference. But logical abstraction can never overcome the rhetoric of traces, in this case a mountain or a river. What logical abstraction attempts to repress is not only the concreteness of the object, but that more than the object was at stake in the pre-conscious arena in which it was appropriated by a certain mode of expression. That mode of expression is perhaps best described by the word, a *scene* or *phantasy*.

If we consider the pre-conscious phantasy which functions as the condition for the emergence of the object, we form quite a different view from the logician's of the orphaned singularity of the object. The pre-conscious phantasy implies that the object is seen, and from a certain point of view. This can be illustrated simply. If I refer to an object, let us say the Matterhorn, I feel reasonably certain that most people will call to mind that startling image of a narrow, snow-covered triangular peak. But in what sense is this *the* image of the Matterhorn? It is the view disclosed from the Swiss side of the mountain; from the Italian side, the configuration is very different. Indeed, from that side of the mountain, the Matterhorn does not look like the 'Matterhorn'. The name 'Matterhorn' then conjures up an image which is seen from a particular point of view, which is specifically located. Its location is not just a topographical line, it implies a subject position, a subject at a certain distance from the object. We can see then that even the elementary idea of an object in school texts on logic is founded on the repression of a scene of phantasy, in which the object is apprehended by a subject, a scene which is marked by a definite location. Ontological discourse, even in its most abstracted form, maintains the traces of another scene in which subject and object are related in a particular setting. I will return to this below.

However, there is another discourse besides the ontological, which is also a preferred mode for philosophers. It is the discourse of temporality, in which the time of the object becomes the immediate object of enquiry. It is in the late eighteenth century that thought which reflected upon itself as *critical* thought thinks its critique through the time of the object. The nature of the object depends upon when it is. Temporality becomes the medium of change. Relations between objects become saturated with time, for time is the index of a process. Philosophical discourse becomes historical through and through. Things are what they are as a result of a historical process and they will become what they will through the analysis of the object's history, and through the object's future, whose past the object now enacts. The object is the present moment of bisection between its origin and its end.

"When is it?" This becomes the typical form of question apparently about the present, but actually about the way the origin and the end are in a particular ratio which we call the present. At one level, this gives rise to a kind of Hegelian journalism, in which intellectuals compete to give more melodramatic interpretations of the present. It is always 'after' or 'towards' or 'in crisis'. It is late, always later than the layman thought. After all, if we were absolutely historically becalmed, with nothing of a transitional character in sight, the market for intellectual interpreters of the age would dry up. Traditional religious eschatology fits in well with radical critical thought, and the poor subject of history is reduced to the white rabbit—always late. But this radical temporalisation of all forms of relation, especially in the area of causality, operates a marked repression in one area of analysis—that of space and spatialisation.

Differential spacings are subsumed into the temporal dimension. Spacings become moments of a process of historical transformation. Time ruthlessly empties space of anything except signs of a successive order. It may be that, intellectually, the only disciplines which are disposed to resist this radical temporalisation of orders and relations are anthropology and psycho-analysis. To both of these, temporalisation is the *effect* of certain relations, rather than the concept through which those relations can be conceptualised. Levi-Strauss' just rebuke to Sartre in *La Pensée Sauvage*, insists that history is a product of some social relations and not others, and therefore cannot function as a meta-category for the analysis of all social relations. Freud is more blatant. The unconscious knows nothing about time. The experience of time is therefore indirect, variable and oblique. In both of them, time is subservient to the movement of desire, to the discourse of the Other.

It is not surprising then how little of the intellectual commentary, which deals with art and architectural objects starts from the issue of space. It is not surprising that so much commentary still turns on the question of "what is it?" (that is, what class is it a member of, what is its essence, what is its meaning, etc.) and "when is it?" (where is it in a sequence, what is its significance, post-what, pre-what, what is its contradiction, etc.). Not surprising. but damaging. When so much architectural and artistic thought, so many drawings, models, interventions, installations and proposals are made in terms of a certain spatial desire, then the available critical vocabulary is a phase apart from what may currently be called *installation's* work.

If the title of this symposium, 'Desiring Practices', has more than a gestural meaning, it ought to be possible to say something of the relation of desire and objects which will illuminate the category of installation, that spatialisation of

objects in accordance with an affect. But where is the language to be had? The rest of this paper is a modest proposal that Freudian psycho-analytic theory may be teased into providing some of the terms needed to link desire with installations in space. Essentially it consists of the idea that analysis can speak of the differential 'scenes' in which the subject and object are caught up, in a way which avoids repeating the questions "what is the object?" and "when is the object?" *Where*, the great topographical question, is not aimed at the object as such, but at the *scene*, which inscribes the places of what is installed.

Desire is not a metaphysical category within psycho-analytic thinking. It is a category which arises from the failure of existence. The baby is born so early that its very survival depends, compared to other animals, upon a long period of nursing. The baby exists, but only within the circuit of life which is completed by the mother. Its biological needs are satisfied by the mother, or whosoever is substituted for the mother, such that the needs do not need to be represented. The mother satisfies the needs of the baby so that the circuit of need and satisfaction is repeated automatically.

Until, to put it mythically, one day the need is not met. At this point, the infant is catastrophically precipitated into the zone of representations. To begin with, as Freud remarks, the unfed baby may hallucinate the satisfaction of the feed. But you cannot drink hallucinations. The non-satisfaction induces, on one hand, the subject of desire, and on the other hand the object as substitution. The desire is born from the economy of non-satisfaction. But the object to which this desire is directed is by now not the object of the circuit need/satisfaction, but the object as object of desire. The world is now the world of desire and representation.

It is a world from which something is missing. This is the starting point, that there is something lacking. It is also its end point. For every desire, for every object of desire, is accompanied by a double, a kind of phantasmatic doppelgänger, the desire which would end desire, the desire to return, the desire to return to the place 'before desire', the paradise in which I have everything because I lack nothing. Each desire, then, is for what Freudian thought designates the 'lost object'. Now the lost object cannot be found; it is not some ur-object which we may patiently reconstruct. Rather, it is the dimension within which desire moves; loss is the effect of the appearance of desire as much as loss is the cause. But it should remind any attempt to foreground the category of 'desire', that it is as much about the condition of loss, as the positive value of desire.

In fact, we already have generated a schema for thinking the subject's relation to objects and space. The subject's world is a world of desire and representations, which are also substitutions. From the beginning, this relation to the subject and space cannot be neutral; space is not a neutral medium for the subject. It is where the subject is already ex-centred, precipitated from that glorious nowhere of the lost object. This is already some analytic advance; the subject is not yet in space as an object might be. Rather, the subject is in a primary exile—an exile of projections and externalisations. There will be no neutral, not even an *ordinary* experience of space, for the very experience of space, or rather the subject's relation to space, is constituted by being the bisection of the moments of desire and loss. Of course, the defences of everyday life will annul this proposition and make even its theoretical statement here seem a little more melodramatic. But it can already be seen that from the point of view of the object, shall we say the architectural object, it matters that the subject is not just an empty psychological space, but the point which is doubly inscribed as loss and desire. Perhaps the important point in the idea of topography, from a sketch to a scale drawing of a form of representation, is that it is characterised as being both an image (representation) of itself and a means of analysing itself.

An obvious example is a map. It is both a representation of a territory and also an analysis of the territory. The analytic conventions such as the contour lines and the ideograms for churches and railway stations use a type of sign which is representational but referential. But imagine that there is a map which does not stand representationally in relation to somewhere else. Moreover, while it deploys signs, these have been emptied of convention and have no key. And yet such a map without a territory, designated objects that have no name, might describe the current situation of certain forms of installation work. It becomes an internalised topography.

This is the topography of the subjects of desire. The subject desires. Desire has a strange affinity to that map with no reference, the installation. Desire is both a representation and a means of analysing that representation. The subject's desire may be expressed as a wish, as a *phantasy*. This phantasy can be thought of as a little scene. It may be largely unconscious on the part of the subject. Indeed, the subject's role in the phantasy may be obscure; certainly the phantasy is wholly that of the subject, but what role does the subject play within the scene beyond that of the produced? It may turn out that the subject is dispersed across the phantasy in a way that fundamentally complicates Freud's view that the author and hero of the daydream are the same. A phantasy may have not such obvious points of identification; it may show no self-evident means of distinguishing between the subject of the phantasy within the phantasy, and the objects of the phantasy within the phantasy. The distinction

can be drawn only within Freud's analysis of desire, whose terms can be glimpsed in his *Three Essays on Sexuality*. His initial distinction is to divide desire into its object and its aim. In this way, a phantasy may be subject to a preliminary analysis, the object of desire, and the aim of the desire.

But for Freud, the object and the aim never exist, save in a particular mode of existence which he terms the oral, the anal, the phallic and the genital. There are various ways open to the Freudian narrator to try and pass these terms by the sceptical listener. For Freud, they are terms which describe the various stages of infantile development in which a succession of bodily zones, erogenous zones, become the loci and, as it were, the topics of that moment of development. In the oral stage, the mouth becomes the privileged organ through its relation to the breast and feeding. The oral moment expresses the lack of differentiation between the infant and the breast-as-a-world. This is brought to a conclusion through the infant's development of a more aggressive mode, which leads to the anal stage. The anus becomes both the place and the topic for a struggle over the infant's shit. The infant's sense of giving the shit as generosity, but of not wanting to give it up on demand, make the anal stage a battlefield for establishing some of the most fundamental cultural rules concerning control and the difference between the inside and the outside. The phallic and genital stages are taken in the more evident sense that the stages each supply their own forms of pleasure and that these essentially take different masturbatory routes to it.

But it is clear that the erotogenic zones and the *aims* appropriate to them are in no way reducible simply to versions of prefigurations of genital sexual relations, just as it is clear that this is no simple teleology. For these are stages of relations between the subject and the object which are not extinguished when they are surpassed. They are never surpassed. It is axiomatic that, for Freud, if the psychical difficulty of maintaining oneself at a certain level is too great, there is a universal tendency to regress, to abandon one stage, one erotogenic zone for the earlier and more certain pleasures of a previous stage. But merely to stress the precariousness of the development and its subjection to regression, still somehow does not prise the stages from a developmental sequence.

A more relevant conclusion, as far as we are concerned, might be to think that the terms oral, anal, phallic and genital describe not so much the erotogenic localisation of the developmental sites of pleasure, as the terms for the enactment of specific types of relations and fixations. In short, they may be the terms for particular modes of experience. 'Orality', we may think, describes a relation between a certain mode of experience of an object, including a certain quality of spatial relation. It may have its origin in the relations between the

mouth and the world, but that relation can be dispersed across the body and can be invested in any of its organs. In this way it might make sense to speak of 'oral vision'. Oral vision would be, first, the vision of the oral stage: what characterises the relation of the mouth to the breast would have to be translated into visual terms. Fortunately, our language already testifies to the archaic link between eyes and orality. You are delicious, I could eat you. The idea of oral vision would call forth an experience of drinking in a world which is not yet differentiated from the act of feeding. Perhaps we might think of orality as a spatial possibility in which the subject's aim is to consume the object and exhaust the register of space. The anal register might be thought of as particularly significant for architecture. For the anal drama is the human subject's first introduction to the limitless problem of the distinction between the inside and the outside. The particular resolution or pathological failure to resolve this issue will mark the subject's experience of the distinction in ways which have yet to be recognised.

The phallic and genital stages are those to which, in some sense, architecture is already partly alerted. The isomorphism between buildings and the phallic trace has long been an architectural trope, though one which it seems unable to employ without a smirk. The real question, of course, is not the relation between the phallus and the tower or skyscraper, but the relations between the tower and the anxiety about castration. The skyscraper is not the embodiment of the phallus (for the phallus is that which cannot be embodied), but rather the manic defence against fears of castration.

The role of castration, which is outside the scope of this paper, is the late moment at which gender arises. If this paper is marked by an absence of remarks about gender, this is largely because the Freudian scheme of sexuality and its development postpones, until after the anal stage, the division of the sexes. Before that, sexual development pursues a singular trajectory. Indeed, however differential the relation of desire to the object, in the two sexes, it will still have a single bedrock in the oral and anal stages. Theories within the human sciences have expended much labour on the consequences of sexual difference at the Oedipal level. Indeed, the Oedipal drama has provided the norm for analysing cultural practices in their sexual division. By contrast, the purpose of this paper has been to suggest how the sexually undifferentiated oral and anal stages may still have much to suggest in the preliminary tasks of mapping the subject's unconscious relations to objects in space.

Making Love/
Making Architecture:

Desiring Practices
Akis Didaskalou

a good metaphor
for thinking
and practising
architecture

... la liberation des victimes de la violence symbolique ne peut s'accomplir par décret.[1]

Is it possible for aspects of (educational) design practice to be likened to aspects of the prevailing masculinist, genitally-centred model of sexual practice?

Is it possible for architectural education to be thought of as a sort of virilisation process, oppressive and frustrating, for both female and male students?

Does it make any sense to compare the sexual liberation of the previous decades with the postmodernist 'end of prohibitions' in architecture?

I will argue in this paper that a metaphorical operation establishing analogies and similarities between (ideas of) sexual and (ideas of) architectural practices respectively, is not only possible and does indeed make sense, but also, that it can potentially be very helpful for a more gender-sensitive architectural educational practice.[2]

Striving for a more gender-sensitive educational practice is understood here as part of a general strategy aiming at a more difference-sensitive architectural educational practice. In other words, a practice attempting to question and interrupt particular systems of oppression, encouraging different, excluded or to-be-imagined possibilities; a practice willing not to forget that, in our differentiated societies, education in general, and architectural education in its

own specific way, if not structurally determined, is at the very least inclined to reproduce and indeed often enhance existing socio-cultural differences and inequalities.

The 'sexual/architectural' metaphor may not be the most common of the metaphors already at work inside architectural and/or urban discourses, but nevertheless, it can by no means be considered an unexpected or novel one.[3] I suggest that the 'sexual/architectural' metaphor can be used as a prompt and effective means for stimulating critical discussion and thought, and/or as a short-cut for the transferrence into the architectural discipline of valuable insights and ideas, of dilemmas and tensions generated in other fields. It thus opens up architecture to new and promising, though complex and controversial, encounters and intersections.

Architecture and sexuality can certainly designate separate realities, differentiated spheres of experience and feeling, more or less institutionalised practices, distinct disciplinary and professional fields or protected conceptual territories. However, one must not forget that they are fundamentally historical categories, socio-cultural constructs or inventions. Their boundaries, both external and internal, are artificial or symbolic (though no less real for this), precarious though often quite durable, and never absolutely meaning-proof.[4]

The idea, then, is to ask students and, certainly, educators as well, to engage in such a metaphorical operation between architecture and sexuality and to compare their own respective habits and conceptualisations; to encourage them to think and re-think the stereotypes, prejudices and certainties informing their attitudes and beliefs; and, finally, to invite them to participate in a dialogic questioning of their modes of understanding and acting. Consequently it is vital to ask them to try and imagine alternative, multiple, existing or to-be-invented possibilities. As a sort of mere illustration of how such an educational process might be initiated, some metaphorical statements are proposed and briefly discussed below. These statements refer mostly to a particular, rather tacit and implicit, aspect of architectural education, to what is sometimes called the 'hidden curriculum', but, there is no reason why this metaphorical operation could not cover other aspects of architecture as well.[5]

I suggest we could propose to our students, at first for individual, and then for dialogic elaboration, some of the following or similar questions:[6]

Why is it that the stable building has to be the only 'raison d' être' of architectural practice, the only origin and recognised end?
Why, in architectural education, is such an emphasis given to the final product? Why is such pressure exerted on the students to produce (ejaculate) visible, even spectacular, completed projects?
Why do all students have to reach, after a carefully monitored process, a male-like orgasm (only one will be accepted) by the end of each studio? How many successful, male-like architectural orgasms must a student be able to exhibit in his/her portfolio before he/she can possibly be recognised as a (male) architect?

Why are we inclined to attribute so little (if any) meaning and value to all the preliminary investigations and design 'foreplay', and this only to the extent we think they will lead us safely (though, not prematurely) to the predefined and prescribed final climax? Where might such students' pleasure (if there is any left) come from? Will such pleasure spring from a labyrinthine design process, from some apparently insignificant details or singular moments, or, will it result from its final achievement and absolute physical exhaustion?

Is it because ejaculation, as the general equivalential coefficient of all penises, is supposed to provide a safe criterion of comparison and evaluation of male potency, that we tend to compare and evaluate our students' performances (and thus, neutralising their differences) by focusing, mainly, on the visible, unambiguous and measurable products and/or results?

Is failure to ejaculate a visibly decent finished product to be considered and treated as a sign of incompetence, of impotence, or, on the contrary, as a sign of, conscious or unconscious, resisting indifference to this kind of competitive game?

Why is so much emphasis given to the designer's intentions, to the authorial-paternal sayings as the most legitimate origin of authentic meaning?

Could some glossy architectural magazines be considered as pornographic? Do they not attract and captivate our architectural desire, without caring or being able to satisfy it? Are they not ready to exhibit any architectural perversion, but in the end promote only one, namely, architectural 'peeping-toms'?

All these questions ask for a comparative discussion and analysis of similarities in aspects of architectural and sexual practices. They will, hopefully, allow both our students and ourselves to become a little more suspicious of the phallocentric (usually unthought, seemingly innocent and taken for granted) preconceptions, ideas, routines, modalities, etc., that may, at least in part, organise, regulate and constrain our sexual and/or architectural activities. The aim is to turn students' attention to the nature of the oppression, symbolic violence and discipline to which they have to subject their minds (and bodies) if

they are to be good (i.e. as male as possible) students, and in the end architects. The intention is to help them understand that the architectural education game in which they are trying hard to engage, may be seen as a predominantly masculine one; to show that their architectural education might also be seen as a sort of virilisation process. In other words, architectural education might be shown to be a process as oppressive and frustrating (mainly for female, but also, for most male students, albeit not in the same way and not to the same degree) as the dominant phallocentric model of sexuality that controls, restricts, normalizes and makes uniform the plurality and heterogeneity of both female and male sexualities, and certainly suppresses other sexualities.

Both the sexual liberation of the previous decades and the recent architectural liberation—the postmodern 'end of prohibitions'—far from signalling the liberation of desire and the unrestricted movement of difference, have continued the perpetuation of the masculine order and authority, by excluding, suppressing or marginalising the different, the other, the multiple, the female. The dividing line is, perhaps, no longer between what is permitted and what is prohibited, but it is still there, between the normal and the perverse, between the inside and the outside. In both sexual and architectural activities, difference, plurality and variety are permitted and tolerated (on many occasions even requested or valued) but only to the extent that they can be appropriated by, and inscribed into, the dominant logic, and securely reterritorialised within the institutionalised limits.

In the case of sexual activities, a hegemonic tendency demands that all and every libidinal flux must, in the end, be modelled and coded according to a well known and prescribed genitally oriented male (hetero)sexuality; a sexuality that is grounded on, and finds its anticipated and unsurpassable limit and telos in, the male orgasm. Not very dissimilarly, in the case of architectural education, what is perhaps valued most of all is the competence to create significant differences. We usually ask our students to try hard to be creative, inventive, original, to produce architectural differences; and yet, they have to do this in order to succeed, in order to win and to dominate. What seems to happen is that, through this architectural, more or less repetitive and ritualistic, game, the movement of desire and difference is caught up in a competitive oppositional structure, and thus the libido, as both generator and product of the movement of difference, is transformed and expressed in the form of a 'libido dominandi', controlling and controlled, calculated and calculating, i.e. a libido complicit with the interests of the male—though not necessarily of all the concrete male students.[7]

We could, certainly, think of more metaphorical statements and/or questions, if we would like to become a little more self-conscious of the symbolic violence that we, as educators, exert on our students, consciously or rather not so consciously, if only because, having already been extensively subjected to this very same violence, we can go on exercising it without even knowing it. Again, as a sort of illustration, I could propose the following questions:

> When we are asking our students not only to learn, but also, to love architecture, to engage and mobilise not only their minds, but their hearts and bodies as well, not only their thoughts and knowledge, but also their feelings and emotions as well, do we really mean it? What kind of love do we have in our mind? Do we really know what kind of knowledge might be compatible with love, being or falling in love, with making love? Do they have to know, in advance, what they have to love? And, is this an object, a process or a relation?

> When we are asking our students to love architecture, are we really asking them to make architecture as if they were making love, or, according to our programming, timing, instructions, prohibitions and corrections? When we are teaching architecture, are we not at the same time acting like (liberal or conservative) sexologists? Are design instructors acting as sexologists exactly because sexologists are usually acting as instructors? Why do they both tend to show such a strong desire for listening to confessional explanations and for correcting everything?

> What are we doing with architectural excesses and perversions? Do we tolerate them only to the extent that, and because, while they are opposing and transgressing the laws, they also remind us of these same laws? Could we think of, or feel, the possibility of an architectural perversion which might be like the infantile perverse sexuality: perverse not because it resists the law, but simply because it ignores any law?

> If, and to the extent that, our pedagogic work consists in directing, channelling, controlling, moderating and programming students' architectural impulses and desires, is not, then, our role somehow similar to that of a female prostitute? Do we not feel obliged to feel a similar libidinal coldness and coolness, to keep the necessary distance from the desires of our students-clients? Is it not the case that the latter may, at least in some cases, despise and even hate us as soon as they have completed their (inter)course?

I suggest that such questions may initiate or imply fruitful lines of inquiry on the possible similarities between architecture and sexuality, but they can by no means exhaust the possibilities of the sexual/architectural metaphor. Metaphoricity, as one of the main mechanisms through which meaning is produced and language evolved, ideally cannot know an inherent limit or ending; the metaphorical activity can move in various and multiple directions, and it can be used either to ratify or subvert the conceptual and experiential ground on which it is based. The similarities between sexual and architectural

ideas might always be attributed to a poetic imagination, or to a rhetorical intention, perhaps to "the male passion for the Same", or, simply, to the unlimited power of analogical thought; metaphoricity, however, is never a purely or simply poetic means and/or effect, nor is wholly arbitrary or disinterested.[8]

Such similarities may also be seen as evidence of the possibility that architecture and the ways in which it is structured, conceptualised, performed, thought and talked about, formed into a discipline, far from being a sexually neutral practice, can on the contrary, similarly to most socio-cultural practices for that matter, be considered as sex-coded and gender-inflected. In such a view, perhaps, we are not very far from a Freudian-like idea of the pervasiveness of sexuality where an understanding of sexuality may be revealing for an understanding of whatever may appear as non-sexual, in our case architecture and/or architectural education. But then, the aim here is not to reduce architecture to a sub-species or effect of sexuality, nor to think of it as if it were founded on some sort of ahistorical sexual essence.[9] Rather, the argument is that the similarities and analogies between sexual and architectural practices may also be seen as an indication of the fact that the ways we perceive, understand, think and practice both sexual and architectural activities are, at least in part, governed and structured according to the same deeply rooted socio-historical rules and principles. In other words, according to phallocentric principles that inform our consciousness, haunt our unconscious and are inscribed into our own bodies.

The above metaphorical statements and questions, meant as part of a gender-sensitive and liberatory pedagogic strategy, are, obviously, selected and orientated towards particular educational aims. By rhetorically and explicitly sexualising aspects of architectural practice they look for possible intersections or homologies between architecture and sexuality, so as to expose the male bias that is at work, informing and constraining activities and representations in both fields; the aim is, with the help of appropriate rhetorical devices, like hyperbole, irony, humour, etc., to initiate and guide the discussion towards questioning the hegemonic masculinity and gender division, and to show that such a reality's diversity, heterogeneity and complexity may not take so well to dualistic hierarchic categories. It must be stressed that it is a rather difficult educational aim, as it may go against the usually prevailing logic of the school which would like the educator's paternal truth to coincide fully with the existing order and the hard facts of reality. It may be a difficult task for the teacher as he/she will have to try to avoid the master's position of formulating a totalising discourse, and thus, he/she will deprive him/herself of the easy, though vain, pleasure of seeing his/her sayings being safely corroborated by the things of reality.

It may, certainly, be a very difficult task for the students as well, at least for some of them. Sexual/architectural metaphorical statements can never be innocent or neutral, and the good intentions of the teacher cannot predefine their meaning or their effects as these are also dependent on the particular situation and on the personal experiences of the students. The same statement may be apprehended differently by different students, and it must be stressed that it is exactly these differences which, through dialogic activity, have to be given space for expression and then become the object of understanding, explanation and, eventually, of critical analysis. These differences may mark political and ethical divergences which cannot be mapped on a common theoretical surface, but it is exactly as difference, disagreement and doubt that they have to be maintained as a condition of possibility for alterity, and hence, for politics.[10] Dialogue, by construing the meaning and the effects of a certain idea, concept or statement as conflictual, will not allow the metaphor to move outside politics.

However, there is always the risk of a pedagogy becoming intrusive, invasive and offensive, and thus enhancing rather than dissolving existing anxieties, frustrations and fears. It is very probable that some students will resist such a metaphorical game, remaining silent or simply pretending to take part.[11] Certainly, there is always the very strong possibility that some students will refuse to be liberated or self-deconstructed only because the teacher-liberator would like them to do so. Nevertheless, these are difficulties and risks that every critical pedagogy has to face and it has to find ways to cope according to the specificity of the situation; the only suggestion I would like to make is that a pedagogy that wants to be emancipatory and liberatory has continuously to remember that it may well be part of the very problem it is trying to deal with.

If, following Pierre Bourdieu, we can say that "liberating the victims of symbolic violence cannot be accomplished by decree", then, obviously, we cannot expect to liberate them, or ourselves, by only playing with metaphors in an educational game, however serious and well-intentioned this game might be. We can neither hope to destroy, as if by magic, nor subvert the symbolic order of things, but we can hope to make more difficult the automatic ratification and the unconditional adherence to the existing order, for the sole reason that the latter exists as it exists—present, visible, real and apparently rational.

Conventional architectural practice, being only too ready to respond immediately to, and satisfy the existing social demands, is unable and often unwilling to radically question these demands and, certainly, its own position in relation to them; similarly, and to the extent that architectural education is still structured according to the model of conventional professional architectural

practice, one can only with great difficulty find within it the space or time to give a chance to rigorous, critical and subversive theoretical work. Expectedly subversive theoretical ideas and concepts (such as text, fold, catastrophe, chora, plexus…), when abstracted and transferred into the architectural scene, usually lose most of their metaphorical power and subversiveness as they are translated into predictable formal exercises, inscribed into and serving the promotional logic of the competitive architectural game.[12] However, even in such cases, something of the subversiveness, the desire, the tension these ideas used to have, might remain somewhere, somehow, as a potentiality.[13]

To the extent that 'sexual/architectural' metaphors make sense and can produce effects, this is possible only because such metaphors are indeed a re-enactment (this time a deliberate and intentional one), only because they are somehow part of this very same social mechanism through which the social difference male/female is constituted, naturalised and legitimised, and then continuously reproduced and reaffirmed as the primordial, fundamental and universal division organising human beings, things, activities, and also, architectures and sexualities in hierarchic ways.[14] If, then, such a metaphorical operation can be used as an instrument of understanding, of critique and subversion, this is only possible because for a long time it has been used and, it is still used, as an instrument of constitution and reproduction of the prevailing social order, as an instrument of reduction, subordination and exclusion.[15]
If it can be used as an instrument of revelation and awareness, this would be possible only to the extent that it might expose what is often invisible, problematise what is taken-for-granted, and make complex and question what appears as simple and coherent: in other words, to the extent that it could exceed, disturb and undermine the very logic within which it has to operate.[16]
If it can be used as an instrument of resistance or of assault, this is because truth in architectural and/or sexual matters is, inevitably and to a large extent, both an outcome and a stake of (not only academic) struggles.

Architecture is not, and possibly cannot be, in the front line of such struggles, but sexuality seems to be much closer to such a front line, not by nature, but because of its social significance and because of (mostly feminist) persistent studies and courageous practices. The sexual architectural metaphor has a much better chance of becoming effective, critical and subversive if it can be sufficiently supported and informed by the theoretical ideas produced in other fields (such as post-structuralism, literary theory, womens' studies, social anthropology…), and also by the experiences, sensitivities and intensities emerging in various gender-specific practices, social movements and struggles.

The idea is to try and open architecture up to some sort of practical cross-disciplinarity, using the metaphor as a sort of bridge, prompt or short-cut for transferring into the educational activities, and more particularly into the design studio, ideas, concepts and questions that will intersect, enhance and politicise already existing or latent predispositions and tendencies oriented towards other, or as yet unknown directions, towards new and different architectural sensitivities and practices. That is, practices seeking to undermine their own phallogocentric foundations, practices that would not necessarily aim for a predetermined completion and end. These would be unruly practices; practices inventing and re-inventing their own rules, practices accepting the ambivalent, the complex, the unknown, the other, the 'female', practices open to and compatible with plural and possibly unstable sexual identities.[17]

The 'sexual/architectural' metaphorical operation, as it is discussed here, is meant to take place primarily on the level of dialogic activities, but it is assumed that its effects will not be confined to a purely verbal level. Such a metaphor is addressed not only to the intellect, is not just a matter of language or mere words, and its effects cannot be purely conceptual. On the contrary, the metaphor is expected to become both a matter of thought and action; in other words, to become a metaphor with which it is good to think and practice architecture.[18] It is expected to be appealing and powerful, familiar and obscene enough, exciting and creative, able to mobilise the minds but also the hearts and, certainly, the bodies of most students, possibly without exclusions and oppression. It is expected to awake and stimulate the desire one can always find in architecture and architectural education; a desire which may be channelled, controlled and blocked by the confrontational structure and the phallocentric logic that, to a large extent, govern both architecturality and sexuality. And yet, desire as such cannot be neutralised or crushed.[19] Its lines of escape, though blocked, are still there, always generating minor or local disturbances, whirlings, recodings, etc., and thus, keeping alive, for the oppressed, both the possibility of resistance and the hope of escape, of moving beyond to an as yet unknown or hardly imaginable architectural practice.

There may be tensions and incompatibilities between these two aims, as they correspond to and reflect differentiated and opposed socio-political and/or gender interests; this escaping, this 'beyonding' may not serve the needs and the interests of the existing underprivileged (sexual and/or architectural) identities well.[20] Eventually, an individual may have to choose one, and to oppose or fight the other; education, however, cannot fail to work on both, even if this means standing at two different levels or places at once.

Playing metaphors, designing with metaphors, living by metaphors is always an interesting and interested activity. Pushing an analogy to its limits may be a disturbing and dangerous thing to do. Taking a relation of similarity or analogy as relation of identity may certainly be misleading. Perhaps we are already misled. However, one may always put the question: what would be the stuff an architectural and/or sexual identity is made of? We cannot foolishly ignore the identities created for us, but why not force seemingly stable identities to remember painfully their own metaphorical past, their unsafe, insecure, unfounded foundations?[21]

Notes

1 Bourdieu, P., "La domination masculine", *Actes de la Recherche en Sciences Sociales*, 84/1990, Paris, p. 12. In several instances, this paper is influenced by Bourdieu's anthropological and sociological insights, using and mis-using some of his concepts.

2 There is an obvious discrepancy between what this paper is actually attempting to deliver and what its title is promising; the title, undoubtedly, promises much more, and, in this sense, may be misleading. I have decided to maintain the title because I would like to maintain the unfulfilled promise as promise, as a sign of emancipatory desire.

3 To give just two examples, one could look as far back as Filarete's *Trattato d' architettura*, or as near as Bernard Tschumi's writings to realise that such a metaphor is not only possible but alive as well. Averlino, A. di P., called Filarete, *Trattato d' architettura*, Milano: 1451-1465, and Tschumi, B., "The Pleasure of Architecture", *Architectural Design*, March 1977) Nevertheless, it remains a fact that the various and multifaceted, material and/or symbolic, literal and/or metaphorical, direct or mediated relations linking the domain of architecture to that of desire, pleasure and sexuality are systematically devalued and suppressed in the histories of ideas, theories and discourses on architecture. See Choay, F., *La Régle et le Modele*, Paris: Seuil, 1980, and Martinidis, P., "The Pleasure of Building", *Spira* 4-5/1989, Athens:, pp. 63-79. Further, one can only agree with M. Gusevich when she says that: "Architectural criticism, unlike literary criticism, is still remarkably prudish; sexuality is still a taboo, as are gender, race, religion, and class". Gusevich, M., "The Architecture of Criticism", in Kahn, A., (ed.), *Drawing, Building, Text*, New York: Princeton Architectural Press, 1991, p. 23. For significant exceptions, see the contributions in Colomina, B., (ed.), *Sexuality & Space*, New York: Princeton Architectural Press, 1992, and the issue on "Architecture and the Feminine: Mop-Up Work", *ANY*, 4/94, New York.

4 "… social decisions mark off the boundaries between different provinces of meaning. Total insulation between one field of experience and another is highly improbable… There is a tendency for meaning to overflow and for distinct provinces to interpenetrate… Sets of rules are metaphorically connected with one another, allow meaning to leak from one context to another along the formal similarities that they show. The barriers between finite provinces of meaning are always sapped either by the violent flooding through of social concerns or by the subtle economy which uses the same rule structure in each province". Douglas, M., (ed.), *Rules & Meanings*, Harmondsworth: Penguin, 1973, p. 13.

5 For the sexist implications of the "hidden curriculum" see Ahrentzen, S., and Groat, L. N., "Rethinking Architectural Education: Patriarchal Conventions & Alternative Visions from the Perspective of Women Faculty", *Journal of Architectural and Planning Research*, vol.9, 2/1992, Chicago: Locke, pp. 95-111.

6 Some of the questions are informed by the devastating critique of the masculinist, heterosexual, genitally-centred model of sexual practice contained in Bruckner, P., and Finkielkraut, A., *Le nouveau désordre amoureux*, Paris: Seuil, 1977.

7 On how sexual desire, through masculinisation, is strongly linked with such matters as personal adequacy, success and achievement, and on why hegemonic masculinity is characterized by an abuse-potential, see Liddle. A. M., "Gender, Desire and Child Sexual Abuse: Accounting for the Male Majority", *Theory, Culture & Society*, vol.10, 4/1993, London: Sage, pp. 103-126.

8 Metaphoricity in itself, as Luce Irigaray has argued, might be considered as an expression of the male passion for the Same, but, perhaps it is too valuable to be rejected—even, if such a thing were possible. She herself, on occasions adopted a subtle strategy of mimicry and mimesis in order "to convert a form of subordination into an affirmation, and thus begin to thwart it…". (Whitford, M., *Luce Irigaray: Philosophy in the Feminine*, London: Routledge, 1991, p. 71)

9 For sexuality as a historical system and its, rather recent, discursive construction see Foucault, M., *Histoire de la Sexualité*, Vol I, Paris: Gallimard, 1978. As regards the multiple and changing meaning of the concept of sexuality Joseph Bristow says: "Yet if ideas about sexual identity have been consolidated in the social imaginary, the truth of sexuality has remained persistently resistant to understanding… Indeed, if one sets out to find definitions of sexuality in reference books published in our own queer fin de siécle, it is really quite surprising how incoherent the whole topic can still appear",he then quotes Jeffrey Weeks, "The more expert we become in talking about sexuality, the greater the difficulties we seem to encounter in trying to understand it." (Bristow, J., "Post-sexuality? The Wilde Centenary", *Radical Philosophy*, 71/1995, London: pp. 2-4). It must be noted that the terms sexuality and/or architecture are often used for phenomena distant in space and time, without taking into consideration the risk of ethnocentric bias or of anachronistic misnaming.

10 See Bennington, G., *Legislations: The Politics of Deconstruction*, London: Verso, 1994, pp. 1-7.

11 See Lather, P., "Staying Dumb?
 Feminist Research and Pedagogy
 With/in the Postmodern", in Simons,
 H. W. and Billig, M., (eds.), *After
 Postmodernism*, London: Sage, 1994,
 pp. 101-132. On the difficulties and
 dilemmas emancipatory pedagogies
 are faced with, see Simons, H. W.,
 "Teaching the Pedagogies: a
 Dialectical Approach to an Ideological
 Dilemma", *After Postmodernism*,
 pp.133-149.

12 For instance, deconstruction as a
 critical practice is reduced to a series
 of fixed concepts, inaccessible and
 repulsive for most students, or, to
 some methodological
 instrumentalities, set of rules and
 technical procedures. Or, what is
 worst, it usually degenerates into an
 already tired and dull formalism or
 stylism that reinscribes the form of
 order and authority it may claim to
 deface or undermine. One may ask:
 how much of Eisenman's "female"
 desire can possibly reach our
 students? Very little, if at all; what they
 usually maintain are but some images
 and the name of the father.

13 On the potential value of formal
 research, and for the need to
 articulate it with politics, Derrida has
 this to say, "The axiom here is that if
 you think formal research is politically
 mystifying, I would say this is a
 political mistake. And you can never
 replace this formal, inner, internal
 research with political action outside
 according to dominant codes of what
 we recognize as political action. We
 have to do both and to do both is very
 difficult and occurs sometimes at the
 same time, sometimes at different
 times. … Political vigilance should lead
 us to analyse the political potential
 within what you call formal research.
 Then this potential, if it remains
 potential, is politically neutralised. …
 You don't have to choose between
 one and the other. On the contrary you
 have to try to articulate the two. It is
 difficult, I agree.", "Jacques Derrida:
 Invitation to a Discussion, Moderated
 by Mark Wigley", *Columbia
 Documents of Architecture and
 Theory (D)*, vol.1, 1992, pp. 7-27.

14 "Gender is understood as the
 'categorization of persons, artifacts,
 events [and] sequences… which draw
 upon sexual imagery [and] make
 concrete people's ideas about the
 nature of social relationships'".
 Strathern, M., quoted in Cornwall, A.
 and Lindisfarne, N., (eds.), *Dislocating
 Masculinity*, London: Routledge, 1994,
 p. 40. For the nature and functioning
 of the social mechanism constructing
 sexual and gender division, and for the
 somatisation of the relations of
 domination, see Bourdieu, P., "La
 domination masculine".

15 "'I, woman', … have paid in my very
 body for all the metaphors and images
 that our culture has deemed fit to
 produce of woman". Quoted in Rose,
 G., *Feminism & Geography*, Oxford:
 Blackwell, 1993, p. 4.

16 In a sense, such an operation may be but another instance of what Mary Ellman called "thought by sexual analogy", i.e. the strong tendency in Western culture to "comprehend all phenomena, however shifting, in terms of our original and simple sexual differences; and… classify almost all experience by means of sexual analogy", a tendency she is trying to expose as ludicrous and unjustified. Ellman, M., *Thinking about Women*, New York: Harcourt, 1968, see also the interesting analysis in Moi, T., *Sexual/Textual Politics: Feminist Literary Theory*, London: Routledge, 1993.

17 For example, see Durham Crout's project "Hearing Aids", for an attempt to open architecture to the concerns of lesbians, gays, bisexuals and people living with HIV disease. Crout, D., "Hearing Aids", *ANY*, 4/1994, New York, pp. 40-41.

18 For an account, in Deleuzian terminology, of the important and creative role that metaphor can play in architectural thought and action, see Girard, C., *Architecture et concepts nomades: Traité d'indiscipline*, Bruxelles: Mardaga, 1986. For the pervasiveness of metaphor in human life, see Lakoff, G. and Johnson, M., *Metaphors We Live By*, Chicago: The University of Chicago Press, 1980.

19 See Deleuze, G., "Désir et Plaisir", *Magazine Littéraire*, 325/1994, Paris, pp. 57-65.

20 "… So it would be timely to ask what interests this 'beyonding' of sexual identity might serve. … such a 'non-identity', as countless feminist analyses have shown, has been precisely the status of women since time immemorial, and this status—for all its supposedly subversive potential—has been the main source of their oppression … Foucault writes that if the arrangements which led to the birth of the human sciences were to disappear, 'then one can certainly wager that man would be erased, like a face drawn in sand at the edge of the sea'. But before that happens perhaps woman's face will have to be etched firmly beside it, if only as a network of scars on a once-smooth surface." Ricci, N. P., "The End/s of Woman", *Canadian Journal of Political and Social Theory*, vol. XV, 1, 2 & 3/1991, Montreal, pp. 312 and 315.

21 If we cannot have or believe in safe and secure foundations, we can always strive for better, sexual and/or architectural, directions. And we can ask—better for whom?

Prisoner of Gender or The Equality of Uncertainty

Discrimination against women is not a characteristic of the world of magazine journalism. The owners of *The Architects' Journal*, EMAP—East Midlands Allied Press—is a giant media empire which employs roughly 60 per cent women, though it must be said that the ultimate board has a pretty familiar look in gender terms. However, for journalists, and I stress that I am talking about magazine journalists here, there is nothing unusual about women chief reporters, news editors, features editors, deputy editors or editors. This is largely because of the long tradition of women's magazines, both of a specialist and generalist nature: everything from *Knitting Today* to *The Lady* to *Cosmopolitan*, *Vogue*, *Marie-Claire* and other titles said to be read (often on the quiet) by men as much as women.

The existence of these magazines, and the resultant place of women in corporate hierarchies in companies like IPC/Reed, produced a force field of women journalists and executives who were hitting the glass ceiling at a fairly high level a long time ago. A number broke through. On local and national newspapers it has been a longer struggle, by no means successful, to achieve anything like the same opportunities.

The experience of women in national newspapers, until very recently, has more accurately paralleled the position of women in architecture: accepted certainly, but not generally thought of as potential major players or decision-makers; often confined to certain predictable areas of the business, the world of kitchen and bathroom design, corresponding to being a fashion assistant or contributor to the women's page.

One does not want to push this analogy too far; suffice to say that there is some common experience, and, it appears, a common determination to do something about it. People like Eve Pollard launching *Women in Journalism* are paralleled by *Women in Property*, which includes architects. The aim seems to be to bypass opposition or hostility by creating rival networks which themselves parallel the men-only relationships established at school, university, rugby club and, as an extreme example, the Masonic lodge. Likewise, in professional bodies. The cartoonist Louis Hellman has long referred to the RIBA as the "Royal Institute of Businessmen Architects" (and presumably there are many commercial practices out there that wish it really was)—a world in which professionals conspire, in a Shavian sense, against the true interests of the public. It must also be said that while the origins of the RIBA, and most other professions, held out public interest as one of the mainsprings of their foundation, the definition of that interest often conveniently suited the private interest of that new breed of economic man, and it certainly was man, the professional.

The RIBA emerged after a prolonged period of economic struggle between designer/managers who saw themselves in the Wren tradition, as cross between the architect, surveyor, project manager, quantity surveyor, clerk of works and main contractor, and the breed of pure contractors emerging at the start of the nineteenth century who claimed to be better organisers of contracts than the designer. Then as now.

The professionalisation of the architect was the consequence, launched on the basis that no client could trust trade, and that an independent hand-holder was needed to ensure fair dealing. From the outset of this new relationship between professional and trade contractor, there was built-in economic rivalry and distrust, which found their expression in contracts based on the assumption of legal hostilities somewhere along the line. The question of gender was non-existent, except in the sense that its non-existence was a reflection of prevailing attitudes in the construction industry. Then as now, more or less.

One of the distinguishing characteristics of professions is their dislike of economic competition between members, or indeed the idea that one member could be a better professional than another. In the case of architecture, this meant fixed fee scales and commissions resulting from personal connections—unless, of course, design competitions were used as a method of separating the architectural sheep from the goats.

The economic basis of the emerging architectural profession was predicated on cheap labour in the form of apprenticed draughtsmen; it is the world painted by Dickens in *Martin Chuzzlewit*, and again not so very far removed from the conditions prevalent in some practices today. There was no question of discrimination against would-be women architects in terms of working practice: it was simply that they virtually never entered into the equation.

Indeed, the revolt against poor conditions and lack of training which led to the foundation of the Architectural Association in 1847 (and ultimately to the establishment of formal architectural education) was entirely based on male membership. It was only in 1893 that the election of a woman, or rather two women, was proposed at the AA, a Miss Ethel and a Miss B A Charles. A special meeting was held, as Sir John Summerson noted in his 1947 history of the AA,[1] to discuss this 'threatened invasion' of a hitherto exclusively male strong-hold. The applications were rejected by a two-to-one majority, despite the support of luminaries such as Sir Banister Fletcher. (Ethel Charles went on to become the RIBA's first associate, and delivered an AA lecture in 1902 entitled "Plea for Women Practising Architects".[2] The AA finally admitted women in 1920, though it was another fifty years until it elected its first woman president, Jane Drew, in 1969).

The model of the architect's office as a domestic household, with the architect as master and toiling designers as domestic servants, survived long after the introduction of formal educational examination, and indeed exists to this day in some grand offices where the concept of payment for overtime is non-existent (as indeed is the concept of overtime). A piquant example of the social model is provided in an article by the former RIBA president Howard Robertson, in a book published in 1955, entitled *Careers for Girls*.[3] Married to a successful woman architect, Doris Howard Robertson (curious that she took both his forename and surname), his thoughts on what prospective employers looked for in a woman architect are instructive: "Almost exactly the same qualities you would look for in a good housemaid—someone neat, obliging, unobtrusive… it is not so much your qualities as a great planner which interest him in the early beginning, as your willingness to help out on the telephone or even to know how to type. The unforgivable sin in a beginner is sloppiness".[4]

Robertson is frank about the problems of setting up in practice—difficult for both men and women, but moreso for the latter: "A woman has the added handicap that she is unlikely to be employed by business clients. The managing director may like her work, but there will almost certainly be some member of the board who would prefer to employ an indifferent man architect to a good woman".[5] Prospects for rural practice were not much better: "It would be more difficult. So much work in the country is picked up on the golf course and in the pub".[6]

Certainly many women architects were reticent about their practice role in the post-war years. A good example is the Chapman Taylor practice, founded by two men (Chapman and Taylor) and a woman, Jane Durham. For some reason her name was superfluous to the practice's brass plate. We have moved a long way since then, although it is not very easy to reel off more than a handful of practices that have been started and are run by women. In schools of architecture, women have virtually achieved equality of numbers, which in the long term suggests that architecture will move closer to some other professions in terms of the gender balance of qualified professionals. Unfortunately, the increasing proportion of women students has taken place against a background of ever-increasing numbers of architecture students generally, and an expanding profession seeking the same, or less, work within the construction industry.

Apart from the sustained boom of the mid- to late-1980s, when young architects could almost name their own salary, the last twenty years have not been economically beneficial to the architectural profession, which is now faced with increasing competition (in terms of job function), an undermining of its economic basis (the outlawing of fee scales), and the imposition of policies

(such as compulsory competitive tendering) which attack the funding basis of architectural practice.

What this has meant is that in good times there has been a premium on having staff working in the office (not good for many women who feel alienated by an 'office culture' in which massive overtime is assumed to be the norm); in bad times there has not been enough work to go round, thus jeopardising the prospects of anyone incapable of giving 100 per cent of their time. This has been unfortunate for women architects, because the way practices might like to operate would suit many women wishing to combine family responsibilities with a professional career, within a loose, rather than conventional, structure. The idea of part-time working, home-working, a split career or project-based work is just, on the face of it, what would benefit practices, as well as coinciding with what the sociologists and economists of the workplace predict as emerging employment trends (the office as a drop-in, serviced headquarters).

Of course, the reason why practices would find this useful would be the savings to be made by employing freelances instead of permanent staff. The advantages of this to the employer scarcely need pointing out in the context of schools of architecture—low wages, no job security, effectively no employment rights, second-class citizens compared with the permanent staff. The only possible advantage to the part-timer is his or her financial independence: they teach because they want to, not because they have to.

The situation for the part-time architect home-worker is not much better, dependent as they are on the flow of work from a practice which cannot cope using its internal staff. There is a direct parallel with freelances and permanent staff in the world of journalism: the ideal arrangement from the point of view of the woman who wants to look after children as well as work, is almost entirely dependent on the goodwill of the employer—unless she is a star in her own right.

The pressures on the profession, not only as a result of the recession, but also because of its apparently endless expansion, mean that what might have been a bonus for women has started to look decidedly questionable. What happens when men are also home-workers and part-timers? Will they not be competing like mad for anything that is going, be it a permanent job or short-term contract to be carried out on the kitchen table? Just at the point where the particular work experiences of women might be seen as a pattern for future employment, and therefore to their benefit, so the general situation of architects makes it increasingly unlikely that most within the profession will be able to do anything except struggle.

This may sound a bleak message, but it is only one editor's view of the likely future of professional employment, on the basis of its current organisation. There might, of course, be new models—an increase in the number of explicitly feminist practices, for example, promoting a particular view of architecture. Even if this occurred, however, it would be unwise to assume that women architects, any more than men, would control the architectural programme. At the most basic level, for example the provision of simple facilities in shopping centres, it is not the nature of the architectural practice that is significant, but the laws and regulations to which the building must conform, and the ethos of the development organisation in respect of its commitment to users rather than (usually hopeless) regulations. In other words, the architect may be able to encourage, but will not be the most important influence on the final brief.

That, of course, could be changed were women able to have more influence on those hidden persuaders of the development world, building regulations, and their kissing cousin, planning law. If I were to devise an agenda for women architects to pursue in respect of tomorrow's buildings, it would largely comprise infiltrating dull bastions of legislative power which command areas of crucial importance to the way we build. The success of the disabled lobby in these matters is instructive. This would have a knock-on effect in respect of the way in which women in architecture are perceived, because it would require a more rounded view about the buildings we design, where they are located and how they are used. If this sounds worthy rather than fun—it is.

One other point: it is surprising that after two decades of the feminist movement in this country, so little energy and enthusiasm has been translated into hard research about the role of women in architectural practice. Why do so many women students give up architecture? Is it because they realise they could be employed more profitably in other areas? Is it because of real or perceived discrimination in the profession? How does architecture compare with other professions? Is it really so much worse, as is frequently claimed? It is difficult to establish even basic information about this subject. Part of the reason for the low priority given to the Women's Group at the RIBA is the lack of a hard-edged programme that can justify its funding in competition with competing claims. More work is needed if the matters discussed here are to be truly debated within the entire profession.

Notes

1 Summerson, Sir J., *The
 Architectural Association 1847-
 1947*, London: Pleiades Books Ltd.,
 1947, p. 34.
2 Referred to in Summerson,
 Architectural, p. 34.
3 Robertson, H., "Architecture", Heal,
 J. (ed.), *Jeanne Heal's Book of
 Careers for Girls*, London: The
 Bodley Head, 1955.
4 Robertson, "Architecture", p. 50.
5 Robertson, "Architecture", p. 51.
6 Robertson, "Architecture", p. 52.

Masculine, Feminine or Neuter ?

Reviewing the Festival of Britain in 1951, the architect Lionel Brett wrote, "It is easy to see that this style of the fifties will be thought flimsy and effeminate by the next generation, but we should lose no sleep on that account".[1] "Effeminate"? What could he have meant? A century earlier, the remark might have passed without comment, but in 1951 it was so unusual for architecture to be connected with gender or sexuality that it caused quite a stir. Gender, once a regular feature of the architect's and critic's vocabulary, had virtually disappeared during the twentieth century. Now, generally speaking, people only use gender metaphors as a self-conscious archaism, when they want to describe earlier architecture in the language of its own time: for instance, Pevsner and Cherry write of the sculpture gallery by Dance and Smirke at Lansdowne House in Berkeley Square "as very masculine after Adam".[2] As a means of characterising the architecture of the present, though, gender metaphors have more or less completely died out over the course of this century. However, just because people no longer talk in gender metaphors, does it mean that the distinctions once signified by the difference between 'masculine' and 'feminine', or between 'manly' and 'effeminate', no longer exist? Can distinctions that were once a routine part of architectural discourse really have disappeared without trace from our way of thinking about architecture? Has architecture lost its gender? Do we only have neuter architecture now?

The reasons why gender terms were removed from the language of architectural criticism in the early twentieth century are straightforward—modernism required architecture to assert is uniqueness and independence from the other arts, and so the language of description had to avoid all references to practices outside architecture; gender metaphors belonged to a convention of criticism common to all the arts—to literature, drama, music, painting—and so were entirely unsuited to defining what was specific and unique about architecture. Nonetheless, gender terminology had supplied an important metaphor of distinction for critics of architecture for the best part of two millennia, and it seems unlikely that the making of these mental distinctions should have ceased simply because the metaphors used to signify them had become unsuitable. What, therefore, has happened in the twentieth century to the distinction once so effectively expressed by the language of gender? Could it be that the very same distinction has now, as it were, been displaced elsewhere? This is the question I want to investigate.

The gendering of architecture within the classical tradition is sufficiently well known to need little description. The metaphor begins with the mythical origins of the orders, according to which, as Bernini in the seventeenth century put it, "the variety of the orders proceeded from the difference between the bodies of man and woman".[3] Bernini was, of course, referring to Vitruvius's account of the different orders, of how the Greeks "proceeded to the invention of columns in two manners; one [Doric], manlike in appearance, bare unadorned; the other [Ionic] feminine…. But the third order, which is called Corinthian, imitates the slight figure of a maiden".[4] Vitruvius' gendering of the orders became a commonplace of the Italian Renaissance, and wherever classical architecture was adopted. Sometimes the classification was elaborated: Sir Henry Wotton, for example, wrote in 1624, "The *Dorique Order* is the gravest that hath been received into civill use, preserving, in comparison of those that follow, a more *Masculine Aspect*:… The *Ionique Order* doth represent a kinde of Feminine slenderness, yet saith *Vitruvius*, not like a light Housewife, but in a decent dressing, hath much of the *Matrone*…. The *Corinthian*, is a *Columne*, laciviously decked like a Curtezane…".[5] Wotton distinguished not just between masculine and feminine, but also between kinds of femininity, between the decency of the matron and the lasciviousness of the courtesan. We see here the rich potential for the extension of gender metaphors, with their capacity to distinguish not just sexual difference, but also sexual orientation—and of course this was what made Esher's "effeminate" so shocking, for he was not saying the Festival of Britain was 'feminine', but that it was a perversion of the normal, masculine, state of architecture. From Wotton's day onwards, terms of sexual deviancy have been just as valuable to critics as straightforward gender distinctions.

The gendering of the orders was a convention that lasted as long as the classical tradition, and was used by architects and non-architects alike. More interesting for our purposes is the characterisation of whole buildings in terms of sexual difference. For example, in 1825, the architect Thomas Hardwick wrote of his former master Sir William Chambers, "The exteriors of his buildings are marked and distinguished by a bold and masculine style, neither ponderous on the one hand, nor too meagre on the other".[6] On the face of it, Hardwick might not appear to have been saying much by describing Chambers' style as "masculine", but anyone familiar with French eighteenth century architecture—as both Chambers and Hardwick were—would have known otherwise.

In France from the mid-eighteenth century onwards, 'masculine' (the usual word was *mâle*) was employed a lot, especially in the attack upon rococo: J.-F. Blondel, for example, writing in 1752, contrasted rococo with "that masculine simplicity" in the buildings of which he approved.[7] And a year later Laugier also wrote: "in a church there must be nothing that is not simple, masculine, grave and serious".[8]

The more systematically-minded of critics went to some trouble to define this term 'masculine'—and none more thoroughly than J.-F. Blondel (whose Academy Chambers had attended in Paris). In his *Cours d'Architecture*, Blondel distinguished between three terms: the 'masculine'[*mâle*], the 'firm'[*ferme*] and the 'virile'[*virile*], as follows:

> A masculine architecture can be understood as one which, without being heavy, retains in its composition the firmness suited to the grandeur of the location and to the type of building. It is simple in its general forms, and without too much ornamental detail; it has rectilinear plans, right angles, and projections which cast deep shade. A masculine architecture is suited to public markets, fairs, hospitals and above all, military buildings, where care must be taken to avoid small compositions—the weak and the great not going together. Often, thinking to create a masculine architecture, it is made heavy, massive and gross—the word is mistaken for the thing.

Blondel's examples include the work of Michelangelo, and in France, the Palais du Luxembourg, the stables and orangery at Versailles, and the Porte St. Denis. He goes on:

> A firm architecture differs from a masculine architecture by its masses; firm architecture has less weight, but nevertheless in its composition and division presents resolute forms with plane surfaces and right angles; everywhere it shows a certainty and an articulation, imposing and striking to the eye of intelligent persons.

'Manly and Austere':
All Saints, Margaret Street, London,
designed by William Butterfield.
From The Builder, 1853

Examples include the Chateaux at Maisons, Vincennes and Richelieu.
He continues

> Although it may seem that a virile architecture differs little from the two
> previous characters, this term is used for works where the Doric order
> predominates. Masculinity or firmness in architecture often need be
> expressed only with rustication or solidity, and do not require the presence
> of this order.[9]

When Blondel turns to the feminine character, as with the virile, he identifies it
with the use of a particular order, but goes on to add some more observations:

> We term feminine an architecture whose expression is drawn from the
> proportions of the Ionic order. The character expressed by the Ionic is more
> naive, gentler and less robust than that of the Doric order, and for that
> reason it must be used appropriately and with discretion in the decoration of
> buildings. It would be a misuse of feminine architecture were a perfectly
> correct but far less appropriate Ionic order to be applied to a building rather
> than the virile treatment which its particular purpose would seem to require.
> Again, we would deem it a wrong use of feminine architecture were the
> projecting parts of the facade of a building solid in style, to be composed of
> curvilinear rather then rectilinear members. Yet another misapplication of
> the feminine would have the effect of imparting uncertainty to the masses as
> well as the details of a building, whereas the intention had been that they
> should arouse admiration. This style should therefore be eschewed in all
> military monuments, buildings raised to the glory of heroes, and in the
> dwellings of princes. On the other hand the feminine can be applied
> appropriately to the exterior decoration of a pretty country villa, a Petit
> Trianon, in the interiors of a queen's or empress's apartments, and in baths,
> fountains, and other buildings dedicated to deities of the sea or the land.[10]

'Bold and Masculine': Somerset House, London, designed by Sir William Chambers, 1776-1796. From J. Britton & A. Pugin, *Illustrations of the Public Buildings of London*, London: 2nd edition, 1838

Within Blondel's scheme of criticism, masculine was unquestionably superior to feminine architecture; masculine architecture was resolute, expressed its purpose clearly, with no more decoration than was absolutely necessary, and conveyed structural solidity and permanence; while feminine architecture, meant to charm, was permitted a degree of equivocation and ambiguity. As we shall see, Blondel's assumption that the feminine was always necessarily inferior runs through the entire history of architectural gendering.

Blondel's concept of masculine architecture continued in use for the rest of the eighteenth century in France. An idea of how it could apply in architectural practice can be had from Boullée, for example, writing, in the 1790s about his design for a town hall—a design which by Blondel's criteria was pre-eminently masculine:

> While reflecting on methods of creating a proud and masculine form of decoration, and on the need for many openings, you may imagine that I was brought up short and thrown into the greatest confusion; a house open to all must necessarily appear as a kind of beehive; and without question, a Town Hall is human beehive; now anyone who knows about architecture, knows how a multiplicity of openings spread across a façade produces what is described as skinniness [*maigreur*]. In decoration it is smooth masses which produces masculine effects....[11]

The language of gender was so much a part of the classical tradition of architecture that one might have expected it to have died out with that tradition. On the contrary, though, with the Gothic revival it carried on, and in both Britain and the USA was used by critics even more than before. For example, when *The Ecclesiologist* reviewed Butterfield's All Saints, Margaret Street, on its completion in 1859, it spoke of "our general admiration for the manly and austere design";[12] and a few years later, in 1884, Robert Kerr referred to the "sometimes too masculine manners of the Gothic revival".[13] 'Feminine' was a favourite term for architecture of which critics did not approve. For example, the critic Beresford Hope discriminated between kinds of Gothic by comparing the "overpowering and masculine qualities of early French Gothic... to Decorated's feminine 'hectic flush'";[14] or Robert Kerr again, "vastly as I admire all French art, I can never divest my mind of the feeling that I am admiring something whose charms are feminine. I say, therefore, that England, the very home of rough-and-ready muscularity, will probably never follow the precise formulas of French taste".[15]

In America, though, gender terminology comes up in a slightly different context. From the 1830s, the failure of America to develop a distinctive national style in the arts was a recurrent concern amongst American architects and critics. The philosopher Ralph Waldo Emerson, reflecting in 1836 on what he saw as the superiority of European art, noted of the work of American artists, writers and architects, that it was "in all, feminine, no character".[16] Whether or not consciously following Emerson, architects and critics in the latter part of the nineteenth century repeatedly presented the issue of the relation of American to European culture in gendered terms. Only when American art became 'masculine' would it have proved its worth. The architect H. H. Richardson was widely regarded as having achieved this state: his work was described by the architect and critic Henry van Brunt, for example, as having a "large, manly vigor".[17] But this was nothing to Louis Sullivan's 1901 eulogy of Richardson's Marshall Field Store in Chicago, which must be the greatest celebration of architectural masculinity of all time:

I mean, here is a man for you to look at. A man that walks on two legs instead of four, has active muscles, heart, lungs and other viscera; a man that lives and breathes, that has red blood; a real man, a manly man; a virile force—broad, vigorous and with a whelm of energy—an entire male.[18]

Sullivan's own architecture in its turn became praised for its masculinity: this is the *Architectural Record* in 1904 on the Guaranty Building in Buffalo:

...the essential element is masculinity. It is an American office building dominated by men and devoted to the transaction of their business in all its multitudinous forms—the elements of activity, ambition and directness of purpose are all shown thereby in its architectural forms.[19]

But the terminology of sexual difference all but ended with Sullivan. By 1924, when he died, gender had ceased to be a common organising metaphor for the whole variety of hierarchical distinctions, 'strong/weak', 'purposeful/equivocal' and so on, which Blondel had outlined, and which had structured the thought of architects and critics for nearly two centuries. One reason for the disappearance of the metaphor was, as I have said, to do with the needs of modernism to develop a critical vocabulary which asserted the independence of architecture from other art practices. However, perhaps what finally finished off the gender metaphor was the tendency of fascist culture, with its pronounced homo-eroticism, to characterise itself as 'masculine'; sometimes this overflowed into architecture, so for instance, in Italy, the Manifesto of Rationalist Architecture proclaimed "The architecture of the age of Mussolini must answer to the character of masculinity, of strength, of pride in the Revolution".[20] Under these circumstances, it was unacceptable for anyone with liberal, anti-fascist politics to use gender metaphors at all, and after 1945, they virtually disappeared. But does the absence of gender terminology in our own time mean that architecture has really become neuter? I have two examples that might make us reflect whether we really have renounced the metaphor of sexual difference.

The first is in what could be called the language of 'form'. As a key term in the critical vocabulary of modernism, 'form' has a long and complex history, at least partly derived from the German philosophical tradition of Kant and Hegel. For Hegel, the form of the work of art was the external, material shape by which the idea was made known to the senses. This theory of art relied upon a direct correspondence between the form and the internal, underlying idea or theme; the work of art whose external appearance failed to communicate the idea had failed in the most elementary requirement of art. During the latter part of the nineteenth century, a considerable amount of intellectual effort went into considering the precise nature of art's means to communicate the idea, and the particular aspects of the idea which art was best equipped to reveal. An

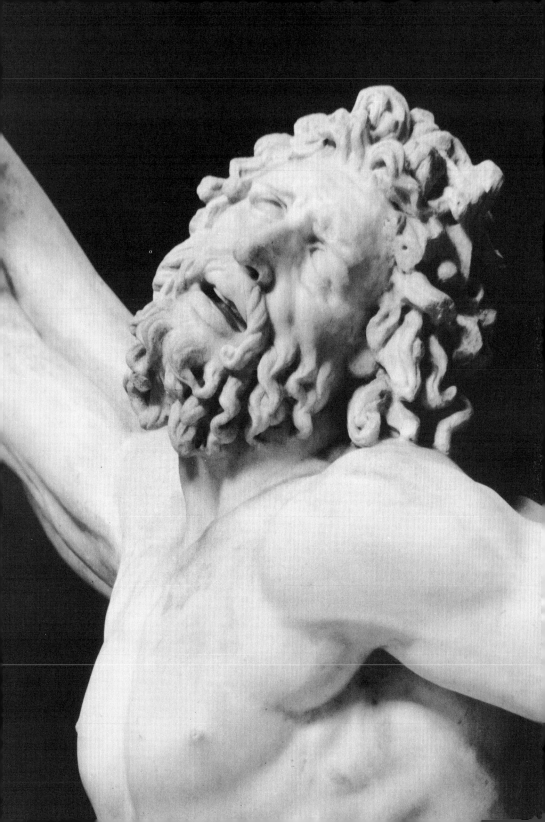

influential line of argument was that the forms of art could and should represent movement: in the words of the aesthetic philosopher, Robert Vischer, writing in 1873, "art finds its highest goal in depicting a moving conflict of forces".[21] Interpreted for architecture, the interest and uniqueness of architecture was perceived to lie in the particular manner in which it represented the static forces of the building's resistance to gravity. Heinrich Wölfflin's analysis of Roman mannerist architecture rested primarily on the way static forms communicated frustrated movement: "the baroque [by which he meant mannerism] never offers us perfection and fulfilment, or the static calm of 'being', only the unrest of change and the tension of transience. This again produces a sense of movement"; and "the ideal of tenseness was promoted by forms which were *unfulfilled to the point of discomfort*", as an example of which he gives the clustering of pilasters.[22] The notion that architecture represents implied movement within forms that are not themselves in motion has been a conventional part of modernist thinking, and still seems to be taken for granted.

What I want to suggest is that this entire notion of form as the static representation of a conflict of internal forces relies upon an ideal of the male anatomy, for it is in the male body that the closest correspondence of external form to muscular effort is to be found. Wölfflin's understanding of 'form' owed a great deal to the reading of classical figure sculpture in German art historical scholarship, originating with Winckelmann.[23] In antique sculptures of the male figure, the quality that was especially admired was the representation in static form of the combined concentration of muscular and psychic effort. Nowhere could this be seen better than in the Hellenistic sculpture of the Trojan priest Laocoön's struggle with the two snakes sent by the Gods to kill him. The ideal female anatomy, on the other hand, lacked this correspondence between its internal muscular structure and its outward, visible form, so the female figure could never realise this quality of frozen energy—and conventionally, classical sculptures of the female nude showed a motionless figure, frequently at rest. It would have been impossible for Wölfflin to conceive his theory of movement in terms of the female body, for it was simply the wrong shape.

Wölfflin's concept of form, which he had developed in his doctoral thesis, was based on the empathetic projection of the sense of one's own body into architectural form. As he put it, "Physical forms possess a character only because we ourselves possess a body".[24] It is through the "most intimate experience of our own body" and its projection "onto inanimate nature" that aesthetic perception occurs.[25] What seems to be clear, though, is that Wolfflin is not talking about bodies in general, but about *his* body, the male body, as the one that gives form its meaning.

Neil Denari: COR-TEX *Details Studio*, 1993.
Photo: Benny Chan

I want to suggest that 'form' as it has been used by most modernists is male, a masculine ideal. If this sounds far-fetched, just look, for example, at what Vincent Scully says about Le Corbusier's Chandigarh:

> the High Court is a great, hollowed-out, concrete mass. Its glass skin is again masked, on the entrance side, by a brise-soleil which keeps the scale integral and pushes upward and out with threatening power. Up through this projection, continued further upward by the hung vaults of the canopy, rise the great piers as purely upward-thrusting forces. Between these, men enter, and ramps of almost Piranesian violence rise behind them. Their physical power can be grasped if we compare them with Paul Rudolph's entrance for his second High School in Sarasota, Florida, which was, as the architect freely admits, inspired by them. The American design has become thin, planar, and linear. It is tautly stretched as a parasol against the sun, and cannot be read as analogous to the confident human body, assuming position in a place, as Le Corbusier's demands to be.[26]

Were one to substitute female ideal beauty for the male ideal, the whole analysis would fall flat. Seemingly neuter, 'form' is, in the way it is generally conceived and discussed in twentieth century architecture, a masculine ideal.

The second area where we might detect signs of gender is in the so-called Machine Architecture developed in California. Characterised by hard, metallic exteriors and soft insides, the word that recurs in the discussion of this architecture is 'dangerous', 'dangerous and inherently unpredictable'—presumably meaning that if you get too close, it might bite your head off—and this dangerousness seems to be one cause of its fascination. The work of Neil Denari presents a subtler version of this genre: Denari has attempted to discard the early twentieth century machine aesthetic characterised by repetition and rigidity—essentially masculine features—and replace it by a machine asethetic which is soft, intelligent, responsive and infinitely pliable—in a sense, feminine. Curiously, though, critics have not wanted to accept this reading of his work. Consider what Lebbeus Woods says about it:

> Historical architecture is too loaded with known associations for him (or so it would seem), whereas the machine is ubiquitous, unaesthetic, amoral, neutral, cool, philosophical. The machine is beyond politics and topicality. It is the inevitable instrument of an intellect seeking to master natural and anonymous forces and at the same time submit to them, as a lover and willing accomplice, yet also as a human being...[27]

Well, this sounds to me just like a description of male sexuality—cool, mastering nature so as to be able to submit to its seductions. Part of the fascination people have with Denari and other Californian 'machine architects' seems to be to do with their work lending itself so easily to being seen as the fulfilment of a masculine ideal.

Even if gender metaphors are no longer a normal part of the language of criticism, gender distinctions still apparently structure our thought processes.[28] The absence of the metaphor does not mean that the distinction has ceased to exist.

One last point remains. Conventionally, the best architecture was always masculine. The characteristics of masculine architecture were there for all to see: they fulfilled an ideal; feminine architecture on the other hand, was not only always inferior, but it generally lacked any specific qualities, positive or negative, of its own. Feminine architecture, generally speaking was merely the inexplicit otherness of the esteemed qualities of masculine architecture. None of this should surprise us, for as others have pointed out, the feminine is simply an invention of male discourse, not a category in its own right: "Male discourse

invents the feminine for its own purposes".[29] But even when people stopped referring explicitly to architecture as masculine or feminine, they still seem to have taken it for granted that the best architecture is always inherently masculine. Is this irreversible? An interesting remark by Michael Sorkin suggests that it need not be. Reviewing Richard Rogers' Patscenter building at Princeton in 1985, he wrote:

> the ensemble does participate deliberately in an historical machine culture, overwhelmingly masculine. One has read in the pages of *Architectural Review* theories of 'British high tech' which pin its prominence on the early childhood training of its progenitors, their pre-pubescent bedrooms glutted with Meccano toys and scale replicas of Sopwith Camels. More directly relevant may be the sartorial history of men managing machines, from the resplendently haberdashered admiral on the bridge of his gigantic dreadnought... to the nattily turned out Marlboro man on the flight deck of the 747. The point is simply this: it's a history of the machine that stands outside the history of architecture and which brings with it special prejudices about the social environment.[30]

Sorkin's view of high-tech architecture is that it suits men, but women look out of place in it. From the point of view of the history of 'masculinity' in architectural thought, Sorkin's article could be the first occasion that a mainstream critic has used 'masculine' not to signify a superior ideal, but rather to draw attention to small minded misogyny. It is a precedent we might learn from.

Notes

1 Brett, L., "Detail on the South Bank", *Design*, no. 32, August 1951, pp. 5-6.

2 Pevsner, N. and Cherry, B., *The Buildings of England: London 1*, 3rd edition, Harmondsworth, Middlesex: Penguin Books, 1973, p. 559

3 Fréart de Chantelou, *Diary of the Cavaliere Bernini's Visit to France*, Blunt, A. (ed.), (trans.) Corbett, M., Princeton, New Jersey: Princeton University Press, 1985, p.9.

4 Vitruvius, *De Architectura*, (trans.) Granger, F., 2 vols., London: Loeb Classical Library, William Heinemann Ltd., and Cambridge, Massachusetts: Harvard University Press, 1970, Book IV, ch.1, §§ 7-8.

5 Wotton, Sir H., *The Elements of Architecture*, London: John Bill, 1624, pp. 35-37.

6 Hardwick, T., "A Memoir of the Life of Sir William Chambers", in Chambers, Sir, W., *A Treatise on the Decorative Part of Civil Architecture,* Gwilt J. (ed.), London: Priestley and Weale, 1825, p. L.

7 Blondel, J.-F., *Architecture Françoise ou Receuil des Plans, Elevations, Coupes et Profils...*, vol.1, Paris, 1752, p. 116.

8 Laugier, M.-A., *Essai Sur l'Architecture*, Paris, 1753, Herrmann, W. and A., (trans.), Los Angeles: Hennessy & Ingalls, 1977, p.156.

9 Blondel, J.-F., *Cours d'Architecture... contenant les Leçons Données en 1750 et les années suivantes*, vol.1, Paris, 1771, pp. 411-413.

10 Blondel, *Cours*, vol. 1, pp. 419 and 420.

11 Boullée, E.-L., "Architecture, Essai sur l'Art", in Rosenau, H., *Boullée and Visionary Architecture,* London: Academy Editions, 1976, p. 131.

12 *The Ecclesiologist,* vol. XX, Cambridge, June 1859, pp. 184-189.

13 Kerr, R., "English Architecture Thirty Years Hence", 1884, reprinted in Pevsner, N., *Some Architectural Writers of the Nineteenth Century*, Oxford: Clarendon Press, 1972, p. 307.

14 Beresford Hope, A. J. B., *The Common Sense of Art*, London, 1858, pp. 19-20.

15 Kerr, "English", p. 296.

16 Emerson, R. W., *Journals*, vol. 4, Boston and New York: Houghton Mifflin Co., 1910, p. 108.

17 Van Brunt, H., "Henry Hobson Richardson, Architect", 1886, in *Architecture and Society, Selected Essays of Henry Van Brunt*, in Coles, W. A. (ed.), Cambridge, Massachusetts: Belknap Press of Harvard University Press, 1969, p. 176.

18 Sullivan, L. H., *Kindergarten Chats*, 1901-2, reprinted New York: Wittenborn Art Books, 1976, p. 29.

19 Smith, L. P., "The Schlesinger & Mayer Building", *Architectural Record*, vol. 16, no. 1, July 1904, p. 59.

20 "Manifesto per l'Architettura Razionale", 1931, in Patetta, L., *L'Architettura in Italia 1919-1943. Le Polemiche*, Milan: clup, 1972, p. 192.

21 Vischer, R., "On the Optical Sense of Form", 1873, (trans.) in Mallgrave, H. F. and Ikonomou, E., *Empathy, Form and Space. Problems in German Aesthetics 1873-1893,* Santa Monica, California: Getty Center, 1994, p. 121

22 Wölfflin, H., *Renaissance and Baroque,* 1889, Simon, K. (trans.), London: Collins, 1984, pp. 62-63.

23 See Potts, A., *Flesh and the Ideal, Winckelmann and the Origins of German Art History*, New Haven and London: Yale University Press, 1994, especially chap. IV, for discussion of this subject.

24 Wölfflin, H., "Prolegomena to a Psychology of Architecture", 1886, *Empathy, Form and Space. Problems in German Aesthetics 1873-1893*, p. 151.

25 Wölfflin,"Prolegomena", p. 159.

26 Scully, V., *Modern Architecture*, London: Studio Vista,1968, p. 48.

27 Woods, L., "Neil Denari's Philosophical Machines", *A+U*, March 1991, pp. 43-44

28 A further instance of the power of the distinction is suggested by Robin Evans. He proposes that part of the interest of Le Corbusier's chapel at Ronchamp—"dedicated to women, masterpiece of subjectivity, reputed destroyer of the right angle and straight line"—is that its distinctly feminine forms were the outcome of an assertively masculine process of creation. See Evans, R., *The Projective Cast: Architecture and its Three Geometries*, Cambridge, Massachusetts and London: The MIT Press, 1995, pp. 287 and 320.

29 Bergren, A., "Dear Jennifer", *ANY*, vol. 1, no. 4, January/February 1994, p. 12.

30 Sorkin, M., *Exquisite Corpse, Writings on Buildings*, London and New York: Verso, 1991, pp. 134-135.

Cherchez la femme:

Francesco Da Cossa: *Month of April*, ca.1480,
detail of noblewomen and noblemen.
Sala Dei Mesi, Palazzo Schifanoia, Ferrara

Where are the women in architectural studies?

How can architectural criticism and historical studies engage issues of gender and feminism? As they are currently practised in the United States, history, theory and criticism reflect the prevailing sexism in architectural education and practice. More importantly, they are mechanisms that provide both ideological and material support for the persistence of sexist practices in that they simply ignore the presence of women in architectural history unless a woman is designated an architect or a major patron, such as in the case of royalty.

Several strategies have been proposed recently by women working in the areas of architectural theory and criticism in the United States to redress this imbalance, from a postmodern focus on the body, to feminist analyses of the work of historic male architects such as Le Corbusier, or analyses of how women respond to environments designed by men.[1] Some of these approaches help unmask practices that legitimate sexism, but often the women who articulate them and the ideas themselves are marginalised and ignored in schools and institutions, just as they are in architectural offices. Nor, to be sure, do postmodern theorists make much of an attempt to give body to their theories, to articulate ways of incorporating their insights into action, whether in terms of historical research, the institutionalised practice of architecture, or other forms of political action.

Caught, on the one hand, between the theoretical question of what feminist design practices might be and how they might differ from those of men, and on the other, by the practical reality of the organisations, educational institutions and design practices in which they participate only marginally, women theorists, critics and historians in the United States have paid scant attention to material practices themselves. The implicit assumption underlying this neglect is the essentialism inherent in such a notion as 'feminist design practice'. Using such a term implicitly ratifies notions already embedded in historical and critical studies about what is legitimate to study in the past, and the appropriate methodologies for doing so.

The need, as I see it now in the 1990s, is to articulate the multiple and sometimes conflicting agendas of feminism in the United States in design criticism and history. Such a practice might enable us to construct new lives

and new relations with architectural practice in part through approaches to criticism and historical inquiry that refuse to fetishise either creativity, or the idea of the romantic artist, or an essentialised feminism that attempts to resolve multiple possibilities of feminism and issues concerning women and design into one voice.

As my own expertise is in history and criticism, I want to elaborate an approach to history that places women, their spaces and their role in the shaping of cities, at the forefront, and not only when women were the designers. This latter approach reinforces concepts of buildings and spaces as constituted by historically dominant groups as not only the norm, but natural and valid for all members of society, regardless of where and how they are positioned. My intention is to uncover spaces, spatial practices and histories that concern women above all, with the argument, following from the work of French sociologist Pierre Bourdieu, that through social practice, spaces are both configured and acquire meaning.[2] This allows us to replace generic comments about the presence of women, their role in the kitchen, or even discussions about famous women, with a very different order of analysis that places the social practices of both women and men at the forefront, and that understands those practices, and therefore spaces, in their contexts. Such a historical approach also represents resistance to totalising interpretations, or metanarratives, and, more specifically, allows us to recover the histories not only of some exceptional buildings, but also, insofar as possible, structures and histories that have not been preserved precisely because of their associations with women. The examples I am presenting here are all works-in-progress, with my research far from complete, so there are more questions to be posed than I can yet answer.

One of the ways to erode the survey monolith is to begin by discussing women who participated in shaping environments or parts of cities, but who have escaped recognition because they were not architects; also, to recover the settings of female labour and other settings for women. I want to propose four examples of the type of research that can be done, all of which come from a joint research project currently underway with a colleague, Barbara Allen, from the University of Southwestern Louisiana. One such example is the work in New Orleans of the Baroness Micaela Almonester y Roxas de Pontalba (1795-1874), whose life was filled with enough adventure for several people.[3] With her mother, the Baroness received an inheritance of property and income from her Spanish father. Once married off to a cousin living in France, Micaela was forced to relinquish her title to these holdings to her husband and his father, but upon her death, Micaela's mother willed her property in France and Louisiana to Micaela alone. Although she wanted to administer her own properties, the

Pontalbas demanded control of this inheritance, as well. After Micaela discovered that she needed her husband's signature to obtain funds for repairs to her houses in Paris, she went to New Orleans and obtained rights to the inheritance in 1830 for herself and her three sons, all of whom had been disinherited by her father-in-law. She also announced her intention to obtain a divorce. The Baron, infuriated at her success in recovering her inheritance and no doubt by the impending divorce, prevailed on the French courts to order his daughter-in-law to return to Paris. When she arrived on October 19, 1834, he shot her four times in the chest, and then committed suicide. Miraculously, given the medical establishment of the day, she survived, although she lost her left lung and most of her left hand. After building a magnificent house on the rue du Faubourg Saint-Honoré in Paris (now part of the United States embassy), she was once again in New Orleans by 1849 to undertake a project she had long planned: the construction of the Pontalba Apartments (1849-51) and the renovation of the Place d'Armes and its transformation into Jackson Square.

The Baroness' father, Don Andres Almonester y Roxas, was an early developer of the Place d'Armes. Originally planned by the French engineer Le Blond de la Tour in 1721, the square faced the Mississippi river and had the other three sides reserved for official buildings such as the Governor's House, and a parish church erected in 1728. When the area was ceded to Spain after the French and Indian War (1763), hurricanes had largely destroyed the extant buildings on the Square, and much of the land was purchased by Don Almonester. He rebuilt the Cathedral of St. Louis after the disastrous fire of 1788, acting as architect and overseer, and he initiated the Presbytery and the Cabildo (City Hall), as well as the flanking buildings.

In 1844, the Baroness outlined to the New Orleans Council a proposal to fit her planned apartments out with a two story arcade, based on the arcades at the Place des Vosges in Paris and her intention to extend those already present on the Cabildo and Presbytery. She also announced other plans for improvements to the Square itself. Whilst the story of the construction of her buildings is a complicated one, with many design changes and several architects and contractors hired, fired, and sued, (too long to be recounted here) the important point that emerges from legal records and letters is that the Baroness considered herself qualified as an architect, and she acted as such, having built several buildings in France and wrestled with architects.

The Pontalba buildings contained sixteen three storey dwelling units, with shops on the ground floor. At some point she changed her mind about the arcades and added the first galleries in New Orleans with cast-iron railings—a feature that was destined to become characteristic of the city's architecture. The railings

include a monogram she designed with her initials—A & P. Throughout construction, she clambered about the scaffolding in men's pantaloons and supervised even the most minute construction details. Hers, too, was the suggestion for the cast-iron fence that still surrounds the Square, and she also donated benches for the area. Although she signed none of the drawings deposited in the city archives, evidence from court cases and letters makes it clear that the design was hers; one of the architects testified that she told him she knew precisely what she wanted, even the dimensions, so that she only needed him to draw up the design for her. The final appearance of her buildings and the Square reflect her determination and her commitment to her own design ideas.

Jackson Square, with the equestrian portrait of Andrew Jackson at the centre, is one of the most prominent and historically significant in the city, and Baroness Pontalba was largely responsible for its appearance. How should we understand her activities? I want to argue that, as feminist historians and theorists have maintained, the personal *is* the political: Micaela moved into the public sphere and became a developer and, for all intents and purposes, an architect and construction manager, because the promise of the domestic sphere so badly failed her. Happy domesticity was not possible with a weak husband and a domineering father-in-law, so she took action first to reclaim her inheritance, something that was possible not in the French courts but in those of the United States, and then to assume a public role by developing and designing buildings on her land.

Another woman, the African American Marie Le Veau, legitimized Congo Square just a few blocks away as the African American centre of New Orleans. Le Veau was a voodoo priestess who conducted her rituals in Congo Square, formerly low-lying swampland where African Americans met in informal groups. When the area was developed, she persisted in using it for her rituals, and it remained the premier African American gathering place in the city, as well as the only place in the entire South where African music could be played. Le Veau was a powerful woman who engendered fear, and she wielded that power effectively; her tale is still told in New Orleans. Similar cases are found in Rome in the person of the *fattucchiera*, or sorceress. The *fattucchiera* encroached on male perogatives by competing with them in the art of healing. A *fattucchiera* was (and still is!) a typical feature of Roman life; she instituted and removed curses, concocted potions and amulets for and against a variety of problems and ills (including abortions), or practiced white or black magic, and in general helped treat the problems and sicknesses, physical and otherwise, of her clients. Naturally she roused the antagonism and ire of the medical profession, but also of the church, particularly for her primitive and non-catholic means of putting

curses on people as a way of handling problems. Already in the eighteenth century she was viewed as a sinister figure because of her chief and defining characteristic: that she held power independent of male authority. Of course, that male authority regularly and systematically was imposed on *fattucchiere*, in repeated efforts to make her submit to the duly constituted male authority. Much research remains to be done on figures such as Le Veau and Roman *fattucchiere* to determine their places in urban environments, how they were represented, and their impacts on their cities.

Given the massive cultural and legal constraints operating until recently, the accomplishments of such women are largely hidden, but they can still be recovered through traditional methodologies. What about the mass of women who, through practice, gave meaning and shape to cities, buildings and urban artifacts? The next two examples entail, first, making the presence of women in these arenas visible, recovering historical memories that for all intents and purposes have died, recovering the spaces or places themselves, and then recasting the discussion of history in such a way as to emphasise the significance of meaning as a result of social practice, rather than the genius of the single male architect or patron. Where possible, I have sought documentation of such presence, whether by photographing particular sites or by locating photographic or other types of images. As you will see, for many reasons, this is not easy.

In architectural and urban history, women such as the Baroness Pontalba have effectively been written out of 'public spaces', in part because of how such places have been defined. Public spaces, or spheres, usually refer to areas traditionally believed to belong to men, and include everything from arenas where political discourse takes place to the settings where men work for salaries.[4] It is counterposed to the domestic, or private sphere, reserved for women but where men dominated nonetheless. Public spaces are commonly understood to have been shaped and used by men, whether these have to do with political or market relations.

A series of paintings by Franz Roesler of the city of Rome give the lie to this notion of public space.[5] Although commentators refer exclusively to the buildings and the ruins, the paintings also document the persistent presence of women in the public sphere, doing many types of work, from sewing to selling, to caring for children. Roesler painted architectural urban landscapes of a Rome that has by now virtually disappeared; and as a consequence, for the past quarter of a century, his paintings have been sold as postcards of 'the Rome that has disappeared', and numerous books with collections of his paintings have been published.

Women Spinning near Siena, ca. 1865
Reproduced by Permission of the
Gabinetto Fotografico Nazionale, Rome

In all of the commentary, however, the striking fact is that no-one talks about the women in the paintings: largely the women who, with their work and presence, bring the streets and buildings to life. Roesler depicted women preparing food for sale, selling food, carrying laundry, (and invisibly present wherever laundry is hanging outside of windows), sewing, selling cloth, strolling with children, or chatting amicably. The visibility of women in these streets, their constant presence and their constant activity, clearly marks their presence in the public sphere—even if they were not allowed to participate in the discourse of men.

A poorly preserved painting in the fresco cycle in the Sala dei Mesi at the Palazzo Schifanoia in Ferrara, Italy (dating from the 1480s) depicts Borso d'Este and his noble friends out hunting against a background of rural scenes—a type of portrayal in a tradition linked to latin calendars or books of hours, in which agricultural scenes mark out the rhythm of the passage of time. Once again, unremarked by art historians, in the lower section of the painting, and at quite a large scale, women appear working: although the fresco is badly damaged, they appear to be doing laundry. Despite the fact that cleaning clothes was one of the principal tasks of women—both for their own families and for pay—there are almost no records of the sites at which this work was done. In fact, public

laundry facilities were present in every city and village, not to mention in the countryside. Laundresses went from house to house collecting dirty clothes, marking each client's laundry with a few stitches of different coloured thread. After separating whites from colours, they left them overnight in tubs of boiling water, with caustic soda or chestnut ashes, they then either took them to the river, or to the laundry, where they washed and dried the clothes.

Most of the antique laundries, from the Middle Ages and the Renaissance, have disappeared; the occasional extant examples were largely completed during the late nineteenth and early twentieth centuries, such as those to the south of Rome and elsewhere in the province of Lazio. More elaborate ones can be found in Spain and Mexico, in convents or out in the countryside. The long, double basin *lavatoie* which once appeared on the outskirts of Italian towns have almost entirely disappeared, and little or no trace remains in documents, guides or other records. Laundries were settings in which women in a neighborhood, or in a village, gathered to work, but also to talk, about their families, their villages, their cities. Like the public fountains where women gathered to collect water for their homes, these were social spaces as much as work spaces, they were collective, they were public, and they were spaces for and, given meaning by women. As in gatherings of women today, they were also informal settings for education, for passing on traditions, for learning about other areas when women from different parts of the province or country entered into the group.

Without direct voices in governance or in policy formation, the activities and conversations of these women disappeared over time, and even the traces of their presence are difficult to locate, more so when their activities were essentially ephemeral, such as spinning or weaving. Most public laundries were destroyed, particularly when new technologies replaced the back-breaking hand labour of women. It is remarkable, in looking at the photograph from the 1860s and the fresco from four hundred years earlier, how little had changed: even to the cloth on the head. But the laundries were also destroyed because they represented vestiges of a domestic sphere—however 'public' they so obviously were—that was not valued in a culture where men determined the order of values in the built environment. Domestic labour did not produce wealth in the same way that land and later factories did. Only inertia or absence of value to the land saved a few of these laundries.

My last example is taken, again, from the city of Ferrara. Two years ago, I began studying several aspects of the city of Ferrara during the Fascist period; my research centred on a popular set of races, the Palio, in which a banner, or palio, of precious cloth was awarded as a prize to the winner.[6] Research on the Palio in Ferrara led me back to the Renaissance, when the aristocratic family that

Women doing Laundry, ca. 1860, Lazio, Italy
Reproduced by Permission of the Gabinetto
Fotografico Nazionale, Rome

dominated Ferrara from the thirteenth century, the d'Estes, sponsored the races. Although a large number of documentary references from the Middle Ages onwards exist on the Palio in Ferrara, I found only one visual representation of the race, part of the same fresco cycle dating from about 1490 by Francesco da Cossa, in the Sala dei Mesi, in the Palazzo Schifanoia. The frescoes portray Borso enacting his public responsibilities and enjoying his private life in the context of the scheme of the entire world, with deities and planets ruling their spheres in the upper two thirds of the images, and Borso ruling his. One small band in da Cossa's fresco of the month of April conflates the various races run for the Palio in all of its versions—horses, donkeys, and foot races for boys, men and women—in one temporal band. The remarkable thing about this panel is that while critics regularly refer to it and discuss Borso, his court, and the painting technique, the most striking features of that small band—women—have been largely overlooked by art historians.[7]

The painting depicts women as part of a complex social hierarchy, part of three tiers of urban society. In the lower zone, as part of the races, women are in movement and in skimpy dress. In the middle zone are courtly guards and officials, all male. The men who occupy the middle section are mounted on horses or involved in discussions in what are traditionally defined as public spaces, where they are clearly exercising their political and administrative roles; the architecture depicted reinforces their public role. The noble women stand

Francesco Da Cossa:
Month of April, ca. 1480,
left (left half).right (right half).
Sala Dei Mesi,
Palazzo Schifanoia, Ferrara

above and apart from the racers in attitudes of solemn watchfulness on the balconies or at the windows of their family palaces, preceded by tapestries and banners that signal their family connections. By contrast with the racing women, the noble women are stiff, immobile, hardly entering into the spirit of an event that at least in part can only be described as vulgar, with scantily clad men and women—one woman even displaying her genitals—racing below them. That social hierarchy was, as the painting demonstrates, also spatially reflected—not only for women, but for other outcast or lower level groups; it is no accident that they occupy the lowest level of the panel. Such public rituals symbolise the relations of power, because the repetition and scale both evoke and reproduce power relations—the men are even depicted as larger than the women, whilst the activities of women are simply background details or titillating additions to the important events of life: an attitude systematically reinforced in the art historical scholarship pertaining to the frescoes.

What does this panel tell us about the position of women in Ferrarese society? Since at least some of the races for the Palio were run during Borso's rule on the via Sabbioni, the men depicted were probably Jews, as was also common elsewhere, and the women were very likely prostitutes.[8] Only *le meretrici* would be seen in attitudes of such *disinvoltura*, such abandon, such vulgar displays of their genitalia. The linkage between these two groups of urban residents is not casual; at various times from the fourteenth to eighteenth centuries, both Jews

Francesco Da Cossa: *Month of April*, ca. 1480,
detail of women racing. Sala Dei Mesi,
Palazzo Schifanoia, Ferrara

and prostitutes were required to wear some type of identifying mark or piece of clothing, and both were confined to specific areas of the Italian Renaissance city in which to live and work.[9] Borso and his successor, Ercole d'Este, repeatedly and unsuccessfully attempted to banish prostitutes from the Palio, as they sought to upgrade and refine the race for Este ceremonial functions and to solidify it as a state display. While he failed to eliminate them from the Palio, Ercole did manage to confine prostitutes spatially to one area behind the church of St. Agnes, as outcasts and marginal members of society. He also placed a tax on their 'commercial activities', and required prostitutes to wear a white neckerchief with a *sonaglio* on it buttoned to their collars as a sign of their social station.[10]

The locations of some of the races provide a good indication of where prostitutes lived and were allowed to walk. The same race in 1475 that had the Jews racing on the via Sabbioni also had the women running from the church of St. Gregory along the via Gusmaria and the via Ripagrande. Prostitutes lived in three areas: *le Gance*, or bordellos, for example, were located on the Strada del Gambero (now via Bersaglieri del Po), just east of the Cathedral and ending in what was once a large canal, but which became via Giovecca. Ercole d'Este used the occasion of extending the Strada del Gambero in 1498, to tear down the houses of ill-repute and move the prostitutes elsewhere. Prostitutes were also confined to the areas between St. Gregory and St. Clement (which faced one another), and the nearby church of St. Agnes.[11]

The example of Ferrara affords a window to public policy toward prostitutes in Italian cities from the fourteenth century onwards, which consisted not in the criminalisation of the act itself, but rather in spatial control and the regulation of movement, habitation, and public presence, specifically limiting their presence in public venues such as streets, or semi-public ones such as hostelries. What do I mean? Cities such as Ferrara, Rome, Bologna, Florence, Venice, Lucca, Milan and Turin, all published statutes that designated streets in which prostitutes could live, and they often provided specific houses or complexes, *postriboli*, for them.[12] Statutes also regulated the days and hours when *le meretrici* could frequent certain streets and under which conditions. The statutes were quite precise: in sixteenth century Rome, for example, prostitutes were allowed to live in via Giulia, from Ponte S. Angelo to Ponte Sisto. A bordello, or *postribolo*, had already been located near Ponte Sisto in the fifteenth century. Via Giulia is well known to architectural historians as the street that Pope Julius commissioned Bramante to design (in tandem with the via della Lungara on the other side of the Tiber), extending from the Palazzo Farnese to the Tiber at the point Ponte S. Angelo crosses to Castel S. Angelo. This long straight street in the heart of Renaissance Rome is lined with churches and important family palaces, including the Palazzo Farnese—as well as the residence of prostitutes. At various times, prostitutes were also allowed to live in the area between Piazza del Popolo and the Arco del Portogallo (at Palazzo Fiano, near Piazza S. Lorenzo in Lucina) in an area known as the Ortaccia, anywhere except for the four main streets leading up to Trinità dei Monti; at the *stufa* (German run baths that were centres of prostitution) known as the Piscinella behind S. Maria in Monticelli; and near S. Maria della Pace at the corner of the via Parione and the via della Pace; near the Chiesa Nuova, in the via Stufa delle Donne (now the via Giglio d'Oro, from the Piazza S. Apollinare to the via del Orso); near S. Angelo in Pescheria, in the area that became part of the ghetto; and right next to the Palazzo Doria in the via della Stufa (now the vicolo Doria).[13]

Prostitutes lived in specific streets throughout the city, in virtually all of the inhabited areas and even in areas dubbed *signorile*, or upper class. The research project here involves understanding why certain areas were chosen, who owned the property, and how the presence of these women influenced future developments.

Statutes in other cities were equally as precise. Prostitutes were required to register, to pay a tax or fee, and in addition, to wear some identifying garment—a white cap, a piece of cloth at the neck—they were forbidden to wear jewellery or fancy garments, or to own property. Laws were repeatedly promulgated that forbade prostitutes from dressing as men, one of the mechanisms by which prostitutes attempted to gain greater freedom of movement and maybe one of the most threatening things they did. The repetition of these laws, and the sanctions attached to infractions, testify to the persistence with which women flouted them. Other laws required prostitutes not to wear masks, no doubt for the same reasons. Court records richly document the resistance of some women to all of these regulations, and to the attempts of the authorities to exercise control over them.

Overall, the specific sexual activities of the women appear to have offended less than their independence and autonomy, that is, their free movement in the city while not under the control of men; or, put another way, their ability to move about the city *as if they were men* (hence the significance of the ban on cross dressing), which also reveals the anxiety about sexual identity on the part of the men who dominated these cities. Their independence from male control was a matter of considerable unease, often quite apparent in the accounts of legal proceedings against women who asserted their independence. Further evidence of this is the ease with which women living alone, or seen in the company of men other than their husbands, or who appeared unescorted in hostelries or at dances, could be labelled *meretrice* and required to pay the relevant taxes.

On the other hand, these flawed women enjoyed a measure of autonomy usually denied women of other stations, and that autonomy was in evidence most insistently on public streets.

Unlike the public buildings of aristocratic men, or of primarily male activities, the bordellos were not typically identified, preserved, or even well documented in court and city records, and the streets on which they were found have, like many others, changed name and character over the centuries. Such places still exist, as for example, in Nuevo Laredo in Mexico near the border with Texas, where prostitutes live and work in an enclave surrounded by 60 foot high walls. One would want to undertake a study of the geography of such places, to

understand why specific places were chosen, how they influenced future development, and how the women shaped their spaces. For example, the Ortaccia in Rome was an area inhabited by foreigners (we also know that many prostitutes were from out of town); and later by artists, too. Was the connection between foreigners, artists and other marginal groups and prostitutes spatially configured as it is today in Rome, with the railroad station a major centre? Did this marginal status help preserve the urban fabric between the Spanish Steps and Piazza del Popolo, where other areas were drastically invaded after the city became the capital of Italy?

The spatial practices in effect for prostitutes, such as constraints on movement, habitation and dress, were political practices as well as social ones, which reinforced a set of values that appeared to be in the natural order of the world: male dominance, female inferiority, and a hierarchy of values that placed prostitutes at the bottom of the scale. Our research tends to suggest that the ideal of the domestic sphere failed for, or did not represent the condition of, many women, from the Baroness to the prostitute, and that in such circumstances, women took control of their lives in part by moving out of the domestic sphere into the so-called public one. For those women without the power and money of the Baroness, legal records, folklore, and mapping of their presence are ways of reinserting women into history. The cultural representations of prostitutes and other women both produced and reproduced power relations, but they also offer opportunities to expose and undermine those relations. By shifting interpretations of the past to alternative ones away from those favored by dominant groups, we open the possibility of undermining those representations and interpretations, and ultimately of overthrowing them.

Notes

1 See, for example, Kanes Weisman, L.,
 *Discrimination by Design: A Feminist
 Critique of the Man-Made Environment*,
 Urbana and Chicago: University of Illinois
 Press, 1992; Colomina, B.,"The Split Wall:
 Domestic Voyeurism," in Colomina, B.
 (ed.), *Sexuality and Space*, New York:
 Princeton Architectural Press, 1992, pp.
 73-130; Bloomer, J., *Architecture and the
 Text: The (S)crypts of Joyce and Piranesi*,
 New York: Princeton Architetural Press,
 1994; Carranza, L., "Le Corbusier and the
 Problems of Representation", *Journal of
 Architectural Education*, Vol. 48 no. 2
 November 1994, pp. 70-81. More
 generally, see essays in the magazine
 ANY and the journals *October* and
 Assemblage over the past decade,
 particularly articles by Bloomer,
 Colomina and Ingraham.

2 Bourdieu, P., *Outline of a Theory of
 Practice*, Cambridge: Cambridge
 University Press, 1977.

3 Huber, L. V. and Wilson, S. Jr., *Baroness
 Pontalba's Buildings, Their Site and the
 Remarkable Woman who Built them*,
 New Orleans: New Orleans Chapter of
 the Louisiana Landmarks Society and the
 Friends of Cabildo Jackson Square, 1964.
 I want to thank my colleague, Professor
 Barbara Allen of the University of
 Southwest Louisiana for sharing her
 research with me; we are preparing a
 book together on women's spaces in
 history, and her project includes the
 work of three women in Louisiana—
 Marie Thérèse Coin, Baroness Pontalba,
 and Marie Le Veau.

4 Fraser, N. "Rethinking the Public Sphere",
 in Robbins, B. (ed.), *The Phantom Public
 Sphere*, Minneapolis: University of
 Minnesota Press, 1992, pp. 1-32;
 Habermas, J., *The Structural
 Transformation of the Public Sphere: An
 Inquiry into a Category of Bourgeois
 Society*, Burger, T., and Lawrence, F.
 (trans.), Cambridge, Massachusetts: The
 MIT Press, 1989.

5 Jannattoni, L., *Roma Sparita negli
 acquarelli di Ettore Roesler Franz*, Rome:
 Newton Compton Editori, 1981.

6 Visentini, N. F., *Il Palio di Ferrara,* Rovigo:
 Istituto pagano di arti grafiche, 1968;
 Tebaldi, D., Vincenzi, L., Lolli, S. (eds.),
 Ferrara e il Palio, Ferrara: Giovanni
 Vicentini Editore 1992. For a more
 general discussion of the races
 elsewhere in Italy, see Dundes, A., and
 Falassi, A., *La Terra in Piazza: an
 Interpretation of the Palio of Siena,*
 Berkeley: University of California Press,
 1975.

7 Schemek, D., "Circular Definitions:
 Configuring Gender in Italian
 Renaissance Festival", *Renaissance
 Quarterly*, Spring 1994. Shemek proposes
 an equally political reading of the
 Renaissance Palio, but she also
 undertakes a provocative analysis of
 gender relations through her study of the
 Palio. I am grateful to her for allowing me
 to review her unpublished manuscript
 while I was completing this paper, and
 for providing me with some new
 documentation.

8 For example, the footrace for men on 24
 April 1475 was run partly on the via
 Sabbioni, the main street in the Jewish
 section of town (although this area was
 not enclosed as a ghetto until 1624).
 The relevant section from the *Statuta
 Ferrariae* is reprinted in Tebaldi, D.,
 "Una lunga storia da raccontare" in
 Tebaldi, D., Vincenzi, L., Lolli, S. (eds.),
 Ferrara e il Palio, pp. 13 and 14.

9 Regulations in Milan required *le meretrici* to wear a hood when they were working in inns and hostelries, but while they walked through the city or suburbs instead they had to wear a white mantle about fourteen inches long on their backs. Later the regulations became more precise, with the mantle described as being buttoned at the collar, and fully covering shoulders, back and breast. In Venice, on the other hand, prostitutes had to wear a yellow kerchief. The Archivio di Stato del Comune di Milano (ASCM), fondo *Provisionum*, Register 14, 1389-1397; ASCM, *Provisionum*, Register 16, 1416-1450; Archivio di Stato di Venezia (ASV), Register 53, *Misti Senato*, 1419-21, c. 328, 23 May 1421.

10 Schemek, "Definitions",*Quarterly*.

11 Melchiorri, *Nomenclatura ed etimologia*, pp. 19-20.

12 For Milan, see Santoro, C. (ed.), *I registri dell'Ufficio di Provvisione di Milano e dell'Ufficio dei Sindaci sotto la dominazione viscontea*, Milan: Castello Sforzesco, 1929; "Litterarum ducalium", Register 2, 1397-1400; Register 12, 1385-1388, in *Antiqua Ducum Mediolani Decreta*, Milan: Malatesta stampatori 1654, pp. 130-133; for Florence, see "Statuto del Potestà", 1325, in Caggese, R. (ed.), *Statuti della Repubblica Fiorentina*, Vol. II, Florence: Ariani, 1921, pp. 270-273; for Venice, Lorenzi, G., *Leggi e memorie venete sulla prostituzione fino alla caduta della Repubblica*, Venice 1870-1872, pp. 31and 32; Alberti, G., "Cortigiane, stufe e la lue nella Roma antica del primo Cinquecento", in *Il Vasan*, 1941, pp. 64ff.; for the city of Lucca, Bonghi, S., *Bandi lucchesi del secolo decimoquarto*, Bologna: Tipografia del Progresso, 1863, p. 174; Archivio di Stato di Lucca, Fondo *Protettori delle meretrici*, vol. I, 1564-1571; for Bologna, Sacchi, F. C. (ed.), *Statuta civilia et criminalia civitatis Bononiae*, 2 Vols. Bologna: Costantino Pisarro, 1735, see in particular Vol. I, p. 487; Archivio di Stato di Firenze, *Ufficiali dell'Onestà*, no. 1, Statuti.

13 In Rome, for example, prostitutes were confined to certain buildings or to areas such as the *Ortaccio* in Campo Marzio, the area between Piazza S. Lorenzo in Lucina to Piazza del Popolo with the exception of the large streets such as those leading to Trinità dei Monte. Pastor, L., *Storia dei papi dalla fine del Medioevo*, Vol. VIII Rome: Desclée e Ci, 1951, pp. 600and 601. In Milan at the end of the fourteenth century, for example, *le meretrici* were required to wear a white mantle about fourteen inches long when walking in the city or suburbs; when they were working inns, they had to wear a hood; in the fifteenth century, the mantle had to have buttons at the neck and cover shoulders, breast and back. Verga, E., "Le leggi suntuarie milanesi", *Archivio storico lombardo*, Milan: 1898, pp. 41and 42; Archivio di Stato del Comune di Milano, *Provisionum*, register 16, 1416-1450; Archivio di Stato di Venice, Register 53, *Misti Senato*, 1419-1421, C. 328, 23 May 1421. Mazzi, M. S., "Il mondo della prostituzione nella Firenze tardo medievale", *Ricerche Storiche*, 1984, p. 340; Trexler, R. C., *Public Life in Renaissance Florence*, New York: Academic Press, 1980, p. 379; *Antiqua Ducum Mediolani Decreta*, Milano: Malatesta stampatori 1654, p. 130ff.

Overlooking:
A Look at
How we
Look at Site

Albert Brassai:
False Sky, 1932-34
© DACS 1996.
Reproduced by
Permission

174

or... site as "discrete object" of desire

Everywhere you shut me
in. Always you assign a
place for me... You set
limits even to events
that could happen with
others... You mark out
boundaries, draw lines,
surround, enclose...
What is your fear?
That you might lose
your property?[1]

In this paper I will talk about a 'lesser part of design'. Tracking the intersecting trajectories of representation, analysis, and design practices, my critical focus is a specific site analysis process associated with modernist methodology, one where design preoccupations and gender inscriptions are tacitly implanted below the analytic horizon. While integral to the design thought process, my subject has been systematically ignored by both architectural and urban design discourse. Its dismissal reflects a value system that disavows the formative influence of site study and unduly premiates a narrow definition of design as intervention.[2] To start: How do attitudes toward analysis and assumptions about representation together spawn a particular genre—or gender—of site knowledge? How does this knowledge determine what we do, and do not recognise as a site? How does it influence design strategies, perpetuate gendered inscriptions, structure mechanisms of site control?

These questions are relevant to architecture because whatever is constructed on site will always be informed by a maker's understanding of site. Always mutable, site is a collection of scales, programmes, actors and ecologies that includes past imprints as well as future changes. To paraphrase Hélène Cixous, it belongs to the order of "feminine" continuity.[3] While many artists recognise that we are always in the midst of site (Walter di Maria, Richard Long or Robert Smithson), formally trained designers prefer to apprehend sites as finite, or fixed. By conceptualising them as distinct pieces (of land) defined through ownership, design thinking institutes a forceful myth: the contained and controllable site. It is a myth linked to assumptions that the goal of design is rational order and the purpose of analysis is preparing thorough site documentation, making way for design's (supposedly benign) controls.[4]

"Something Happened..."
Plaque in Lowell, Massachusets
Photo: Patricia Phillips

Before going further, I should say that expectations about the role of site study in the design process can only be intuited, not traced in scholarly terms. This is because analysis is conceived as a minor practice compared to the rest of the creative thought process. But this 'background' realm (to borrow Mary Daly's gynoterms) should not be subordinated to a 'foreground' where 'fabrication' and 'objectification' are presumed, by the patriarchy, to occur.[5] In what follows I want to recast analysis as the locus of an 'other' kind of making (to 'out' its as yet-figured ground), reviewing how we frame, or sight site, as both conceptual construction and physical location. Gender theory is useful for this, but even while calling for expansive notions of site study, it does risk a reductive understanding. According to Ann Bergren, "the poverty of our terms and theories of gender is that none get beyond the understanding of the feminine in terms of the marked versus the unmarked alternative".[6] As she reminds us, "Male discourse invents the feminine for its own purposes. Women subscribe to it at their peril".[7]

Wary of these dangers, I will examine some of the operations and gender inscriptions associated with site study, including the 'analysis myth' structuring the analytic gaze. This myth is 'construed' by three interrelated assumptions: first, that analysis is inconsequential to site definition (it accepts site boundaries as given); secondly, that it is objective, yielding neutral descriptions (records of site 'data'); and thirdly, that it is only preparatory to design. I suggest that site is gendered by analysis practices that associate it with a notion of the 'feminine' construed in terms of a 'lack'. Specifically, I am interested in how we look at sites with respect to overlooking—a habitual site analysis practice that contributes in very particular ways to the construction of knowledge of site.

The notion of overlooking is presented here with all its richness of meaning intact. There is overlooking as 'hovering over' or 'looking down from'—implying a distanced, detached, possibly aestheticising point of view. Then, there is overlooking as 'forgetting' or 'omission'—when we let certain kinds of information slip by or 'fall through the cracks'. There is also overlooking as 'dismissal' or 'exclusion'—stronger than omission, suggesting a certain determined inattention, oversight, or even a conniving disregard. And finally, there is overlooking as 'looking down upon', in the sense of 'supervising' or 'supra-intending'—suggesting the presence of possible mechanisms of control. Together (and separately), the operations of overlooking are aspects of gendered production, structured by and reinforcing a dominant patriarchal order.

Bugs. Museum of Natural History, Paris.
Photo: Andrea Kahn

Overlooking

Begin by hovering over: the prevailing analysis drawing is an over-view, reputedly the clearest and most comprehensive site description. Unlike a section cut, the omniscient plan-from-above diminishes the legibility of crucial conflicts at ground level—it imposes a maximal degree of spatial (and temporal) order on the sight below. Acts of inventory draw out categorical distinctions (use, building type, block morphology, infrastructure, formal patterns, class, etc.). Emphasising boundaries (most often abstract ones) identifies site falsely as building lot. The advantage of these analysis practices is that site is made manageable. But it is only apparently fixed, since the contained area always remains perceptually (and practically) part of a larger situation (infrastructural networks, ecosystems, etc.). For example, the building lot of Trump's infamous plan for Manhattan's Upper West Side may end at 72nd Street, but the project's site extends to the 158th Street sewage treatment plant in Harlem that would bear the infrastructural burden of development. The problem is that a site's disparate aspects and structuring scales can never be simply disentangled or distilled. What remains unaccounted for in representations that hover over is anything that cannot be assigned a 'proper' place—fluid reciprocities, interlocking events and fluctuating scalar relations. What is lost is always in conflict, somehow, with traditional site definitions held in place by known modes of description.

Hovered over, site is conceptually disassociated from perceived situation. In terms of gender inscriptions, it is structured as a discrete 'feminine' figure, objectified by the male gaze. Site's identification with property, and its objectification have profound ramifications. The site seen in plan is akin to the depiction of woman in what Cixous and Clément have described as man's "most satisfying" dream: the woman lying, waiting, in sleep, with "just enough life" but "not too much", "intact, eternal" (site is rarely thought of as temporary), "absolutely powerless".[8] Captured by a gaze that overlooks, site (like the repressed dream woman) is "Kept at a distance so that [man] can enjoy the ambiguous advantages of the distance".[9] Looked over, site is reckoned as a scene under design control.

Consider, for example, how the calculated methods of conventional analysis—which privilege the clear over the chaotic, the elemental over the relational, the static over the mobile—are inadequate to the task of recognising (or representing) the incalculable angles of a site's lived complexity: ephemeral or temporary events, traces of living bodies, registrations of cyclical, or seasonal changes, marks of fleeting occupations signalling the practices of everyday life. Instead of elaborating site's fullness, all that is registered is the blank trace of design's desire. These omissions are a function of hovering over. Confronted by

Max Ernst: *France,* 1962.
© SPADEM/ADAGP,
Paris and DACS, London 1996.
Reproduced by Permission

myriad spaces in the same place (political, economic, social, sexual, permanent and temporary etc.), schematic overviews reduce the incommensurable to one acceptable image—a practice analogous to gender stereotyping, which also cannot admit admixture. In the interest of preparing a 'suitable' [submissive] site, externally derived, so-called 'rational', orders are superimposed. The result is an underarticulation or erasure, a smoothing over or flattening out of the contestatory.

Site, like woman, is missing something.[10] It is the bearer, but never the maker, of meaning. In conventional design practice, discovering this 'lack' is the crucial first step in preparing a site for intervention. To situate the designer in this process, let me return to "Man's dream":

> I love her—absent, hence desirable, a dependent nonentity, hence adorable. Because she isn't there where she is. As long as she isn't where she is. How he looks at her then. When her eyes are closed, when he completely understands her, when he catches on and she is no more than this shape made for him: a body caught in his gaze.[11]

In this dream, man loves woman "Because she isn't there where she is". And so it is too, with maker and site. Once it is distilled, reduced and objectified, the site is supposedly available for design. But design's dream starts before this.

Design decisions can always be traced back to particular supra-intentions of analysis practice. By supra-intentions, I mean those logics and values structuring initial site observations. What we frame as 'the site to be analysed' is always and already prescribed by expectations regarding the scope and character of its possible futures, and conversely, how we analyse it introduces a site conception that resonates through all phases of design.

As David Harvey observed, the "proper way to see" is wholly dependent on who is looking, what they are looking for, and why.[12] Now, I would like to posit that in traditional design practices, the "proper way to see" has historically been guided by principles that seek to master site, and that this desire for mastery contributes to, and reinforces the habitual practices of "overlooking" outlined above. To paraphrase Elizabeth Grosz (substituting "makers" for "men" and "site" for "women"):

> unless [makers] can invent other ways to occupy [sites]... until [site] is conceived in terms other than the logic of penetration, colonisation, and domination... until [makers] no longer regard [sites] as the provenance of their own self-expression and self-creation, until [makers] respect [sites] that are not theirs... [makers] cannot share in the contributions that [sites] have to offer reconceiving space and place.[13]

To say aloud what I have been hinting at all along, the relationship between maker and site (embodied by operations of overlooking) has historically been one of domination, analogous to the "enclosure of women in men's conceptual universe".[14] And so to conclude, I want to suggest another relationship between maker and site.

Oversights/Other Sites

In between hovering and forgetting, omission and supra-intention, there resides a different concept of the 'oversight'. These 'other' sites—unsightly sites—resist objectification by conventional modes of representation. They are as varied as any situation's capacity for change—a function of experiential overlaps between a beholder and a fungible constellation of scales, programmes and events. They may be specific places. Times Square in New York City is one where reductive classification is defied. Here the (inter)national site where the 'ball drops' every New Year's Eve is a regional reckoning point, a local neighbourhood plagued with failing enterprise, a focus of global capital investment. At the brightly lit

centre of Disney distraction is a darker edge, a realm of prohibited attractions. Houston Street (also in New York City) with its shear walls and gaping holes, is another example that does not follow ownership's rule, but suggests more mutable configurations of the overhead, the underground, the peripheral, the slipped. These other sites expand and contract without discernible limit (like the shared but physically disjoint ground between an uptown sewage plant and a downtown development). They are situations summarily dismissed by disciplined exclusion. Or they can be temporary trajectories, experiential re-mappings like J.B. Jackson's *Stranger's Path* (following a modest visitor through a modest city), or Louis Aragon's *Paris Peasant*, tracking forth and back through the arcades, always closer and closer to the Theatre Moderne, the theatre of bodily desires.

To sight these over-sites means revisiting places we thought we already understood—reconsidering terms of definition and their allied gender inscriptions. Moving beyond the 'poverty' of gender theories (returning to where I began), Bergren asks, "How many genders are there? How many permutations and combinations of bodies?"[15] In an ongoing project variously called "Nomad Mapping", "Unsightly Sites" and "Mobile Ground", I am exploring a process of site study that asks similar questions, regarding site as a fluid composition with multiple permutations. Folding across the intersecting vectors of "overlooking", this work is a critique of modernist analysis and its allied representations. Its purpose is to dispel the analysis myth and to alter the relationship of maker and site through a practice called Site Construction (so termed to acknowledge that site is always constructed through the conventions of, and according to the values inherent in, analysis methods).[16]

With its affinity for the technical and verifiable, conventional site analysis masquerades as a descriptive endeavour, concealing its real inscriptive and prescriptive force behind the 'analysis myth'. Even though its techniques and methods are ideologically charged and gendered practices conditioning how problems are framed, the modern predilection for scientific legitimation in research, and modern architecture's related predisposition toward the rationalisation of site, obscure the play of design's desires on the supposedly neutral analytic field. In contrast, the practice of Site Construction drops any pretence of objectivity to openly adopt partial—incomplete and biased—points-of-view.[17] It also accepts the interpretative force of site description, acknowledging the crucial connection of analysis to design. Rather than producing pseudo-empirical, pre-design documents, site constructions are explicitly designed understandings of site.

Annie Leibovitz: Bette Midler in the roses, 1979.
©1996 Annie Leibovitz/Contact.
Reproduced by Permission of the Artist

Site construction differs from conventional analysis in specific ways. Taken together, these have profound implications for the built environment since they directly inform the programming practices that structure design actions. First, site construction is an extractive method. It does not impose generic rules, but derives precise measures from a site's inherent, if not immediately apparent, orders. Recognising these orders is the first step in programming 'from the ground up'. Instead of ascribing to historically sanctioned forms of intervention, design strategies initiated with measures extracted through site construction are calibrated by existing site characters, and can adapt to appreciate (rather than depreciate) their value.

Secondly, site constructions strive toward multiple representations rather than a single authoritative view. Again the ramifications for design are significant. Design projects, and the programs that shape them, reflect different modes of site description. Consider standard programming initiatives based on traditional analysis methods: when programmes lift out and separate difference, impose a singular scale, or disregard experiential continuities, they are the conceptual offspring of analysis practised as inventory, literally building upon the remains of analytic parcellisation. By admitting possibly incommensurate site views, site constructions provide for design strategies that can include densely layered temporal and spatial figures at many interrelated scales. These counter the consequences of analyses that dissect and prepare sites for controlled (and controlling) interventions, conceptualised as discrete.

Thirdly, site constructions neither search out nor represent a lack. They consider site not as an empty vessel, but a source of meaning. For design practice, this suggests existing conditions be respected and utilised rather than treated as dispensable obstacles standing in the way of some pre-determined plan. In terms of gender, site is no longer construed as a passive receptacle.

Finally, to dispel the illusion, associated with the analysis myth, of contained and controllable sites (and in so doing, to substantially alter its gender implications), site construction disengages the definition of site from that of property, conceiving (and perceiving) it not as an object, or static figure, but as mobile ground. In terms of design practice, this shift dislocates repressive design strategies held in place by more divisive analysis methods—powers that seek to break site down in preparation for its colonisation by designs announced in a rhetoric of patriarchal control. Here, the maker no longer dominates, but instead negotiates and even co-operates with unforgettable site forces that can never be brought entirely under control.

As a design practice, site construction works against the representational and gender biases of the objectified, eternal and almost absent 'dream woman', redefining site as an 'other' kind of feminine—a lively, open, ever-present situation.

An earlier version of this text was delivered at the 1995 European ACSA Conference, "The Geography of Power," May 1995, Lisbon, Portugal.

Notes

1 Irigaray, L., *Elemental Passions*, New York: Routledge, 1992, quoted by Grosz, E., in "Women, Chora, Dwelling", *Architecture and the Feminine, Mop-up Work*, Vol. 1. No. 4, Jan-Feb 1994, p. 22.

2 An extensive search under 'site analysis' and related topics in the *Avery Architectural Catalogue* yields next to no materials, and no categories for 'analysis drawings' exist in their slide or drawing collections. According to at least one critic/theorist this is because "Architects burn the evidence". Programming is another underthought aspect of the design process, as Ellen Whittemore's ongoing research on the urban design programming reveals.

3 Cixous, H., "The Sex of the Text", *Three Steps on the Ladder of Writing*, New York: Columbia University, 1993, p.133.

4 These assumptions are structured by design's "patriarchal unconscious". See Mulvey, L., "Visual Pleasure and Narrative Cinema", Brian Wallis (ed.), *Art After Modernism*, New York: Godine, 1983.

5 Daly, M., "Outercourse", *The Bedazzling Voyage,* San Francisco: Harper Collins, 1992, p. 1.

6 Bergren, A., "Dear Jennifer", *Architecture and the Feminine, Mop-up Work* Vol.1. No. 4, Jan-Feb 1994, p. 15. On this poverty: "I hate such reductive analyses because they tap into the sexism in which we all participate—into the degree to which we all are formed by these long inherited, deeply entrenched notions of the feminine and the masculine, just as we are formed by equally long and deep notions of race— and thereby steal a pernicious plausibility", p.14.

7 Bergren, "Jennifer", p. 12.

8 Cixous, H. and Clément, C., *The Newly Born Woman*, Minneapolis: University of Minnesota Press, 1988, p. 66.

9 Cixous, and Clément, *Woman*, p. 67.

10 Mulvey, "Pleasure", p. 362.

11 Cixous, and Clément, *Woman*, p. 67.

12 Harvey, D., *The Urban Experience*, Baltimore: Johns Hopkins, 1989, p. 1

13 "… unless men can invent other ways to occupy space… until space is conceived in terms other than the logic of penetration, colonisation, and domination, unless men can accord women their own space and negotiate the occupation of shared spaces, until men no longer regard space as the provenance of their own self-expression and self-creation, until men respect spaces and places that are not theirs, entering only when invited and accepting this as a gift, men cannot share in the contributions that women have to offer in reconceiving space and place." Grosz, "Chora" p.27.

14 Grosz, "Chora" p.27.

15 Bergren, "Jennifer", p. 15.

16 I am also foregrounding this previously backgrounded practice in design studio teaching, where the project of Site Construction replaces site analysis as the first stage of design.

17 Moving beyond the myth of objectivity is a crucial first step in moving beyond design strategies constrained by the now obvious problems associated with modernist theories, bolstered by patriarchal illusions of timeless or scientific truths.

'Tan Hawaiian with Tanya'.
From R. Venturi, D. Scott-Brown and S. Izenour,
Learning from Las Vegas, Cambridge, MA:
The MIT Press, 1986. Reproduced by permission
of The MIT Press

Desiring Practices
Neil Leach

Architectural Models

The presentation of models that have been coloured and lewdly dressed with the allurement of painting is the mark of no architect intent on conveying the facts; rather it is that of a conceited one, striving to attract and seduce the eye of the beholder, and to divert his attention from a proper examination of the parts to be considered, toward admiration of himself. [1]

Mark Wigley picks up on these comments in the context of gender in *Sexuality and Space*.[2] What Wigley misses, however, are the sexual references that underpin Alberti's comments. Alberti is referring here to the world of prostitution. Models should not be "coloured and lewdly dressed with the allurement of painting". The words in the original Latin which have been translated here have secondary connotations that refer to 'rouging', 'pimping' and 'ornaments to the breast'.[3] It is quite clear that what Alberti means is that models should not be 'tarted up'—models should not 'seduce' the viewer. Models that are tarted up divert the viewer's attention away from "a proper

examination of the parts" towards admiration of the architect who prepared the model. Architects should not use models to draw attention to themselves.

Alberti's comments about models call to mind Vitruvius' anecdote about the architect Dinocrates and his model. According to Vitruvius, Dinocrates was "a tall man of fine form", who stripped himself down to a lion's skin, and anointed his skin with oil—presumably to bring out his muscular features—so as to catch the attention of Alexander the Great. By 'tarting' and 'dressing' himself up, the architect had become, in effect, the 'painted' model. As is well known, the ruse paid off. Dinocrates caught Alexander's attention and was able to show him the model he was carrying for a project on Mount Athos. Alexander was less impressed by Dinocrates' architectural proposal—which was clearly impractical—than by his initiative in 'selling himself' to his potential client. Alexander—a noted homosexual—duly took Dinocrates into his 'service'. Prostitution, of course, is not limited to women. "This was how Dinocrates", concludes Vitruvius somewhat snidely, "recommended only by his good looks and dignified carriage, came to be so famous".[4]

Vitruvius' condemnation of self-display has a special relevance today in our image-conscious society. We live in a culture of self-display and self-advertising, where the image is often fetishised under the influence of the media society, and commodified under the conditions of late capitalism. We live in a culture where we are increasingly obsessed with appearances. The privileged role of the image in contemporary society has important ramifications, I would maintain, for a profession such as architecture which is so bound up with the image.

In an article in the *Independent on Sunday*, entitled "Architects: Last of the Die-Hard Sexists", Joanna West highlighted the sexism that exists within architecture.[5] Women are clearly disadvantaged within the profession, and West attributed this to a number of factors, such as the length of architectural training, the irregular hours and so on. Significantly, West observed that this sexism exists in architecture *despite* the profession's liberal façade. This liberal façade is based no doubt on architecture's reputation for a liberal *aesthetics*. In contrast to a predominantly conservative general public, architects are known for their often radical and avant-garde aesthetic outlook. Yet it could be argued that this very emphasis on the visual dimension may not only mask a more reactionary political agenda, but it may also contribute to it in some measure.

This paper offers a critique of an architectural culture whose obsession with the image threatens to promote an increasingly superficial outlook. It considers the impact of the cult of the image on practices within the office, and reflects on what relevance this may have for the question of woman.

The Surfeit of the Image

Our present condition has been described in terms of an "ecstasy of communication".[6] We live in an era of multi-media communication, where technological advances in telecommunications and in methods of visual reproduction ensure that we are constantly being bombarded with images. The world has become 'xeroxised' into infinity. It has generally been assumed that this bombardment of images leads to an 'information society', which promotes a high level of communication. Yet according to some commentators, this ecstasy of communication has precisely the opposite effect: "We live in a world", as the French thinker, Jean Baudrillard, has observed, "where there is more and more information, and less and less meaning".[7] It is precisely the surfeit of information which denies information: "Information devours its own content. It devours communication and the social".[8]

This situation is exacerbated by our cultural situation, dominated as it is—in Baudrillard's terms—by simulation and hyper-reality. The effect of hyper-reality is that the distinction between the real and representation of the real begins to be effaced.[9] As the real passes to the hyper-real, a new objectivity results. Objects become detached from their original complex cultural situation, and this condition promotes instead "a gaze which sweeps over objects without seeing in them anything other than their objectiveness".[10] As a consequence of this new objectivity, notions of depth, perspective and relief, which are traditionally associated with the subjective viewer, are reduced. Under the influence of hyper-reality, the increasing objectification of the gaze induces a general aestheticisation.[11]

The world has become aestheticised. Everything has become appropriated as art. As Baudrillard himself comments, "Art has today totally penetrated reality… The aestheticisation of the world is complete".[12] It is precisely in this aestheticisation that the object loses its content and is divested of its meaning.[13] Thus the surfeit of the image—the excess of communication and information— implies the opposite, a reduction of communication and information. All this is exacerbated under the condition of hyper-reality, whereby content is consumed and absorbed within a general process of aestheticisation. The world therefore threatens to be perceived increasingly in terms of a proliferation of aesthetic images empty of content.

The Aestheticisation
of the World

Baudrillard's comments on the reduction of meaning within an aestheticised world seem to owe their origins to the observations of Walter Benjamin on the relationship between aesthetics and politics in his essay, "The Work of Art in the Age of Mechanical Reproduction".[14]

Within the context of Benjamin's essay, it can be seen that a privileging of the image is itself not innocent. There is a potential corruption within this very process of aestheticisation. For, as Walter Benjamin points out, politics and aesthetics may collude, the latter concealing the former; one can use aesthetics to mask an unsavoury political agenda, to present it as palatable. The Nazis exploited this in their Nuremburg rallies, the Futurists exploited this in their aestheticised call for war. The very putrefaction and destruction of war was celebrated by Marinetti as an aesthetic experience.[15]

The spirit of the Futurists, it would seem, is echoed in the work of Lebbeus Woods who clearly finds the death and destruction in Sarajevo a deeply aesthetic experience. "War is architecture, and architecture is war!" he proclaims.[16] The warnings of Walter Benjamin, it seems, have not been heeded. Nowhere are the problems of aestheticisation more pertinent than here in this superficial fetishisation of the image.

While Benjamin was addressing the specific question of Fascism, the problem can be seen to extend to all aspects of society. It is particularly relevant in the context of Baudrillard's comments on the saturation of images in our present media society.[17] Indeed, it would seem that our present condition is characterised by a form of aestheticisation, as Bernard Tschumi has observed, which extends to the very heart of our architectural culture.[18] This condition is most marked, in some of our architectural magazines, and in our very schools of architecture.

For Benjamin the effect of aestheticisation can be understood in quasi-neurological and psychoanalytic terms, as a defence against the 'shock' which characterises the modern condition: "Benjamin relies on a specific Freudian insight, the idea that consciousness is a shield protecting the organism against stimuli… Under extreme stress, the ego employs consciousness as a buffer…".[19] The aesthetic experience thus serves as a form of 'narcotic': "It has the effect of anaesthetizing the organism, not through numbing, but through flooding the senses. These stimulated sensoria alter consciousness, much like a drug, but

they do so through sensory distraction rather than chemical alteration". Thus the aestheticisation of life induces a form of numbness. To aestheticise is, in effect, to anaesthetise, to reduce any notion of pain to the level of the seductive image.[20]

What is at risk in this superficial aestheticisation of life, this reduction of life to the depthless image, is that the political and social content is subsumed, absorbed and denied.[21] The seduction of the image works against any under-lying sense of social commitment. Architecture is potentially compromised within this aestheticised realm. Architects, apparently, are particularly susceptible to an aesthetic which fetishises the ephemeral image, the surface membrane. The seduction of the aestheticised image represses the political, the social. The world becomes aestheticised and anaesthetised. In the glossy, seductive world of the image, the aesthetics of architecture threaten to become the *ana*esthetics of architecture.

Learning from Las Vegas

One of the first to recognise this increasing obsession with the image was Guy Debord. In 1967, Debord produced his influential work, *The Society of the Spectacle*. Long before the media society had fully developed, long before advertising and other blandishments of the consumer society had taken a firm hold, Debord had recognised the traits. In *The Society of the Spectacle*, he comments on how the capitalist framework presents society in terms of superficial, commodified surface images. In his famous comment, Debord notes: "The whole life of those societies in which modern conditions of production prevail presents itself as an immense accumulation of spectacles. All that once was directly lived has become mere representation".[22]

Within the Society of the Spectacle,

> People are spectators in their own lives, and even the most personal gestures are experienced at one remove… (Thus) if modern society is a spectacle, modern individuals are spectators: observers seduced by the glamorous representations of their own lives, bound up in the mediations of images, signs, and commodities…[23]

It is perhaps ironic that Debord should publish his book the year after Robert Venturi published *Complexity and Contradiction in Architecture*.[24] While Debord had railed against a superficial world of the commodified image, Venturi embraced it and actually celebrated it. While Debord saw the world of the commodified image as the source of contemporary alienation in society, Venturi saw it as a model to be followed in architecture.

Venturi presented an image of Main Street. In terms of composition, Main Street was "almost all right".[25] Venturi seemed oblivious to the fact that it is a celebration of the market economy that he is promoting. What dictated many of the billboards were essentially advertising—and hence commercial—concerns. We might excuse Venturi's uncritical celebration of commodified images as an aberration, an eccentric architectural viewpoint, were it not for the fact that a few years later along with Denise Scott-Brown and Steven Izenour, he devoted not just one illustration to the commercial street, but an entire book. In *Learning from Las Vegas*, they celebrated the advertising hoardings of the world's most famous gambling town.

They are quick to point out, of course, that they are not engaging with the commercial activities of Las Vegas. "Las Vegas's values are not questioned here… this is a study of method, not content".[26] They are not interested in the content, only in the form, as though it were possible to disassociate one from the other.

It is perhaps no coincidence that Venturi, Scott-Brown and Izenour should celebrate Las Vegas, city of advertising, city as advertising. Their uncritical treatment of the values of Las Vegas replicates the liquidation of meaning in advertising itself. Las Vegas, city of the desert, whose own desertification of cultural values reflects the degree-zero cultural depth of the desert around it. Las Vegas, city of advertising, whose bewitching enchantment mirrors the attraction of the desert itself. Las Vegas, the ultimate city not of architecture, but of the commodified sign, the empty seductive triumph of the superficial. It is precisely this celebration of surface, as Baudrillard notes, which effaces any possibility of architecture in Las Vegas:

> When one sees Las Vegas at dusk rise whole from the desert in the radiance of advertising, and return to the desert when dawn breaks, one sees that advertising is not what brightens or decorates the walls; it is what effaces the walls, effaces the streets, the facades and all the architecture, effaces any support and any depth, and that it is this liquidation, this reabsorption of everything into the surface… that plunges us into this stupefied, hyper-real euphoria that we would not exchange for anything else, and that is the empty and inescapable form of seduction.[27]

What is at play here is the principle of seduction. (And I refer here to seduction in its broadest sense, and not in the narrow sense of *sexual* seduction). Seduction, Baudrillard argues, is that which extracts meaning from discourse and detracts it from its truth.[28] Just as the coloured model for Alberti strives to "attract and seduce the eye of the beholder", to divert attention away from "proper examination" of the model, so seduction attempts to enchant the

LEARNING
FROM
LAS VEGAS
Revised Edition

Robert Venturi Denise Scott Brown Steven Izenour

Front Cover of R. Venturi, D. Scott-Brown and S. Izenour,
Learning from Las Vegas, Cambridge, MA.: The MIT Press,
1986. Reproduced by permission of The MIT Press

viewer on a purely visual level, and to prevent any deeper level of enquiry.
Seduction can therefore be contrasted with 'interpretation'. Whereas
interpretation seeks to rupture the realm of surface appearances, and to enquire
after some underlying truth, so seduction seeks to ensnare the viewer within an
enchanting world of the superficial, never to look beyond. By dallying within the
realm of appearances, this superficial seduction suppresses and stifles any
quest for meaning. Its only logic is its own circular logic of seduction. Seduction
thus operates within an aesthetic and aestheticised realm, which absorbs all to
the surface, and which denies any deeper political enquiry. Yet seduction is not
apolitical. (And this is an important point.) Precisely by denying a more
interpretative search for the truth, it slips into a politics of acquiescence, and
subscribes to the dominant forces of the market place. Thus advertising lends
itself to this logic of seduction, this politics of consumption.

'Tan Hawaiian with Tanya'

In *Learning from Las Vegas* Venturi, Scott Brown and Izenour champion an architecture of advertising. They promote an uncritical celebration of the image. The advertising hoarding becomes the ultimate icon that is celebrated throughout their book, and featured on the front cover: 'Tan Hawaiian with Tanya'.

What, then, can we read into this image, an image which Venturi, Scott Brown and Izenour celebrate so much as to give it a place of honour on the very cover of their book?

On a straightforward level this image supports a culture of the image. Tan Hawaiian with Tanya. Anoint yourself with oil like Dinocrates. The argument has come full circle. It is the cult of the seductive image. While Alberti had argued against the *seduction* of the viewer, Venturi, Scott-Brown and Izenour argue for the advertising hoarding, that 'empty and inescapable form of seduction'.[29] They argue for what they call an "architecture of persuasion".

Yet beyond this, the image reveals the liquidation of meaning in advertising itself. The very seduction of the image promotes an uncritical acceptance of the image. It operates within an aestheticised realm where important political and social questions are not addressed. What relevance, then, does Venturi, Scott-Brown and Izenour's celebration of the advertising hoarding have on the question of gender in architecture? The full significance of their position now becomes clear. A tanned, bikini-clad figure is used to promote a sun tan lotion. Woman becomes woman-as-commodified-image. The hoarding exploits woman in the most blatant fashion, and yet no comment is passed on this important ethical question. By celebrating this display of woman-as-image, the authors are effectively sanctioning this exploitation, and are wallowing in a realm of the uncritical and the superficial. This is all the more ironic, given Denise Scott-Brown's published criticisms of the patriarchal star system in architecture,[30] and the conscious introduction of non-gender specific language in later additions to *Learning from Las Vegas*.[31]

It is perhaps too obvious to remark that advertising exploits women. It does so by the mechanism of seduction which draws all to the surface, and celebrates the depthless image. Women are treated not as women, but as commodified images of women, decorative, seductive accoutrements to help sell a product. I am not arguing here that seduction is some inherently feminine characteristic—far from it—rather I am arguing that in the culture of late capitalism, dominated as it is by patriarchy, women are particularly susceptible to being exploited by

Bacardi commercial: *Aunty Beryl*

the forces of commodification. This is not a celebration of the qualities of women as ontological beings, but a cynical exploitation of women as marketable, commodifiable images.

Venturi, Scott-Brown and Izenour's celebration of the image finds its architectural expression in later built works. Thus the steel trusses in their National Gallery extension—like Tanya—become decontextualised and desemanticised. They are rinsed of all meaning and recoded as non-structural decoration. However, my argument about this obsession with the image is not directed towards architectural form, but towards how it may influence the practices in the office.

Aunty Beryl

In a recent recruitment advertisement, a prominent architectural practice played off a well known cinema commercial for Bacardi rum. The original Bacardi advert opened with a voice-over of an East End accent describing a seemingly hum-drum night at the pub. "Peckham on a Monday night", "The Dog 'n' Duck down the High Street", "Aunty Beryl", "Catching the last bus home". This voice-over contrasts sharply with visual images which depict an island paradise. The commercial presents Bacardi as though drinking it will transport you out of the local pub to some exotic desert island. Thus the voice-over "Peckham on a

Recruitment advertisement, T. P. Bennett
Partnership: *Aunty Beryl*.

Monday night" is paired up with an image of a palm-fringed beach. "The Dog 'n'
Duck down the High Street" is linked with a bar on that beach, and "Aunty Beryl"
becomes a suitably exotic young bar-maid. "Catching the last bus home" turns
into a group of young men running down the jetty and leaping into a speed boat.
The Bacardi advert plays upon a certain narcotic quality in the drink itself.
Bacardi will transport you from the grim reality of life in Britain to the exotic
utopia of the desert island.

This theme of the Bacardi commercial is cleverly adapted by this architectural
firm in its own advertisement, openly playing upon the theme of the earlier
advert, yet reappropriating it to represent their own office ethos.

What is significant here is that this second advert does not need to resort to the
utopian escapism of the Bacardi advert. "Peckham on a Monday night", far from
being transformed into its opposite—the remote idyll of an island paradise—
remains within the space of London and is actually heightened into the
intoxicating frenzy of central London. This is an aestheticised image of the city, a
view that is reinforced by other images in the advert. Emblems of everyday life
such as "The Dog'n'Duck down the High Street" and "Next Door's loft
conversion" are represented as seductive images of hi-tech buildings. The ethos
of this image-conscious office is clear.

Recruitment Advertisement: Peckham on a Monday Night
Reproduced by permission of T. P. Bennett Partnership

What is at work here is an aestheticisation. There is an implicit parallel being drawn between the effects of Bacardi and the intoxicating effects of working in the aesthetic environment of an architectural office. It is as though the anaestheticising effect—the numbing effect that Walter Benjamin had observed—of the aesthetic moment replicates the narcotic effect of alcohol. Just as Bacardi is purported to transport the drinker into an imaginary realm displaced from the grim reality of "Peckham on a Monday night", so the second advert, while remaining within the space of the High Street, seeks to transport the viewer into an aestheticised version of the real. Aestheticisation has a similar effect to Bacardi.

This has important ramifications for the question of gender, the same mechanisms which were observed in the Venturi, Scott-Brown and Izenour celebration of the 'Tan Hawaiian with Tanya' image are repeated here in this advert. "Aunty Beryl" becomes younger, sexier and more attractive than anyone's impression of Aunty Beryl would ever convey. There is deliberate irony at play here. The young woman is described as "Aunty Beryl" precisely because she is not Aunty Beryl.

"Aunty Beryl" is a young, attractive icon for a youthful, dynamic firm of architects, purveyors of seductive images. For a firm of architects the

Next door's loft conversion

Recruitment Advertisement: Next Door's Loft Conversion
Reproduced by permission of T. P. Bennett Partnership

receptionist sets the tone for a celebration of the image which governs the whole ethos of that office. It is the image that is celebrated here, woman as a commodified-image-of-woman. The receptionist is part of a calculated stage set, in which glossy brochure, vase of flowers and smiling, pretty receptionist all play their part. At one level, then, the receptionist can be equated with the glossy brochure and the vase of flowers. Receptionist equals flowers equals brochure. The receptionist is exploited for her image. Yet this is no innocent image. It is an image that has been commodified according to the laws of a strictly gendered marketplace. The attractive, female receptionist has become an object of consumption, so that in effect the receptionist *sells* her sexuality, no less than television hostesses or women used in car advertisements.[32] This mechanism reaches its extreme manifestation in the case of female models being used to flank the presentation of prizes in male snooker tournaments.[33]

Yet this logic threatens to spread beyond the reception desk. Indeed the 'receptionist' seems to embody closely the characteristics of the "accommodating, neat, obliging, 'house-wife' figure, willing to answer the phone on occasions", which, as Paul Finch has observed, Howard Robertson had recommended as the ideal female architect.[34] Nor is it uncommon for female architects to be asked to double as receptionists, which is itself part of a broader process of marginalisation.[35] As the architectural profession becomes

Recruitment Advertisement, T. P. Bennett Partnership
Reproduced by permission of T. P. Bennett Partnership

increasingly obsessed with the aestheticised world of the image, the seductive, alluring ephemeral realm of the superficial, so the image will begin to influence the politics of the office itself. The cult of self-display, the cult of self-advertising, threatens to stifle any deeper understanding of human relations. Women become women-as-image. In the gendered marketplace of the contemporary office, female architects risk being valued not for their abilities as architects, but for the attractiveness of their appearances. Practices threaten to become *desiring* practices. Architects threaten to become architectural models— architectural models expected to sell themselves according to a commodified image of themselves, anointing themselves with oil, 'painting themselves', 'striving to attract and seduce the eye of the beholder'. Although female architects may undertake strategies which attempt to resist or undermine this tendency, it remains, I would suggest, the dominant paradigm within the existing patriarchal system.

While, no doubt, some would argue that such prejudices have always existed, they are being fed, I would maintain, by the contemporary obsession with the image. While others would argue that woman has always been perceived in terms of the image, and that she has learnt to play this to her advantage, I would argue in reply that under the conditions of late capitalism the problem has been exacerbated.[36] While others still would argue that the same 'logic of the

The Dog'n'Duck down the High St

Recruitment Advertisement: The Dog 'n' Duck down the High Street
Reproduced by permission of T. P. Bennett Partnership

reception desk' could equally apply to men, I would reply that women will always be more susceptible. Such logic remains trapped within the uncritical realm of seduction, and plays into the hands of established patriarchal power structures. Such logic subscribes to the dominant forces of the market place, and reinforces the existing imbalance by means of a politics of acquiescence. So long as the culture of late capitalism is dominated by patriarchy, female sexuality will remain an object of consumption.

Joanna West noted with some surprise the sexism that exists within the architectural profession. Architecture, after all, is known for its liberal façade. Yet I would reply that this liberal façade is but a liberal *aesthetic* façade. There is a danger in confusing a radical aesthetics with a radical politics, and of conflating the aesthetic with the political. (This, I think, is the trap into which architecture frequently falls). Yet it is not that the aesthetic is fundamentally disjoined from the political. A radical aesthetics may in fact mask and even promote a reactionary politics. Architecture will always be susceptible to sexism and a reactionary politics, not *despite* its façade of liberalism, but precisely *because of* that façade, a façade which is no more than a façade of aesthetic liberalism.

Lines of Resistance

We live in the 'society of the spectacle' where the ontological has slid into the representational, and where the fetishised image has become an object of consumption. We live in a world where 'learning from Las Vegas' means learning not from the ethics of Las Vegas, but merely from the superficial images of Las Vegas—a world where ethics have been eclipsed by aesthetics. We live in a world where the commodified image has been privileged over any question of content. In this world of self-display, architects threaten to become objects of consumption falling prey to the gender prejudices of the marketplace. In an image-conscious society—and, more especially, within an architectural profession which so fetishises the image—the position of 'woman-as-woman' is compromised by the celebration of 'woman-as-image'. Architects become architectural models.

It is important, then, to offer some form of resistance to this otherwise all-consuming condition. This resistance would be most effective, no doubt, by working within the framework of the 'society of the spectacle', and exposing it for what it is; it might take its cue, for example, from the work of Cindy Sherman, or the feminist campaign against advertisements which 'degrade' women. It is beyond the scope of this paper, however, to suggest what precise strategies this resistance might adopt. Given the space available, all this paper can hope to do is to expose the inherent problems. It does so by engaging with discourses traditionally perceived as being 'outside' architecture. Such discourses, it is argued, offer the possibility of exposing architectural theory to a range of sophisticated critical techniques which highlight its shortcomings, and thereby allow it to become more rigorously self-critical. It is precisely by engaging with the work of Jean Baudrillard, for example, on the question of simulation, that consequences of the uncritical celebration of simulation by some architects are revealed. This paper, then, has sought to expose the problems inherent in the privileging of the image within architectural culture, and to explore the ramifications of this situation for the question of woman. The premise here is that by understanding the mechanisms by which images are constructed, architects may become more aware of the consequences of their use of visual imagery in the design process. In other words, although this paper in itself suggests no solution, by identifying a problem, it points the way forward towards a possible solution. For once a problem has been identified, it becomes a different sort of problem. It is no longer a problem by which we are trapped, but a problem with which we can deal.

Notes

1 Alberti, L. B., *On the Art of Building in Ten Books,* Rykwert, J., Leach, N., Tavernor, R. (trans.), Cambridge, Massachussets: The MIT Press, 1988, p. 34.

2 Wigley, M., "Untitled: The Housing of Gender", in Colomina, B. (ed.), *Sexuality and Space*, New York: Princeton Architectural Press, 1992, p. 355.

3 Alberti's original words *"fucatos et picturae lenociniis falleratos"*, make clear references to the world of prostitution. *"Fucatos"* may mean 'rouged'; *"lenociniis"* refers to 'pimping', and *"falleratos"* refers to 'ornaments to the breast'.

4 Vitruvius, *The Ten Books on Architecture*, Morgan, M. H. (trans.), New York: Dover, 1960, p. 36.

5 Watt, J., "Architects: Last of the Die-Hard Sexists", *Independent on Sunday*, 29 January 1995.

6 This term is borrowed from Jean Baudrillard. Although Baudrillard is cited extensively in this article, his views are not necessarily endorsed, especially on the question of gender.

7 Baudrillard, J., "The Implosion of Meaning in the Media", *Simulacra and Simulation*, Glaser S. F. (trans.), Ann Arbor: University of Michigan Press, 1994, p. 79.

8 Baudrillard ascribes this seemingly paradoxical situation to two factors. First, information, rather than creating communication, "exhausts itself in the process of communication". Thus meaning is itself also exhausted in the staging of meaning. Secondly, according to Baudrillard, the pressure of information pursues an irresistible destructuration of the social. "Thus information dissolves meaning and dissolves the social, in a sort of nebulous state dedicated not to a surplus of innovation, but, on the contrary, to total entropy". Baudrillard, *Simulation*, p. 80 and 81.

9 On this see Gane, M., *Baudrillard's Bestiary*, London: Routledge, 1991, p. 101.

10 Gane, *Bestiary*, p. 101.

11 Aestheticisation here refers to the process by which an object becomes transported into a superficial aesthetic realm and treated as an aesthetic object.

12 Baudrillard, J., "Towards the Vanishing Point of Art", quoted in Bürger, P., *New Left Review*, Nov./Dec. 1990, p. 184.

13 As Mike Gane argues, "This displacement has serious consequences. The crucial one is a general aestheticisation of life, as everything falls under the sign of art which nevertheless, and paradoxically, loses all content". Gane *Bestiary*, p. 101.

14 Benjamin, W., "The Work of Art in the Age of Mechanical Reproduction", *Illuminations*, Zohn, H. (trans.), London: Fontana, 1992, pp. 234 and 235.

15 "War is beautiful", Marinetti claimed, "because it establishes man's dominion over the subjugated machinery by means of gas masks, terrifying megaphones, flame throwers, and small tanks. War is beautiful because it initiates the dreamt-of metallization of the human body. War is beautiful because it enriches a flowering meadow with the fiery orchids of machine guns. War is beautiful because it combines the gun-fire, the cannonades, the cease-fire, the scents, and the stench of putrefaction into a symphony. War is beautiful because it creates new architecture, like that of the big tanks, the geometrical formation flights, the smoke spirals from burning villages, and so on…" (see Benjamin, "Reproduction", pp. 234 and 235).

16 Woods, L., *War and Architecture*, New York: Princeton Architectural Press, 1993, p. 1.

17 As Susan Buck-Morss comments, "Bombarded with fragmentary impressions [the eyes] see too much—and register nothing". Buck-Morss, S., "Aesthetics and Anaesthetics: Walter Benjamin's Artwork Essay Reconsidered", *October*, 62, Fall 1992, p. 18.

18 "A general form of aestheticisation has indeed taken place, conveyed by the media. Just as Stealth Bombers are aestheticised on the televised Saudi Arabian sunset, just as sex is aestheticised in advertising, so all of culture—and of course this includes architecture—is now aestheticised. 'Xeroxised'. Furthermore the simultaneous presentation of these images leads to a reduction of history to simultaneous images: not only those of the Gulf War interspersed with basketball games and advertisements, but also those of our architectural magazines and, ultimately, to those of our cities". Tschumi, B., "Six Concepts in Contemporary Architecture", *Theory and Experimentation*, Papadakis, A. (ed.), London: Academy Editions, 1993, p. 15.

19 Buck-Morss, "Anaesthetics", p. 22. Buck-Morss provides a comprehensive discussion of the effects of aestheticisation within the context of both neurological and psycho-analytic debates.

20 The meaning of the term 'aesthetic' has changed radically with time. The ancient Greek, 'aesthesis', referred not to abstract theories of beauty, but to sensory perceptions. 'Aesthetics' and 'anaesthetics' share the same root, but the latter has remained closer to the original meaning. On this see, Buck-Morss, "Aesthetics", pp. 1-41. See also, Godzich, W., Foreword to de Man, P.,*The Resistance to Theory*, Minneapolis: University of Minnesota Press, 1986, p. xiv.

21 Mark Wigley argues precisely the opposite: "The possibility of political critique therefore lies on, rather than behind, the surface. Indeed it requires a certain fetishisation of the surface". Wigley, M., "Theoretical Slippage", in Whiting, S., Mitchell, E., Lynn, G. (eds.), *Fetish*, New York: Princeton Architectural Press, 1992, p. 122.

22 Debord, G., *Society of the Spectacle*, Nicholson-Smith, D. (trans.), New York: Zone Books, 1994, p. 12.

23 Plant, S., *That Most Radical Gesture*, London: Routledge, 1993.

24 Venturi, R., *Complexity and Contradiction in Architecture*, New York: The Museum of Modern Art, 1966.

25 Venturi, *Complexity*, p. 104

26 Venturi, R., Scott-Brown, D., Izenour, S., *Learning from Las Vegas*, Cambridge, Massachusetts: The MIT Press, 1988, p. 6.

27 Baudrillard, J., "Absolute Advertising, Ground-Zero Advertising", *Simulation*, pp. 91-92.

28 Baudrillard, J., "On Seduction," in Poster, M. (ed.), *Selected Writings*, Stamford: Stamford University Press, 1988, p. 149.

29 Here I am not equating the seduction of the surface image with the question of woman. Mark Wigley addresses this connection in his critique of David Harvey: "Harvey condemns 'an architecture of the spectacle, with its sense of surface glitter and transitory pleasure, of display and ephemerality, of jouissance', which is identified with 'orgasmic effects', 'pleasure, leisure, seduction and erotic life… lust, greed and desire'. Of course, all these terms are traditionally applied to the artifact 'woman,' the culturally constructed figure of both sexuality and surface". Wigley, M., "Slippage", p. 98.

30 Scott-Brown, D.," Room at the Top?
 Sexism and the Star System in
 Architecture", in Berkeley, E. P., (ed.),
 Architecture: A Place for Women,
 Washington and London: Smithsonian
 Institution Press, 1989, pp. 237-246.

31 In the revised edition, as Denise Scott-
 Brown points out, the text has been
 "de-sexed", and the architect is no
 longer referred to as "he". Scott-
 Brown, "Sexism", p. xv.

32 See Dyer, G., *Advertising as
 Communication*, London and New
 York: Methuen, 1982, pp. 120-123.

33 On this see Hearn, J., and Parkin, W.,
 *'Sex' at 'Work': The Power and
 Paradox of Organisation Sexuality*,
 Brighton: Wheatsheaf, 1987, p. 102.

34 Robertson, H., "Architecture", Heal, J.
 (ed.), *Jeanne Heal's Book of Careers
 for Girls*, London: The Bodley Head,
 1955, p. 50, quoted by Finch, P., *The
 Prisoner of Gender*, in this volume.

35 I am reminded here of a recent
 incident when two architects—a
 husband and wife team—took up a
 single job-share position with a firm of
 architects. Significantly the female,
 and not the male, was asked if she
 would mind acting as receptionist on
 occasions.

36 Wigley stresses the identification of
 'woman' with 'surface, mask and
 ornament'. Wigley, "Slippage", p. 122.
 It should be pointed out, however, that
 Lacan associates the masquerade
 with men as much as with women.
 Lacan, J., *The Four Fundamental
 Concepts of Psycho-Analysis*,
 Sheridan, A. (trans.), London: Penguin,
 1979, p. 193.

Cinematic
Space:

Desiring and Deciphering

Space is a special and privileged part of the cinema's mode of representation. The screen image is always etched in space. It may create an illusion of depth, a road stretching away into the distance (as in Gus van Sant's *My Own Private Idaho*), or a flat surface of framed light and shade (as in Sternberg's close-ups of Marlene Dietrich). The cinema also draws on a pre-existing 'vocabulary' of places which carry with them particular resonances accumulated through cultural tradition. A story may exploit the uncanny house and cellar (as in Hitchcock's *Psycho*), a log cabin in the snow (as in Welles' *Citizen Kane*), or the 'poetics' of stairs, wardrobes, boxes and so on. These images are like clichés, in that they are well-worn and familiar, but the cinema can use them rather as emblems, recognisable signifiers, unstable and elusive but insistently resonant.[1]

The cinema may recycle, as it were, images from a 'pool' or *langue*. However, it is in the process of becoming *parole*, integrated into the story and onto the screen, that such images may be animated by 'desire' and analysed in terms of 'desiring practice'. There are two 'desire generating' subjectivities, obviously, at issue here. First of all, there is the diegetic subject located in a desiring or fearing relation to space and place inside the story world. Secondly, there is the spectator as subject, located in a reading relationship to spaces and places of desire or fear as they appear on the screen. Furthermore, the cinema's ability to juxtapose places creates a further dimension of cinematic space. The 'creative geography', for instance, of Soviet montage shows someone walking through, say, the Kremlin Square and looking towards something, shown in the next shot such as, say, Big Ben. However, as Eisenstein showed with his theory and use of montage, intercutting can create further dimensions of meaning with the cross-cut juxtaposition of two images. This specifically cinematic relation is articulated through the language of cinema itself. Cinematic space may imply space off-screen, or it may appear naturalised, but essentially it exists only in the rectangle of the screen, through editing, and heightened by framing or camera movement.

Point-of-view shots may create a relation between the perceiving subject and what is seen. Moreover, if the subject's perception is directed towards a space already invested with connotative meaning, the cinema simultaneously articulates its own space and that of cultural tradition and resonance. The

emblematic place becomes an element in cinematic space which brings the subject and its desire together. On the other hand, the relation between a figure and a given, resonant place may be open to interpretation by the spectator, while the significance of the setting may be beyond the story's, or the character's, awareness. It is at this point that the spectator is invited to become, in Gaston Bachelard's terms, a 'topoanalyst' or, in the language of film criticism, to read the mise-en-scène.

Bachelard introduces the concept of topoanalysis in the following way:

> Of course, thanks to the house, a great many of our memories are housed, and, if the house is a bit elaborate, if it has a cellar and a garret, nooks and corridors, our memories have refuges that are all the more clearly delineated. All our lives we come back to them in our day-dreams. A psychoanalyst should, therefore, turn his attention to this simple localisation of our memories. I should like to give the name topoanalysis to this auxiliary of psychoanalysis.[2]

He then goes on to discuss the way that space in poetry can light up the memories of a reader who then pauses to daydream. In the cinema, it is rare that the spectator is allowed a 'space' for daydreaming in the helter-skelter movement of the plot. However, the cinema, drawing on certain resonant images, can activate a collective memory, which may be both culturally specific, as, for instance, in the case of the American log cabin, and culturally diffused through the spread of a powerful culture and its popular imagery. Obviously, this is particularly true in Western culture for Hollywood cinema. Hollywood has recycled the *langue* of the traditional European folk-tale into its own preferred narrative structures and, simultaneously, as the most powerful entertainment industry of the twentieth century, it has spread its own cinematic imagery and mythology across the world. Mise-en-scène, space and place are central to the signifying system of Hollywood cinema, evoking genre, its narrative possibilities and constraints, but also more detailed nuances of culturally shared significance. The intercutting of space or place may then carry these inherent meanings further. Juxtaposition creates links across the images either to produce antinomy and binary opposition, or to produce analogy and an extension of meaning into similarity.

A house and a landscape. One encloses and conceals. The other stretches out and leads away. One carries the connotation of stasis and the other carries the connotation of movement. One is an emblem of the interior and a private world, the other an emblem of the exterior and the public world. One has a surface that can be embellished, the other promises change and transition. While an embellished surface is on the side of image, change and transition are on the

side of narrative. Both are projections into space and imply a topography or mapping that invades cultural imagination. From the perspective of feminist aesthetics, these binary oppositions are also invested with the binary opposition of gender.[3]

The Western, perhaps more than any other genre of Hollywood popular cinema, retains residues of the narrative structure of the folk-tale in which the space of the plot, its pattern, sequence and type of events, match the spatial organisation of the narrative's formal structure. These gendered spaces have further importance in the Western. In the portrayal of colonial wars against the indigenous people, the United States' colonialism is represented more as a movement of settlement than conquest. Narrative momentum is generated not so much by the simple departure of the hero alone, but by a need to transform the terrain of adventure and discovery into a land in which settlement, and consequently the sphere of the feminine, can be established. A home or homestead as signifier of stable space, the sphere of the family and the feminine, as well as an emblem for the stasis which is disrupted by the beginning of a narrative, then acquires another dimension of meaning in binary opposition to an image of nomadism imposed indiscriminately on the indigenous people. As a result, the aesthetic conventions of narrative space and their realisation through the ideologies of gendered place are enlisted in the playing and replaying of the settlement mythologies that haunt the Western genre, without closing off the hero's chance to reject the feminine and the stability of the home and family.

The movie that comes to mind here is John Ford's *The Searchers* (1955). The opening sequence illustrates the double subjectivity discussed above. A diegetic point-of-view articulates the characters' desiring relation to each other. They are located in cultural spaces invested with opposing meaning and emotion, thus inviting the spectator's understanding and analysis. Cultural binary oppositions are then re-articulated through the language of the cinema as shots, cut together and developed into a sequence. *The Searchers* literally opens within the interior space of the homestead, established by the presence of a woman, the sphere of the feminine. The film then cuts between her space and that of a horseman, a figure in the distant landscape, following the path that leads to the house. When another man, and then children, join the woman on the porch, the connotations of the space shift from that of the house as the site of the feminine to that of the homestead as the site of settlement. The polarisation then becomes that of a wanderer, alone in the landscape, to a settler, on the porch with his family. The story, of course, then revolves around a quest for a young girl who is captured by the war-chief and thus forced to follow a nomadic existence. The story closes with a symmetrical shot, taken from inside the

homestead, as a new couple is formed and the lone wanderer, once again shot from the inside, remains outside. This time, the camera stays on the inside and the movie comes to an end.

I have tried to illustrate the way in which cinema can transform narrative pattern into image and articulate pre-existing spatial resonance and reverberation into and across the space of the screen. In the example of *The Searchers,* the primitive spaces of the folk-tale narrative pattern are re-inscribed on to the ideologically over-determined, politically resonant space of the West. The simple motif of inside/outside, house/landscape is thus recycled, both recognisable and distorted, using the obviousness of topography to visualise new mythological assumptions. Space is supremely absorbent of metaphor. Spatial imagery naturalises complex social ideas, so that the spaces that open up for individual reverie, as Bachelard points out so beautifully, also become vehicles for closing off contradiction and simplifying the raggedness of social existence into the obviousness of 'myth'. At the same time, these mythic topographies reveal the obviousness of their workings and can quickly lose their transparency, becoming material for a different kind of topoanalysis—the analysis, that is, of how space articulates meaning and, in this instance, how it becomes further naturalised on the screen.

I want to transform the previous narrative juxtaposition between house and landscape, with its implied opposition between male and female, into a different configuration. The house can acquire a metaphorical topography of its own and within its own structure. Inside and outside thus come to imply an opposition between appearance and concealment, between the visible and the invisible, and out of these oppositions, another mythology of femininity congeals into metaphors of space. Surface embellishment leads to an association with masquerade, artifice and the cosmetic, and all the ambivalence that is attached to certain iconographies of feminine enigma. A space of secrecy, an inside of otherness is created. This phantasmatic space acts as a conduit which then carries disparate connotations and associations on to images of woman so that, in turn, the connotations and associations of femininity can be projected on to apparently disparate ideas and images. A spatial pattern attracts other homologous spatial patterns, which then elide into a multi-layered condensation, or extend into a network of displacements. Images of women are haunted by spatial metaphor which promises a possible unveiling of surface to reveal concealed secrets.[4]

Hitchcock draws on these homologous relations, associating femininity with masquerade and enclosed space, particularly in his 1947 film *Notorious*. Ingrid Bergman plays a woman with a double division between her surface

appearance and internal essence. She is treated by Cary Grant as an essentially duplicitous woman, typically having an alluring exterior concealing a treacherous nature. While she is then forced to live out this role as a spy, seducing Claude Rains, as she herself says, "for the secrets", for her the division is between her inner vulnerability and exterior defensiveness. This division, characteristic of the femme fatale, is realised on the level of mise-en-scène when Ingrid Bergman first visits the house of the enemy agents. The exterior/interior division of the house echoes her topography, and her own disguise heightened by her seductive beauty, echoes the secret and mysterious nature of the house. As Ingrid Bergman walks into the entrance hall, Hitchcock intercuts between her look and shots, from her point of view, of closed doors. According to convention, backed by the logic of spatial juxtaposition, cross-cutting from a character's point-of-view creates a cinematic space for subjective thoughts or feelings. In this case, the visualisation of subjectivity is carried further, through the mise-en-scène, to visualise the character's curiosity and her desire to discover the secret, hidden, as it might be, in any resonant space: behind closed doors, locked in a drawer or a box. The topography of curiosity and secrecy condenses with the cinematic device of the point-of-view. At the same time, for the spectator who cares to read the image further, the intercutting continues and extends the metaphoric relation between the secret, concealed space and Ingrid Bergman's own masquerade.

The cinema's demand on the spectator to read, to indulge, in this case, in topoanalysis, may vary. It may well only be the critic who finds the space in time to concentrate on the unspoken aspects of a dramatic moment and place them in the wider context of cultural tradition and signification. Even so, the cinema builds meaning out of spatial resonance and reverberation, literally visualising the poetics analysed by Bachelard, and subliminally or consciously the effect must flow over on to any audience. While spatial imagery may generate and be extended into metaphor, suggesting, for instance, the space of secrecy and curiosity, or the binary opposition of cultural antinomy, space may also embody abstract or ideological ideas, providing them with a physical obviousness that belies their dependence on social construction. Social hierarchy depends on the spatial metaphor of strata, and the pyramidal shape that organises the relation between the high and the low, the rulers and the ruled, the elite and the masses. Bachelard points out:

> Logicians draw circles that overlap or exclude each other, and all their rules immediately become clear. Philosophers, when confronted with outside and inside, think in terms of being and non-being. Thus profound metaphysics is rooted in an implicit geometry which—whether we will or no—confers spatiality upon thought: if a metaphysician could not draw what would he think? Open and closed for him are thoughts.[5]

Freud made use of spatial imagery to try to convey the obscure and difficult concept of the psyche and the relationship between consciousness and repression. In his analysis of Wilhelm Jensen's *Gradiva*, he uses the imagery of Pompeii to show how the unconscious may be visualised as buried and ancient, but also available to excavation and interpretation—if the excavated signs can be interpreted accurately.[6] (Lacan, of course, complicated this rather over-simple imagery). Freud emphasises the significance of spatial imagery in the concept of the uncanny. But here, his analysis is closer to Bachelard's topoanalysis. Certain spaces activate associations and connotations for the psyche. The uncanny, too, in some of its aspects, tends to inhabit concealed, buried spaces carrying connotations of both the womb, everyone's first home, and the tomb, the last home of others, often visualised as archaic, containing the decaying human body.

In his film *Blue Velvet*, David Lynch uses spatial imagery as a directly rhetorical device, designed to set in motion a conscious demand that the spectator decipher the topographical layout on the screen. He uses imagery of surface and nether worlds to convey the presence of repression, and its return, in the collective psyche of a fictional 'small town America'. the opening sequence establishes the rhetoric, the topography and its metaphorical implications. The sequence begins with a sunlit, leafy small-town street inhabited by schoolchildren and the benign authority of the fire brigade. The sequence ends in the darkness of the undergrowth, where, invisible to normal eyes, hideous insects are locked in mortal combat. This binary opposition is easy to understand. However, it foreshadows further imagery in the story yet to come: oppositions between night and day, the institutions of law and the criminal underworld, between conscious perception and unconscious experience. However, the surface world is depicted as surface. It has the immaterial, almost uncanny quality of the cliché which speaks of appearance and nothing more, and the impermanent, almost comical quality of the postcard which has no substance other than connotation. On the other hand, unlike the flatness and colour saturation of the opening images, the darkness draws the camera forward with the force of fascinated curiosity. The sequence sets up a spatial configuration around the home itself, which is suspended between this opposition between surface and underworld. The image of the 'homely' is quickly rendered 'unheimlich', uncanny. The cinema, once again, articulates the relation between the spaces and thus creates an extension of reading and potential meaning.

The specific properties of the cinema can also come into play in creating this further textual level in *Blue Velvet*. Reverberances travel from image to image, linking them together into chains of significance. This is the point where the

mechanisms of a dream can be seen to work, where condensation and displacement can find equivalents in cinema through the rhetoric of visualisation. There is a syntagmatic sliding from shot to shot, which creates associations across disparate images, creating links and resonances between them. The meanings that were set up in the opening sequence are carried forward. As Jeffrey goes out for his evening walk, the opposition between surface and nether worlds is re-introduced through camera movement and sound. The camera travels forward into the darkness of the trees and branches, repeating the camera's movement into the undergrowth in the opening sequence, but this time it is intercut with Jeffrey as he looks around him. The strange noise that accompanied the movement also returns to the sound track. In the next shot, with a dissolve, the camera continues its movement into Jeffrey's ear. The opposition between surface and nether worlds is now transferred to Jeffrey's own state of mind, with the cinematic rhetoric 'showing' the spectator that this opposition is also that of the psyche, between consciousness and the unconscious. The layers of significance that appear on the screen are no longer those of juxtaposition and opposition, but are displaced across the unfolding images of the story.

Cinematic space acquires another dimension as images link, set off resonances that are picked up elsewhere and, later on, spread out into a web of related meanings. The critic, and in this case also the spectator, are asked to decipher the images, moving from the inherent significance of a given topography to wider metaphorical implications. The cinematic text becomes flattened, as it were, into a puzzle for the spectator to decipher. The spectator may be transported, out of a simple position of consumption, into one of active curiosity, desiring to know not only what takes place within the subjective consciousness of the characters on the screen, but the extra-diegetic significance of the image-clues on offer.

> The dream content... is expressed as it were in a pictographic script, the characters of which have to be transposed individually into the language of the dream-thoughts. If we attempted to read these characters according to their pictorial value, instead of according to their symbolic relation, we should clearly be led into error. Suppose I have a picture puzzle, a rebus, in front of me... Now I might be misled into raising objections and declaring that the picture as a whole and its component parts are nonsensical... But obviously we can only form a proper judgement of the rebus if we put aside criticisms such as these of the whole composition and its parts and, if instead, we try to replace each separate element by a syllable or a word that can be represented by that element in some way or other. The words which are put together in this way are no longer nonsensical but may form a phrase of great beauty and significance.[7]

Notes

1 My comments on space and the cinema are expanded further in "Pandora's Box: Topographies of Curiosity" in *Fetishism and Curiosity*, London: British Film Institute, 1996.

2 Bachelard, G., *The Poetics of Space*, New York: The Orion Press, 1964, p. 8

3 These two figurations can work as emblems for the gendered topography of simple story plots, of the kind discussed by Vladimir Propp in *The Morphology of the Folk Tale*. (Propp, W., Wagner, L. A. (ed.), *The Morphology of the Folk Tale*, Scott, L. (trans.), 2nd edition, Austin and London: University of Texas Press, 1968). A home marks the formal space of a beginning, a point of departure, the stasis which must be broken or disrupted for the story to embark on its narrative path. The hero leaves the confines of the domestic, settled, sphere of his childhood, the maternal space, as it were, for the space of adventure and self-discovery as an adult male. The horizontal, linear development of the story events echo the linearity of the narrative structure. The two reach a satisfying point of formal unity in the literal linearity of the pattern drawn by the hero's journey, as he follows a road or path of adventure, until he comes to rest in a new home, a closing point of the narrative, a new point of stasis, marked by the return of the feminine and domestic space through (as Propp has demonstrated) the function Wedding. (Although Propp analysed tales with a heroine protagonist, they significantly end with a return home and not the function Wedding). This gendering of narrative space overflows into aspects of Hollywood genre cinema, most particularly the melodrama and the Western, but also into aspects of film noir.

4 Mary-Ann Doane, in an extremely interesting discussion of the philosophical and cinematic metaphor of the veiled woman, makes this point: "The veil, in a curious dialectic of depth and surface, reduces all to a surface, which is more or less removed, more or less accessible. It is not a privileged depth, interiority or psychology of the woman which is inaccessible but her sexualised, eroticised and perfected surface, the embodiment of pure form". (Doane, M-A., *Femme Fatale: Feminism, Film Theory and Psychoanalysis*, London: Routledge, 1991, p. 56). Thus, she is suggesting, spatial figuration has to be transformed so that the secret essence of femininity is not at issue, but rather, the cultural currency of the image. Once the image is reconfigured so that its coding achieves visibility, it can be deciphered. The process of deciphering would reveal personification of certain ideas and fantasies, through images of femininity as such.

5 Bachelard, *Poetics*, p. 111 and 112.

6 Freud, S., "Delusion and Dream", *Sigmund Freud, Standard Edition*, vol. 9, London: Hogarth Press, 1953.

7 Freud, S., "The Interpretation of Dreams", *Sigmund Freud, Standard Edition*, vol. 5, London: Hogarth Press, 1953, p. 277 and 278.

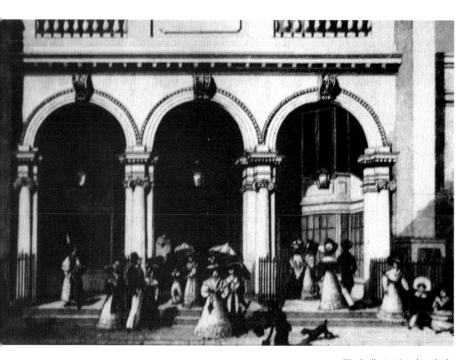

'The Burlington Arcade as both
Public and Private Space'.
Thomas H. Shepherd:
Burlington Arcade, Piccadilly,
London: Jones & Co., 1828

Subjective Space: A Feminist Architectural History of the Burlington Arcade

Feminist concerns are being addressed and developed with much success in fields such as history, art history, cultural studies, geography and philosophy. This paper raises the implications of feminism for the practice of architectural history. In so doing, it questions the basic tenets of architectural history, and proposes a new gendered practice: first, by suggesting new objects of study—the actual material which historians choose to look at; and secondly, by rethinking, from a feminist perspective, the intellectual criteria by which historians interpret those objects of study. In short, this paper is concerned with defining the methodological approaches of a new gendered practice—that of a feminist architectural history.

Such a project is necessarily both theoretical and historical. Theoretically, it is motivated by feminist concerns and draws its methods from various other disciplines, particularly history, art history, cultural geography and philosophy. Historically, these concerns are explored through the study of architectural space, which in this paper are the places of upper-class leisure and consumption in London's West End of the early nineteenth century, specifically, the Burlington Arcade built off Piccadilly between 1818 and 1819.

Architectural History and Feminist Architectural History

Before detailing the actual historical and theoretical content of this paper, it is worth noting the academic context within which it is located, and which it radically critiques. Architectural history can be broadly described as a practice which studies the history of buildings. Although approaches vary, traditionally architectural historians have tended to concentrate on those buildings financed by wealthy and influential patrons, and to analyse them in terms of their form and aesthetics. In architectural history, feminists have sought so far to establish a history of women architects by uncovering evidence of women's architectural contributions.[1] Although useful in providing new material, this work rarely questions conventional architectural historical models, or raises methodological issues concerning, for example, the status of the architectural object, the role of the architect and the kind of analysis relevant to the objects of study.

But it is important to note at this stage that feminism is composed of numerous diverse and often contradictory approaches. This paper proposes a particular practice of feminist architectural history which, using critical techniques developed through feminist work, extends the work of marxists in the field of architectural history. Marxist architectural history entails seeing buildings as the products of the processes of capitalism, and as such, as being implicated in the political, social and cultural values of the dominant classes and élite social groupings. Although marxist architectural historians have considered the social production of architecture and its reproduction through image and text, seldom

'Viewing Commodities'.
The Burlington Arcade
Photo: Iain Borden

has this work been from a feminist perspective.[2] The intention here is to position a practice of architectural history which is critical of both patriarchy and capitalism, and also seeks to recognise the ways in which systems of gender and class oppression intersect with systems of racial, ethnic and sexual domination.

Locating the Object of Study

This paper takes as its theoretical point of departure the paradigm of the 'separate spheres'—the ideology which divides city from home, public from private, production from reproduction, and men from women. The origins of this separate spheres ideology are both patriarchal, resulting from the rule of the 'father' in contemporary western societies, and capitalist, following the dominance of capitalism in these societies. It is both an oppositional and hierarchical system, consisting of a dominant public male realm of production

(the city) and a subordinate private female one of reproduction (the home). The separate spheres is the most pervasive spatial configuration of sexual and social relations, yet, as an ideological device, it does not always describe the full range of all urban dwellers' lived experience.

Unfortunately, architectural history, even that written from a feminist stance, has so far tended to accept this prevailing ideological system. However it is possible, following on from the work of the French philosopher Jacques Derrida, to 'deconstruct'[3] the male/female polarity of the separate spheres, exposing it as a binary system which allows things to be only 'like' or 'not like' the dominant category, and instead to replace prevailing intellectual norms with new formulations. To do this there needs to be a three-fold intervention.[4]

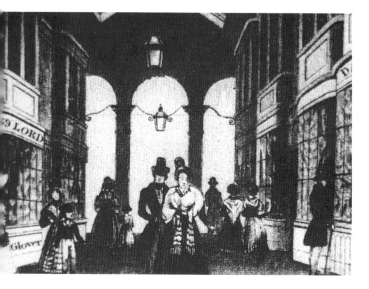

'Mimicking Domesticity'. *Interior of the Burlington Arcade.*
From J. Tallis, *London Street Views*, London: John Tallis, 1838,
part 71

First, the binary pair must be reversed so that the term occupying the negative position is placed in the positive position. Until now this has been the stance of feminist architectural historians who have reassessed the importance of women's role in the private realm and domestic architecture,[5] or who have sought to describe a uniquely female architectural heritage.[6] In short, they emphasise the patriarchal historical linkage of women with the home. Such a strategy runs the risk, however, of simply reproducing the binary pairing, albeit with the female sphere in the dominant position.

Secondly, there must be a movement of displacement, in which the negative term is displaced from its dependent position. This is a possibility implicitly dealt with by art historians who have re-evaluated the negative status of the female private sphere by looking at the suburb as the site of production—specifically, at the Parisian suburb of Passy as the artistic production of Impressionist artist Berthe Morisot.[7] Alternatively, cultural historians and theorists have debated the engagement of women in the public realm of the city.[8] More recently, models of public masculinity are starting to be re-defined in connection with constructions of domesticity.[9] In all these cases, a term originally represented negatively in patriarchal ideology (e.g. reproduction, private, female, suburb) is reinterpreted by connecting it with one of patriarchy's positive terms (e.g. production, public, male, city).

Still missing from these two tactics is, however, the third and most important intervention, that of the identification of a term which is undecidable within a binary logic—a term that includes both binary terms and yet exceeds their scope. It is this critical move which this paper demonstrates, showing that there are architectural spaces within the city which are neither wholly private nor public, male nor female, urban nor domestic. Simultaneously, though not denying the historical importance of the ideology of the separate spheres, it shows that architectural history cannot be adequately and entirely described within its binary parameters.

But how do such concerns determine the choice of an object of study for a feminist architectural history? Here the decision to focus on the Burlington Arcade demonstrates a number of criteria. First, the historical period in which the arcade was built—the Regency years between 1811 and 1821—is one of theoretical importance. It precedes the emergence of the ideology of the separate spheres as the dominant capitalist and patriarchal configuration of gender and space, and so is critical to an examination of the construction of this ideology. Secondly, the new kinds of spaces which emerged during this period, particularly in London, due to the rise of commodity capitalism, were places of consumption, exchange and display, where women were highly visible as consumers. The important notion here is that consumption, as a socio-economic activity, cannot be confined within the separate spheres ideology by virtue of the fact that it is neither production nor reproduction. The arcades are therefore important as, in the words of the cultural critic Walter Benjamin (1892–1940), they were "the primeval landscape of consumption".[10] Thirdly, in terms of their spatial configuration, the arcades provide an archetypal example of the interpenetration of public and private space; they are both privately owned and publicly used, both building interior and city street. For Benjamin, they were "bourgeois interiors forced outwards".[11]

A Theoretical
Framework for Analysis

So far, theory has operated in this paper as an organising mechanism for choosing objects of historical study. The Burlington Arcade has been located as an object of study for a feminist architectural history since it is a space that demonstrates the problematic nature of binary knowledge—it is both a public and a private space and a place of neither production nor reproduction, but consumption. However, beyond locating the object of study, it is also necessary to develop theoretical models for organising historical enquiry and architectural analysis. Traditional modes of architectural history have talked about the arcade in terms of aesthetics, form, physical modification and spatial typology,[12] but a practice of feminist marxist architectural history has a different agenda. Marxist architectural historians, traditionally interested in looking at the production of architecture, are now beginning to express an interest in exploring historically the nature of spatial experience and the ways in which architecture has been appropriated and used as a setting for everyday life. Simultaneously, contemporary feminists in cultural geography are increasingly looking at issues of consumption; feminist historians and art historians are examining the relationship between representation and experience, while current debates in feminist theory are focusing on female difference, subjectivity and identity. From these concerns can be identified three areas upon which a feminist marxist architectural history might focus: architectural production, representation and experience. This paper shall now briefly look at each of these in turn.

Production

The work of the marxist philosopher Henri Lefebvre provides a useful theoretical framework through which to examine the production of architectural space. Rather than considering the production of the urban realm simply through the activity of the building industry and urban design professions—as do many historians—Lefebvre's concern is with the conceptual as well as material production of space. Production of space, for Lefebvre, is in effect social reproduction, a social process involving a coming into consciousness, and thus a process not dissimilar to feminist concerns with both social and biological reproduction. Lefebvre suggests that the social production of space works through three different, yet interactive, levels: 'spatial practice', material or functional space, 'representations of space', space as codified language, and 'representational space', the lived everyday experience of space.[13] For an architectural historian, it follows that the (re)production of architectural space is a social process, i.e. that architecture must be considered as both structured by

and structuring of social relations. For feminists, the emphasis shifts to examine the importance of space in the production of gender relations, and, conversely, the significance of gender in spatial constructions. This paper investigates the gendered aspects of spatial practice, representation and experience in turn in the Burlington Arcade. It looks first at commodity consumption as the dominant spatial practice in the arcade, and then shows how the arcade necessarily involved representation and experience as part of its contribution to the reproduction of Regency London.

The first London arcades were constructed during the early decades of the nineteenth century in the fashionable and wealthy residential areas of the West End around Piccadilly.[14] The emergence of commodity capitalism in London at this time required new outputs for the sale of commodities—the Burlington Arcade was part of a scheme to promote the area west of Regent Street as an upper-class shopping zone.[15] In order to exploit the luxury market, it was important to create a privately owned realm within the public zone, a place socially protected from the street for an élite class of shopper. Arcades, such as the Burlington, were intended both as places of static consumption and as covered routes for an 'agreeable promenade'—and as such provided a new kind of urban space.[16] The luxury commodity industry required products to be displayed not as use-values with a necessary productive process lying behind them, but as pure commodities—items for exchange. This focus on display and exchange, geographically divorced from the place of production, allowed shops to be smaller (and also allowed narrow strips of unusable urban land to be economically developed). The spatial layout of the arcades exploited this possibility—the shallow depths of the shop units and their wide frontages enhanced viewing possibilities. The shop fronts in particular became the most important feature of the design by utilising the dual properties of glass. As a transparent material, glass allowed an interior view and an opportunity for both presenting and protecting the commodities. As a reflecting material, glass acted as a mirror for 'conspicuous' consumers to view themselves. Glass was also a very expensive material which added to the perception of the arcades as luxury zones.[17]

However, the new building typology in itself was not enough to ensure the commercial success of the arcade. In order to sell the luxury goods, a new labour force and a larger consumer population were also necessary. It was intended that women fill such roles. As with the other new shopping venues, the exchanges and bazaars, where the labour force was almost entirely female,[18] one of the contemporary reasons for building the Burlington Arcade was "to give employment to industrious females".[19] Although we do not know exactly how many women worked in the Burlington Arcade, we do know that six of the

'The Dandy - Femininity/Masculinity'. From G. Cruickshank,
The Dandies Coat of Arms, London: T. Tegg, 1819

original forty-seven shop owners were women.[20] We can also presume from the kind of 'genteel businesses' located in the arcade, such as milliners, hosiers, hairdressers, jewellers and florists, that the customers were intended to be female as well as male.[21]

Here we have looked at commodity consumption as the dominant form of spatial activity in the arcade, and at women's increasingly important role as consumers of commodities. However, the French feminist philosopher Luce Irigaray has pointed out that women are, in a patriarchal society, often 'owned' by men and treated as commodities; as mothers, wives, daughters, as virgins and as prostitutes. In so doing, Irigaray has reworked the marxist theory of commodity fetishism so that women are the commodities in patriarchal exchange.[22] The fact that during the early nineteenth century the word commodity was used to describe a woman's genital organs—a modest woman was a 'private commodity' and a prostitute was a 'public commodity'—serves to highlight women's role as commodities.[23] In this light, consumption and commodification begin to look rather different, and an examination of the area around the Burlington Arcade in the early decades of the nineteenth century gives us the chance to focus on some of the gendered aspects of bourgeois consumption and to think of how the role of woman-as-commodity might be conceived of spatially.

If we take a closer look at the district immediately surrounding the arcade at the beginning of the nineteenth century we find that it was an area of male upper-class leisure, housing a large number of male venues, such as the coffee houses, gaming rooms and clubs of St. James's Street and Pall Mall. Bond Street was the site of male fashion or dandyism, a term nowadays used to refer to

over-dressed effeminacy, but which in the Regency period reflected an intense preoccupation with masculinity and self-presentation as suited to the bachelor. The streets in the vicinity of the Burlington Arcade also provided lodgings in the form of chambers and hotels for the single men of the nobility, gentry and professional classes.[24]

As part of the services provided for its male population, the area around the Burlington Arcade was known for its high class brothels and courtesans' residences, and the streets of St. James's, Pall Mall, Piccadilly and the Haymarket formed a circuit notorious for street walkers.[25] As a consequence, the arcade played an important part in the commerce of prostitution. Through its location in an upper-class male district the arcade provided a wealthy clientele, and in terms of its spatial layout it offered a covered place for prostitutes and their clients to promenade. The design of the shops, as discrete (and discreet) self-contained units, each with individual and private staircases to upper chambers, allowed them to be used for prostitution by the shop girls themselves.[26] Architecturally, the spaces of the arcade, having been constructed to maximise the potential for looking at commodities on display, provided easy places for men to gaze at the 'professional beauties'.[27] This latter term may have referred to the female shoppers and shop girls, as well as to the prostitutes, and to pornographic images concealed inside snuff boxes and watches within tobacconists' and jewellers' shop displays.

Representation

So far, we have considered the ways in which the Burlington Arcade was (re)produced as an architectural space through different types of consumption. It was designed as a space for female consumers, or shoppers, but used by men as a place in which to consume female commodities as images, as bodies on display, and as prostitutes. Obviously, the role of consumer and commodity provide quite different historical experiences for women. If we are to take issues such as subjectivity and identity seriously, we need to look at the ways in which our knowledge of female experience is obscured historically through the construction of gendered systems of representation. Through the work of feminist art historians, we learn how images of women in paintings rarely represent women's own lives, but stand, for example, for qualities of purity and innocence, or evil and destructive forces.[28] Similarly, in sculpture, figures of women are used as allegories of, for example, liberty and freedom.[29] Such media use both the female body and ideas of the 'feminine' to stand for abstract concepts and values. In terms of space, however, there is still much to explore. Feminist geographers, although useful in pointing to considerations of gender in the production of space, have not yet begun to analyse social spaces as systems

of representation; it is here that a feminist architectural history can make a contribution in defining a new gendered practice.[30]

Representations of the Burlington Arcade were structured around images of the female body and ideas of the feminine in order to signify simultaneously both innocence and seduction. On the one hand, the Burlington Arcade located the female body of the shop girl as the site of desire in order to attract male custom.

'Women on Display'. [unknown author] *The New Exchange*, London: [unknown publisher], 1772

In literature and art representations, spaces of commodity consumption like the Burlington Arcade, with their primarily female work force and female customers were frequently depicted as places of sexual intrigue. For example, in a print of the *New Exchange* (1772) the female occupants are literally pointed to by a male figure as the focus of male attention, and in George Cruikshank's, *The Bazaar* (1816) the bazaar is represented as a place for arranging sexual liaisons. Similarly, in 'Humphrey Hedgehogg's' poem *The London Bazaar: or, Where to Get Cheap Things* (1816), women are clearly one of the 'things' to be 'got' cheaply.[31] Guides to the sexual and other leisure pursuits of the Regency man about town identifed bazaars as scenes of sexual seduction, and specifically mentioned the Burlington Arcade as a place to pick up pretty women.[32] Similarly, in literary accounts of the adventures of sporting men or ramblers, the Burlington Arcade

featured as a pleasure resort.[33] Architectural references also played a part in the gendering of the spaces of the Burlington Arcade; the use of scaled-down miniaturised elevations, combined with the lack of servicing elements usually found on the exterior face of buildings, created an almost theatrical effect. The atmosphere of unreality was emphasised by the unusual quality of the light. It was quite rare at this time for an outside space to be covered and lit through roof lights and the feeling of otherworldliness may have increased the connection of the arcades with a state of mind removed from the everyday character of the city—a world of fantasy, desire and seduction, notions connected with patriarchal constructions of 'the unknowable' as 'the feminine'.

On the other hand, the presence of a female figure also provided an image of purity and virtue in the perilous city, signifying security in order to attract female shoppers. In contemporary novels aimed at women readers, shopping venues were represented as respectable female zones.[34] Ideas of safety were also conjured up architecturally through references to the home environment and aspects of domesticity. The intimate scale of the arcade and interior details— such as bow windows, low doorways and fireplaces—represented bourgeois ideologies of family and stability, and so attracted 'virtuous' dressmakers and milliners and kept them off the perilous streets. Each shop unit was in essence a miniature home, with individual staircases, living and sleeping chambers.

These various uses of the female figure and the feminine all detracted from women's identity. However, by far the most pervasive gendered representation is, and was, the prostitute, a figure with whom all women who occupied the arcade were conflated. The female shopper was required to express the status of her husband through her 'conspicuous consumption'—the items she bought, the clothes she wore and the amount of leisure time she spent shopping. Furthermore, any concern with appearance was also characterised as trivial and superfluous, and so female shoppers were susceptible to being labelled a 'dolly mop' or part-time prostitute. Similarly, shop girls were denigrated as 'sly-girls' who supplemented their income with part-time prostitution. Although prostitution did often provide extra income for women whose wages were otherwise inadequate, the term was used indiscriminately to describe any young single working woman, regardless of whether she was being paid for sexual favours. Contemporary male commentators linked all the common female occupations—including actresses, ballet dancers, laundresses, milliners, seamstresses and servants—to prostitution.[35]

In order to unravel this association of women with prostitution in the arcade, it is necessary to think simultaneously of the social mechanisms of patriarchy and capitalism. The development of commodity capitalism at this time required

women to enter the public spaces of the city both as producers and consumers, but to do so involved moving beyond the immediate control of the male in the patriarchal family unit. The increasing movement of women into spaces outside the family home resulted in the extension of patriarchal control into public spaces of the city, codified through government legislation, such as the Vagrancy Acts of 1822. These laws exerted control over female urban movement in public urban spaces through the figure of the prostitute.[36] Representing public women as prostitutes, while connecting prostitution with sexual deviancy or criminality, meant that women who populated public zones of the city were seen as social and spatial transgressors.

In later Victorian London, the prostitute, through her notorious ability to carry and spread disease—syphilis through her body, immorality through her mind— came to symbolise the chaos and disorder of the health, transport and sanitary problems of the city as a whole. As a result, prostitutes were spatially confined in nineteenth century Lock Hospitals, through the Contagious Diseases Acts of the 1860s. Arcades themselves were also employed to regulate the feminine and mercurial city. In 1855, a number of schemes put forward to counter city congestion employed huge arcades around London.[37] *The Great Victorian Way*, proposed by Joseph Paxton (1801-1865), would have been a ten mile arcade linking all of London's major railway stations, with covered transport, apartments, shops, offices and other entertainment facilities. Given that arcades were associated with prostitution, *the Great Victorian Way* looks like a proposal for an enormous brothel. In this light, its popular name—*the Great Girdle*—is of particular interest for connecting the female body to the city; *the Great Girdle* was to control London in the same way a girdle restrains the wayward female body.

Experience

As we have seen, gendered forms of representation mask our historical knowledge of the women who occupied the arcade and the city around it. To hear of the experience of women in the Burlington Arcade, we would need to find the personal memoirs of the shoppers, shop girls and prostitutes. Although some feminists have used women's real and imaginary writings about their urban experiences as evidence of their lives in the city,[38] feminist historians are currently debating whether female subjectivity can be located historically through empirical evidence of experience.[39] Emphasis is being placed instead on interpreting the categories of historical enquiry. Gendered terms of identity, such as 'woman', 'female' or 'feminine', are shown to be social constructions which vary historically in relation to structures of masculinity and according to differences among women.[40] In this way, feminism offers possibilities of looking

'The Burlington Arcade as both
Public and Private Space'.
Thomas H. Shepherd:
Burlington Arcade, Piccadilly,
London: Jones & Co. 1828

at differences of class, sexuality, race and culture which reinforce or oppose
gender oppression, thus complicating history still further.

In the Burlington Arcade, we see, for example, clear differences of class in the
women who occupied it—the professional mistresses and street-walkers, the
shoppers and shop girls. The private ownership of the Burlington Arcade meant
that there were regulations concerning spatial behaviour. The arcade was locked
at night, and when open during the day, movement through it was required to
be quiet and slow. Such regulations were enforced by the beadles (entrance
guards), who kept the working class from entering this luxury upper-class
shopping zone. However, the wealthy prostitute or courtesan could bribe the
arcade beadles, entering the arcade both to spend money and meet clients.
Conversely, the working-class prostitute was kept outside the arcade gates,
picking up her clients from the street. Similar class differences occur in the
experience of shoppers and shop girls. The female shopper spent money on
fashion and personal commodities, yet when the working-class shop girl did so,
she was accused of 'dressing up', or rising above herself. She was criticised for
her vanity and deviant sexuality, just as male commentators identified the love
of finery as a main cause of prostitution. Here, dress, by offering women the
possibility of rendering class identity invisible, posed a threat to social order.
As a result, men blamed female sexuality and classified the working class
'imitator' as a prostitute or sexual deviant, while other women were protected
by their class status from such mis-representations.

Differences of race are also apparent in the arcades. The arcaded *Quadrant
Colonnade* (1817-1823) section of Regent Street was modelled by its architect,
John Nash (1752-1835) on the Parisian arrangement of mixing shops and flats.
This mixture of foreign buildings and people—Regent Street was at this time
renowned for promenading Frenchmen—worked initially as an attraction in

229

terms of the exotic and the different.[41] However, being French at a time when France and England were political rivals was also something to be distrusted; French connections were perceived as signs of immorality. Prostitutes in the Burlington Arcade were considered to be French, while, conversely, the French women living near the Quadrant were thought to be prostitutes. Similarly, the foreign influence of Italian opera and French ballet in neighbouring theatres was deemed responsible for a lack of morality in the colonnade; as a result, the colonnade was demolished in 1848.

A further set of issues to be noted in this history are the assumptions made about female and male sexuality. Specifically, male desire, for the prostitute, shopper and shop girl, is perceived only in terms of male heterosexuality, while the sexuality of the prostitute, shopper and shop girl is equally unquestioned. We should also question the assumed link between being female and having feminine qualities—and between male and having masculine qualities—as a fixed and unchanging one. For example, the figure of the dandy exceeds the representational possibilities of the male-masculine/female-feminine polarity. The male dandy was interested in being on display, but here the displayed object, unlike the female shopper and shop girl, is male.[42] The way in which the figure of the dandy slips through the conventional gendered classification helps to explain the association of dandies with sexual deviancy, both as effeminate and as homosexual—a myth which appears to have no historical grounding.

Explorations of the relations between gender, class, race and sexuality provide an important focus for current feminist theoretical discourse about female subjectivity and experience. Metaphoric spatial terms, such as 'standpoint', 'position' and 'margin', are being used to allow for differences in female identity.[43] Feminist architectural history is able to extend this discourse by providing historical evidence of real spatial practices. For example, if we reconsider some of the different female experiences in the Burlington Arcade described above, but now with specific reference to spatial location, we can see that identity is constructed in relation to architectural space. First, it is the spatial boundary of the Burlington Arcade, guarded by the beadles, which works to differentiate between the courtesan and other working-class prostitutes. Secondly, the spatial proximity of shop girl and female shopper in the arcade shops meant that the former learned how to imitate the dress and manners of upper-class women. Thirdly, the same spatial proximity of the shop girl to the male shopper meant that her sexual reputation was open to lurid speculation.

The Practice of a Marxist Feminist Architectural History

This paper has outlined the methodology of a feminist marxist architectural history and demonstrated through the example of the Burlington Arcade how this new gendered practice can be used to examine architecture historically. It is beyond the scope of this paper, but important to note, that such a mode of enquiry can, and should, be used to investigate gender, class, sexual and racial divisions in contemporary architectural spaces. Furthermore, bringing feminist and marxist concerns to bear on architectural history in this way allows a different kind of engagement with a number of other practices. On the one hand, thinking about the critical role that architecture plays in the construction of identity may provide new models for the notion of experience in feminist history and theory. On the other hand, considering different experiences of occupying architectural space may suggest new ways of designing architecture. By thinking about architectural history from a feminist perspective, the categories of use, representation and experience emerge as critical to the understanding of gender and architectural space. These three categories—use, representation and experience—are precisely those which a social architecture should consider.

Notes

1 See, for example, Walker, L., *British Women in Architecture 1671-1951*, London: Sorello Press, 1984.

2 See for example, Clarke, L. (ed.), *Building Capitalism*, London: Routledge, 1992; Colomina, B. (ed.), *Architectureproduction*, New York: Princeton Architectural Press, 1988; and King, A. D. (ed.), *Buildings and Society: Essays on the Social Development of the Built Environment*, London: Routledge and Kegan Paul, 1980.

3 The technique of deconstruction for Derrida is a literary technique aimed at disturbing the assumed relationship between reality and representation, or between the sign and the referent.

4 I have adopted this three stage strategy from Elizabeth Grosz. See Grosz, E., *Sexual Subversions*, St. Leonards, Australia: Allen and Unwin, 1989, p. xv.

5 Hayden, D., *The Grand Domestic Revolution*, Cambridge, Massachusetts: The MIT Press, 1981; Roberts, M., *Living in a Man-Made World: Gender Assumptions in Modern Housing Design*, London: Routledge, 1991; and Wright, G., *Moralism and the Model Home*, London: University of Chicago Press, 1985.

6 Lobell, M., "The Buried Treasure", in Berkeley, E. P. (ed.), *Architecture: a Place for Women*, London: Smithsonian Institution Press, 1989, pp. 139-158.

7 Adler, K., "The Suburban, the Modern and une Dame de Paissy", *Oxford Art Journal*, vol. 12, no. 1, 1989, pp. 3-13; and Pollock, G., *Vision and Difference: Femininity, Feminism and the Histories of Art*, London: Routledge, 1988.

8 Wilson, E., "The Invisible Flâneur", *New Left Review*, vol. 191, 1992, pp. 90-110; and Wolff, J., "The Invisible Flâneuse", *Theory, Culture and Society*, vol. 2, no. 3, 1985, pp. 37-46.

9 Tosh, J., "Domesticity and Manliness in the Victorian Middle-class", in Tosh, J. (ed.), *Manful Assertions: Masculinities in Britain since 1800*, London: Routledge, 1991, pp. 43-73.

10 Quoted in Frisby, D., *Fragments of Modernity*, Cambridge, Massachusetts: The MIT Press, 1988, p. 192.

11 Benjamin, W., *Charles Baudelaire: a Lyric Poet in the Era of High Capitalism*, London: Verso, 1973, p. 135.
 See, for example, Geist, J. F., *Arcades: the History of a Building Type*, Cambridge, Massachusetts: The MIT Press, 1983.

13 Lefebvre, H., *The Production of Space*, London: Blackwell, 1991.

14 The two arcades constructed at this time were the Royal Opera Arcade (1815-7), Pall Mall, designed by John Nash and George Repton (see the *Survey of London*, vol. 29-30, London: Athlone Press, 1960, pp. 240-249; and Geist, *Arcades*, pp. 313 and 314), and the Burlington Arcade, (1818-1819), Piccadilly, designed by Samuel Ware, (see the *Survey of London*, vol. 31-32, pp. 430-434; and Geist, *Arcades*, pp. 318-327).

15 See for example, Davies, T., *John Nash*, Newton Abbot: David and Charles, 1966, p. 74.

16 Ware, S., "A Proposal to Build Burlington Arcade", 16 March 1808, and schematic plans, 1815, 1817 and 1818 for the Burlington Arcade and Burlington House, Collection of Lord Christian, Royal Academy of Arts Library, London; "Covered Passage, Burlington House", *The Times*, 3 April 1815; *The Gentleman's Magazine*, vol. 87, part II, September 1817, p. 272; and Tallis, J., *Tallis' Illustrated London*, London: John Tallis and Co., 1851, p. 154.

17 The Burlington Arcade contained particularly costly large sheets of glass. See "Destructive Fire in Bond-Street and Burlington Arcade", *The Times*, 28 March 1836, p. 3.

18 Feltham, J., *The Picture for London 1821*, London: Longman, Hurst, Rees, Orme, and Brown, 1821, p. 264.

19 "The Opening of the Burlington Arcade", *The Gentleman's Magazine*, vol. 87, part II, September 1817, p. 272.

20 "Opening", p. 272.

21 London Topographical Society, *John Tallis's London Street Views 1838-40*, London: Nattali and Maurice, 1979, pp. 238 and 239.

22 Irigaray, L., "Women on the Market", in *This Sex Which Is Not One*, Ithaca: Cornell University Press, 1985, pp. 170-191.

23 Grose, F., *A Classical Dictionary*, London: S. Hooper, 1788; Grose, F., *Lexicon Balatronicum: Dictionary of Buckish Slang, University Wit and Pickpocket Elegance*, London: C. Chappel, 1811; and Egan, P., *Grose's Classical Dictionary of the Vulgar Tongue*, London: Sherwood, Neely and Jones, 1823.

24 Tallis, *Tallis'*, and Feltham, *Picture*.

25 Chancellor, B. E., *The Pleasure Haunts of London*, London: Constable and Company Ltd., 1925, pp. 185-187; Evans, H., *The Oldest Profession: an Illustrated History of Prostitution*, London: David and Charles, 1979, p. 90; and Henderson, A. R., *Female Prostitution in London 1730-1830*, London: University of London, 1992, p. 130.

26 Evans, *Profession*, p. 116; Jenkins, S., *Landlords to London*, London: Constable: 1975, p. 113; and Mayhew, H. and Hemyng, B., "The Prostitution Class Generally", *London Labour and the London Poor*, vol. 4, London: Morning Chronicle, 1861-62.

27 Colby, R., "Shopping off the City Streets", *Country Life*, vol. 136, 19 November 1964, p. 1346.

28 See, for example, Nead, L., *Myths of Sexuality: Representations of Women in Victorian Britain*, Oxford: Blackwell, 1988; and Griselda Pollock, *Vision and Difference: Femininity, Feminism and the Histories of Art*, London: Routledge, 1988.

29 See, for example, Warner, M., *Monuments and Maidens*, London: Picador, 1988.

30 See, for example, Massey, D., *Space, Place and Gender*, Cambridge: Polity Press, 1994, pp. 179 and 180.

31 Dyer, G., "The 'Vanity Fair' of Nineteenth Century England: Commerce, Women and the East in the Ladies Bazaar", *Nineteenth Century Literature*, vol. 46, no. 2, 1991, pp. 196-222.

32 *Ramblers Magazine or Fashionable Companion*, vol. 1, no. 1, 1 April 1824, p.16; and *Ramblers Magazine or Annals of Gallantry, Glee, Pleasure and Bon Ton*, vol. 2, 1820, p. 28 and p. 207.

33 Egan, P., *Life in London*, London: Sherwood, Neely and Jones, 1821.

34 Burney, F., *Evelina*, London: Jones and Co., 1822.

35 See, for example, Mayhew, and Hemyng, "Prostitution", pp. 217 and 255; and Ryan, M., *Prostitution in London*, 1839, p. 174.

36 *The Vagrancy Act*, 1822, 3 Geo. IV, cap. 40, s. 2. All prostitutes occupying public streets or highways unable to give a satisfactory account of themselves were deemed to be 'idle and disorderly' and so deserving of three months' hard labour. See *The Vagrancy Act*, 1822, 3 Geo. IV, cap. 40, s. 2, p. 134. Prostitution itself was not a criminal offence, but soliciting, living off immoral earnings and running 'houses of ill-fame' were offences selectively enforced against. See Emsley, C., *Crime and Society 1750-1900*, Harlow: Longman Group Ltd., 1987, p. 134.

37 Paxton, J., "The Great Victorian Way", *Report of the Select Committee on the Metropolitan Communications,* 1855, vol. 10, pp. 78-96; and Moseley, W., "The Crystal Way", *Report of the Select Committee on the Metropolitan Communications*, 1855, vol. 10, pp. 52-7.

38 See, for example, Wilson, E., *The Sphinx in the City: Urban Life, the Control of Disorder, and Women*, London: Virago, 1991.

39 See, for example, Scott, J. W., "The Evidence of Experience", *Critical Enquiry*, vol. 17, Summer 1991.

40 See, for example, Davidoff, L., *Worlds Between: Historical Perspectives on Gender and Class*, London: Polity Press, 1995; Hall, C., *White, Male and Middle Class: Explorations in Feminism and History*, Cambridge: Polity Press, 1992; Poovey, M., "Feminism and Deconstruction", *Feminist Studies*, vol. 14, no. 1, 1988, pp. 51-65; and Scott, J. W., "Deconstructing Equality Versus Difference: or, the Uses of Poststructuralist Theory for Feminists", *Feminist Studies*, vol. 14, no. 1, 1988, pp. 33-50.

41 According to George Sala, who explored the roof above the colonnade as a child, there was a lively and entertaining life among the lodgers, many of whom were foreign and theatrical. Sala, G., *Twice Around the Clock, or the Hours of Day and Night in London*, London: Houlston and Wright, 1859. See also Hobhouse, H., *A History of Regent Street*, London: Queen Anne Press, 1975, pp. 72 and 73

42 See, for example, Wilson, E., *Adorned in Dreams: Fashion and Modernity*, London: Virago Press, 1985, p. 180.

43 See, for example, Flax, J., *Thinking Fragments: Psychoanalysis, Feminism and Postmodernism in the Contemporary West*, California: University of California Press, 1991; Haraway, D., "Situated Knowledges: the Science Question in Feminism and the Privilege of Partial Knowledge", *Feminist Studies*, vol. 14, no. 3, Fall 1988, pp. 575-603, especially, pp. 583-588; bell hooks, *Yearnings*, Boston: Turnaround Press, 1989, pp. 245-253; Nicholson, L., "Introduction", in Nicholson, L. (ed.), *Feminism/Postmodernism*, New York: Routledge, 1990, pp. 1-16; and Probyn, E., "Travels in the Postmodern: Making Sense of the Local", in Nicholson, L. (ed.), *Feminism/Postmodernism*, pp. 176-179.

The Architect:

Katerina Rüedi

Commodity and Seller in One

Timothy Dalton: *Untitled*, 1991.
Photo: Katerina Rüedi

> What lay on the pillow was a charnel-house, a heap of pus and blood, a shovelful of putrid flesh. The pustules had invaded the whole face, so that one pock touched the next. Withered and sunken, they had taken on the greyish colour of mud, and on that shapeless pulp, in which the features had ceased to be discernible, they already looked like mould from the grave. One eye, the left eye, had completely foundered in the bubbling purulence, and the other, which remained half open, looked like a dark, decaying hole. The nose was still suppurating. A large reddish crust starting on one of the cheeks, was invading the mouth, twisting it into a terrible grin. And around this grotesque and horrible mask of death, the hair, the beautiful hair, still blazed like sunlight and flowed in a stream of gold. Venus was decomposing. It was as if the poison she had picked up in the gutters, from the carcasses left there by the roadside, that ferment with which she had poisoned a whole people, had now risen to her face and rotted it.[1]

Emile Zola's novel, *Nana*, a tale of a Second Empire prostitute, ends with the decaying body of a once beautiful woman, displayed as a metaphor of the disintegration of the times. As Nana putrefies from smallpox, her rotting beauty is paralleled by the flow of the Parisian crowd, dazed by the declaration of war:

> The crowds stretching away into the distance were surging along like flocks of sheep being driven to the slaughterhouse at night. These shadowy masses rolling by in a dizzying human flood exhaled a sense of terror, a pitiful premonition of future massacres.[2]

Female depravity and urban chaos here seep into one another; architecture, sex and death symbolically entwine.

In *The Sphinx in the City*,[3] Elizabeth Wilson describes how female sexuality became a symbol of the uncontrollable character of the nineteenth century city. Women plunged into space after space, opening up their senses and purses to the tactile experience of goods in the department stores, or offering up their bodies as commodities, whether for industrial labour or mass-prostitution. This transgression of their 'great confinement' exposed, through their own bodies, the 'monster within the sleep of reason'—the socially disruptive forces unleashed by industrial capitalism. Indeed, when Zola describes Nana in the outline plot for the novel, he could be describing the voraciousness of industrial capitalism itself:

[Nana] ends up regarding man as material to exploit, becoming a force of Nature, a ferment of destruction, but without meaning to, simply by means of her sex and her strong female odour, destroying everything she approaches, and turning society sour just as women having a period turn milk sour... Nana eats up gold, swallows up every sort of wealth; the most extravagant tastes, the most frightful waste. She instinctively makes a rush for pleasures and possessions. Everything she devours; she eats up what people are earning around her in industry, and on the stock exchange, in high positions, in everything that pays. And she leaves nothing but ashes.[4]

Susan Buck-Morss, in her commentary on Walter Benjamin's Passagenwerk project,[5] discusses industrial prostitution not simply as a phenomenon transgressing social and spatial gender codes, but rather as a profound problem for the mechanisms of capital itself:

Whereas every trace of the wage labourer who produced the commodity is extinguished when it is torn out of context by its exhibition on display, in the prostitute, both moments remain visible. As a dialectical image, she 'synthesises' the form of the commodity and its content: She is 'commodity and seller in one'.[6]

The body of the industrial prostitute presents a dilemma; as a convergence of stereotypical images of desire, it conforms to the conventions of the commodity fetish. Yet it also overtly presents, at the point of sale, the normally concealed, alienated, physical body of the producer; present in the flesh as a living, breathing entity, it is at the same time an inanimate object, a product. Emerging as a mass phenomenon for the first time in the industrial cities of the nineteenth and early twentieth centuries, industrial prostitution bares the alienated body and so bears the contradictions of capital.[7]

The body of the mass-prostitute also exposes the centrality of sexuality and desire within consumption. Consumption is associated with women generally, often as a process of mutual constitution and reflection. In the commodity fetish, woman recognises images of desire that structure them both. The producer and seller of the commodity, in contrast, have traditionally been male. These two gender stereotypes collide in the body of the prostitute. First, as a commodity 'she' is ambiguously gendered; in her female role she is a (masculine) producer, in the position of a male he is a (feminine) image for consumption. She also rejects the binarism of sexuality-for-reproduction which is a key foundation stone of patriarchy. The co-existence of both 'masculinity' and 'femininity' in the same body constitutes the prostitute of either sex as a profound threat. Secondly, as seller, she refuses her subordinate cultural status. Present at her own transaction, she can negotiate her economic value and define, change or withhold her services. She can also reconstruct herself as both an object and a producer of pleasures.[8] She can disempower the desires of her

customer and devalue his money.[9] Such disruption to the economic and sexual order must therefore be repressed by symbolic and literal violence. The industrial prostitute had no rights of association; she was spatially isolated, legally erased, financially exploited and physically brutalised by men.

This was also precisely because s/he was not alone. Prostitution, by exposing the relationship between sexuality, labour and commodity production, reveals a chorus of companions in other, seemingly asexual occupations marketing personal services. In particular, the the traditionally masculine professions, like those of the 'oldest profession', bare similar terrors of sexuality and desire. Could this be one of the reasons why, in Zola's figure of Nana, or Wilson's Sphinx in the City or Buck-Morss's prostitute-as-emblem, female sexuality is linked with urbanity? What will we discover if we undress this rampant female body?

We will find a man. And if we undress him, in turn, we will find, in Luce Irigaray's words, "extreme confusion… a dark night that is also fire and flames".[10] Indeed, the greatest fear that men have is not of women but of men—of themselves. Capital, its cities and commodities have largely been the fruit of the acts and desires of men. They have worn feminine metaphors to distance and veil the masculinity, not only of their production as physical artefacts, but also of the entire exchange system of capitalist patriarchy. The stereotypes of masculinity as stable identity and order, exteriority, production and action, and femininity as chaos and disorder, interiority, reproduction and passivity are largely the offspring of masculine consciousness. Women have remained outside the institutions of their formation. Today such gender stereotypes sit uneasily with many members of both sexes, yet persist covertly at all levels of culture. Their logic remains powerful, locking each half of the population into tempting complicity.[11]

Women, but especially men, cannot acknowledge this problem. For even more problematic than she becoming a 'he' (as many women have in industrial culture), he cannot, above all, become a 'she'. This is why masculinity cannot abdicate the mastery of appearances and bear its own sexual objectification, for then it would acknowledge its own commodification and prostitution. That is why the commodity must retain feminine attributes, and its producer must remain masculine. Only she, the commodity, can be the object of the male gaze. Thus, in the most literal examples, explicit depictions of female genitalia can take place in full-frontal pornography, whilst the representation of the erect penis is proscribed by law. The literal phallus, like the cultural power of masculinity, must not be represented or appropriated by 'the other', and especially not for a 'female' pleasure.[12] For in his objectification, his 'phallus' might be taken away from him; in becoming beautiful, desirable and

consumable, he may be (symbolically) castrated.

Indeed, the re-appropriation of 'the phallus' is precisely what happens within homosexuality. Here, the binary opposition of masculine/feminine internalises and the certainties of the male, like Nana's face, disintegrate. The seductive homoerotic male body is the ultimate icon of commodifiable masculinity. Precisely because its transgressions are explicitly internal to patriarchy's most dominant symbols, homosexuality, even more than prostitution, presents a profound threat to the patriarchal order.[13] Homophobia, literally the fear of man, therefore still firmly protects the homogeneity of masculinity today.[14] It rejects the uncertain flows of sexual identity and worships the objectivity and cohesiveness of the masculine type. It elevates as natural, rather than as political, men's and women's need to possess and enact masculine conventions; it imprisons them both within sexual and political conformity.[15]

Homophobia seethes beneath the surface of the architectural profession. The ubiquitous grey suits of professionals represent the joyless masculinity that comes with conformity; this plain, obedient cloth also symbolically corsets the knowledge and practices of architecture. Most male practising architects vow that gender and sexuality have nothing to do with their discipline; many female practising architects will add that they should have nothing to do with it. An ideologically neutered masculine figure forms the only dominant architectural role model. Thus, whilst woman has used broader economic and cultural empowerment to enter architectural education, at the end of the process, she has exited into practice a decimated figure.[16] Internalising architecture's knowledges and practices—the discipline as handed down to her through the tradition of the great architectural masters—she has reconstructed herself, but only as a 's/he', in the image of the neutered, homophobic male. The desire to disrobe him of 'his pin-stripe' has not been permitted to her or to the homoerotic male; both have remained closeted within these 'vertical prison bars' of the professional's symbolic wrapping.

That buildings in the late twentieth century are commodities for consumption is difficult to dispute; that architects themselves have become commodities is perhaps more difficult to swallow, because it suggests that the identity, marketability and price of most architects is beyond the control of individual architects themselves. Yet, most professional architects in the industrial era have practised under precisely these conditions.

In the nineteenth and early twentieth centuries the parallel between the professionalisation and commodification of occupations lay in the absorption of workers and professionals into discourses of power ensuring identical bodies

and codifiable practices. This historical period coincides with the rise of the economic era of Fordism.[17] Fordist economy relied on the ideology of 'universal' needs and a homogenous working class on a standard wage.[18] Such needs were defined by objective professional expertise and realised through technical expertise. Fordism's political counterpart was thus the stable, technocratic state 'managing' the economy 'on behalf' of the people; the 'honey, don't worry I'll fix it', 'job for life', time-and-motion choreographers of industrial bodies and commodities. Professional expertise, science and technology were the meat-hooks of Fordist capital. The worker, in order to be manageable, was neutered.

However, the homogeneity of Fordism became its greatest limit. Standard needs were quickly satisfied, closing the consumption cycle and thus sales and profits; translated into universal rights, they enabled workers to form unions, resist their exploitation and so limit the productivity of capital. Such limits had to be overcome by the stimulation of consumption and the depoliticisation of the workforce; the technocrats turned to female patterns of employment.

Under post-Fordism, the spatial isolation of producers, casualised, part-time work, multiple tasks and absence of collective bargaining (typical of female domestic work and prostitution) became the new orthodoxy.[19] The shift to 'decentralisation and flexibility', 'down-sizing and delayering' of the post-Fordist era, could thus be said to have been achieved by a feminisation of previously asexual or masculine workforces. Replacing a single need with that of sub-cultures, market niches and planned obsolescence, the new post-Fordist body/commodity has also changed, becoming a fluid, multi-faceted entity.[20] A feminisation of consumption has taken place alongside production.

In architecture, Fordism was the era of professional formation. With cheap printing and photography, knowledge, like objects, had become freely available, posing a threat to architects. New occupational groups—civil, structural and mechanical engineers, surveyors and contractors—claimed the right to the possession of unpoliced architectural knowledge, the control of the building process and the resultant status and profits. Unable to keep command of production in the construction industry, the professional architectural institutes in Europe and the USA came into being instead, to protect the consumption of architects—by transforming its body of knowledge and practices into a high-security commodity.[21]

The profession sought the control of its own reproduction through an alliance with the state and its legitimisation of formal education. Education became the assembly-line of architects as commodities. From the end of the century onwards, entry to professional practice was only through the long and arduous

examinations of the university, which ensured product quality through conformity to a standard curriculum. Here the body of the architect was attached to expertise and the 'product' gained a professional warranty and exchange value in the marketplace.

Today, profound changes have occurred to the identity and exchange value of architects. First, in the UK, the end of mandatory fee scales, state compulsory competitive tendering and internal absorption of architectural services within design-and-build and management contracts have all thrown architects onto the mercy of the open market. Like the prostitute, practising architects today do not exert collective economic power, but negotiate individual services with specific clients. Secondly, 'under-employment' has isolated architects, as the majority retreat into 'one-man-band' practices and are unable or unwilling to retain membership of a professional body. Thirdly, the state imposition of quality assurance legislation and ever more stringent planning and building law, combined with the culture industry's highly effective appropriation of the image value of architecture, means that financial survival depends on conformity to external stereotypes. Architects today select a market niche, seducing with the S+M of high-tech, the old-fashioned Victorian lace-and-suspenders of neo-vernacular and occasionally the cool, elegant sophistication of high-class good taste; architecture and architects today could be called 'empty vessels to be filled by capital's desires'. Architects instead provide 'architectural services', ministering to the pleasures of the client, haggling over fees; hiring and firing at will, they are, more often than not, hired and fired themselves. Education is also becoming a 'service' industry. Part-time staff, with individually negotiated (and badly paid) contracts are a feature of the hippest, most glamorous schools. Student 'customers' select and assemble 'modular' courses, consuming education, yet are defined in quotas, implying that education still produces *them*.[22] 'Working from portfolio', practising architects today are the casualised part-time workers of Post-Fordism.[23] They could be said to have lost their manhood.

But is this emasculation a matter of despair? In architecture schools numbers of female students and tutors have risen. Gender and queer studies are making their mark. The consensus regarding design teaching (and the consequent authority of male role models) is no longer taken for granted. In practice, architects have entered new territories; they are designing film sets, furniture, LP covers; they are retraining as schoolteachers, space-planning advisors, brief writers, community advisers, management contractors and developers; they are writing, drawing, making installations, inventing new tricks, selling themselves, their wares, their images. Capital, having nurtured the Victorian childhood and Fordist adulthood of the professions, recognises

that, to sell himself in the global marketplace, the 'old boy' must be fragmented, moulded and reconstructed as a 'new girl'.

Only for the 'old boy' is the confusion of this sex change a tragedy. For women and homosexuals, it is a familiar condition, one within which they have learned to find opportunities and pleasures. For what is being lost are, in fact, only the outworn certainties of the patriarchal order, with all their injustices and denials. Professionals have for too long claimed an autonomy and objectivity not permitted to other workers and have imposed, as 'natural and neutral', bodies of knowledge and models of practice which are, in fact, patriarchal and contestable; students have disregarded the privileges of a system that exchanges elite education for universal taxation, transforming structural inequality into individual personality. Academics and students, and especially professionals, have fetishised the reproduction rather than challenged the production of their discipline and its sexual politics. The struggle by the 'old boy' to repossess the new 'female' architectural economy, shows the distress caused by the profession's loss of power.

This fear of emasculation is nowhere more evident than in the curricula for courses in professional studies and practical experience, which remain firmly entrenched within homogenous Fordist conceptions of architectural knowledge. Here, the profession continues with ever greater determination to protect the 'old boy' through its homophobic and misogynist vision of practice. In the UK, plans are afoot to standardise the examination further, in line with the US model, in the hope that this will provide a new 'added value' for the architectural commodity. Today, the architect is more defensively policed than in the nineteenth century, when the profession came into being. Professionalism does not easily tolerate heterogeneity, it still dwells within the unreconstructed house of Fordism.

Feminism's assertion of gender, sexuality, desire and the personal as political provides a position from which to challenge the homophobia and misogyny of patriarchy. The alliances of sexuality and desire are necessarily cross-disciplinary and provide common languages between different cultural practices. Thus, whilst feminist studies suggest, very importantly, that the tactics of each individual are important, they also show that, together, groups can enact strategic change. Everyone produces, acquires or learns a gender, sexualities, desires. These constitute powerful shared experiences. Yet patriarchy in general, and the architectural profession in particular, would have us think that this is irrelevant to our practices.

Indeed, feminism and, in particular, queer studies still do not form a

respectable position for a practising architect to profess to; prostitution as a model for professionalism is very unwelcome at the boardroom table. The prostitute's practice is dangerous, precisely because it threatens the sexual order; its desires are therefore entrapped immediately within gender stereotypes. In architecture, a similar 'repression' maintains its knowledge within narrow and elitist forms. And, although 'he' has inevitably gained great benefits, 'the male' is ultimately as imprisoned by this as 'the female'.

The profession must change. Its 'production line', education, through which it redesigns its commodities, is the best place to start. Within education, the professional courses need the most immediate and radical change. It is time to strip the armour plate from our bodies of knowledge and our practices; it is time to open them up to the politics of desire. This will free not only women, but especially men.

Notes

1 Zola, E., *Nana*, Holden G. (trans.), Harmondsworth: Penguin, 1972, p. 470.
2 Zola, *Nana*, p. 465.
3 Wilson, E., *The Sphinx in the City*, London: Virago Press, 1991, Ch. 3 "The Cesspool City".
4 Zola, *Nana*, pp. 12 and 13.
5 Buck-Morss, S., *The Dialectics of Seeing*, Cambridge, Massachusetts: The MIT Press, 1990.
6 Buck-Morss, *Dialectics*, pp. 184 and 185, internal quotations taken from Benjamin, W., *Gesammelte Schriften*, 6 vols., Tiedemann, R. and Schweppenhäuser, H. (eds.), Frankfurt-am-Main: Suhrkamp Verlag, 1972, vol. V, p. 422 (J 59,10) and p. 55 (1935 exposé).
7 Elizabeth Wilson suggests that during the Victorian era large numbers of women found it necessary to enter prostitution in order to earn (or, in the case of middle class women) supplement an income. Wilson, *Sphinx*, Ch. 3, "Cesspool".
8 "I decide what he can get, for how much, and within what time. And I make money off them". A Dutch prostitute quoted in Davis, N. (ed.), *Prostitution: An International Handbook on Trends, Problems and Policies*, Westport, Connecticut: Greenwood Press, 1993, p. 197.
9 "By taking away the customer's money, as well as his erection, the prostitute performs a double, and even more satisfying and effective, emasculation". Benjamin, H. and Masters, R. E., *Prostitution and Morality*, London: Souvenir Press, 1964, pp. 280 and 281.
10 Irigaray, L., "La Mysterique", *Speculum of the Other Woman*, Ithaca: Cornell University Press, 1985, p. 191.
11 Both men and women in the architectural profession successfully ignore the current high drop-out rate of female students, the tiny percentages of women practitioners and the small scale of their commissions. The continued dismissal of gender inequality as an issue in architecture means that the taking up of a binary gendered position is still absolutely essential within the discipline. It is only *after* affirming that gender differences exist within architecture, only after making the subject a public, explicit and contestable one, that the space for a more open-ended relationship between genders, sexualities and desires can, in turn, be created.
12 The relative absence of pornography for women reinforces this. The repression of female desire from an early age through the lack of public male sexual pornographic models or institutions for collective female sexual pleasure privatises her desire, removing it to the politics of the bedroom. Although this is an important site of change in gender relations, it is a profoundly isolated one.
13 'Created' as a category of perverts in the nineteenth century, homosexuals were therefore erased even more forcibly than women from the public spaces of the city. Locked within its 'closets', made invisible, homosexuality is still profoundly unacceptable as a social practice; unlike the economic empowerment of female labour, which ultimately affirms the status of masculinity by its symbolic worship of the values of production, homosexuality places 'feminine' consumption within the very heart of man.
14 It is highly significant that my 1993 *Shorter Oxford Dictionary* does not contain this word, which has been in use in the gay community for some time.

15 Such homophobia is not necessarily specific to men; many women reject transgressions of the binary sexual order as fervently as men.

16 In the UK, approximately 35% of first year architecture students are female. Only 9% of practicing architects are women. The unreliability of these statistics is itself a sign of the problem, in that the profession has not thought it necessary to commission any major survey of women in architecture.

17 When Henry Ford, the 'father' of Fordist economy, proudly stated that: "[t]he first moving line ever installed [in the Ford factory] came in a general way from the overhead trolley that the Chicago packers use in dressing beef", thus proclaiming that the slaughterhouse was the inspiration for his assembly line, he was celebrating the successful abstraction of human bodies from the carnage of production (Ford, H., *My Life and Work*, London: William Heinemann, 1922, p. 81). Instead, its mechanisation and fragmentation of animal carcasses, human labour, physical space and symbolic ritual silently ensured the docility of both beasts and men. Men, like animals, became identical, positioned in a process which they did not control. The sanitisation of the slaughterhouses exemplified by the whiteness of tiles, oilcloth aprons and refrigerated trucks is thus paralleled by the asexuality of the white coats of the largely male doctors, engineers, scientists and architects managing the commodified body.

18 Ford's famous dictum—"You can have it [the Model T car] in any colour as long as it is black"—embodied Fordism's dependence on the standard commodity; his workers' ubiquitous six-dollar-day wage extended the fixed identity and price to a human producer and Ford's Taylorist management techniques ossified standardisation as ideology.

19 Indeed, under Fordism, the large numbers of women entering the labour market for the first time had been able to do so precisely only under these conditions. This had been their attraction.

20 Benetton has changed Ford's dictum to "Any colour as long as it is a sweater". See Murray, R., 'Benetton Britain: The New Economic Order, *Marxism Today*, November 1985.

21 Magali Sarfatti Larson explains why and how the commodification of the professional takes place: "professional work, like any other form of labour, is only a *fictitious* commodity; it cannot be detached from the rest of life, be stored or mobilised... it follows therefore that *the producers themselves have to be produced* if their products or commodities are to be given a distinctive form" (author's italics). Sarfatti Larson, M., *The Rise of Professionalism: A Sociological Analysis*, Berkeley, University of California Press, 1977, p. 14.

22 Economically, students are generally being weaned off the 'universal rights' to free education once promised by the modernist welfare state. Instead, poverty is preparing them for the 'business is war' ethos of the marketplace. In this battleground, women and ethnic minorities become the first ones to fall to the economic sword.

23 This is yet another post-Fordist euphemism which characterises job-insecure self-employment and the necessity of such workers to rely on a 'portfolio' of different clients—in fact, rather like the prostitute.

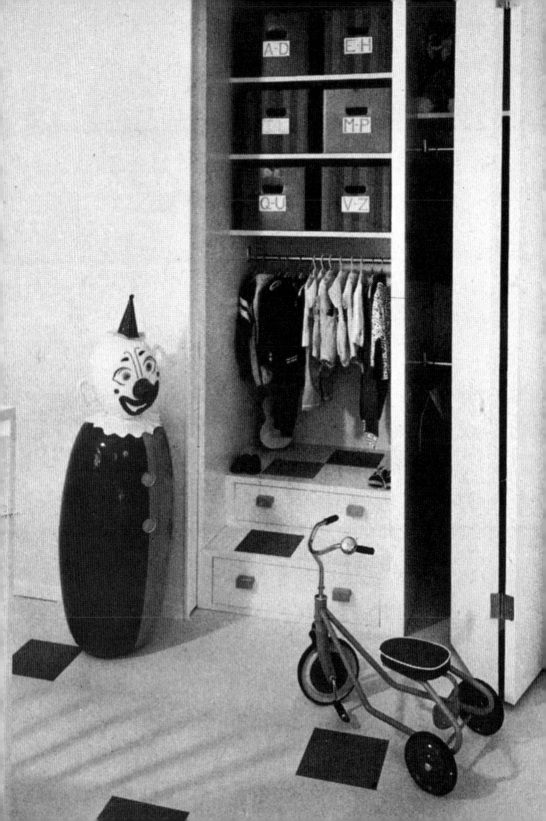

A-D E-H

M-P

Q-U V-Z

Desiring Practices
Henry Urbach

Closets, Clothes, disClosure

Child's closet. From S. Schuler,
The Complete Book of Closets and Storage, 1969

247

The word 'closet' holds two distinct but related meanings. On the one hand, a closet is a space where things are stored. In this regard we might say, "Your clothes are in the closet". But when we observe, "Joe has been in the closet for years", we are not recounting his efforts to match trousers and tie. Instead, we are describing how he makes himself known to others. In this sense, the closet refers to a way that identity, and particularly gay identity, is concealed and disclosed. Concealed *and* disclosed because gay identity is not quite hidden by the closet, but not quite displayed either. Rather, it is represented through coded gestures that sustain uncertainty.

These two closets are not as different as they might appear. Taken together, they present a related way of defining and ascribing meaning to space. They both describe sites of storage that are separated from, and connected to, other room–like spaces, spaces of display. Each space—storage and display— excludes and defines, but also depends upon the other. The non–room, the closet, houses things that threaten to soil the room. Likewise, in a social order that ascribes normalcy to heterosexuality, the closet helps heterosexuality to present itself with certainty. The stability of these arrangements—a clean bedroom free of junk, and a normative heterosexuality free of homosexuality— depends on the architectural relation between closet and room.

The two closets resonate against one another within a linguistic and material network of representations that organise the relation between storage and display, secrecy and disclosure. The sexual closet refers, through an operation of metaphor, to the familiar architectural referent. The built–in closet, in turn, petrifies and disseminates, as architectural convention, the kind of subjectivity described by the homosexual closet. The built–in closet concretises the closet of identity, while the closet of identity literalises its architectural counterpart.

Despite their overlapping meanings in the present, the two closets bear histories that remain distinct and irreducible. We will take each of these in turn, beginning with the built–in closet, and focusing in particular on the clothes closet, even though closets have also been used for storing linens, cleaning supplies and other provisions. The closet we know today was invented as a new spatial type in mid–nineteenth century America. For centuries, Europeans and Americans

12 X 12

12 X 18

Second floor plan for a
Labourer's Cottage. From A. J.
Downing, *The Architecture of
Country Houses*, 1850

had stored clothing in furniture; sometimes it hung from wall pegs or hooks. Now, for the first time, a kind of wall cavity was produced for household storage. Briskly disseminated among all social classes, the closet effectively outmoded wardrobe, armoire and chest. These free-standing, mobile cabinets (which still exist, but without the same primacy) had encased clothing within the precinct of the room. Now, the place of storage was at, or more precisely *beyond*, the room's edge.

Armoires, chests and the like are volumetric objects with unambiguous spatial presence. By contrast, the closet presents itself more surreptitiously. Where the former are decorative objects, often lavished with paint, carving and inlay, the closet expresses itself only by a door plane, often smooth and unadorned. Unlike the closet, storage cabinets often display locks or key holes to indicate their concealed interior at the exterior surface. Free-standing, decorated, upright objects, armoires and the like are able to suggest, if not quite imitate, the clothed human body.

From about 1840 onwards, the closet offered, instead, diminished architectural expression. The storage of clothing had been respatialised as a kind of shameful secret. The closet not only concealed the things it contained but, significantly, it also promised *to hide itself*.

One of the most influential of the mid–nineteenth century American "pattern books", Andrew Jackson Downing's *Cottage Residences*, first published in 1842, describes the closet in the following, perfunctory way:

> The universally acknowledged utility of closets renders it unnecessary for us to say anything to direct attention to them under this head. In the principal story, a pantry or closets are a necessary accompaniment to the dining room or living room, but are scarcely required in connection with any of the other apartments. Bed–rooms always require at least one closet toeach, and more will be found convenient.[1]

249

the necessary mouldings. A hint for the treatment of such

[Fig. 268.]

furniture may be taken from the plain Gothic wardrobe, Fig.

[Fig. 269.] [Fig. 270.]

269. Fig. 270 shows the interior of the same. Let this ward-

Illustration from A. J. Downing,
The Architecture of Country Houses, 1850

As spaces which merely *accompany* fully described rooms, closets are outlined in plan drawings but not otherwise elaborated. This is likewise the case with another pattern book of the period, Samuel Sloan's *The Model Architect* of 1852. Although Sloan lavishes attention on myriad aspects of house planning and construction, he mentions closets only in passing to say that they must be "fitted up and fully shelved".[2] Their height, ventilation, light, surface treatment and other spatial qualities are not represented at all. In these mid–nineteenth century texts, as in constructed domestic space, the closet was rendered barely visible.

Concealing the storage of clothes and other possessions, the closet may have served to address widespread ambivalence about material acquisition and the accumulation of excess. This ambivalence appears clearly in an 1882 lecture by Harriet Beecher:

The good sense of the great majority of business men—and women—is in favour of enterprise, and of that frugality and economy which shall result in amassing property.... And yet there exists at the same time in the community... a vague sense of the unspirituality of the treasures of this life, and of the dangers that inhere in them, together with some sort of conscience—they know not what—or fear.[3]

For Americans of the period, encountering an expanding industrial economy alongside the resurgence of Christian morality, wealth had come to represent both virtue and decadence. It could be amassed but not comfortably shown. In this context, it seems, Americans looked to the closet to moderate display while not interfering with actual possession.

The closet worked, along with other architectural strategies, to advance an extensive reform movement that aimed to invest the American home with signs of moral propriety. Increasingly strict codes of behaviour were given architectural form as, for instance, the stairway to second–floor bedrooms moved out of the entrance hall to a less visible part of the interior. Likewise, programmes and spaces once joined were separated into discrete rooms with

Clothes storage cupboards.
From W. B. Field, *House Planning*, 1940

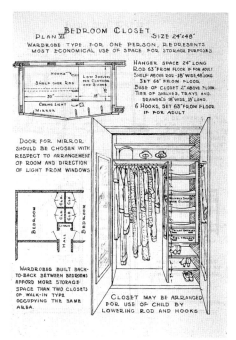

Bedroom closet for one person.
From M. M. Wilson, *Closets and Other Storage
Arrangements for the Farm Home*, 1934

distinct degrees of privacy. At a wide range of architectural scales, efforts
mounted to moderate the visibility of spaces now deemed private. Downing
proposed that the 'ideal' of domestic planning was to keep "each department of
the house… complete in itself, and intruding itself but little on the attention of
the family or guests when not required to be visible…".[4] Consistent with other
transformations of the American house, in a relatively small but powerful way,
the closet provided concealment without eliminating access.

Holding clothes in abeyance, the closet not only hid 'excess' in general terms,
but more specifically the sartorial multiplicity of the wardrobe. If a person's
various garments offer a repertory for self–representation, the closet served to
ensure, instead, that only those garments worn at any particular moment would
be visible. In this way, what was worn could sustain a kind of singular legitimacy.
The closet contained the overflow of garments and their meanings to heed
Downing's maxim, a statement which neatly captures the spatial thrust of the
era: "The great secret of safe and comfortable living lies in keeping yourself and
everything about you in the right place".[5]

In the course of the last century and a half, the architecture of the closet has
sustained a particularly strict relation between closet and room. Regardless of
adjacent conditions, the closet usually opens to a single room—a room it is said

to be 'in'—even though, in fact, it is *next to* this room, or between one room and another. In general, closets receive neither anterior nor lateral expression. Windows or doors rarely appear at the rear or side of the closet, even though they might serve to admit light and air as well as passage.[6] A monogamous relation thus emerges between the closet and its room, between the room and its closet. The room relies exclusively on its closet and the closet depends uniquely upon its room.

The threshold between closet and room mediates their relation, simultaneously connecting and dissociating the two spaces. Although the closet door may take many forms (among them, sliding, pocket and hinged single or double doors), the door always shuts to conceal the interior of the closet and opens to allow access. Moreover the door is usually articulated to minimise its own visibility, often set flush or painted to match the surrounding wall. As much as possible, the closet presents itself as an absence, a part of the (not–so) solid wall at the room's edge. According to a domestic planning manual from the 1940s: "Closets should not interfere with main areas of activity in a house. They should be accessible but inconspicuous".[7]

The tension between visual concealment and physical access has driven the architectural elaboration of the closet/room pair. But, despite its formidable architectural strength, it fails to contain the tension exerted by contrary imperatives: storage versus display, keeping things hidden versus keeping things handy. The closet, in the end, can only be so inconspicuous. The door cannot help but hint at the space beyond its planar surface. There is always some seam, gap, hinge, knob or pull that reveals the door as a mobile element. Moreover, the door displays the presence of the closet beyond by setting parameters for decorating and furnishing the room. One does not, for example, place furniture in front of a closet door as though it were part of the wall.

Holding things at the edge of the room, simultaneously concealing and revealing its interior, the closet becomes a carrier of abjection, a site of *interior* exclusion for that which has been deemed dirty. Julia Kristeva's psychoanalytic and socio–cultural analysis of abjection examines how things which are considered dirty and therefore subject to exclusion are never fully eliminated. Rather, they are deposited just beyond the space they simultaneously soil and cleanse. This partial, incomplete elimination keeps that which is dirty present so it can constitute, by contrast, the cleanliness of the clean.[8]

It is with this in mind that we can understand the peculiar architecture of the closet–room pair, along with its urgency for mid–nineteenth century Americans and continuing presence. Closet and room work together to keep the room

clean and the closet messy, to keep the contents of the room proper and those of the closet abject. They do not eliminate 'dirt', but reposition it across a boundary that is also a threshold. The closet door mediates imperatives of visual concealment and physical access, undermining the separation of closet and room while stabilising their difference.

The closet of sexual secrecy, named after the built–in closet, existed long before it was first called 'the closet' in the early 1960s. For at least a century, as David Miller, Eve Sedgwick, and others have demonstrated, the closet was a social and literary convention that narrated homosexuality as a spectacle of veiled disclosure.[9] The closet was the late–nineteenth century device by which "the love that dare not speak its name" could be spoken and vilified. It served a larger social project committed, as Michel Foucault has shown, to establishing homo– and hetero–sexuality as distinct and unequal categories of identity. Instead of polymorphic sexual practices, there was now a taxonomy of new sexual types. In Foucault's account: "The sodomite had been a temporary aberration; the homosexual was now a species".[10]

The closet organised homosexual identity as an open secret, a telling silence. Like the wall seams and door pulls that betray the closet, the absence of wedding bands and other positive assertions of heterosexuality would raise the spectre of gay identity even without forthright disclosure. One could neither be fully legible nor fully invisible; instead, dissemblance would serve to reveal a condition otherwise unstated.

'Heterosexuality' cast its abject other into the (yet unnamed) closet, at once nearby and far–off, hidden and accessible. Positioned in this way, the category of homosexuality accrued all the phantasmatic impropriety required by heterosexuality to secure its own proper domain, the sanctity of its own, tidy bedroom.[11] Excluded, but always just over there, homosexuality was identified with promiscuity and degeneracy. By contrast, heterosexuality was identified with procreation, fidelity and true love.

Despite its presence throughout the early part of this century, the homosexual closet was not named as such before the 1960s. The term 'closet', in this sense, arose in America during the period of political foment that produced, among other events, the Stonewall riots of June 1969. The nascent gay rights movements identified the closet as a tool of homophobic heterosexism and advanced a new battle cry: "Out of the closets! Into the streets!"

From then on, 'coming out' has been understood as the origin of gay identity, the *sine qua non* of physical security, legal protection and social dignity. 'Coming

out' is imagined, rather idealistically, as a way of rejecting the closet and its hold on gay self–representation. And, indeed, within a regime of (almost) compulsory heterosexuality, the personal and political value of coming out must not be underestimated. But, at the same time, its effects on the architecture of the closet should not be overstated. Where heterosexuality is presumed, coming out can never be accomplished once and for all. As Sedgwick has argued, the sustenance of gay identity (where straight identity is presumed) depends upon continuous acts of declaration.[12] To reveal gay identity in one situation does not obviate the need to reveal it again in the next. Every new acquaintance, every

Mark Carranza: Irvine, California.
Reproduced by Permission of
The Institute for the Prevention of Design

new situation demands a repetition of, or retreat from, disclosure.

For the past century, then, imagining an opposition of 'in' and 'out', gay identity has found itself in a double bind. Wherever one is, relative to the closet, one risks *both* exposure and erasure. But the binary logic of the closet/room pair, the rigid opposition of in and out, does not account for the dynamic entanglement of closet and room, the ways in which they constantly separate and reattach, the ways in which one is always *both* in and out, *neither* in nor out. This binary

obsession has radically constricted the ways that gay people feel they can 'disclose', rather than perform, identity.[13]

To come out and declare "I am gay"—whether to another person or to oneself— is to submit to a host of ideological imperatives: self–unity ("I"); immutability over time ("am"); and the given characterisation ("gay"). These are crude and brittle words, unable to capture the diachronicity and multivalence of identity as played out in social space. Performer k.d. lang seemed aware of this when, shortly after coming out in the national media, she appeared on the Radio City Music Hall stage, took the mike, and gingerly teased her audience: "I…AM…… (by now, soap bubbles had begun to fill the stage) …A………LLL……L…L……LL.:…. LLLL………LLLLLLL…… Lawrence Welk fan".

Toying with the architecture of the closet and its codes of disclosure, k.d. points toward the possibility of manipulating language, verbal and sartorial codes alike,

Across America, People Are Coming Out

NATIONAL COMING OUT DAY...

to elaborate 'identity' as a lively, ongoing process of resignification. This is something Mikhail Bakhtin theorised in his model of language as a site of social contest. The word, for Bakhtin, becomes "one's own" only when the speaker populates it with his or her own accent and adapts it to his or her own semantic intention.[14] Consider, then, the reinvention of the once derogatory 'queer', 'fag' and 'dyke' as affirmative terms. Or the practice, common among gay men during the 1970s, of displaying a coloured handkerchief in the rear jeans pocket. Appropriated from the uniform of labourers, the handkerchief served not only to display sexual orientation, but also to indicate, with considerable nuance, particular sexual interests. Extending from the inside of the pocket to the outside of the trousers, the handkerchief also recapitulated, at the scale of the body, the larger spatial relation governing the storage and display of gay identity.

In recent years, gay people have learned to re-articulate other, more overtly homophobic codes of dress: (macho) tattoos, (Nazi) pink triangle, (gym teacher) hooded sweatshirt, (military) crew cut, (femme fatale) lipstick and (skinhead) Doc Martens. These gestures of *détournement*—when done well, and before they ossify into new norms—underscore the relation of homo– and hetero–sexualities without necessarily adopting the violence and inequity of their opposition. They are simultaneously effects of the closet and moments of its loosening.

Since the closet was invented alongside homo– and hetero-sexuality over a century ago, gay people have needed to work with and against it. Often the closet has served homophobic and heterosexist interests. At the same time, however, it has also provided for other, surprisingly articulate meanings.

The impressive architectural stability of the closet notwithstanding, it has not always—and need not necessarily—describe a spatiality so rigid. A wide range of spatial practices, including architectural scholarship and design, offer opportunities to redress, provoke and reconfigure the relation of closet and room. Working with and against the closure of the closet, it is possible to produce an expanded space between closet and room. Here, in this realm between storage and display, between the dirty and the clean, new opportunities for the representation of 'identity' emerge.

Long before the built–in closet was invented, there was another kind of closet, a very different kind of space. From the late–fourteenth to the nineteenth centuries, the closet referred, in terms both architectural and social, to an inhabitable room. In England and much of continental Europe, the 'closet' (or its analogue, such as the French *grand cabinet*) described a place for retreat, prayer, study or speculation.[15] It served not only as a private sanctuary, but also

as a special repository for the storage and display of books, paintings, and other treasured objects.

During the fifteenth century in England, a closet particular to royal residences emerged. Closely associated with the private apartments of the sovereign or other nobility, this closet referred to a chamber used for retreat, writing, contemplation, small receptions and religious activities.[16] At Hampton Court, 'holy–day closets' were added in 1536 to provide the King, Queen and their invited guests with semi–private spaces of worship apart from the court.[17] Eventually, the closet also came to refer to a pew·in the chapel of a castle occupied by the lord and his family. Through its various incarnations, the royal closet allowed for gathering and interaction with others.

A private retreat, a small gathering space, a wall cavity for storage, a condition of gay secrecy: in what ways can the 'closet' continue to unfold, opening itself to other spatial forms, uses and meanings? Consider this: extending from the inside of the closet door frame to some distance in front of the closet, there is an interstitial space that appears, disappears and reappears again and again. Where the door slides or folds, the space is not so deep but, in the case of the ordinary hinged door, it is a space of considerable dimension. This is a space I call the *ante-closet*, the space before the closet. It is in the ante-closet where one selects clothes, where one dresses and undresses oneself, where one changes.

I recall my discovery of the ante-closet when I was a young boy. There, standing before a built–in closet, I discovered something about my own representational range. To be frank, this did not happen in front of my own closet, not the closet filled with the clothes little boys wore in New Jersey in the late 1960s. Instead, it was in my parents' room, in-between the hinged doors to my mother's closet, that I first found and learned to occupy this important little space.

On the inside surface of both doors was a tall mirror lit by delicate, vertically mounted fluorescent tubes. I remember pushing the switch as the lights flickered and hummed, then positioning the doors so the mirrors reflected space, and me, to infinity. Before removing my own clothing, I carefully selected an outfit from my mother's wardrobe—dress, shoes, necklace, handbag. The transformation was brief and private, as I never chose to display my new look to others. But it was a privacy that was profoundly limitless, a moment where selfhood and otherness became completely confounded. The paired mirrors redoubled every gesture to infinity as I saw myself, in a moment of narcissistic plenitude, transformed: grown–up, autonomous and lovely.

Claude Simard: *Bodysuits*, 1991, installation view.
Reproduced by Permission of the
Jack Shainman Gallery, New York

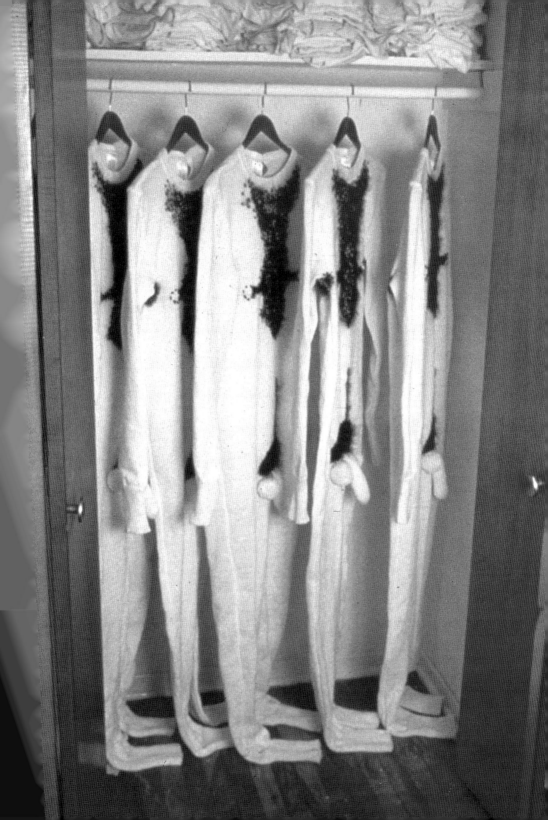

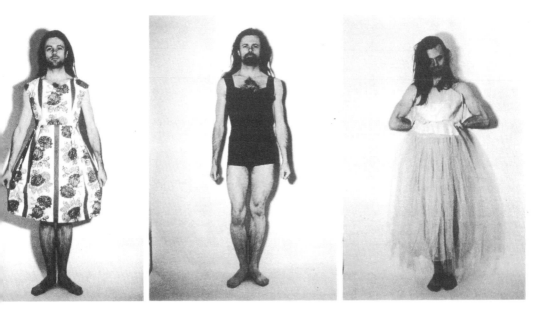

Chuck Nanney: Unique Colour Prints, 1992.
Reproduced by Permission of the Galerie
Jousse Seguin, Paris

Nowadays, despite my more gender–consonant wardrobe, I continue to extend my representational range in the ante-closet. Between the closet and the room, in this ephemeral space, I explore the effects of sartorial gestures and imagine their significance to others. Respectable merino cardigan? Raw leather tunic? Mao jacket? Velour cigarette pants? Where the ante-closet contains a mirror, I am able to consider these modes of identification visually, as others might see them. Where there is no mirror, I rely instead on memory and imagination. Private and social realms interpenetrate as the line between what I hide and what I show breaks down, and I start to see myself *as* another.[18]

The ante-closet can be further elaborated with reference to Gilles Deleuze's notion of the *pli* or fold. The *pli* is a space that emerges, both within and against social relations, to constitute a space of self–representation at once connected to and free from social norms. In the *pli*, Deleuze writes:

> ... the relation to oneself assumes an independent status. It is as if the

> relations of the outside folded back to create a doubling, allow a relation to
> oneself to emerge, and constitute an inside which is hollowed out and
> develops its own unique dimension…[19]

The *pli* is not a secure idyll, a place of unobstructed selfhood. But it is,
provisionally, an enclave. Social codes, inequities and violence penetrate the *pli*
through and through, and yet it remains possible, in this space, to work with
them. In the *pli*, the representational range of clothing, the multivalence of
sexualities and identities, does not threaten and does not need to be foreclosed.

The ante-closet has a curious status in architectural drawings, conventionally
rendered as a kind of graphic interruption. The notation for 'door swing' is an
arc that traces the passage of the unhinged edge from open to shut. Whether
drawn as a light solid line or a series of dashed segments, this arc does not
indicate, as other lines do, 'cut' material. Instead, it registers the possibility of
movement and spatial manipulation. At once conventional and abnormal, a
moment of graphic folding, the door swing draws attention to the possibility of
making and remaking space.

Like Doc Martens and hooded sweatshirts—worn by different people to diverse
effects—the ante-closet is an effect of reappropriations and resignifications
without end. It waits there, around the boundary between closet and room, for
reactivation as the space of changing. It neither obliterates nor interferes with
the spatial presence of closet or room, but brings them instead into a more
complex and fluid adjacency. An expanded edge between closet and room, the
ante-closet works with and against these spaces, dissolving their tired
opposition to sustain the possibility of another arrangement.

We can imagine other kinds of ante-closets, other ways of elaborating the
threshold between closet and room. A sliding rod that extends way beyond the
closet; an inhabitable closet that is spatially continuous with its room; a closet
that opens promiscuously to multiple spaces, even exposing itself to the exterior
of the house: these are among the alternatives open to further architectural
research. I have learned from my childhood encounter that the ante-closet is
most exciting, most able to enrich the relation of storage and display when there
is a play of scales from the bodily to the infinite and when the architectural
elements can be manipulated—slid, swung, pushed or grabbed. Sometimes the
ante-closet swells; at other times it recedes and disappears. It may be there if
we desire it, if we need it, if we make it come between the closet and room.

Acknowledgement
In addition to the organisers of Desiring Practices, I would like to thank the following people
for helping me to advance the essay: Stephen Hartman, Catherine Ingraham, Mary McLeod,
Joan Ockman, John Ricco, Brian Walker and Mark Wigley.

Notes

1 Downing, A. J., *Cottage Residences*, New York: Wiley and Putnam, 1842, p. 7.

2 Sloan, S., *The Model Architect*, Philadelphia: E. S. Jones & Co., 1852, p. 14.

3 Beecher, H. W., "The Moral Uses of Luxury and Beauty", *Outlook*, xxv, March 16, 1882, p. 257.

4 Downing, *Cottage*, p. 3.

5 Gardner, E. C., *The House that Jill Built, after Jack's Had Proved a Failure*, New York: W. F. Adams Company, 1896, p. 166.

6 An American house planning guide from 1940 notes: "*Ventilation* of the clothes closet generally waits for the opening of the door into the bedroom…. Daylight, particularly sunlight, is valuable as a steriliser, but we seldom manage to admit it to the closet". Field, W. B., *House Planning*, New York: McGraw Hill, 1940, p. 149.

7 Wilson, M., *Closets and Storage Spaces*, Washington DC: US Department of Agriculture Farmers' Bulletin no. 1865, 1940, p. 1.

8 Kristeva J., *Pouvoirs de l'horreur*, Roudiez, L. S. (trans.), Paris: Editions du Seuil, 1980, *Powers of Horror: An Essay on Abjection*, New York: Columbia University Press, 1982.

9 See Miller, D. A., *The Novel and the Police*, Berkeley and Los Angeles: University of California Press, 1988, especially Chapter 6: "Secret Subjects, Open Secrets". Also see: Sedgwick, E., *Epistemology of the Closet*, Berkeley and Los Angeles: University of California Press, 1992.

10 Foucault, M. *La Volenté de savoir*, Hurley, R. (trans.), Paris: Gallimard, 1976, *The History of Sexuality*, vol. 1, New York: Random House, 1978, p. 43. Foucault writes, on pages 42 and 43: "This new persecution of the peripheral sexualities entailed an *incorporation of perversions* and a new *specification of individuals*. As defined by the ancient civil or canonical codes, sodomy was a category of forbidden acts; their perpetrator was nothing more than the juridical subject for them. The nineteenth century homosexual became a personage, a past, a case history, and a childhood, in addition to being a type of life, a life form, and a morphology, with an indiscreet anatomy and possibly a mysterious physiology. Nothing that went into his total composition was unaffected by his sexuality."

11 Diana Fuss writes: "Homosexuality, in a word, becomes the excluded; it stands in for, paradoxically, that which stands without. But the binary structure of sexual orientation, fundamentally a structure of exclusion and exteriorisation, nonetheless constructs that exclusion by prominently including the contaminated other in its oppositional logic. The homo in relation to the hetero, much like the feminine in relation to the masculine, operates as an indispensable interior exclusion—an outside which is inside interiority making the articulation of the latter possible, a transgression of the border which is necessary to constitute the border as such". Fuss, D., "Inside/Out", in *inside/out*, Fuss, D. (ed.), New York: Routledge, 1991, p. 3.

12 Sedgwick writes: "Furthermore, the deadly elasticity of heterosexist presumption means that, like Wendy in *Peter Pan*, people find new walls springing up around them even as they drowse: every encounter with a new classful of students, to say nothing of a new boss, social worker, loan officer, landlord, doctor, erects new closets whose fraught and characteristic laws of optics and physics exact from at least gay people new surveys, new calculations, new draughts and requisitions of secrecy or disclosure." Sedgwick, *Epistemology*, p. 68.

13 Judith Butler asks: "Is the 'subject' who is 'out' free of its subjection and finally in the clear? Or could it be that the subjection that subjectivates the gay or lesbian subject in some ways continues to oppress, or oppresses most insidiously, once 'outness' is claimed? What or who is it that is 'out', made manifest and fully disclosed, when and if I reveal myself as lesbian? What is the very linguistic act that offers up the promise of a transparent revelation of sexuality? Can sexuality even remain sexuality once it submits to a criterion of transparency and disclosure, or does it perhaps cease to be sexuality precisely when the semblance of full explicitness is achieved?" Butler, J., "Imitation and Gender Subordination", in Fuss, *inside/out*, p. 15.

14 Holquist, M. (ed.), *The Dialogic Imagination, Four Essays by M.M. Bakhtin*, Emerson, C. and Holquist, M., (trans.) Austin: University of Texas Press, 1981. On pages 293 and 294, Bakhtin writes: "As a living, socio–ideological concrete thing, as heteroglot opinion, language, for the individual consciousness, lies on the borderline between oneself and the other. The word in language is half someone else's. It becomes 'one's own' only when the speaker populates it with his own accent, when he appropriates the word, adapting it to his own semantic intention. Prior to this moment of appropriation… it exists in other people's mouths, in other people's contexts, serving other people's intentions: it is from there that one must take the word, and make it one's own…".

15 According to the *Oxford English Dictionary*, a text from 1374 notes: "In a closet for to avyse her bettre, She went alone". A novel of 1566 states: "We doe call the most secret place in the house appropriate unto our owne private studies… a Closet.". *Oxford English Dictionary*, 2nd ed., vol. III,

Oxford: Clarendon Press, 1985, s.v. "Closet", p. 349.

16 According to a text from 1625: "If the Queens Closet where they now say masse were not large enough, let them have it in the Great Chamber". *Oxford English Dictionary*, p. 349.

17 Bickereth, J. and Dunning, R. W. (eds.), *Clerks of the Closet in the Royal Household: 500 Years of Service to the Crown*, Phoenix Mill: Alan Sutton, 1991, pp. 5–6.

18 Ricœur, P., *Soi–même comme un autre*, Blamey, K., (trans.) Paris: Editions du Seuil, 1990, *Oneself as Another*, Chicago: University of Chicago Press, 1992. On page 3, Ricœur writes: "… the selfhood of oneself implies otherness to such an intimate degree that one cannot be thought of without the other, that instead one passes into the other…".

19 Deleuze, G., *Foucault*, Paris: Editions de Minuit, 1986. Hand, S. (ed. and trans.), *Foucault*, Minneapolis: University of Minnesota Press, 1988, p. 100.

Gender
and an
architecture
of

Brenda Vale

environmental
responsibility

This paper introduces a discussion and definition of the concept of an architecture that is environmentally responsible. It suggests that such an architecture is incompatible with the modern quest for innovation and originality in design. Parallels are drawn with the traditional domestic role of women in society, which eschews innovation in favour of the repetition of actions with a long cultural tradition—cooking, sewing, knitting, child-rearing. The suggestion is made that women who accept this traditional role and identify their feminism with it are potentially more effective at producing an architecture of environmental responsibility than those who wish to emulate the traditional male role of the one-off act of innovative creation. Equally, men who embrace, metaphorically, the repetition and sameness of the domestic sphere may be more accepting of the need to create a self-effacing and environmentally responsive architecture.

Art, and perhaps Architecture, could be defined as the consumption of resources for the creation of a product or goal that is not necessary for survival, but that is desirable for cultural or symbolic reasons. However, an architecture that is environmentally responsible could be defined as one that responds to climate; minimises its use of resources; is responsive to change, to repair, to re-use etc. and that is produced essentially to aid the survival of life on the planet. The question is, therefore, can environmentally responsible architecture contain the necessarily superfluous symbolic gesture within its minimal use of resources? Or, because it tends to produce repetitive climatic and site-specific solutions, can it never claim to be an art because essentially it has to lack innovation? In terms of the definitions of the woman's role drawn above, an environmentally responsible architecture is culturally traditional, akin to the role of woman in the domestic sphere.

In fact, the definition of an environmentally responsible architecture parallels a possible definition of vernacular building. This latter is normally thought of as building that provides necessary shelter and that responds to its place through its siting and use of local materials. It must be recognised that vernacular building does not necessarily imply that the building is actually constructed by the users for themselves. It can be, but it can also be large scale and constructed by an organised team of trained specialist craftsmen. Brunskill

recognised this in his establishment of vernacular size-type, enshrined in "the Great House, the Large House, the Small House and the Cottage".[1] However, vernacular building is not regarded as an art form, nor is it concerned with the innovative and visually unusual or different. This is not to say that aesthetics are not considered within the vernacular approach; the symmetry with which windows and doors are placed, the handling of scale and exterior form often suggest that aesthetics are important. Nor does it follow that only one solution is the appropriate one for a particular location: any Cotswold village shows that the same material used in the same climate produces different buildings. However, these buildings are all related and belong to a family. What is missing, just as with an environmentally responsible architecture, is the novel and innovative solution for its own sake.

This is not to say that a society concerned with the responsible use of available materials could never produce symbolic buildings. The existence of the great medieval cathedrals would tend to suggest that this was not the case. The cathedrals were the product of both a Europe that was far more united than it is today, and a highly organised and highly trained specialist building industry. However, they did not, on completion, represent one person's architectural vision, and they were altered and adapted over the centuries in response to newly defined needs. This was so much the case that often it was not thought worthwhile to record the name of the individual designers of the buildings. Nor are the buildings necessarily innovative in overall architectural form, although detail and decoration may differ. These great symbolic buildings are based on a bay structure which is equally appropriate for a house, but which, when transferred to the scale of the nave of Lincoln or Salisbury Cathedrals, becomes a major feat of engineering. Thus the ordinary had a direct link with the symbolic. The quality and quantity of decoration also signified that more time and effort had been expended on the larger and more symbolically important building. Moreover, every individual sculptor, glazier, mason and carpenter contributed to the design as part of the process of making, and the final product could not be anticipated in all its details because of the nature of the process that gave rise to it. A stonemason in the thirteenth century understood the way of working with the material under the chisel, allowing the design to alter and evolve as the stone was cut, but keeping within the same design intention, so that each stiff leaf capital in, say, the nave at Wells Cathedral, is not a true copy of the next, but a copy only of the overall intention.[2] This approach runs through the whole building to give an individual difference to each despite the similarity of the main concept: the overall form of Lincoln is not so different from that of Salisbury, but each building's individuality is instantly recognisable.[3] The symbolic building here represents the changing aspirations of a collective rather than the single artistic aspiration of the individual.

Opening any recent architectural journal reveals how far design has moved from this vernacular approach to an obsession with architecture which, like art, is novel. Architecture is now appraised on what it looks like and how different this appearance is from anything that has gone before. Very few buildings are now judged on how easy they were to construct, how well they respond to climate, how easy they are to recycle: issues fundamentally connected with minimising the resources that go into any building. For the architectural critics writing in the journals, these appear to be lesser considerations than the basic 'god' of aesthetics. All attention is now focused on the final product and very little on the process or the performance of building.

Parallels can be drawn between these approaches to architecture and involvement of men and women within different spheres of the arts. Women have been renowned as ballet dancers, opera singers and actresses, leaving men to produce the paintings, the musical compositions and, since the Renaissance, the great architectural statements. Historically, women have tended to be involved in the arts that concentrate on the process of the experience, whereas men have created the artistic products.[4] Pavlova is still known as a very great dancer, even though few living have seen her dance. The art of the process lives on in cultural memory whereas the art of the product lives on in physical reality.

However, no building can be said to be environmentally responsible unless the process of construction and the performance of the product are included in the overall judgement. To judge such a building on the product alone is not enough. Traditionally, these areas of performance are where women have excelled in the arts. Women, rather than breaking from these roles to emulate those of men, may see that they can contribute more to the development of this type of architecture if they accept these traditional process- and performance-focused roles.

The observation that the involvement of women in the arts has been linked to process rather than product has parallels with the way that women operate within the domestic environment. Bringing up children in the home, the traditional role of women, is a process that results in the children leaving. There is no product, only the memories of childhood. This is comparable to the cultural memory of Pavlova's dance. The work and effort that women put into the home, whether or not they also work outside it, never has a discernible product, it leaves only a trace in memory. Conversely, when men talk about their lives, they talk frequently in terms of products: the career, the promotion, the company car, the pension.

The art of the process and performance also involves the user in a way that the art of the product does not. It is within cultural memory that the art of performance is recorded, that is, within the memory of the audience. As such it becomes changed and altered by that audience. In the same way, a building that is environmentally responsible will, of necessity, include the user as part of the overall system. The conventional idea of the 'green' building may give rise to a structure made of recycled timber, with a grass roof and non-toxic finishes. Such a building has given consideration to the use of resources, but all these moves do not necessarily react with the building user in any way which is different from a conventional building. The user may be invited to view the materials and form as a simple abstracted but 'greenish' sculptural element within the landscape. However, the environmental goal of, for example, only using within the building the water that falls upon its roof, involves each user of that building. Each user's response to this goal will determine whether the goal can be achieved. At some point in the design process, the designer has to empathise with the future, and unknown, building user to determine whether it is possible to achieve the goal through the user, or whether the solution will not be accepted. It is impossible to conceive of a building that is to be heated by heat gains from its living occupants without the occupants being aware that they are part of this strategy. The attempt to distance the building users from the target goals seems a dead end approach; the Wallasey School used the heat gains from the school children and the lighting to maintain acceptable internal temperature levels, but attempted to control the users through providing very heavily sprung door closers, so that external doors could not be left open and heat lost.[5] Consequently, it was a great effort for a small child to open the door, which sends strange subliminal messages about the relationship between the child and the school as represented by its building. Perhaps an architecture that is environmentally responsible will end the era of the user who never interacts with the building and the expert who dictates internal conditions without any direct feedback from the users.

To empathise with any users of a building it is necessary to be able to imagine oneself within another sphere. To do this, it is necessary to understand the material world that makes up that sphere. So much of an intrinsic understanding of materials and their use has been lost in the modern world of flat-pack architecture, where components manufactured in factories are just assembled on site, forcing both designers and users to become divorced from the process of making. However, a woman is still brought up to absorb skills in an informal and experiential way, rather than only to learn skills in a formal academic setting. Just as the thirteenth century stonemason was apprenticed and learned through 'doing', so much of the work in the domestic sphere, the work that underpins society—the work of cooking, cleaning, child-rearing, sewing—is still work that

is handed down within the home, rather than taught in the schoolroom. It is still women who cook and sew and make up stories for their children, using skills which have been learned through observation, participation and practice, just as the apprentice stonemason developed skills in the past. With the rise in rational and abstract thinking that came with the Renaissance, this experiential approach to learning which produced the great medieval monuments was shifted down the social scale, where those who were intellectually less able held on to the craft tradition and, in building terms, produced those structures that are now recognised as responsive to climate, careful with resources and materials, that are recycled and reused. Industrialisation pushed this vernacular even further to the fringe where it clung on as the popular arts, for example the art of painting fairground equipment, canal art, even the simple act of sign painting, at least until the middle of the twentieth century.[6] Now such traditional craft-based skills have been squeezed further to reside only in the home and in the hands of women. It is still women who knit by hand, and even this is now a dying craft. Is knitting the last vestige of those empirical skills that made the great cathedrals?

If one way of achieving an architecture of environmental responsibility is to recreate the vernacular approach, which might include an experiential learning of building skills, is this still possible today? If Ruskin failed to imitate this approach in the nineteenth century, when the building industry was still largely craft-based, then there is little hope for a building industry that is essentially an assembly of manufactured components with builders increasingly following the manufacturer's specifications and instructions for assembly, rather than interpreting the intention through the use of their own skills.[7] There is only one way to assemble a dry-wall partitioning system according to the manufacturer's instructions, but more then one way to finish a wall of traditional sand-cement plaster. This MFI rather than Makepeace approach again concentrates on the product at the expense of process. The variation that might have been brought in through each contributor to the construction process, introducing an individuality of detail, is absent in the age of the flat-pack building, as design is separated from construction. The current methods of design education, particularly architectural design, do not encourage the learning of building skills and such learning as does occur takes place in the lecture room rather than on the building site.

Moreover, the ability to anticipate building performance, particularly where there is a necessity to empathise with potential building users, is also something seldom taught as part of an architectural education. The aspects of design that relate to process and performance are confined to the lecture room, with no attempts made to link these into the studio design projects. Indeed, creativity is thought to be undermined by technological considerations, and the building user is often seen at best as an absence and, at worst, as an annoyance.

However, if an environmental architecture requires the co-operation of the building user, then what is needed is a system that can imagine the unpredictable in a situation. A tree grows in response to unpredictable stimuli within the environment and the environmentally responsible building needs to do the same. Hence, the requirement for designers to be able to empathise with the user as the user responds to the totality of the building and not just to the isolated part of a small sub-system of a sub-system. The approach must of needs be holistic. To what extent is this holistic approach more the natural gift of the female rather than the male? Is it possible to accept the myth that exists in society that women have the gift of empathy, and, if accepted, does this mean that women are more likely to produce an environmentally responsible architecture?

The problem is not, perhaps, seeing empathy as a female attribute, but rather thinking again about the traditional domestic role of women and how this might relate to an empathetic approach to architectural design. The empathetic approach is hard to demonstrate if the building is viewed only as a product, for hidden work is involved that may not be visible in the presentation drawings for the exhibition or the glossy uninhabited photographs for the journals. The more the views of numerous building users are taken into account with their varying needs, the more difficult it is to suggest that there is one ideal novel design solution to the brief. Rather than the tight fit solution, the approach has to be one of 'long life, loose fit', which, like the cathedral building discussed earlier, may change over the years. It may be that women can accept this approach because of the parallels with the traditional woman's role in the domestic sphere; it is accepted that this work is unregarded and largely hidden.

The real problem is that not only is this work in the domestic sphere disregarded, but it is also denigrated by women who are keen to become the career equals of men. Perhaps this wish is no more than an unconsidered reaction to the ideas of St. Augustine, which still linger in a Christian culture. He stated that the woman was the vessel that nurtured, but she was not the source of the materials that produced the next generation.[8] If science has now revealed that material from both parents forms the next generation, can this not be accepted without the need also to assume male values and denounce the traditional female roles as second best? Much cultural tradition is lost with the jettisoned traditional female role, particularly that of knowledge and skills handed on from one person to the next, knowledge often reinforced by repetitive actions and rote learning, approaches to teaching that are still regarded as old-fashioned and regressive. However, it is just this experiential learning that is required if an architecture of

environmental responsibility is to be realised, together with the acceptance that much of the work and effort put into the process of making may not be evident in the final product.

That women should have equality with men is indisputable. The problem arises when women want to behave as men, thereby jettisoning all the cultural traditions of what it means to be female. The skills and knowledge that rest with women in the domestic sphere are dismissed as being of no value, for they have no association with men and their goal centred approach to the world. It is, after all, this goal centred approach that has produced the environmental problems of the industrialised world. However, an architecture that is environmentally responsible has to belong to its locality, it has to work with the elemental forces that surround it, it has to be self-effacing. The hope is that women will realise that they are, at present, the best people to understand this need, providing they are prepared to retain a female cultural tradition.

Notes

1 Brunskill, R. W., *Illustrated Handbook of Vernacular Architecture*, London: Faber and Faber, 1971, p. 22.

2 The transepts and eastern bays of the nave of Wells Cathedral were completed by 1215. The figurative scenes and images introduced to some of these stiff leaf capitals only serve to underline the different approaches of the separate stone carvers: compare the foreshortened narrative figures of 'the fruit stealers' in the south transept with the integrated but naturalistic approach of 'the lizard corbel' in the north transept.

3 Lincoln and Salisbury Cathedrals contain the same elements of vaulted nave, double square ended transepts, retro-choir, cloister and polygonal chapter house. Lincoln, however, was constructed over a longer period (1191-1256) and shows development and change, whereas Salisbury, which was started in 1220 and substantially complete by 1258, is far more consistent in its design approach.

4 There are individuals that cross these boundaries (there are more male orchestral conductors than female, a conductor being involved in the process of making music), but the trend is discernible.

5 Clayton, W. P., *Notes on the new St. George's Secondary School*, County Borough of Wallasey, Cheshire, 1966; Davies, G. M., Sturrock, N. S. and Benson, A. C., "Some results of measurements on St. George's School Wallasey" *Journal of the Institution of Heating and Ventilating Engineers* Vol. 13, July 1971, pp. 77-84

6 Jones B., *The Unsophisticated Arts*, London: The Architectural Press, 1951.

7 "Ruskin had, for instance, acted as adviser to Deane and Woodward in the building of the Oxford Museum. The employment of a genuine Irish peasant craftsman to carve the stone ornament, did nothing to mitigate his disgust, or to deter his resignation, in the matter of the iron roof". Furneaux-Jordan, R., *Victorian Architecture*, Harmondsworth, England: Penguin Books, 1966, p. 135. It was the technology of the iron roof that was developed and exploited in the architecture of the next century, not that of the hand-carved decoration.

8 "… him from whom and her in whom you formed me in time". Saint Augustine, *Confessions*, Chadwick, H. (trans.), Milton Keynes: Open University Press, 1991, p. 6.

Desiring Practices Exhibition, October 1995.
RIBA Architecture Centre.
Photo: Rut Blees Luxemburg

Practice: the Significant Others

Introduction

A dinner party in a north London kitchen, October 1993. At the table are five women and two men. Our host has invited a group of architects to swap ideas for a future, as yet unknown, project. The conversation turns around current pursuits and preoccupations, predominantly focusing on work. Trained as architects, we are all practising 'architecture' in some form, but these forms are varied, marginal, and certainly do not reflect the idealised image of the architect-hero we were led to expect. For some, a series of part-time jobs with no security or advancement is an economic imperative, while others are trapped within the limits of a traditional career path. These choices may be the manifestation of millennial labour conditions, but something else is at stake. This very gathering signifies a shared feeling that our occupation leaves us with a sense of dissatisfaction, a lack. A lack of space, or territory, or autonomy, in which to practice our desires. It is more than a sense of disenfranchisement: it is a feeling of symbolic castration. Can it be a coincidence that most of us are female?

The traditional classifications which keep theory remote from practice, writing remote from construction, sexuality remote from administration (to cite three arbitrary examples) were evidently problems within our own activities. Although our experiences were personal and singular, the replication of boundary transgressions across a range of architectural working practices suggested a more structural deficiency. Borne out by common experience, we shared a conviction that the regulated space of architectural practice was restrictive, limited in its scope, underdeveloped, inflexible; its interests did not acknowledge our experience or satisfy our architectural desires. Where was the scope for a desiring practice?

'Skirting' the issues

The technical-rational ideology of architectural practice (which limits it to professionally defined services representing an 'ideal' state of architectural production) fails to account for the changing activities many architects actually perform. While acknowledging that such activities are related to broad social changes, I contend that the forms of practice taken up within the broad category of architecture have other influences, the origins of which are simultaneously invisible (patriarchy), but also close to the surface (only 9% of architects are female). In common with other cultural products, the structure and ideology of the profession, its values and interests, predominately reflect phallocentric interests. Although a profession with a liberal public image, architecture ironically finds scant space to locate the female or the feminine either as a symbolic or a corporeal presence. It is time for architecture to put its own domestic space in order.

Desiring Practices developed out of an urgent need to investigate the forbidden spaces of architectural practice, taking gender as the focus of its enquiry. While many forms of architectural expression—writing, publishing and becoming active at a political level—remain under-scrutinised, Desiring Practices specifically wished to challenge the order of practice. Starting with our own experiences, we wished to explore the myriad emancipatory ways in which architectural production can take place. Our intention was to find new sources for beginning an investigation into the multiple directions that architectural work can take, in an attempt to find a new acting position for those—men as well as women—whose voices and bodies are currently excluded from the architectural mainstream.

For myself, a personal mission runs in parallel with the more general aims of the project. My own work has always fallen somewhere between practices, crossing as it does between writing, teaching and building. An 'identity problem', not so much for myself as for others. As an architectural assistant, working in London's building boom of the 1980s, a desire to go into education was regarded at best, with suspicion, at worst as treachery. Every bureaucracy I have encountered has bargained for my soul—my total commitment. What I have regarded as an attempt to maximise the benefits of variety, adventure and exchange has been interpreted by patriarchal organisations as flirtation, absence of single-minded purpose and unreliability. While for me the transgression of boundaries is an enriching experience, I have learnt that others do not share this opinion: I do not declare the existence of an 'other' life if my livelihood depends on it. While this is a problem for men and women alike, it is clear that a gender issue is implicated here. Working practices—conditions of part-time work, the structure

of the working day, the division between office and home, the ways pension rights and benefits are calculated, the ways in which education and practice organise given periods of life—are arranged by men to suit men. Part-time practices are, and have always been, women's misfortune.

The personal

My personal interest is in how the social construction of sexual difference, and the value ascribed to gender roles, becomes institutionalised in the practices of everyday (including professional) life and how one can change them. Recently, architectural scholarship has begun to address this issue and this work has been received by an eager audience, clearly recognising a collective lacuna in the traditional concerns of architectural discourse. This work has tended to take up a position of theoretical postmodernism. However, an important part of feminist research is to step outside of the circular logic of rationalised theoretical thought and to reformulate the terms of the argument in relation to (women's) lived experience of the political and social world. Its aims are social, but its means are personal, political and symbolic. At least for me, therefore, questions of gender (perhaps more than sexuality) are a fertile but under-explored territory in which to make a critique of dominant ideologies and their social practices. Such critiques begin with my own experience.

To focus on the exclusion of women opens to interrogation concerns about the spatial and material practices of architecture. It raises questions such as who is allowed to speak, who has access to architectural products, as well as the social and working relationships which produce its spaces—which production methodologies prevail, and who claims authorship. Received wisdom limits the possibilities for rethinking the values ascribed to these spaces, and access to the political processes that allow us to change them. For instance, women's experience of the streets, parks and public transport, as well as housing—the city—is not the same as men's, but with some notable exceptions, architecture remains indifferent to this 'other' experience. We need to debate what is meant by 'tidy', 'humane', 'safe', 'clean': concepts that architects regularly accept unquestioningly. One of the questions Desiring Practices poses is: who is the ultimate judge of what things 'mean'? Meaning is the product of creative dialogue which puts the individual—the 'I'—into play. Who decides the value of my work and how I should produce it?

The Desiring Practices project proposes criticisms that raise questions about epistemological validities within the discipline of architecture. Architecture has a long relationship with the ideology of 'mastery', not only at the symbolic level ('God, the architect of the Universe') but also at the practical. Mastery implies a

totalising ethos which reduces temporal, topographical, sexual, material, conflictual difference to the masculine, singular, active. Its ideology of domination through knowledge, represented in the profession's publications such as the RIBA's *Plan of Work*, belies the shrinking realities of the profession.

> The Plan of Work… sets out… the key tasks of the architect's management function. The responsibility here is to foresee, as far as practicable, all the problems that are likely to arise, to make arrangements to ensure the solution to them in good time, and to take the necessary action on unplanned eventualities. In this role of leader the architect's responsibility is total… *He* [my emphasis] should create a complete guide to the action of the whole job…[1]

Although business-oriented firms to whom this document is addressed (and who form the profession's most powerful voice) lean towards the large and multi-disciplinary, with its attendant desire for total control, there is now huge scepticism in the masterplan as a viable operational and design strategy. This is an ironic liaison that unites social groups as disparate as community activism and *laissez-faire* politics, including Desiring Practices.

Notwithstanding the attempts to define practice through instrumental procedures, it is precisely because the contingent conditions of practice are impossible to predict that it maintains its ability to challenge, surprise and confound. To keep practising is to develop, to know more, to acquire judgement. But every situation presents the unforseeable: the *un*known. To me, this is the most pleasurable part of practising: it is also the reason why it is so rarely theorised. Desiring Practices wanted to scrutinise the terms of practice's theorisation and claim back its procedures as flexible situations of unique, participatory and pleasurable activity. In turn, it was important for us to theorise the forms of practice adopted.

I see the production of the events by Desiring Practices as a form of architectural practice in itself. On a personal level, as a 'practising' architect, it absorbed a considerable proportion of my life (working and otherwise) over a period of two years. In one sense of the word 'practice', therefore, the project manifests aspects of the truly habitual. To the extent that it depended on the events' success, however, the project was not a question of 'just practising'. It was a one-off performance which had to work first time round. This is also the case with building projects. An attention to detail, an appreciation of the complexity and connections of various aspects of the project, an ability to anticipate desired goals and to deliver them on time are common to Desiring Practices and building projects alike.

My other practices—the production of buildings, drawings, writing and research—were usurped to make space for Desiring Practices. Yet in many ways the activities engaged in and the knowledge used on the latter slip imperceptibly between the category of builder, writer or researcher and that of symposium and exhibition organiser. The tasks involved share numerous similarities: programming, project management, fund-raising, dealing with bureaucracy, marketing, and they can be ordered in the same way as the *Plan of Work*: inception, feasibility, design, cost analysis, tendering, site supervision. In addition, our project demanded the habitual tasks of the manager: setting up structures of office administration, evaluating successes and failures, staff resourcing and recruitment, spatial organisation and financial planning to name but a few. Moreover, public relations, publicity and fund-raising played a major role in the project and confirmed for me the importance of the architect's role in the construction of her own identity.

Unlike practice, however, the making of Desiring Practices cried out for a reassessment of the conventional relations of production and representation of the architectural project. As one form of desiring practice, it was important that our own practice attempted to address some of the shortcomings our own critique had identified.

The political

The problem of the binary raises interesting questions in relation to a commitment to the representation of multiple voices and desires. For me, the relativism of competing narratives fails to address two fundamental practical problems in the struggle to change the status quo. At a practical level, we have to start by acknowledging that our society is structured, at a symbolic level, around a binary whose foundational difference is sexual (the biological and symbolic possession/lack of the phallus). Although the challenge to this symbolic framework is an essential project because it is of crucial significance for the fundamental shift in society's order, there is an urgent need for political and social strategies for action while we await the dismantling of existing structures. I argue that such strategies *must* employ the binary, so as to demonstrate the injustices and inconsistencies which lie behind the 'truth' of patriarchal culture. We must use the binary against itself. While the binary insists on the categorisation of difference, to erase such difference before the dominance of the existing framework has been broken and the 'other' has found a voice, is to subsume the voice of the 'other' to that of the dominant ideology and in the process to erase it.

The acknowledgement of multiple positions (such as those which privilege race, class, production or capital) implies a relativity of theoretical critiques that, it has been argued, locate feminism as just one among many views competing for position. This offers the tactical advantage of enlisting solidarity from other voices that would seek to undermine the white/male/western/heterosexual/middle class frame of the world. However, the theoretical equality of sexual 'otherness' is called into question when subjected to the critique of the specificities of the social and political world. While there is an obvious problem with meta-narratives of feminism that attempt to elide the differences between women across social, economic, racial and geographical boundaries, it remains possible to contextualise the position of women in the social realm without resorting to a crude biologism. Insisting on the acceptance of the prevailing binary of sexual difference as the starting point for a critique of current conditions does not negate other differences: it simply locates the condition of being female (spatially, economically, geographically) as a fundamental particular in the realm of the 'others'. I claim, therefore, that important as it is to maintain the multiple narrative at a theoretical level, at a pragmatic one, the efficacy of the binary has yet to run its course.

Desiring Practices was conscious of difficulties in dealing with these issues, at times knowingly using the binary and at others deliberately using strategies that worked against it. The project itself took shape under the conventional classifications of textual and visual work (symposium and exhibition)—itself a binary classification. It followed that the team was bifurcated around the organisation of these two events as well. While this could be regarded as an illustration of the hierarchical and binary division characteristic of the dualities practice/education, theory/design, conception/making, manager/worker, in practice the situation was more fluid. While it is probably true that the three founder members of the project had most freedom to move between these individual sites of action, the project re-evaluated for many of us the interdependence of various forms of architectural production (specification writing, building work, scheduling, the working drawing, management) and demanded a reassessment of the importance of all the components of the team's effort in order to achieve our goal. In as much as Desiring Practices mirrors architectural practice, reconsidering the relationship between 'designer' and 'executor', the form taken by the written, the drawn and the object, the sites of bodily and imaginative encounter, and the means of recording the actual process, demonstrates the purpose of re-evaluating the instruments and the knowledge of architectural production.

In common with other feminist projects, Desiring Practices shared a commitment to developing new paradigms of criticism and of action which rejected conventional philosophical epistemologies which have been shown to be partial, historically contingent and politically interested. However, as these theories have passed into mainstream culture they have come to be regarded as a historical, objective and 'natural', so much so that they have become invisible. The 'neutrality' of such 'truths' remain unchallenged because their interests go unrecognised. In patriarchy, the phallogocentric position of the 'truth' takes primacy in the order of things. A woman's position is spoken *for* her. In order to define a new 'speaking position' which acknowledges the gender of the speaker, there must be an insistence on new strategies of reference over and above 'the subjective'. The Desiring Practices project requires a renegotiation of the terms and conditions on which architectural debate can take place. This means relinquishing—and asking others also to relinquish—existing relations of 'truth', and an acceptance of a revised vision in which realities and appearances are no longer considered self-evident and taken for granted.

The key to such a project implies a willingness to risk one's creativity without securing for it the safety of a known outcome, which is to say, incorporation within a shared theoretical framework. On the other hand, there is a danger that to relinquish any reference to existing theory is to risk incoherence or to retreat into the silence of subjectivity. Therefore, this project insists that a new relationship is established—one in which the revisionary position can be taken up only with respect to current norms of practice and theory. In our case, the strategy was to subvert the ordering implied by the binary, expecting that other readings would emerge. The problem with this aim may perhaps best be illustrated with reference to the following quote taken from a review of one of the project's exhibitions: "… it all remains a bit nebulous, and inevitably one's suspicion is that the intention is not entirely clear either… one feels a lot of issues are being rolled into one, with a resulting loss of focus".[2]

The project's reception by the press, sponsors and audience is interesting with reference to the representational strategies of the project. In the sense that buildings have a life beyond the control of their designer, Desiring Practices has a public life independent of its originators. This allows for multiple interpretations and engagements. While being democratic (anyone may participate in its reading), it engenders fear that the author's intentions, which must secrete the 'truth', might be misunderstood. In all aspects of culture, including architecture, this fear is assuaged by control over the dissemination of information and publicity; and by fastidious cultivation of image—personal, corporate and drawn—including reference to recognised hero-models. Desiring Practices' resistance to suggesting what the answers were, merely where they might lie,

together with our attempt to work with the material presented to us rather than exclusively invited (and of course, an absence of role-models), implies a commitment to admit to the contingent possibilities of the work 'out there' rather than any preconceived model of practice (or practitioner). This was clearly regarded as problematic.

Desiring Practices never quite overcame this problem. The prerequisite of securing financial and spatial support involved convincing those who did not necessarily share our horizon that the exercise was of value. Although unprecedented in architectural projects, our remit was welcomed by the Arts Council whose staff were familiar with the presence of both feminism and postmodern theory in artistic endeavour. Other bodies did not prove as easy to convince, and to this day the project remains mysterious to many in the institutions of architecture (including academic ones). While not unaware of the possibilities for an 'economy of truth' in the presentation of the project, the really interesting aspect of our determination to represent the project in the way *we* desired, was to discover who was open to it and who was not.

The body

'Habeas corpus'
'You will have the body'

The historical absence of the female body from the sites of architectural production has relegated it to the object of symbolic representation: in the origin myths of the classical column, for example, or the symbolic embodiment of virtues such as justice or liberty. The frequency with which the symbolic female body is inscribed in architecture occurs in proportion to the living body's distance from the 'hard labour' of the building site. The arguments that have characterised the female body as passive, fickle, carnal and dissembling, have also relegated the female labour force to the back rooms of design offices, to the 'sensitive' projects, to the domestic world (kitchens and bathrooms a speciality) and to interior design. The systematic exclusion of the female from the articulation of both her own symbolism (not just as the object of representation but as subject in the creation of the symbolic) and from participation in constructing the practice of architecture, means she remains largely unrepresented in architectural culture.

The survival and protection of architecture's sacred knowledge relies on its reproduction through generation after generation of architects. The parallel between this process and maintenance of patrilineal kinship (through naming, marriage, and property rights) is intended. In architecture, this patrimony is

encoded both in its epistemology and professionalism—the theoretical and the practical branches of its knowledge. Significantly, the term reproduction implies a 'naturalisation'—an inevitability—which reinforces the ideology of the dominant power group. It is a premise of our project, however, that in reality, such relations are not reproduced: rather, they are produced. They are not inevitable but are used knowingly to maintain power in the hands of those parties whose interests they serve.

The scarcity of role models has important implications for the female architect. On the one hand, the models open to men are defining and confining; the absence of such preordained roles allows women the freedom to play the market as they will. On the other hand, my own experience suggests that colleagues, clients and patrons alike feel more comfortable with those who are like themselves: the 'other' is treated with suspicion. The attributes of the charm school sit uncomfortably beside the 'gravitas' of the trustworthy professional. Proving oneself in every new situation exacts its weary toll. But however impossible the task may seem, it is essential for women to announce their presence on their own terms; to resist or manipulate the stereotypes and refuse to remain hidden as the support staff in the office back room.

The RIBA's headquarters in Portland Place is a central locus for the production and control of the patrimony of architecture. As a body politic, the Institute is one of the crucial sites in which one can contest Architecture's official values. We took the view that our challenge could be most effectively made known if we took it to the Institute rather than locating ourselves in opposition to it. While we knew we ran the risk of being viewed as complicit with RIBA's own politics, our intention was actually to subvert it. The free market which operates the current administration means that its spaces are commercially available, permitting those with the means to buy access. In the enterprise economy, cash bought us a critical take on the profession. We determined to put the female body—both symbolic and actual—back into architecture.

Our strategy involved filling the building with female bodies at the symposium; locating and naming those taking part at their places around a conference table, the central feature of the exhibition there; and symbolising women's 'possession' of the Institute by implying the presence of the meeting which appeared to be on the point of taking place. The subversion of the room's designated function (exhibition space) into a different one (conference room) went unperceived by many of those who innocently entered spaces already laden with the iconography of the gentleman's club. They didn't notice that the paintings of past Presidents had been supplanted with (largely) Women's work.

The body politic

A principle of the project was that it would not form a platform for the display of the organisers themselves. Although most of the people involved in the project had work to contribute (we were writers, teachers, makers, builders), one of our missions was to question the competitive basis of architectural work, and the star system which values the novel, the glamorous and the individual. We aimed to stress the rewards of collaboration and co-operation. With the possible exception of these essays, the names of those associated with the project remain deliberately obscure, and the project lives by its collective title, not the names of its founders.

This practice goes against the grain, requiring determination and a re-evaluation of expected rewards. A democracy can only operate if those involved are committed to it; so disagreements sometimes become passionate. Although this makes them an invaluable part of the experience, promoting respect and advocacy, there were moments when different viewpoints threatened to undermine the stability of the group. Delegation and personal responsibility became inextricable as conflicting opinions about where ultimate decisions rested were fought through in public. As none of us were paid, the project stood outside the normal economy. Everyone made a bargain with their other life, exchanging this for the satisfaction of simply being involved.

Desiring Practices began life around a kitchen table and continued a peripatetic existence in common with other marginal pursuits. Comprising, at its largest, seventeen people working part-time, at weekends and during out-of-office hours, in deserted offices and at home, our project resembled an under-cover operation. We used the spaces of the city (restaurants, cafés, pubs) as our meeting room. Communication relied on masses of photocopying, and would have been impossible without the phone and fax. In common with the experience of many women, 'a room of one's own' remained an elusive and desired space. It was the experience of holding the project together during key moments of spatial and temporal simultaneity that reaffirmed my personal conviction that architecture's mission—especially for women—is not (yet) redundant.

Postscript

The final day of the symposium provoked one question of particular interest from a member of the audience. The question was directed at the organisers, and I was on the podium. It concerned the reasons why the form of the symposium had not itself been reinvented. This observation implied two things:

that a 'radical' conference should by definition reinvent its own form and that the form it took was *the* privileged aspect of its existence. Something about this proposition reminded me of those debates that are current in architectural discourse, extrapolated to the practice of conference organising: the desire for novelty, the fascination with form at the expense of content, the suspicion with anything that smacks of precedent. Not for the first time in the history of the project, the equation of architectural practice with symposium organisation seemed clear. Clearer still, the same ideologies lay beneath both.

My response has two strands: first, that reinvention is a useful weapon in specific circumstances but involves its own tyrannies, not least of which is a blind adherence to the pursuit of 'progress' without considering its relation to the past, present or future. The aspects of the Desiring Practices project which were reinvented were carefully planned to achieve specific purposes. We used a binary ordering sometimes as a mask, at other times purposely working against such a device in order to reveal its shortcomings. Knowing this would provoke fluid readings and challenge accepted notions of control, we took the risk anyway. Secondly, the question revealed the presence of the binary in another way: by privileging the form of the symposium over the process which brought it about. If practising has any value at all—and this was a key premise of the project—I contend that it lies in the relations and structures that *produce* it and not necessarily on its material outcome, the product of that practice. So, if finally we fell prey to yet another dualism, at least it was not unwittingly.

This essay is a reflection on that question; a reflection which draws an analogy between the practice of architecture and the process of production of the Desiring Practices project. I hope it illustrates the tentative beginnings of one form of desiring practice.

Notes
1 "Working To The Plan", *Plan of Work for Design Team Operation*, reprinted from *The RIBA Handbook 1973*, London: RIBA Publications Ltd., 1973, (no page nos.).
2 Melhuish, C., "Blurry Vision", Review of Desiring Practices Exhibition (RIBA Venue), *Building Design*, 6 October 1995, p. 23.

Desiring Practices Exhibition, October 1995, detail of
'conference table' installation. RIBA Architecture Centre
Photo: Rut Blees Luxemburg

Biographies

Dr. Jennifer Bloomer is Distinguished Visiting Critic in Architecture at Yale University, USA. She is the author of Architecture and Text: *The (S)crypts of Joyce and Piranesi.* She is currently working on *The Matter of Matter: Architecture in the Age of Dematerialisation.*

Jos Boys is programme leader of new courses in Architecture and Urban Studies at De Montfort University, Milton Keynes, UK. She is completing a Ph.D entitled "Concrete Visions?, The Production and Consumption of Architecture 1530-1995". Previous publications include chapters in *Matrix: Making Space: Women and the Man Made Environment* and *A View from the Interior: Women, Gender and Design.*

Judi Farren Bradley is a Senior Lecturer at the Kingston School of Architecture and Course Director of Professional Studies. She is one of the founding members of the Green Audit Research Project, and co-editor of *Green Shift.*

Victor Burgin is an artist and writer. He teaches in the Board of Studies in History of Consciousness at the University of California, Santa Cruz. Previous publications include *The End of Art Theory* and *Between.* Forthcoming publications are *In/Different Spaces; Place and Memory in Visual Culture* and *Some Cities.*

Karen Burns is completing a Ph.D. on "John Ruskin, tourism, sex and *The Stones of Venice*", in the Department of Art History and Cinema Studies at the University of Melbourne. Her essay "A House For Josephine Baker" is forthcoming in *Postcolonial Space(s)*, Princeton Architectural Press, 1996.

Clare Cardinal-Pett is Associate Chair for Academic Affairs at the Department of Architecture, Iowa State University, USA. She teaches design, drawing, computer graphics and history/theory of representation. Her research focuses on drawing and historical methods of construction documentation.

Mark Cousins is the Director of General Studies at the Architectural Association. He has recently published parts of his Friday morning lectures on The Ugly and Danger and Safety. He is co-author, with A. Hussain, of *Michel Foucault.*

Akis Didaskalou studied architecture at the Aristotle University of Thessaloniki, the Architectural Association and the Bartlett. He is currently teaching architectural theory and design at the School of Architecture at the Aristotle University of Thessaloniki.

Paul Finch read history at Cambridge University. He has been an architectural property and construction journalist since 1972. He edited *Building Design* for eleven years and is now editor of *The Architects Journal.*

Adrian Forty is lecturer in the History of Architecture at the Bartlett, University College London, UK, where he runs the Master's Course in History of Modern Architecture. His book *Objects of Desire* was published in 1986, and he is currently writing a book about the history of the relationship between architecture and language.

Diane Ghirardo is a Professor at the School of Architecture, The University of Southern California, USA. She is a past president of the Association of Collegiate Schools of America, Editor of the *Journal of Architectural Education*, author of *Mark Mack, Building New Communities* and editor of *Out of Site.*

Andrea Kahn is an architect practising theory and criticism in New York City, USA. She teaches in the Urban Design Programme at Columbia University, and the Architecture Programme at the University of Pennsylvania. She is editor of *Drawing/Building/Text*.

Neil Leach is lecturer at the University of Nottingham, UK, where he directs the M.A. in Architecture and Critical Theory. He is co-translator of *L. B. Alberti, On the Art of Building in Ten Books*, and editor of *Rethinking Architecture* and *Architecture and Revolution*.

Laura Mulvey is post-graduate studies co-ordinator at the British Film Institute, London, UK. Between 1974 and 1982 she directed six films with Peter Wollen. Her publications include *Visual and Other Pleasures, Citizen Kane* and the forthcoming *Fetishism and Curiosity*. She recently directed a documentary film *Disgraced Monuments* about public art and iconography in the former Soviet Union.

Jane Rendell is an architectural designer and historian. She conducts Ph.D research at Birkbeck College, University of London, into gender and space in early nineteenth century London and teaches gender studies, urban history and architectural design at University College London, Winchester School of Art and De Montfort University, Leicester, UK. She is a founding member of the Strangely Familiar group and co-editor of *Strangely Familiar: Narratives of Architecture in the City*, *The Unknown City* and *InsideOut*, (both forthcoming).

Katerina Rüedi is an architect and Diploma Course Director at the Kingston University School of Architecture, a Ph.D. student at the Bartlett, UCL, deputy editor of *The Journal of Architecture* and co-founder of Desiring Practices. She has published essays in *AA Files*, *a/r/c*, *Innovative Austrian Architecture*, *Daidalos* and *diVersa*.

Henry Urbach is a doctoral candidate in History and Theory of Architecture at Princeton University, USA. He has published articles on related themes, including: "Morpheus mépris: the Murphy bed and obscene rest" in *Center 9: Regarding the Proper*; "Peeking at Gay Interiors", *Design Book Review 25*; and "in medias res", *Assemblage 24*.

Brenda Vale, M.A., Ph.D., RIBA, is a Reader in Green Architecture at the University of Nottingham, UK. Her interest in buildings that have little or no environmental impact began as a student, survived the arrival of three children, and has culminated in the construction of an autonomous house in Southwell, UK.

Sarah Wigglesworth has been principal in her own practice since 1986. She is a Senior Lecturer at Kingston University and has taught and lectured in other UK and overseas schools of architecture. In 1991 she was jointly awarded the Fulbright Arts Fellowship to study architectural practice and theory, resulting in several publications. Both her father and great-uncle were architects.

Colophon

Edited by
Duncan McCorquodale
Katerina Rüedi
Sarah Wigglesworth

Copy Editing by
Maria Wilson

Designed by
Maria Beddoes and Paul Khera

Cover image by
Mark Carranza: Irvine, California.
Reproduced by Permission of
The Institute for the Prevention
of Design

Printed by Spider Web, UK

ISBN 0 9521773 9 0

Black Dog Publishing Limited
PO Box 3082
London UK

British Library Cataloguing-in-
Publication Data.
A catalogue record for this book is
available from the British Library

Acknowledgements

The Desiring Practices project in general, and this book in particular, would not have been possible without the help of a great many people.

The editors would like to thank the following organisations and individuals for their financial support:

The Arts Council of England Architecture Unit, and in particular Rory Coonan and Nicole Crockett.
The Arts Council of England Public Arts Unit and in particular Tim Eastop.
The Thomas Cubitt/Tarmac Trust.
The Kingston University School of Architecture and in particular Professor Peter Jacob.
The Kingston University Staff Research and Development Fund and its director Sue-Ann Lee.
The Bartlett School of Architecture and in particular Professors Pat O'Sullivan, Christine Hawley and Peter Cook.
The Royal Institute of British Architects.
The Architecture Foundation, S. T. S. Bates Architects, Bingham Cotterell Ltd., CD Partnership, Daria Gan, L'Express Cafe, The Library, Odalisque, Patisserie St. Quentin and an anonymous donor.

We are also very grateful for the help and support of:
Faisal Ahmad-Noor, Arcaid, Archivo Carlo Molino, Neil Allfrey, Caroline Austin, Morag Bain, Elizabeth Bandeen, Sherry Bates, Maria Beddoes, Biblioteca Centrale di Architettura Sistema, Bibliotecario Politecnico di Torino, Catherine Blain, Winston Blake, Steve Bowkett, Hazel Burr, Mark Chalmers, Judith Clark, Abel Damoussi, William Day, Frank Duffy, Professor David Dunster, Aaron Firth, Richard Gammon, Trevor Garnham, Didier Garnier, Brian Greathead, Robert Hawkins, Dr. Tanis Hinchcliffe, Helen Iball, Barnaby Johnstone, Paul Khera, Gordana Korolija, James Lau, Henry Leapman, Sue-Ann Lee, Gabriela Ligenza, Lesley Lokko, Helen Mallinson, Zoe Miller, Sandy Percival, Paul Ponwaye, Mary Puddifoot, Elizabeth Rabineau, Bill Robertson, Mark Rowe, Javier Sánchez-Merina, Tessa Schmalhaus, Alex Shaw, Peter Siddell, James Soane, Christine Sullivan, Dr. Philip Tabor, Professor Elena Tamgno, Jane Tankard, Victoria Thornton, Jeremy Till, Kate Trant, Sophy Twohig, Bill Ungless, Teggy Webb and Maria Wilson.